American Stories

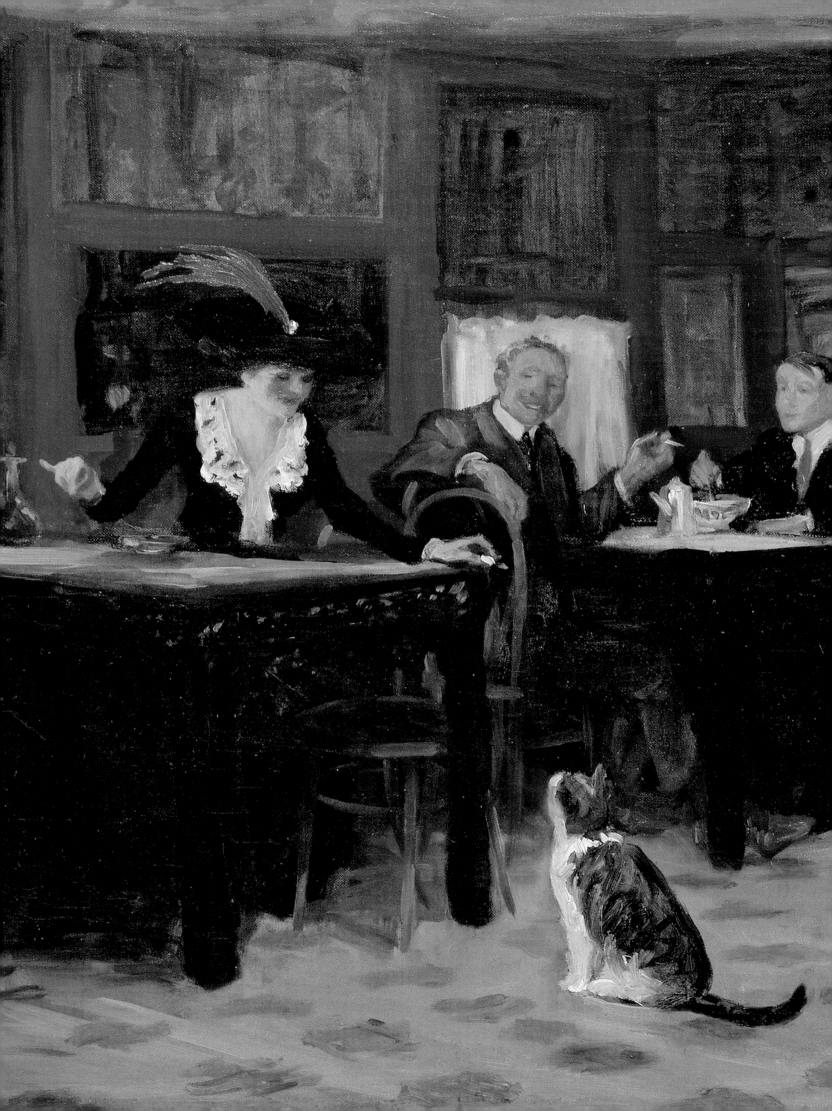

American Stories

Paintings of Everyday Life
1765–1915

Edited by H. Barbara Weinberg and Carrie Rebora Barratt

ESSAYS BY CARRIE REBORA BARRATT, MARGARET C. CONRADS,
BRUCE ROBERTSON, AND H. BARBARA WEINBERG

The Metropolitan Museum of Art, New York
Yale University Press, New Haven and London

This catalogue is published in conjunction with the exhibition "American Stories: Paintings of Everyday Life, 1765–1915," on view at The Metropolitan Museum of Art, New York, from October 12, 2009, through January 24, 2010, and at the Los Angeles County Museum of Art from February 28 through May 23, 2010.

The catalogue is made possible by the William Cullen Bryant Fellows of the American Wing.

The exhibition is made possible by Alamo Rent A Car, The Marguerite and Frank A. Cosgrove Jr. Fund, The Peter Jay Sharp Foundation, the Henry Luce Foundation, and the Oceanic Heritage Foundation.

Education programs are made possible by The Mr. and Mrs. Raymond J. Horowitz Foundation for the Arts.

Published by The Metropolitan Museum of Art, New York
John P. O'Neill, Publisher and Editor in Chief
Gwen Roginsky, General Manager of Publications
Margaret Rennolds Chace, Managing Editor
Harriet Whelchel, Editor
Bruce Campbell, Designer
Chris Zichello, Production Manager
Robert Weisberg, Assistant Managing Editor
Penny Jones, Bibliographer

Unless otherwise specified, all photographs were supplied by the owners of the works of art, who hold the copyright thereto, and are reproduced with permission. We have made every effort to obtain permissions for all copyright-protected images. If you have copyright-protected work in this publication and you have not given us permission, please contact the Metropolitan Museum's Editorial Department. Photographs of works in the Metropolitan Museum's collection are by the Photograph Studio, The Metropolitan Museum of Art; new photography is by Juan Trujillo. Additional photograph credits appear on p. 222.

Separations by Professional Graphics, Inc., Rockford, Illinois
Printed and bound by Arnoldo Mondadori Editore S.p.A., Verona

Jacket/cover illustration: William Merritt Chase. *Ring Toss*, 1896 (detail of fig. 134)
Frontispiece: John Sloan. *Chinese Restaurant*, 1909 (detail of fig. 166)

Library of Congress Cataloging-in-Publication Data

American stories : paintings of everyday life, 1765–1915 / edited by H. Barbara Weinberg and Carrie Rebora Barratt ; essays by Carrie Rebora Barratt . . . [et al.].
 p. cm.
 Published in conjunction with an exhibition held at the Metropolitan Museum of Art, New York, Oct. 12, 2009–Jan. 24, 2010, and at the Los Angeles County Museum of Art, Feb. 28–May 23, 2010.
 Includes bibliographical references and index.
 ISBN 978-1-58839-336-4 (Metropolitan Museum of Art [hc]) —
 ISBN 978-1-58839-337-1 (Metropolitan Museum of Art [pbk.]) —
 ISBN 978-0-300-15508-2 (Yale University Press [hc]) 1. Genre painting, American—Exhibitions. 2. United States—In art—Exhibitions. 3. Manners and customs in art—Exhibitions. I. Weinberg, H. Barbara (Helene Barbara). II. Barratt, Carrie Rebora. III. Metropolitan Museum of Art (New York, N.Y.) IV. Los Angeles County Museum of Art. V. Title: Paintings of everyday life, 1765–1915.
 ND1451.A43 2009
 754.0973'0747471—dc22
 2009026663

Contents

Director's Foreword

It is fitting that the exhibition and catalogue *American Stories: Paintings of Everyday Life, 1765–1915* coincide with a yearlong series of events and activities that celebrate American art at The Metropolitan Museum of Art. Among them is the reopening of the American Wing's Charles Engelhard Court and period rooms following their renovation. Within the next two years, we will inaugurate the redesigned galleries for American paintings and sculpture. These major projects reaffirm the Museum's long-standing commitment to the arts of this nation. Indeed, American art has been central to the mission of the Metropolitan since its founding in 1870. A number of American artists served as founding trustees of the museum, ensuring that the nation's art would be collected and displayed, and in a speech given at the Union League Club in November 1869, William Cullen Bryant, the poet and editor in chief of New York's *Evening Post*, applauded the advent of "an extensive public gallery" that would display masterpieces of American art.

American Stories highlights the variety and strength of American artistic achievement from the colonial era through the period leading to World War I, as scenes of ordinary people engaged in daily activities continually occupied the nation's finest painters. Thanks to the participation of our many lenders, the paintings in this exhibition and its attendant publication represent an extraordinary range of work by America's best artists—including John Singleton Copley, Charles Willson Peale, George Caleb Bingham, William Sidney Mount, Richard Caton Woodville, Eastman Johnson, Winslow Homer, Thomas Eakins, Mary Cassatt, John Singer Sargent, William Merritt Chase, and John Sloan. Within their respective boundaries of time and place, these painters conveyed a myriad of tales using assorted settings, players, and narrative devices. Through their imagery, they also confronted the nature of American identity; attitudes toward race; reality and myth in the American West; and the process and meaning of making art, as they recorded America's growth from an isolated colony to a participant in international affairs.

The exhibition and accompanying volume were initiated under Director Emeritus Philippe de Montebello, whose abiding interest in art historical scholarship informed the selection and investigation of these artworks. We recognize and thank the Metropolitan's organizers, H. Barbara Weinberg, Alice Pratt Brown Curator of American Paintings and Sculpture, and Carrie Rebora Barratt, Curator, American Paintings and Sculpture, and Manager, The Henry R. Luce Center for the Study of American Art, who expertly envisioned and implemented the exhibition and publication from inception to completion. Throughout this undertaking, we have enjoyed our partnership with the Los Angeles County Museum of Art, the second venue for the exhibition. Our principal colleague there has been Bruce Robertson, Consulting Curator in the Department of American Art, who brought wisdom and vision to the project and contributed an essay to the catalogue. We are also grateful to Margaret C. Conrads, Samuel Sosland Curator of American Art at The Nelson-Atkins Museum of Art in Kansas City, for her input on the exhibition and for her catalogue essay.

We extend our deep gratitude to each of our lenders and equally to our generous funders. For its legacy of exhibition support at the Metropolitan Museum, we are thankful to Alamo Rent A Car. The Marguerite and Frank A. Cosgrove Jr. Fund assists endeavors involving American Impressionist painting, of which there are many examples in this exhibition. We thank The Peter Jay Sharp Foundation, the Henry Luce Foundation, the Oceanic Heritage Foundation, and The Mr. and Mrs. Raymond J. Horowitz Foundation for the Arts for their continued and substantial gifts toward initiatives in American art at the Metropolitan. This richly illustrated catalogue was made possible by the William Cullen Bryant Fellows of the American Wing.

Thomas P. Campbell
Director
The Metropolitan Museum of Art

Lenders to the Exhibition

Addison Gallery of American Art, Phillips Academy, Andover, Massachusetts, fig. 168

Albright-Knox Art Gallery, Buffalo, fig. 58

Amon Carter Museum, Fort Worth, Texas, figs. 128 and 157

The Art Institute of Chicago, fig. 95

Brooklyn Museum, figs. 41, 50, and 87

Buffalo Bill Historical Center, Cody, Wyoming, fig. 51

Carnegie Museum of Art, Pittsburgh, fig. 71

Chrysler Museum of Art, Norfolk, Virginia, fig. 169

The Cleveland Museum of Art, fig. 65

Corcoran Gallery of Art, Washington, D.C., fig. 119

Crystal Bridges Museum of American Art, Bentonville, Arkansas, figs. 46 and 52

The Detroit Institute of Arts, fig. 131

Fenimore Art Museum, Cooperstown, New York, fig. 64

Fine Arts Museums of San Francisco, fig. 156

Harvard University Art Museums, Fogg Art Museum, Cambridge, Massachusetts, fig. 79

The Huntington Library, Art Collections, and Botanical Gardens, San Marino, California, fig. 69

Indianapolis Museum of Art, fig. 80

Joslyn Art Museum, Omaha, Nebraska, fig. 136

Los Angeles County Museum of Art, figs. 60, 101, 124, and 175

Maryland Historical Society, Baltimore, fig. 18

Memorial Art Gallery of the University of Rochester, New York, fig. 166

The Metropolitan Museum of Art, New York, figs. 2, 16, 34, 39, 47, 48, 61, 82, 83, 86, 88, 89, 93, 96, 97, 98, 99, 102, 110, 118, 121, 122, 125, 132, 160, and 162

Museum of Fine Arts, Boston, fig. 7

Museum of Fine Arts, Houston, fig. 164

National Gallery of Art, Washington, D.C., figs. 10, 12, 100, 114, and 174

The New-York Historical Society, figs. 26, 30, 62, and 67

North Carolina Museum of Art, Raleigh, figs. 63 and 66

Pennsylvania Academy of the Fine Arts, Philadelphia, figs. 11, 17, 19, and 25

Philadelphia Museum of Art, figs. 91, 109, 120, and 159

Royal Academy of Arts, London, fig. 113

Saint Louis Art Museum, figs. 4, 44, and 104

Shelburne Museum, Shelburne, Vermont, fig. 54

Smith College Museum of Art, Northampton, Massachusetts, fig. 40

Smithsonian American Art Museum, Washington, D.C., figs. 68 and 130

Stark Museum of Art, Orange, Texas, fig. 84

Sterling and Francine Clark Art Institute, Williamstown, Massachusetts, figs. 37 and 112

Terra Foundation for American Art, Chicago, figs. 22 and 117

Toledo Museum of Art, Ohio, fig. 126

Virginia Museum of Fine Arts, Richmond, fig. 177

The Walters Art Museum, Baltimore, Maryland, figs. 35 and 45

Whitney Museum of American Art, New York, fig. 167

Winterthur Museum, Delaware, fig. 20

Worcester Art Museum, Massachusetts, fig. 142

Yale University Art Gallery, New Haven, fig. 172

The Anschutz Collection, fig. 152

Art and Elaine Baur, fig. 107

Marie and Hugh Halff, fig. 134

Philip and Charlotte Hanes, fig. 14

Manoogian Collection, fig. 49

Ted Slavin, fig. 133

The Terian Collection of American Art, fig. 165

Mathew Wolf and Daniel Wolf, fig. 90

Anonymous lenders, figs. 43 and 74

Contributors to the Catalogue

CARRIE REBORA BARRATT, *Curator, American Paintings and Sculpture, and Manager, The Henry R. Luce Center for the Study of American Art, The Metropolitan Museum of Art*

MARGARET C. CONRADS, *Samuel Sosland Curator of American Art, The Nelson-Atkins Museum of Art, Kansas City*

BRUCE ROBERTSON, *Professor of Art History, University of California, Santa Barbara, and Consulting Curator, Department of American Art, Los Angeles County Museum of Art*

H. BARBARA WEINBERG, *Alice Pratt Brown Curator of American Paintings and Sculpture, The Metropolitan Museum of Art*

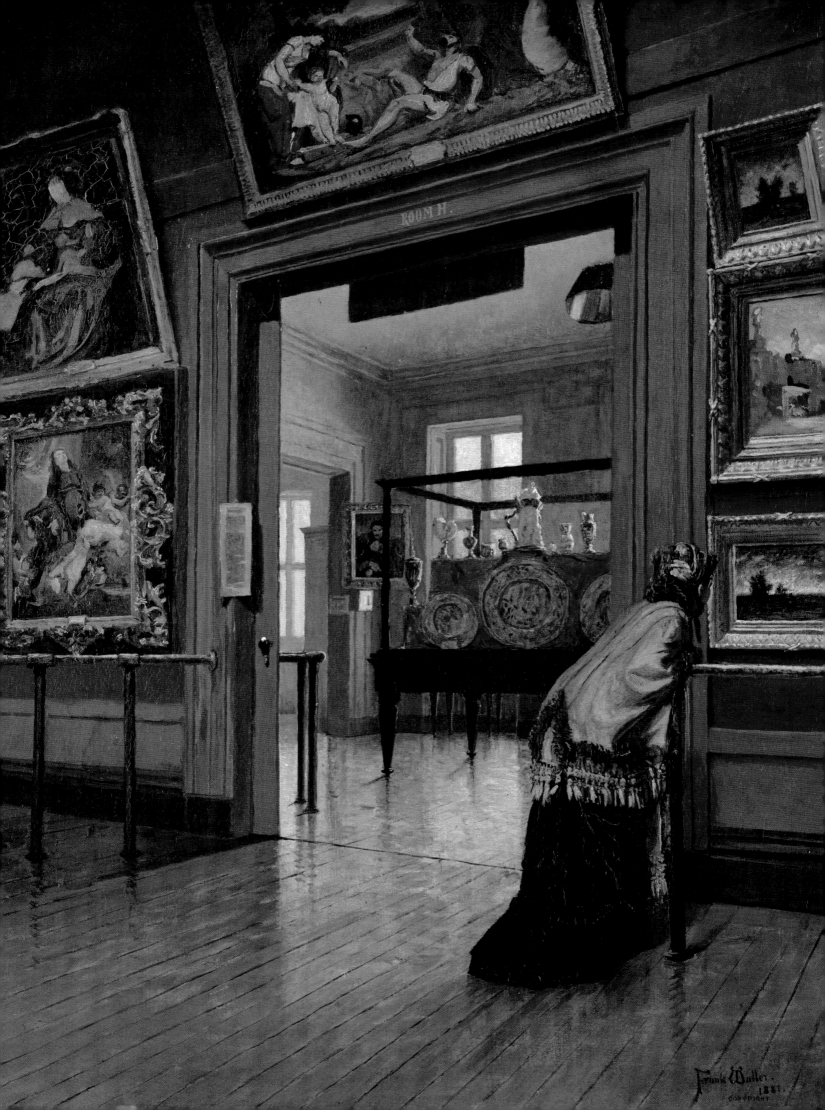

Preface and Acknowledgments

American Stories: Paintings of Everyday Life, 1765–1915 presents more than one hundred works that portray people engaged in life's tasks and pleasures, at home and abroad, during an epochal century and a half. From the decade before the American Revolution to the eve of World War I, what began as a rural and agricultural society became more urban and industrial and reacted to technological innovations that would forever alter the understanding of time and space. A group of modest British colonies became states; new states pushed the frontier westward to span the continent; and the nation—reunified after the Civil War under an increasingly powerful federal government—became a leading participant in international affairs. At the heart of daily life, family structures changed; gender roles were redefined; the population grew as a result of greater wealth and became more diverse through immigration; and citizens witnessed the advent of racial divisions that would shake America to its core.

Throughout this complicated, transformative era, artists responded to the forces and events that shaped American history and culture and to the various professional spheres that they themselves inhabited. Our choice of works for display in the exhibition and for discussion in this catalogue favors refined compositions, credible treatment of the human figure, and skillful execution relative to available training, materials, audiences, and patronage. Seeking a visually and intellectually coherent account of daily life as the nation developed, we have concentrated on a core group of major painters who defined the temperament of their respective periods: John Singleton Copley, Charles Willson Peale, George Caleb Bingham, William Sidney Mount, Richard Caton Woodville, Eastman Johnson, Winslow Homer, Thomas Eakins, Mary Cassatt, John Singer Sargent, William Merritt Chase, and John Sloan. Included in addition to selections of their works are high-quality examples by lesser-known artists that also manifest a broad array of subjects and styles.

Our study is limited to depictions of ordinary events or events witnessed by average Americans. Some stories, like Brook Watson's encounter with a shark in Havana Harbor (fig. 10), are, to be sure, extraordinary. Yet Watson was an average midshipman taking a swim when the incident

Frank Waller. *Interior View of the Metropolitan Museum of Art when in Fourteenth Street*, 1881 (detail of fig. 118)

occurred in 1749; it is Copley's account, painted nearly thirty years later and composed for maximum narrative effect, that makes the episode seem to transcend daily life. William Tylee Ranney's *Advice on the Prairie* of about 1853 (fig. 51) and Arthur Fitzwilliam Tait's *Life of a Hunter: A Tight Fix* of 1856 (fig. 52) may likewise tell remarkable stories, but they also capture incidents that their protagonists apparently experienced. Further, they appealed to urban viewers who vicariously enjoyed frontier and wilderness adventures. We have excluded accounts derived from history, myth, and literature, emphasizing instead those based on artists' firsthand observation, documentation, and interaction with clients. One could say that our chosen narratives are analogous to original—not adapted—screenplays.

The paintings themselves determined our chronological parameters. Matthew Pratt's *American School* of 1765 (fig. 2), a unique and ingratiating colonial conversation piece, or group portrait with narrative elements, establishes the leading edge. Pratt's canvas blends the documentary subtlety of John Smibert's *Bermuda Group* of 1729–31 (fig. 6) with some of the cartoonish energy of John Greenwood's *Sea Captains Carousing in Surinam* of about 1752–58 (fig. 4). The latest works in our display—two dissimilar views of modern life by George Bellows and Sargent (figs. 175 and 177, respectively)—date from about 1913, by which time Marsden Hartley, Max Weber, and other American modernists influenced by cubism, fauvism, and abstraction were disdaining narrative and representation, and movies were beginning to challenge paintings as vehicles for storytelling. If we were to continue our chronology, we would consider the politically and culturally isolationist 1920s, when conservative painters such as Edward Hopper and Reginald Marsh, participants in the Harlem Renaissance such as Archibald Motley, and some erstwhile modernists such as Hartley and Weber turned or returned to narrative and figuration as reassuring national modes. During the crisis of the 1930s, American storytelling reached a climax in works by regionalists such as Grant Wood and Thomas Hart Benton. But these tales, like new accounts of American literary, biblical, and historical painting, remain to be told in other exhibitions.

Our exhibition and catalogue cover the period from 1765 to 1915, which is further divided into four sections. In each, we describe the era briefly and consider how its character and

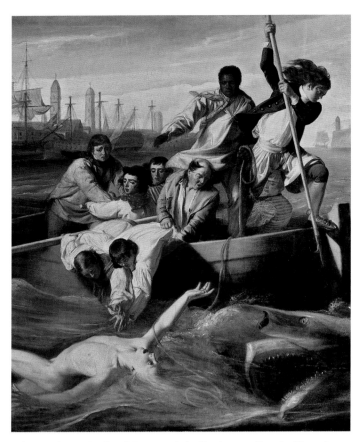

John Singleton Copley. *Watson and the Shark*, 1778 (detail of fig. 10)

events affected what stories our artists chose to tell. We are equally interested in the means by which painters told stories, and we examine their choices of settings, players, action, and narrative devices, as well as their responses to foreign proto-types, travel and training, exhibition venues, and audience expectations. We also explore how contemporaneous viewers might have understood these painted stories—and what they might signify when we read them through the prism of our own time. Because we know that meanings of paintings, like those of written texts, shift with the reader's time, methodology, or viewpoint, we concede that our interpretations are only provisional, not definitive.

Although we organized our study chronologically, we realize that archetypal themes recur throughout our four sections, serving as long linear warps to our chronological wefts, the-matic longitudes to our historical latitudes. For example, all of these painters of everyday life were consistently interested in gender roles, courtship, marriage, raising children, and growing old; how families functioned and were maintained against society's pressures; and how individuals related to the family, the community, and the wider environment. Time and again our painters addressed the attainment and rein-forcement of citizenship; attitudes toward race; the frontier as reality and myth; and the process and meaning of art making. We observed that painters of American stories, who at first

focused only on individuals, progressively expanded their subject interests to include the family, society, the nation, and the world. In shifting their attention from the local and site specific to the wider horizon, they metaphorically recapitu-lated America's territorial expansion and emergence on the international stage.

Comparisons between works from different eras are reveal-ing. For example, Francis William Edmonds's *New Bonnet* of 1858 (fig. 34) seems visually and rhetorically distant from Theodore Robinson's *Wedding March* of 1892 (fig. 117), although both canvases address family life. In Edmonds's scene, each object in the middle-class American parlor and every gesture of the artfully directed figures—from the little girl who has delivered the bonnet, to the daughter who admires it, to the parents who are shocked by its cost—are easily understood. By contrast, the narrative in Robinson's portrayal of a bridal party promenading along a French vil-lage lane is subtle and is captured spontaneously. Although we know that Robinson's painting transcribes naturalistic ele-ments and tells a story, we cannot immediately apprehend its details or its point. In the decades between Edmonds and Robinson, both narrative requirements and stylistic trends evolved in response to changing artistic resources and view-ers' standards and desires.

Relationships between the narrative arc and style of painted American stories and those of contemporaneous literary texts are also provocative. For example, the stories implied by Copley's 1768 portrait of Paul Revere incising a teapot (fig. 7) and Cassatt's image of a young woman taking tea of about 1880–81 (fig. 121) may be read, respectively, as painted coun-terparts of Benjamin Franklin's pointed aphorisms and of Henry James's reflections on the inner life of the individual. Our viewers and readers will surely tease out other themes, issues, and parallels embedded in the works we have gathered.

We begin our analysis with "Inventing American Stories, 1765–1830," looking at Copley, Peale, Samuel F. B. Morse, and others who managed to tell stories within the expressive bounds of portraiture. Desiring only portraits, most colonial patrons treated artists as tradesmen who supplied bespoke and private pictures, attitudes that prompted Copley to complain in about 1767: "Was it not for preserving the resembla[n]ce of perticular [*sic*] persons, painting would not be known in the plac[e]. The people generally regard [paint-ing] no more than any other usefull trade."[1] Serving their sitters' self-conscious interest in how they appeared in the eyes of others, portraitists often emulated British prototypes, which they knew through imported prints or visits to London galleries and private homes. Although they focused on individuals and specific locales and relationships, the clev-erest of them responded to broader narrative agendas and to the natural impulse to tell stories. Their works reflect shifts in

population, social strata, and artistic practice and patronage as the colonies were transformed into a nation.

As patrons gradually learned to read portraits for more than likeness and to appreciate artistic license, portraitists began to reveal their sitters' desired social positions and to delight them with more elaborate compositions. In his ingenious depiction of Benjamin and Eleanor Ridgely Laming of 1788 (fig. 12), for instance, Peale went beyond the picture's principal function as a double likeness of a married couple to explore the subtleties of a tender relationship and gendered role playing, universal narrative themes that would have been legible even to those unacquainted with the Lamings themselves. The bodily conduct and gestures that Peale depicts suggest the mutual admiration between a man and a woman and the sexual nature of romantic love. Later in this period, painters would tell new stories in works made for increasingly receptive patrons and for public exhibition. Through *Gallery of the Louvre* of 1831–33 (fig. 22), for example, Morse proposed that his compatriots should achieve political and cultural independence from Europe even as they learned from the Old World's greatest artistic achievements. In showing visitors making art in a modified version of the Salon Carré, Morse delivers a visual lecture on education and morality in America, creating one of the era's consummate narrative paintings.

In "Stories for the Public, 1830–1860," we see American artists adopting new modes of pictorial storytelling, primarily in the form of genre paintings. Works described as genre (a French term that refers to types, sorts, or categories) are clearly delineated, humorous, didactic or moralizing, and designed to appeal to a wide clientele. These domestic scenes of lower- and middle-class characters were often inspired by old master Dutch or more recent French and English prototypes, usually known through popular prints. Whereas the creation of portraits was circumscribed by individual commissions and private display, the emergence of genre paintings coincided with an expanding audience for public exhibitions; the development of mechanisms for selling art in shops and at auction and for making and distributing reproductions; the appearance of illustrated publications ranging from cheap newspapers and almanacs to luxurious gift books; and the increasing cultural literacy and wealth of middle-class patrons that enabled them to appreciate and acquire all these visual resources. Mount, the most successful American genre painter, along with Bingham, Edmonds, Lilly Martin Spencer, Woodville, and others, reinforced in their works popular notions of national identity and character and competed with contemporaneous Hudson River School landscapists for attention and patronage. Paintings by all these artists echo the spirit of Ralph Waldo Emerson's 1837 *American Scholar* address, in which he called for cultural self-sufficiency: "Our day of dependence, our long apprenticeship to the learning

of other lands, draws to a close. The millions that around us are rushing into life, cannot always be fed on the sere remains of foreign harvests. Events, actions arise, that must be sung, that will sing themselves."[2]

American genre painters favored depictions of courtship, families, and community life in rural settings that, by contrast with menacing cities, were associated positively with fundamental national values. Edmonds's *City and Country Beaux* of about 1838–40 (fig. 37) invites the viewer to consider the virtues and vices of each milieu as a young woman chooses between a self-satisfied country bumpkin and a slick Yankee who has just arrived on the scene. In *Kiss Me and You'll Kiss the 'Lasses* of 1856 (fig. 41), Spencer's young woman, surrounded by a luxuriant array of fruits and baking supplies, saucily tempts viewers to come close but only if they are willing to risk contact with her sticky spoon. The painting illustrates a tale of feminine wiles and independence, at least within the confines of a homemaker's purview. The creators of these little domestic dramas always provided obvious settings, characters, gestures, and details so that audiences could read them easily and recognize themselves in relation to them.

Rather than confronting the deepening rifts between blacks and whites, immigrants and native workers, and

William Sidney Mount. *The Power of Music*, 1847 (detail of fig. 65)

geographical regions, American genre painters approached these fraught subjects euphemistically. Bingham tamed the perceived perils of the frontier and the influx of immigrants in *Fur Traders Descending the Missouri* of 1845 (fig. 48). When he sent the canvas from Missouri for exhibition and sale by lottery at New York's American Art-Union, he disclosed the work's specifics in the title he gave it: *French-Trader—Half breed Son*. Preferring to elide ethnicity, officials at the Art-Union renamed it to highlight the industry and the locale depicted, thus making it even less objectionable and more emblematic. In *War News from Mexico* of 1848 (fig. 46), Woodville distilled contemporary politics and race relations into a scene that takes place on the porch of the rural American Hotel. There a gathering of white men, united by their interest in the Mexican-American conflict, are set apart from a woman and an African American man and child, who are merely peripheral witnesses. In *The Power of Music* of 1847 (fig. 65), Mount commented on race in a different but equally reassuring country context, showing an African American man excluded from a group of whites yet enjoying the sound of the fiddle played by one of them. Amiable in its subject and suggesting that racial divisions might be harmonized, *The Power of Music* captivated viewers when it debuted in 1847 at New York's National Academy of Design, and it became the first American painting made into a lithographic print for international distribution. Johnson's *Negro Life at the South* of 1859 (fig. 67) also echoes familiar genre themes— in this case a family at home and music making—but it describes African Americans in Washington, D.C., not in the countryside. Although Johnson's painting addresses race more frankly than did Woodville's or Mount's, it tells an ambiguous story. On the eve of the Civil War, apologists for slavery could read the image for signs of easy living and family solidarity despite forced servitude, whereas abolitionists could interpret the dilapidated buildings and humbly dressed people as symbols of slavery's moral failings. The canvas, which launched Johnson's career when it appeared at the National Academy of Design in 1859, signaled painters' adoption of the open-ended story lines that would define postwar scenes of everyday life.

"Stories of War and Reconciliation, 1860–1877" reveals how Homer, Johnson, Eakins, and others responded to the Civil War, Reconstruction, and the Centennial. Fought by volunteers, not professional soldiers, the Civil War was essentially democratic, as is reflected in Homer's description of the life of common soldiers in a series of anecdotal paintings he began to show in 1863. The most ambitious of these is *Pitching Quoits* of 1865 (fig. 79), which depicts a group of soldiers relaxing in camp. These soldiers had ordered picturesque red uniforms like those of the Zouaves, Berber tribesmen who had fought with the French in the Crimean War (1853–56).

Inevitably, the American Zouaves became easy targets in battle and they soon adopted standard Union blue. Canvases such as Homer's *Veteran in a New Field*, also of 1865 (fig. 82), reflect the artist's more profound understanding of the war's impact and meaning as it drew to a close.

Seeking to assuage the sorrow brought on by the war and to heal the nation's fractured spirit, American painters of everyday life turned away from political content. Responding to the assertion of women's societal responsibilities after the loss of so many men in combat, Homer and other artists portrayed them in new roles. In his *Croquet Scene* of 1866 (fig. 95), Homer shows women competing with men on a literally level playing field, where strategy rather than strength carries the day. Such paintings celebrate the return to peaceful pursuits and document the middle-class fad for recreation in general, and croquet in particular. Expressing nostalgia for prewar innocence and the commemorative atmosphere of the Centennial, many artists portrayed children. Seymour Joseph Guy, for example, made his reputation with charming, sometimes provocative images such as *Story of Golden Locks* of about 1870 (fig. 90) and *Making a Train* of 1867 (fig. 91). And, as the agrarian basis of American life gave way to urbanization and industrialization, artists who were themselves working in thriving cities manifested the longing for earlier, simpler times in their nostalgic depictions of the countryside. In his *Talking It Over* of 1872 (fig. 98), Enoch Wood Perry even located the avatars of George Washington and Abraham Lincoln in a country setting. Unlike their antebellum predecessors, however, artists of this time were likely to show rural locales, including seaside resorts, as merely temporary retreats from urban life rather than sustainable habitats.

By the mid-1870s, the taste of American viewers and patrons had matured in response to their expanded opportunities for travel; ready access to prints, photographs, illustrations in magazines and journals, and other reproductions; and exposure to art in newly founded museums. As these viewers and patrons, principally in the prosperous industrial Northeast, came to value contemporary continental—especially French—art, American painters yielded to an unprecedented internationalism, embracing new stories and new means by which to tell them. Assisted, like their patrons, by easier trans-Atlantic transportation and communication, they studied abroad in ever-growing numbers; lived in European cities and art colonies; and adopted subjects and styles from academic to Impressionist to explore as expatriates or to accommodate to American situations upon their return home. They were as likely to paint people enjoying everyday life in Paris or the French countryside as they were their subjects' counterparts in New York or New England. Their works reveal an appreciation of the journalistic, candid, fragmented, oblique narrative that inflected foreign examples, and an evasion of the

Seymour Joseph Guy. *Making a Train*, 1867 (detail of fig. 91)

harsh realities of modern existence. American painters also operated in a newly complex and professionalized art world, which broadened their opportunities for displaying and marketing art on both sides of the Atlantic, often in competition with foreign examples, as they attended to the judgments of a newly serious and credible art press. Meriting comparison with Emerson's nationalistic pronouncement of 1837, a letter of September 1867 from twenty-four-year-old Henry James to his fellow writer Thomas Sergeant Perry predicts the internationalist spirit to which late nineteenth-century American artists would respond. James wrote, "I think that to be an American is an excellent preparation for culture. We have exquisite qualities as a race, and it seems to me that we are ahead of the European races in the fact that more than either of them we can deal freely with forms of civilisation not our own, can pick and choose and assimilate and in short (aesthetically &c) claim our property wherever we find it."[3]

Finally, in "Cosmopolitan and Candid Stories, 1877–1915," Homer is joined by Eakins, Cassatt, Chase, Sargent, Sloan, Bellows, and others who redefined American identity in an international context and explored fresh modern subjects for their painted stories. The works of these artists amplify many of the issues that had been addressed in scenes of everyday life between 1860 and 1877. Artists continued to record the lives of women as devoted mothers, dedicated household

managers, participants in genteel feminine rituals, and resolute keepers of culture. Cassatt's *Woman and a Girl Driving* of 1881 (fig. 120) tells of the daily routine of affluent late nineteenth-century women and indicates the artist's own appreciation of female empowerment by portraying her sister Lydia as she takes the reins of a small carriage and, presumably, manages her own path. In *A Reading* of 1897 (fig. 130) and *Mosquito Nets* of 1908 (fig. 131), Thomas Wilmer Dewing and Sargent, respectively, commemorate quiet feminine pastimes and the escape from mundane existence into the realm of the imagination. Eakins, Thomas Anshutz, Frederic Remington, and others examined men at work and leisure and celebrated new American heroes such as cowboys, who, in paintings such as Remington's *Fight for the Water Hole* of 1903 (fig. 164), serve as icons of American masculinity and of the receding frontier.

As tension escalated between fading rural traditions and increasing urbanization and industrialization, artists investigated city environs and suburban retreats, including new sites for leisure, consumption, and entertainment. They preferred allusion to description and were even more euphemistic in dealing with modern life than their predecessors had been. In *Idle Hours* of about 1894 (fig. 128), for example, Chase, the leading Impressionist formed on American shores, depicts fashionable figures taking their ease on a placid greensward along a beach in Southampton, Long Island. Unlike earlier accounts of rural recreation such as Jerome B. Thompson's *Belated Party on Mansfield Mountain* of 1858 (fig. 39), which emphasizes visitors' awe before the grandeur of nature, Chase's canvas suggests his figures' calm absorption in their unprepossessing suburban surroundings. By contrast, Sloan, a leader among the Ashcan artists who challenged American Impressionist decorum after 1900, was committed to recording the modern world more frankly than either Thompson or Chase did. Yet in works like *Picnic Grounds* of 1906–7 (fig. 167), which portrays a mundane urban locale and features blithely uninhibited working-class girls, Sloan typically maintains the cheerful outlook preferred by the Impressionists. Sloan's associates among the Ashcan artists encouraged viewers to share their own immersion in modern life by inviting them to experience other distinctive urban venues that had not previously appeared in paintings. In *Orchestra Pit, Old Proctor's Fifth Avenue Theatre* of 1906–7 (fig. 172), Everett Shinn offers front-row seats at a vaudeville show. In his contemporaneous *Club Night* (fig. 174), Bellows provides ringside seats at a brutal boxing match, which women, who could have seen the painting, would not have been allowed to attend.

American scenes of everyday life have not been gathered in major exhibitions or studied comprehensively in critical publications for more than thirty-five years. In 1973, Hermann Warner Williams produced an exemplary book, *Mirror to the*

American Past: A Survey of American Genre Painting, 1750–1900, and the following year Patricia Hills organized *The Painters' America: Rural and Urban Life, 1810–1910*, an exhibition for the Whitney Museum of American Art. Also in 1974, Donelson F. Hoopes, with Nancy Dustin Wall Moure, organized *American Narrative Painting* for the Los Angeles County Museum of Art but combined scenes of ordinary life with images of historical themes. Subsequent exhibitions that focused on aspects of American storytelling include *Domestic Bliss: Family Life in American Painting, 1840–1910*, organized by Lee McCormick Edwards and others for the Hudson River Museum in 1986; *Facing History: The Black Image in American Art, 1710–1940*, organized by Guy McElroy and others for the Corcoran Gallery of Art in 1990; *American Impressionism and Realism: The Painting of Modern Life, 1885–1915*, organized by H. Barbara Weinberg, Doreen Bolger, and David Park Curry for The Metropolitan Museum of Art and the Amon Carter Museum in 1994; and *Young America: Childhood in Nineteenth-Century Art and Culture*, organized by Claire Perry for the Cantor Center for Visual Arts, Stanford University, in 2006. Books on related subjects include Sarah Burns's *Pastoral Inventions: Rural Life in Nineteenth-Century American Art and Culture*, published in 1989, and Elizabeth Johns's influential *American Genre Painting: The Politics of Everyday Life*, published in 1991. There has been an abundance of scholarship on the foremost painters of everyday life considered in our exhibition. Among them, only Mount lacks a recent monograph, and many lesser-known painters warrant more scrutiny than they have received.

Studies of Western painting have flourished and a steady stream of exhibitions and publications that deal with the frontier, pioneers, cowboys, and Indians has appeared. Among the exhibitions are *The West as America: Reinterpreting Images of the Frontier, 1820–1920*, organized by William H. Truettner and others for the National Museum of American Art in 1991; and *Remington, Russell and the Language of Western Art*, organized by Peter H. Hassrick for the Trust for Museum Exhibitions in 2000. The Ashcan artists, both as individuals and as a group, have also been the subject of recent exhibitions and publications, among which Rebecca Zurier's are among the most noteworthy. In addition, the proliferation of well-researched catalogues of public and private collections has permitted in-depth examination of many American paintings of everyday life by curators most familiar with them and has provided an indispensable resource for us.

We acknowledge the contributions of Williams, Hills, and other scholars mentioned above and cited in our bibliography as we essay this new overview of American paintings of everyday life, works that described and defined Americans as individuals, citizens, and members of ever-widening communities. These works fulfill a notion expressed in 1892 by American Impressionist Childe Hassam: "A true historical painter," said Hassam, is "one who paints the life he sees about him, and so makes a record of his own epoch."[4]

We welcome the opportunity to thank many people who helped us to realize this exhibition at the Metropolitan, beginning with Director Emeritus Philippe de Montebello, to whom this volume is dedicated. As always, Philippe supported our scholarship and brought his wisdom to bear on our enterprise, encouraging us to take this fresh look at American narrative painting. Upon succeeding to the directorship in January 2009, Thomas P. Campbell took an immediate interest in the project and has brought his own insights and good judgment to bear on the exhibition, its catalogue, and related programs. Mahrukh Tarapor, former Associate Director for Exhibitions, coordinated preparations with help from Martha Deese, and Doralynn Pines, former Associate Director for Administration, endorsed our efforts. Emily Kernan Rafferty, the Metropolitan's President, was a great advocate for the exhibition. Nina McN. Diefenbach, Vice President for Development and Membership, and her associates, especially Andrea Kann and Christine Begley, coordinated contributions for the exhibition from Alamo Rent A Car, The Marguerite and Frank A. Cosgrove Jr. Fund, The Peter Jay Sharp Foundation, the Henry Luce Foundation, the Oceanic Heritage Foundation, and The Mr. and Mrs. Raymond J. Horowitz Foundation for the Arts, and, for the catalogue, from the William Cullen Bryant Fellows of the American Wing. To these valued sponsors of our efforts at the Metropolitan, we are deeply appreciative.

We depended upon numerous institutions and individuals for information and assistance. Three repositories that deserve special notice are the Archives of American Art, Smithsonian Institution, and the Library of Congress, both in Washington, D.C.; and the New York Public Library. Our lenders not only agreed to share their treasures with our audiences, but they also furnished information about them. We are grateful for their generous responses to all our requests and inquiries, and we offer thanks to the following individuals and their associates: Brian T. Allen and Susan Faxon, Addison Gallery of American Art, Phillips Academy, Andover, Massachusetts; Louis Grachos and Douglas Dreishpoon, Albright-Knox Art Gallery, Buffalo; Rick Stewart and Rebecca Lawton, Amon Carter Museum, Fort Worth, Texas; James Cuno and Judith A. Barter, The Art Institute of Chicago; Arnold L. Lehman, Charles Desmarais, and Teresa Carbone, Brooklyn Museum; Robert E. Shimp, Buffalo Bill Historical Center, Cody, Wyoming; Richard Armstrong and Louise Lippincott, Carnegie Museum of Art, Pittsburgh; William J. Hennessey and Jefferson Harrison, Chrysler Museum of Art, Norfolk, Virginia; Timothy Rub,

Charles L. Venable, and Mark Cole, The Cleveland Museum of Art; Paul Greenhalgh and Sarah Cash, Corcoran Gallery of Art, Washington, D.C.; Alice Walton, Robert Workman, Christopher Crosman, and Elizabeth Workman, Crystal Bridges Museum of American Art, Bentonville, Arkansas; Graham W. J. Beal, Kenneth Myers, and James Tottis, The Detroit Institute of Arts; Paul S. D'Ambrosio, Fenimore Art Museum, Cooperstown, New York; John E. Buchanan Jr., Robert Futernick, and Timothy Anglin Burgard, Fine Arts Museums of San Francisco; Thomas W. Lentz and Theodore E. Stebbins Jr., Harvard University Art Museums; John Murdoch and Jessica Todd Smith, The Huntington Library, Art Collections, and Botanical Gardens, San Marino; Maxwell Anderson, Anthony Hirschel, and Harriet Warkel, Indianapolis Museum of Art; J. Brooks Joyner and John Wilson, Joslyn Art Museum, Omaha, Nebraska; Dennis A. Fiori and Nancy Davis, Maryland Historical Society, Baltimore; Grant Holcomb and Marjorie Searl, Memorial Art Gallery of the University of Rochester; Malcolm Rogers, Elliot Bostwick Davis, and Erica E. Hirshler, Museum of Fine Arts, Boston; Peter C. Marzio and Emily Ballew Neff, Museum of Fine Arts, Houston; Earl A. Powell III and Franklin Kelly, National Gallery of Art, Washington, D.C.; Louise Mirrer, Linda Ferber, Kimberly Orcutt, David Burnhauser, and Scott Wixon, The New-York Historical Society; Lawrence J. Wheeler and John Coffey, North Carolina Museum of Art, Raleigh; David Brigham, Derek Gillman, and Lynn Marsden-Atlass, Pennsylvania Academy of the Fine Arts, Philadelphia; the late Anne d'Harnoncourt, Kathleen A. Foster, and Joseph J. Rishel, Philadelphia Museum of Art; MaryAnne Stevens and Edwina Mulvany, Royal Academy of Arts, London; Brent R. Benjamin and Andrew Walker, Saint Louis Art Museum; Stephan F. F. Jost and Deborah Shenk, Shelburne Museum, Shelburne, Vermont; Jessica Nicoll and Linda Muehlig, Smith College Museum of Art, Northampton, Massachusetts; Elizabeth Broun and Eleanor Jones Harvey, Smithsonian American Art Museum; Sarah E. Boehme and Richard Hunter, Stark Museum of Art, Orange, Texas; Michael Conforti and Marc Simpson, Sterling and Francine Clark Art Institute, Williamstown, Massachusetts; Elizabeth Glassman, Elizabeth Kennedy, and Katherine Bourguignon, Terra Foundation for American Art, Chicago; Don Bacigalupi and Lawrence W. Nichols, Toledo Museum of Art, Ohio; Alex Nyerges, Thomas N. Allen, Sylvia Yount, and Elizabeth O'Leary, Virginia Museum of Fine Arts, Richmond; Gary Vikan and William R. Johnston, The Walters Art Museum, Baltimore, Maryland; Adam D. Weinberg and Barbara Haskell, Whitney Museum of American Art, New York; Leslie Greene Bowman and Anne Verplanck, Winterthur Museum & Country Estate, Delaware; James A. Welu and Elizabeth Streicher, Worcester Art Museum, Massachusetts; Jock Reynolds, Helen Cooper, and Robin Jaffee Frank, Yale University Art Gallery, New Haven. The American paintings dealers Susan E. Menconi and Andrew L. Schoelkopf, and Eric Widing of Christie's, offered indispensable advice; D. Frederick Baker, Pamela Ivinski, Richard Ormond, and others answered queries. We are very much indebted to the private lenders who sacrificed their own enjoyment of their works to share them with our audiences. We thank Philip Anschutz of The Anschutz Collection, and his associate Darlene Dueck; Art and Elaine Baur; Marie and Hugh Halff; Philip and Charlotte Hanes; Richard A. Manoogian of the Manoogian Collection, and his associates Jonathan Boos and Cheryl M. Robledo; Ted Slavin; Juliana Terian Gilbert of The Terian Collection of American Art, and her associates David Nisinson and Jeffrey Schmunk; Mathew Wolf and Daniel Wolf; and two anonymous lenders, one of whom was represented by Karl Gabosh.

Plans for the exhibition were implemented by many skilled colleagues at the Metropolitan Museum. Kirstie Howard drafted our contracts with the advice of Sharon H. Cott, Senior Vice President, Secretary, and General Counsel. Nina S. Maruca organized registration with the help of Aileen Chuk. Conservators Michael Gallagher, Dorothy Mahon, George Bisacca, and Cynthia Moyer cared for works from our own collection and for loans. Linda M. Sylling coordinated our handsome installation in collaboration with our gifted exhibition and graphic designers Michael Batista and Constance Norkin, respectively. Pamela T. Barr oversaw the exhibition labels. Taylor Miller supervised construction and Clint Coller and Richard Lichte worked their magic with lighting. American Wing technicians Don E. Templeton, Sean Farrell, Dennis Kaiser, and Chad Lemke brought their usual professionalism to installing the exhibition, and Gerald P. Lunney and his colleagues in the packing shop were key collaborators. Morrison H. Heckscher, the Lawrence A. Fleischman Chairman of The American Wing, and curators Kevin J. Avery, Alice C. Frelinghuysen, Peter M. Kenny, Amelia Peck, Thayer Tolles, and Beth Carver Wees cheered us on. Catherine Scandalis organized photograph orders for the catalogue, and Elaine Bradson, Catherine Mackay, Sally King, and Elizabeth Wallace attended to innumerable details. Our research assistant, Katie Lynn Steiner, offered unfailingly professional and cheerful help to the curators and every other staff member associated with the project, at both the Metropolitan and at the Los Angeles County Museum of Art, our second venue. Essential to the lasting importance of our exhibition is this publication. In addition to Katie Steiner, we thank Elizabeth Athens, Megan Holloway Fort, Stephanie L. Herdrich, and intern Adam Thomas as members of the core team on the project. Their efforts were aided by the staff of the Thomas J. Watson Library, especially Deborah Vincelli. Jennie Choi provided critical technical assistance with digital

exhibition reporting. The staff of the Image Library, especially Carol Lekarew and Julie Zeftel, working with Andrew Gessner, shared their excellent resources. In the Museum's Photograph Studio, Barbara Bridgers and Juan Trujillo responded skillfully to our many requests for assistance.

It is impossible to thank adequately the extraordinary professionals in the Metropolitan's Editorial Department who transformed our manuscripts and illustrations into this publication. John P. O'Neill, Publisher and Editor in Chief, championed the project and offered astute counsel. Margaret Rennolds Chace ably coordinated the administrative details. Harriet Whelchel brought her gifts as an editor and her infinite tact to the task of preparing the texts for publication, and Penny Jones compiled and confirmed our references. Bruce Campbell devised the striking design, balancing scholarly imperatives with our desire for a beautiful presentation. He worked closely with our capable production team: Gwen Roginsky, Peter Antony, Chris Zichello, and Robert Weisberg. For the wisdom, patience, and devotion of these talented colleagues we are truly grateful.

Many people in the Metropolitan were dedicated to our goal of reaching the widest possible audience. Harold Holzer, Senior Vice President for External Affairs, gave us invaluable advice. Egle Žygas was our skilled press officer, working with Elyse Topalian, Mary Jane Crook, Jennifer Oetting, and other members of the Communications staff. Led by Deborah Howes and with the advice of Andrea Bayer, Interim Head of Education and Curator of European Paintings, educators planned resources and programs, for which we owe special thanks to Hilde Limondjian, Lisa Musco Doyle, Mikel Frank, Joseph Loh, Nicole Leist, John Welch, Michael Norris, Brittany Prieto, Alice W. Schwarz, William B. Crow, Florence Umezaki, Stella Paul, Kathryn Waggener, Masha Turchinsky, Merantine Hens, Sarah Hornung, Rebecca McGinnis, Deborah Jaffe, Karen Ohland, and Pamela Freeman. Our Web Group—Lasley Poe Steever, Eileen Willis, and Piotr Adamczyk—managed our representation on the Museum's website. The Metropolitan's Merchandising staff prepared exhibition-related products, and we thank them, too, for their partnership and creativity.

At the Los Angeles County Museum of Art, the exhibition was adeptly implemented by members of the Department of American Art: Devi Noor, Curatorial Administrator, Lois Sein, and Austen Bailly, Associate Curator, with the advice of Ilene Susan Fort, The Gail and John Liebes Curator of American Art. The presentation at LACMA owes much to Irene Martin, Director of Exhibitions, and her colleagues Sarah Minnaert, Elaine Peterson; Nancy Russell, Laura Benites, and Shannon Haskett in Registration; and Renee Montgomery and Shelly Cho in Risk Management. The installation was designed by Victoria Behner, Amy McFarland, and Meghan Moran, and overseen by Jeff Haskins and Marilyn Bowes. Fund-raising was organized by Stephanie Dyas and VanAn Tranchi, and educational programs were managed by Mary Lenihan. Thanks are owed, as well, to Michael Govan, Chief Executive Officer and Wallis Annenberg Director; Melody Kanschat, President and Chief Operating Officer; and Nancy Thomas, Deputy Director, Collections Administration, for their encouragement and support.

Finally, we again express our gratitude to all our sponsors and lenders for their enlightened interest in American art and their commitment to presenting this new study of American paintings of everyday life.

1. Copley, letter to Benjamin West or Captain R. G. Bruce, ca. 1767, in Copley and Pelham 1914), p. 65; see also p. 7 in this volume.
2. Ralph Waldo Emerson, "The American Scholar," in Emerson 1841, 1940), p. 45. In August 1837, before publication, Emerson's remarks were delivered as the Phi Beta Kappa address at Harvard University.
3. James, Cambridge, Mass., to Thomas Sergeant Perry, September 20 [1867], reproduced in Horne, ed. 1999, p. 17.
4. "Hitherto historical painting has been considered the highest branch of art; but, after all, see what a misnomer it was. The painter was always depicting the manners, customs, dress and life of an epoch of which he knew nothing. A true historical painter, it seems to me, is one who paints the life he sees about him, and so makes a record of his own epoch." Hassam quoted in Ives 1892, p. 116.

American Stories

Inventing American Stories, 1765–1830

CARRIE REBORA BARRATT

In the spring of 1764, the Philadelphia portraitist Matthew Pratt sailed for London as an escort for his cousin Elizabeth Shewell, who was engaged to marry his colleague Benjamin West. West had left Pennsylvania four years earlier on a study trip to Rome and London funded by forward-thinking patrons, whose goal was that the Grand Tour would transform the promising but regional limner into a sophisticated and worldly portraitist who would return to serve them. By the time West sent for his fiancée, however, he had dashed his patrons' hopes: as his artistic skill increased, so had his ambition to remain abroad. West completed and sent several copies of Italian paintings to his financial backers, who surely appreciated the works. Later, they would be impressed by the news that their American protégé had become such a sensation that King George III of England invited him to paint at court. Nevertheless, they were disappointed to hear that West would not be returning home. Eventually they might have taken a chance on sending Pratt abroad with similar motives, but not for the time being.

Although Pratt got to London in a roundabout way—as a courier for the more talented artist and without monetary support—once he had delivered cousin Betsy into the arms of her betrothed, he was free to take advantage of the same study opportunities in London that had afforded success to his friend. He studied works by Allan Ramsay and Nathaniel Dance at exhibitions of the Society of British Artists and the Free Society of Artists; he also studied West's work closely. At the time, West was at work on a group portrait of five young American students playing cricket on the grounds of Eton College. Entitled *The Cricketers* (fig. 1), West's painting was not merely an assemblage of likenesses, but rather a conversation piece, a traditional English group portrait with subtle narrative conveyed through gestures and attributes. Pratt followed suit and created his own conversation piece, one that told his American story.

In *The American School* (fig. 2), the artist seats himself sideways and cross-legged at the easel, his sharp profile silhouetted against the canvas, which bears his signature at bottom left.[1] The canvas on the easel includes a bit of curtain at upper right—the sort of drapery ubiquitous in portraits of the time—and the chalk-drawn figure of a woman, which was very much apparent to viewers then but is now invisible to the naked eye, the result of an inherent defect in the lead white pigment Pratt used; today she can be seen only in ultraviolet light (fig. 3). Holding a palette and maulstick, Pratt presents himself as a painter, the importance of which cannot be overestimated for someone just off the boat from Philadelphia with neither academic training nor patronage. He also freely admits that his American school includes another painter, West, whose figure, dressed in green on the left of the composition, acts as a bookend to that of Pratt. But West does not paint. Instead, he instructs the three draftsmen at the table, who make studies from the antique with graphite on blue paper. As seen on the walls of the spring 1766 exhibition of the Incorporated Society of Artists of Great Britain, *The American School* advertised Pratt as an apparently academically trained painter who set an expert example in the studio school with the requisite tools of his advanced trade. Four years West's senior and wanting never to be mistaken as his student, Pratt thus bluffed his way through the spring exhibition season with a canvas that portrayed more of an American white lie than an American story. Back in Philadelphia by 1768, Pratt managed to build a fairly respectable career for himself, although he never convinced his American patrons that his talents should be valued beyond his ability to capture an authentic likeness.

In her apt interpretation of *The American School*, the art historian Susan Rather uncovered the modus operandi that had engaged Pratt and, more to the point of this essay, that would captivate three generations of early American artists: "The picture, far from passively mirroring an actual situation, represents an active attempt to shape public perception of the colonial painter."[2] Pratt wished to assert himself as a painter with the support of a knowing viewer or patron who

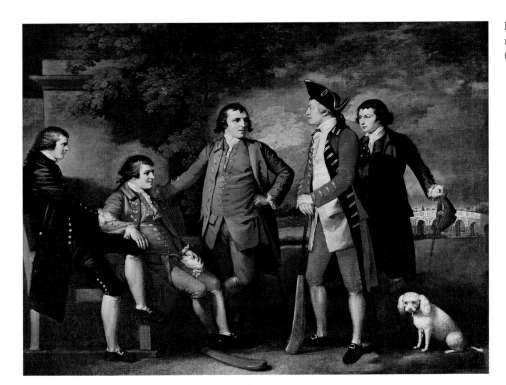

Fig. 1. Benjamin West. *The Cricketers*, 1764. Oil on canvas, 40 × 50 in. (101.6 × 127 cm). Private collection

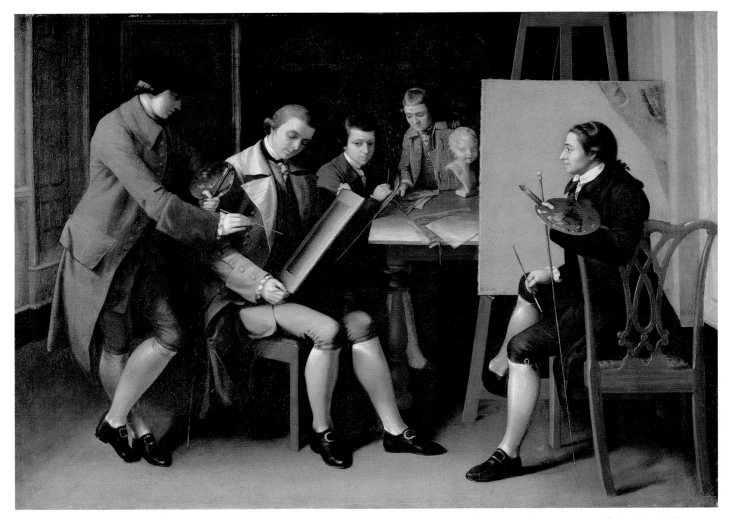

Fig. 2. Matthew Pratt. *The American School*, 1765. Oil on canvas, 36 × 50¼ in. (91.4 × 127.6 cm). The Metropolitan Museum of Art, New York. Gift of Samuel P. Avery, 1897 97.29.3

understood the importance of his profession. In retrospect, although Pratt's manifesto may seem light-years away from William Sidney Mount's *Painter's Triumph* of 1838 (fig. 25), it prefigures the very essence of that work: Pratt's desired response to his conversation piece would be captured sixty years later in Mount's triumphant painter and agreeable viewer. Neither work focuses on the actual painting in question—Pratt's is just a sketch and Mount's canvas is turned away—rather, the role of the artist is paramount in both.

The artists featured in this essay each grappled with this problem. Between 1760 and about 1830, American painters were forced to work within the relatively limited compositional possibilities of portraiture and an equally limited scope of patronage for the arts. West, Pratt, John Singleton Copley, Charles Willson Peale, Gilbert Stuart, Ralph Earl, Samuel F. B. Morse, and their colonial British and early national American colleagues struggled to convince their patrons that while portraiture served its purposes in the realm of private and personal enhancement, the country at large would be better served by paintings that covered a more expressive range of subject matter.

Very few portraitists strayed into other subject areas of art. Those who did were compelled to return to portraiture with some dispatch, or to find another line of work entirely. John Greenwood and his *Sea Captains Carousing in Surinam* (fig. 4) provide a cautionary tale. The Boston-born Greenwood enjoyed a reasonably successful career as a portrait painter. In

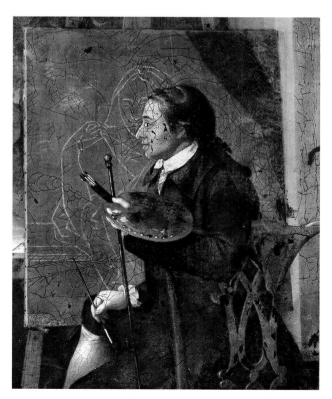

Fig. 3. Matthew Pratt. *The American School*, detail of figure and easel under ultraviolet light

1752, in pursuit of greater artistic opportunity and perhaps a little adventure, he followed a group of colonial sea captains and privateers to the Dutch outpost of Surinam on the northeast coast of South America.[3] There Greenwood remained for six years, making portraits, keeping a diary of sites, rendering diagrams of architecture, and recording recipes and local color in general.[4] The lucrative but treacherous trade in lumber, horses, rum, sugar, molasses, coffee, indigo, and slaves took time, and the men of business waited in pubs. Inspired by the heady atmosphere of South America, in which all bets were off in terms of upstanding behavior in life and art, Greenwood concocted a twenty-two-figure tavern scene, including at least seven portraits, mainly of Newport businessmen. He was obviously seeking to mimic William Hogarth's satirical paintings, such as *A Midnight Modern Conversation* (fig. 5). The reputable Esek Hopkins is the one raising a wineglass; his brother Stephen Hopkins is standing, tipping a punch bowl; Nicholas Cook, later governor of Rhode Island, holds the long pipe; the proper merchants Godfrey Malbone and Nicholas Powers dance with each other; Joseph Wanton is fat and asleep; and Captain Page is getting sick into his pocket.[5] Greenwood portrayed himself leaning against the door, vomiting, a lowly painter among affluent traders who are nonetheless subject to the intoxicating effects of alcohol and economic ambition. By the time the French and Indian War put a halt to English trade with South America, Greenwood's extended "lost weekend" was over. In 1758 he left Surinam for Europe; he eventually settled in London as a dealer of curios and rarely painted again.

With the exception of Greenwood's unique narrative scene and works by the highly motivated history painter John Trumbull, paintings produced before the turn of the nineteenth century portray a single figure accompanied by attributes of his or her life. Among the greatest challenges an early American painter could attempt was to connect one figure to another in a companion or pendant portrait to be hung across the parlor or stair hall. Only the cleverest artists could convince a patron to allow two or more people to appear together on a single canvas. Painters in America operated within the conscripted system of simple, virtuous portrait making to earn their living. They had to think creatively and sell their work persuasively if they wanted to excel or push the limits.

Left to their own devices, America's savviest painters—each of whom plays a part in this essay—learned to tell stories in portraits. The seminal inspiration came from John Smibert and his masterpiece *The Bermuda Group* (fig. 6), which hung in his Boston studio from 1729, when he began work on it, until long after his death in 1751. Devised to tell the tale of the Anglican Reverend Dean George Berkeley's missionary project to create a school in the New World for the conversion of

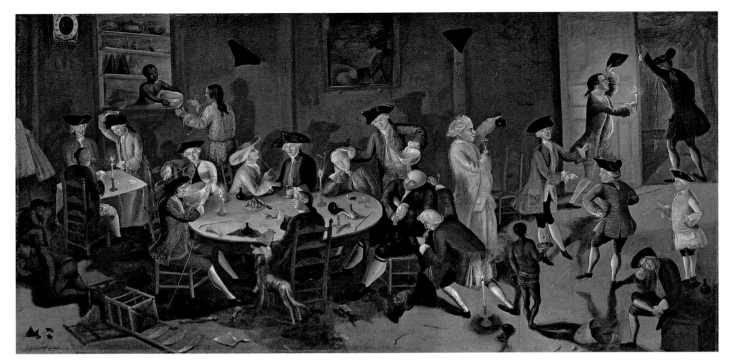

Fig. 4. John Greenwood. *Sea Captains Carousing in Surinam*, ca. 1752–58. Oil on bed ticking, 37¾ × 75¼ in. (95.9 × 191.1 cm). Saint Louis Art Museum. Museum Purchase 256:1948

blacks and Indians to Christianity, the picture captivated successive generations of Boston painters and patrons who came to understand the subtle ways in which Smibert (who included himself at left, looking knowingly at his viewer) told the story within the restrictive space and limited possibilities of a conventional group portrait.[6] Berkeley himself, in clerical garb at right, looks to the heavens for inspiration. The grand visions, the organizational necessities of a trip, the

domestic exigencies, the disappointments, the hurt pride, and the destroyed careers and friendships are all conveyed in small gestures and the apt arrangement of the figures. John Wainwright, seated with pen and journal, had encouraged his friend Berkeley to undertake the venture but in the end did not make the trip with him. Berkeley's financial advisers, John James and Richard Dalton, stand behind the table, backing the group, as it were. The Reverend's wife and infant

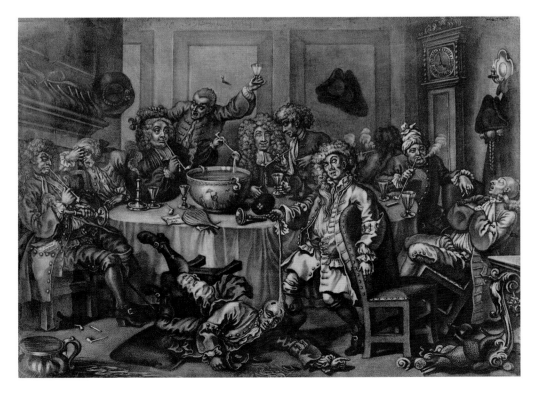

Fig. 5. Elisha Kirkall, after William Hogarth. *A Midnight Modern Conversation*, ca. 1733. Mezzotint, 14⅝ × 17¾ in. (37.1 × 45.1 cm). Yale Center for British Art. Paul Mellon Fund B1970.3.1321

son, Henry, remain by his side, despite the dangers and misfortunes to come. Smibert never painted such a picture again but worked instead on standard portraits—by all accounts quite contentedly—sharing with visitors to his studio the considerable collection of European paintings he had brought to these shores for teaching.

Smibert's singular example encouraged the next generation of artists to create great paintings with rich content that implied narrative. Copley, for example, offered in his portraits fabrics, fashions, furniture, and originality beyond what Bostonians could purchase on the street. He persuaded his clients that a portrait could convey fantasy rather than simply recording the truth. As the art historian Paul Staiti astutely noted, Copley's "project in portraiture was not the creation of accurate likenesses but the production of authenticating narratives about people."[7] Ironically, Copley complained that "people generally regard [painting] no more than any other usefull trade, as they sometimes term it, like that of a Carpenter tailor or shew maker, not as one of the most noble Arts in the World," even as he exploited his role as a provider of a bespoke product—a custom-made portrait—in order to captivate his clientele.[8]

Following Copley's lead, Charles Willson Peale took on the mission in Revolutionary-period Baltimore and Philadelphia, where his incredibly enterprising spirit not only resulted in modernized portraits for discerning clients but also led to the opening of museums and art galleries as venues for public display. He gave his numerous offspring ambitious names—Raphaelle, Rembrandt, Titian, Sophonisba—and put them in positions of cultural leadership so that his exhibition projects

would survive into the next generation. In turn, Samuel F. B. Morse devoted himself to ensuring that early national-period New York City had art exhibitions that would instruct and edify an increasingly democratic populace. A master communicator in both paint and with a pen (and later through his eponymous code of dots and dashes), Morse recognized that a great artist could also be a great teacher and that the best paintings went beyond capturing mere likeness in order to tell captivating and persuasive stories taken from history, literature, mythology, and everyday life.

The period in American history bracketed by Copley's best work on the one chronological end and Morse's on the other is frequently characterized as radical.[9] Consider the sweeping and drastic changes in politics, culture, religion, business, and domestic life that occurred between October 26, 1760, when George III became king of England, and March 4, 1829, when Andrew Jackson was inaugurated as the seventh president of the United States. To get from ruling monarch to leading democrat, from colony to nation, America sustained a revolution that was as much an internal civil conflict as it was a war for independence. With transformation manifested on all fronts, the prevailing monarchical hierarchies and gentry-dominated system of leadership came under attack and eventually crumbled. The time-honored criteria for power and influence—family, education, property, wealth, leisure—were replaced by republican principles accessible in some measure to almost any God-fearing, community-minded individual capable of hard work. A new government endorsed a Declaration of Independence, ratified a Constitution, and elected a president rather than crowning a king.

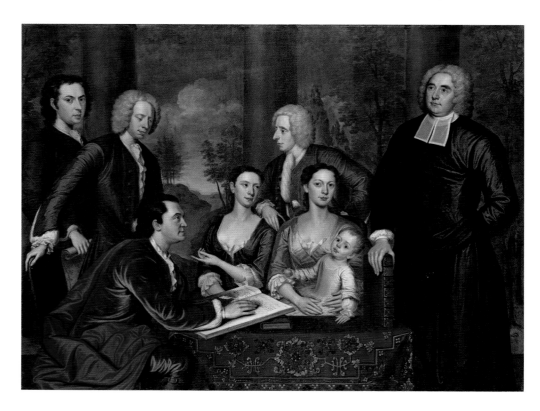

Fig. 6. John Smibert. *The Bermuda Group,* 1729–31. Oil on canvas, 69½ × 93 in. (176.5 × 236.2 cm). Yale University Art Gallery. Gift of Isaac Lothrop 1808.1

In an era that saw imports increase at an unprecedented rate, Americans came to understand the difference between consumption and capitalism, the former relying on foreign ports to satisfy desire and fulfill needs and the latter creating domestic industry and burgeoning economic markets. Before long, the Erie Canal—the waterway built between 1818 and 1825 to connect the eastern seaboard to the Great Lakes—had facilitated inland shipping and revolutionized domestic commerce. By the 1820s the country had grown geographically from a stretch of British colonies along the Atlantic seaboard to a network of territories as far south as Louisiana, northward to Maine, and westward to Missouri. The population swelled from a group of families of primarily British Anglican descent to nearly ten million residents (including slaves and free African Americans) by 1820, in large part owing to an influx of white European immigrants in search of work, security, religious freedom, and the promise of abundance.

This period bears witness to the likes of Samuel Adams, the firebrand political activist and passionate speechmaker who fought for American rights against all odds, and his near contemporary, the frontiersman Daniel Boone, whose intrepid actions for westward expansion set the stage for Lewis and Clark in the next generation. The German immigrant John Jacob Astor bought his first piece of American real estate in 1789, just after George Washington was elected the first president of the United States by a unanimous vote in the Senate. Washington would serve two terms, succeeded by six single-term presidents over the next three decades, as the country's leadership transitioned at breakneck pace to keep up with rapid change.

The Burden of Portraiture

Portraiture suited a country that celebrated individual accomplishment. Likenesses of presidents, government leaders, and military heroes contributed to the cultural project of recording the important or commendable deeds of the few. For the many whose lives were untouched by heroic events, attachment to art came along with key familial occasions—birth, death, engagement, marriage, the building of a first home—moments, according to the scholar Margaretta Lovell, "that mark the movement of family substance in an orderly, prescribed manner."[10] It is, indeed, extremely rare to find a portrait from before the turn of the nineteenth century that does not record a significant event. The notion that an artist might paint a picture for his own pleasure or to record a community event would have been inconceivable. As the historian Neil Harris outlined more than forty years ago in an essay that remains definitive on the subject, American artists succumbed to "the burden of portraiture," knowing that their patrons would reward accuracy over flourish, functionality

over inspiration, and that they deemed portrait making a private service.[11] Postcolonial change in America caused quick shifts in many professions—such as lawyers, politicians, clergymen, farmers, bankers, and shopkeepers—but not for artists, who continued to be called upon to produce accurate likenesses of select individuals. As Harris put it, "The need for extemporization and subterfuge, endless stratagems and disappointing delays, left behind an acute sensitivity to status, and ambiguous attitudes toward business values."[12]

In this regard, Copley's inspired portrait of his friend and colleague Paul Revere (fig. 7) can be seen as one that abides by the rules of the game for colonial portraiture—it is an accurate, intricate, and apparently truthful likeness—even as it presents an artistic strategy beyond the norm. This very famous portrait has become so inextricably connected with the patriot of midnight-ride fame that it is worth noting that this 1768 image of Revere predates his galloping call to arms of April 1775. At the time he sat for Copley, Revere was Boston's most charismatic and versatile silversmith and engraver. The two men had known one another since at least 1763, when Copley ordered from Revere a bracelet and locket cases for his portrait miniatures.[13] The occasion for the portrait sitting is unrecorded—circumstantial evidence, including the fact that Revere kept the picture, suggests that he may have accepted his portrait as payment for goods he had made for Copley—but the artistic freedom exercised by the portraitist for his obviously complicit subject resulted in a picture of epic narrative proportions.

By 1768 Copley was an expert at recording what Lovell has called "artisanal masculinity," that is, the means and vocabulary by which an artist identifies his male sitters according to established tropes of presentation.[14] Copley knew how to approach a military hero, a rich businessman, a literary man, and other character types, each one legibly identified, much like a character in a play or a novel. For example, the affluent merchant Nicholas Boylston wears a lavish robe and rests on his ledgers (1767, Museum of Fine Arts, Boston); John Winthrop, a scientist, is shown with a telescope (ca. 1773, Harvard University Portrait Collection, Cambridge); the orator Richard Dana holds his palm against his chest (ca. 1770, private collection); Woodbury Langdon, a man of letters, holds an unsealed document (1767, Dallas Museum of Art). Within fifty years, these understated identifiers would be transformed by other artists into obvious props and poses (drunks hold liquor bottles, businessmen hold money, and lovers openly woo their women) in multifigure narrative scenes that tell not only about the conduct of individuals pictured but also about issues in society at large. In Copley's time, gestures were reified in English etiquette books, and subtle elegance was prized. The social codes of polite behavior were taught in

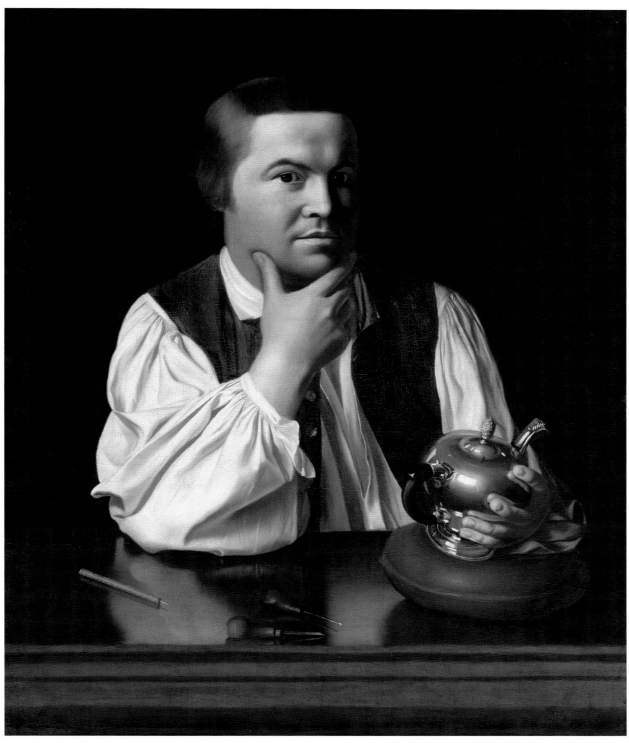

Fig. 7. John Singleton Copley. *Paul Revere*, 1768. Oil on canvas, 35⅛ × 28½ in. (89.2 × 72.4 cm). Museum of Fine Arts, Boston. Gift of Joseph W. Revere, William B. Revere, and Edward H. R. Revere 30.781

the colonies, the main code being that of controlled bodily deportment.[15] Copley's clients, including Revere, wished to appear serene and relaxed as well as confident and moderate. Copley's portraits were visual equivalents of Samuel Johnson's principles for biography, which stipulate that the vital elements for telling a person's life story are subtle clues rather than absolute truths about the person.[16] A successful portraitist, like a successful biographer, had to use keen observational

tactics to convey an authentic and socially persuasive representation of his subject.

The clues to Revere's social and professional position include the unbuttoned white smock, the lack of a coat, the contemplative hand-to-chin pose, the uninscribed teapot, the hammering pillow, and the needle and burin. He is clearly a silversmith, but that much Copley could have communicated with a spoon or a porringer, forms Revere made in number

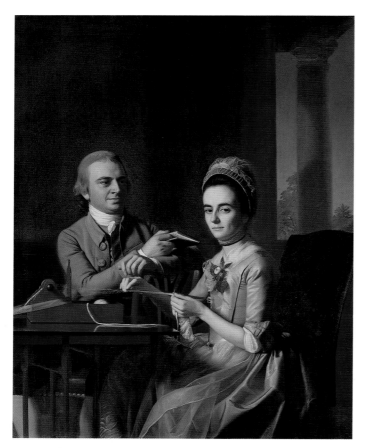

Fig. 8. John Singleton Copley. *Portrait of Mr. and Mrs. Thomas Mifflin (Sarah Morris)*, 1773. Oil on ticking, 61⅝ × 48 in. (156.5 × 121.9 cm). Philadelphia Museum of Art. Bequest of Mrs. Esther F. Wistar to The Historical Society of Pennsylvania in 1900, and acquired by the Philadelphia Museum of Art by mutual agreement with the Society through the generosity of Mr. and Mrs. Fitz Eugene Dixon, Jr., and significant contributions from Stephanie S. Eglin, Maude de Schauensee, and other donors to the Philadelphia Museum of Art, as well as the George W. Elkins Fund and the W. P. Wilstach Fund, and through the generosity of Maxine and Howard H. Lewis to The Historical Society of Pennsylvania, 1999 EW 1999-45-1

in 1768, whereas he made only one teapot in that year. Viewers at the time would have deemed the teapot a rather confrontational element, as most Bostonians boycotted tea in 1767, when the Townshend Acts imposed duties on it and other imports. The decision to show Revere with the only teapot he made in 1768 results in a story that reaches beyond biography—the usual province of portraiture—and into narrative that would have been understood and appreciated by those who saw the painting.

Copley's double portrait of the radical Whig Thomas Mifflin and his wife, Sarah Morris (fig. 8), takes up a story very similar to that in his portrait of Revere: the weaving of fringe was a political statement, a homemade act of defiance against Parliament for imposing taxes on imported laces and trims for women's clothes. As in the portrait of Revere, this picture's defining element tells as much about a story that spoke to an entire community of interest at the time as it does about personal biography. A painter of Copley's artistic and entrepreneurial ability might have produced more portraits linking personal biography to contemporary events if he had been more politically inclined, had less at stake, or, as some have speculated, if he had been a patriot.[17] Copley's nonpartisan balancing act kept him in good stead with his clientele and, in the best of his Revolutionary-period work, resulted in richly rendered portraits imbued with an atmosphere of foreboding but scant narrative.

And yet, even as he was pleasing his patrons, Copley seemed eager not only for freedom from the political arena of Boston, but also for what he dreamed would be a less restricted and more inspirational field in London. Once abroad in 1774, he sought commissions to paint historical works, and while

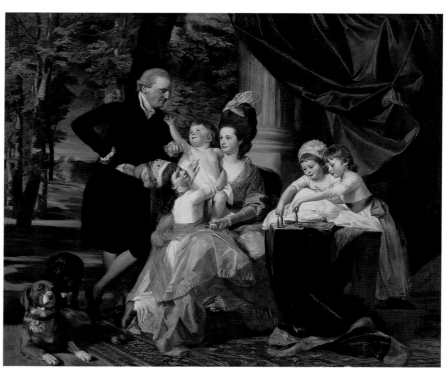

Fig. 9. John Singleton Copley. *Sir William Pepperrell and His Family*, 1778. Oil on canvas, 90 × 108 in. (228.6 × 274.3 cm). North Carolina Museum of Art. Purchased with funds from the State of North Carolina 52.9.8

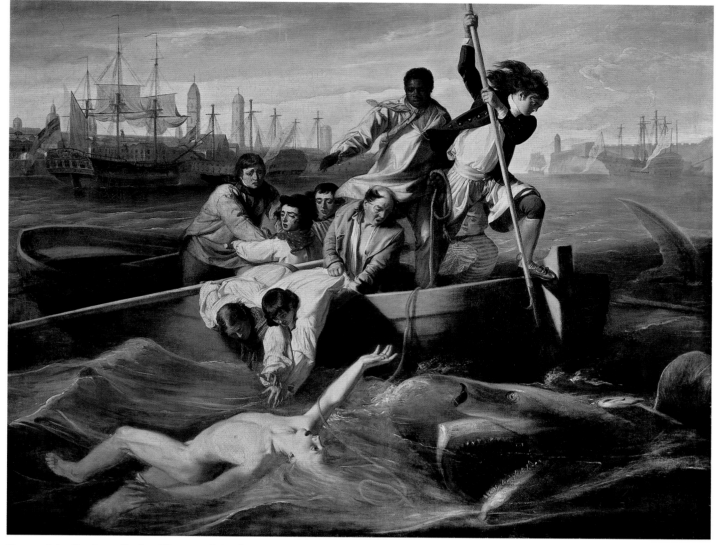

Fig. 10. John Singleton Copley. *Watson and the Shark*, 1778. Oil on canvas, 71¾ × 90½ in. (182.1 × 229.7 cm). National Gallery of Art, Washington, D.C. Ferdinand Lammot Belin Fund 1963.6.1

waiting for such commissions to come through (as they would a few years later), he stayed with portraiture, teasing out the narrative possibilities of multifigure compositions, as in his own family portrait (1776–77, National Gallery of Art, Washington, D.C.) and in a large canvas for Sir William Pepperrell (fig. 9), the challenge for both of which was to portray high-spirited families in positions of good fortune, when in fact both were mourning recent deaths—of Copley's infant son and of Pepperrell's wife, Elizabeth Royall—and the loss of confiscated property and wealth.

By the time he was invited by the prominent British merchant Brook Watson to paint an episode from his childhood, Copley was well versed in narrative portraiture. With the encouragement of an eager patron, he threw all caution and subtlety to the wind and painted the daring *Watson and the Shark* (fig. 10) for public exhibition at the Royal Academy of Arts. It illustrates the tale, as recalled by Watson, of a horrific shark attack: in 1749 the orphaned Watson was fourteen years

old and crewing for his guardian, a merchant marine, in Havana Harbor, Cuba, when he was attacked by a shark while swimming. Watson was dragged underwater three times and lost a leg before his fellow crewmen were able to save him by stabbing the beast with a boat hook. Scholars have since debated what Copley knew before making this painting and how he knew it, fewer than three years after leaving Boston.[18] He apparently obtained a scenic engraving of Havana Harbor; studied Raphael's *Miraculous Draft of Fishes* (1516, Royal Collection, London) and Charles Le Brun's series of drawings that conveyed his theories on facial expression; and brilliantly satisfied the criteria of Edmund Burke's definition of the Sublime.[19] He then created a scene of horror and uncertainty that compels the viewer to participate in the drama.

Yet Copley made certain, on his patron's behalf, that the story would be understood as a scene from Watson's real, daily life—as uncommon as the events of that day may seem.

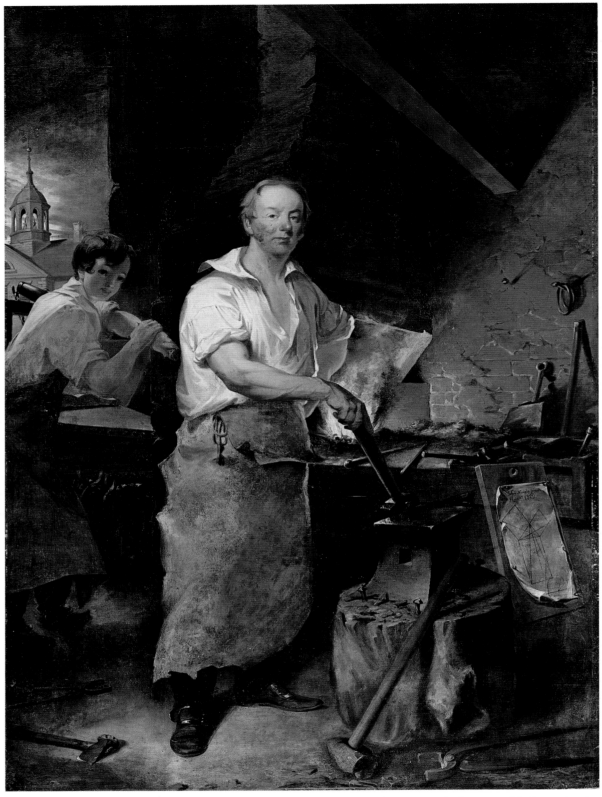

Fig. 11. John Neagle. *Pat Lyon at the Forge*, 1829. Oil on canvas, 94½ × 68½ in. (240 × 174 cm). Courtesy of the Pennsylvania Academy of the Fine Arts, Philadelphia. Gift of the Lyon Family 1842.1

The exhibition title for the picture told the tale: *A boy attacked by a shark, and rescued by some seamen in a boat; founded on a fact which happened in the harbour of the Havannah.* The topographical logic and identifiable buildings lock the central action on to a maritime stage, turning an expansive port into an enclosed, legible space. Every aspect of the work caters to the subject's desire for absolute clarity of narrative detail. Watson promoted himself and Copley's picture by giving his story to the local papers and inscribing it on the picture's frame in a large, rectangular tablet. Watson

encouraged viewers to see the picture not merely as an incident from his life but, more important, as proof that a good and moral man could triumph over adversity. As it says on the frame: "A high sense of integrity and rectitude with a firm reliance on an over ruling providence united to activity and exertion are the sources of public and private virtue and the road to honours and respect." Copley had come a long way: from Paul Revere's teapot to Brook Watson's shark, from a composition meant to convey a personal story to a full-blown tableau communicating a public message.

Copley was a quick study, an artist who picked up the tricks of the trade with ease and effortlessly changed his manner of working to suit clients according to time, place, and purpose. In Boston, he had worked with plenty of demanding and calculating patrons, including some who seemed to understand immediately the potential for a portrait to convey a narrative separate from likeness and straight biography. Watson, however, was arguably Copley's most cunning patron to that date, with a need not only for a complicated, retrospective narrative, but also for an operatic message put forth in a public venue: the Royal Academy of Arts attracted hundreds of spectators from the upper echelons of London society.[20] What Watson desired, and Copley would have wanted to achieve, was a portrait that confirmed the subject's moral reputation. The shark picture succeeded in portraying Watson—a controversial character despised in some circles for dishonorable business practices and unethical political motives—as having been delivered from the jaws of death, a fate accorded only those of high moral fiber and undeniable goodness.

Few if any British subjects followed Watson's lead in engaging a painter to create for them a redemptive narrative. The one notable American example would come some fifty years later, in Philadelphia. In 1826 the portraitist John Neagle received from the Scottish immigrant Patrick Lyon, an aging and affluent mechanical engineer who was the city's principal manufacturer of fire engines, a commission for a full-length portrait that told a story from Lyon's past, some twenty years earlier (fig. 11).[21] Neagle looked to Copley for inspiration: in the resulting work, he shows Lyon wearing the same style of shirt as the one Revere wore in Copley's portrait. Neagle also looked to Copley's solution for Watson—which he would have known through engravings—to create a storytelling portrait for a patron who wished to make a moral point about a past incident.

The portrait of Lyon as a young man at his former profession would present the idea that his present industrial ventures had their roots in an earlier noble, artisanal enterprise. Lyon asked to be pictured as he would have looked in 1798, the year he was imprisoned for three months in the Walnut Street Gaol on the charge of having robbed the Bank of Pennsylvania of more than $160,000. He provided the alibi

that he had been having dinner at a Delaware tavern on the night of the crime but was nonetheless charged on the grounds that he had recently been hired to change the locks on the vault and would have known how to gain access to the cash. Lyon published his defense in a critical pamphlet, sued the bank for malice and false imprisonment, and eventually won $9,000 in damages.[22] His acquittal became local legend: the story of a common man who sued the bank and was vindicated by the new American legal system.

Lyon desired that Neagle's portrait record his innocence in perpetuity, and he was quite specific about the details of the story to be told on the canvas. He wished to be shown in his former smithy, "'with my bellows-blower, hammers, and all the et-ceteras of the shop around me.'"[23] Neagle would have had to re-create the scene through research. He turned to his first teacher, Bass Otis, who during his youth had worked as an apprentice forger in upstate New York and whose recent painting, *Interior of a Smithy* (ca. 1815, Pennsylvania Academy of the Fine Arts, Philadelphia), would have provided some clues. Neagle also studied Lyon's old tools and talked to him about the arrangement of the space. As per the client's precise instructions, the view from the window is contrived purely for effect; it shows the prison where Lyon spent three months. Lyon further directed: "'I wish you to understand clearly, Mr. Neagle, that I do not desire to be represented in the picture as a gentleman—to which character I have no pretension. I want you to paint me at work at my anvil, with my sleeves rolled up and a leather apron on.'"[24] Without a portrait of the young Lyon from which to work, Neagle composed an ingenious image of a skilled and happy workingman. In keeping with the old-fashioned idea behind the work, Neagle gave it a descriptive title prior to its exhibition at the Pennsylvania Academy of the Fine Arts: *Full length Portrait of Mr. Patrick Lyon representing him as engaged at his anvil*. In terms of subject matter, Lyon's portrait could be the art historical antecedent of late nineteenth-century paintings of rugged workingmen, such as Thomas Anshutz's *Ironworkers' Noontime* (fig. 156), but in fact Lyon had never been a virile laborer. Even in his youth, he had been the brains of the operation, studying complex drawings and theorems in order to develop implements for his clients.[25] Indeed, Neagle's success lay in making a modern painting that harked back to colonial precedents, catering to his client's direct instructions to make a new picture that told an old story.

Domestic Bliss

American portraitists' eagerness to elaborate on everyday life in their work was particularly attractive to husbands and wives wishing to commemorate their domestic contentment. The British cultural historian Kate Retford recently explained:

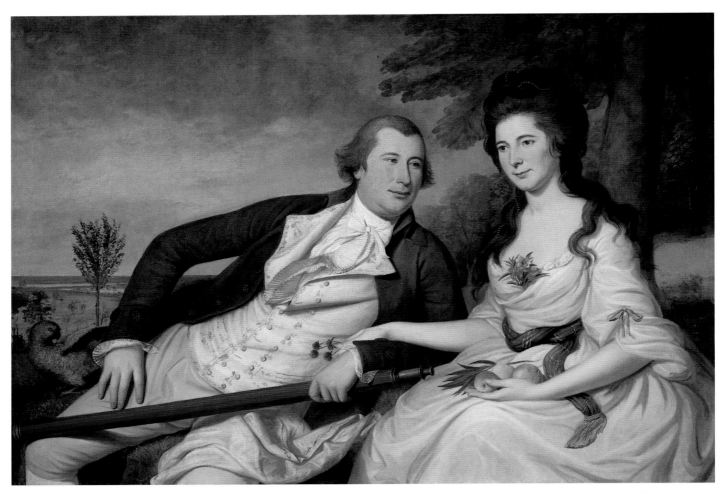

Fig. 12. Charles Willson Peale. *Benjamin and Eleanor Ridgely Laming*, 1788. Oil on canvas, 41¾ × 60 in. (106 × 152.5 cm). National Gallery of Art, Washington, D.C. Gift of Morris Schapiro 1966.10.1

"As the dictates of prescriptive and fictional literature were transformed by the imperatives of sensibility in the middle decades of the century, raising private virtue to a newly important and fashionable plane, so too was the visual language of portraiture."[26] By this time, the adornment of a house had become a standard occasion in a painter's repertoire, on par with a marriage or a birth in marking the betterment and upward trajectory of a couple or family. While primarily enjoyed by the sitters themselves and their immediate family, the display of a special portrait in a grand home was as close to a public viewing as one could get in the eighteenth century. A fine portraitist could commit rare glimpses of a client's private life to canvas, thus engaging his sitters in highly personalized narratives that would be viewed by others.

In America, the best example of this enterprise may be the double portrait that Charles Willson Peale constructed for the Baltimorean Benjamin Laming and his wife, Eleanor Ridgely, in the fall of 1788 (fig. 12). Except for a few rare portraits of his own family, Peale had previously kept husband-and-wife clients on separate canvases, each hierarchically presented with proper attributes and appropriate compositional links

to one another. Laming, a sugar and rum merchant who the year before had purchased Darley Hall, a landed estate just outside the city, contacted Peale for a variety of images for his new home: within the year, Laming received a single portrait and a portrait miniature of himself, as well as the double portrait.

Laming must have requested a very special likeness, compelling Peale to use a large horizontal canvas in order to fit both figures in one composition and to fill it with narrative clues and personal attributes. The picture took six weeks to paint, a long time for Peale, during which he recorded in his diary his struggles and Benjamin and Eleanor Laming's frequent visits and sittings. He began the work on September 18, 1788, when he "sketched out the design"; he then worked on the canvas daily, often scratching out and repainting to get it right.[27] Laming sat several times, his wife on fewer occasions, including a short visit for what Peale called "a sitting for consideration" and another session on the 29th, "for her hands." On the 30th, the artist painted "flowers in Mrs. Laming's bosom—the tucker and other parts of her drapery"; on October 1, he painted Mr. Laming's shirt frill and "after dinner

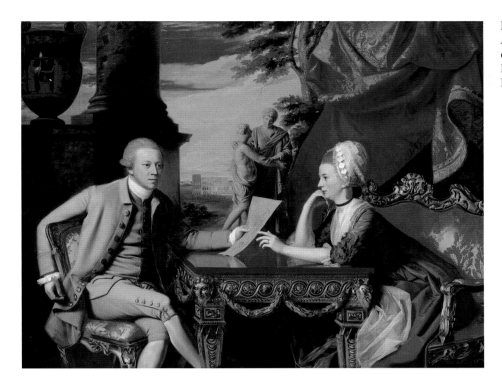

Fig. 13. John Singleton Copley. *Mr. and Mrs. Ralph Izard (Alice Delancey)*, 1775. Oil on canvas, 68¾ × 88 in. (174.6 × 223.5 cm). Museum of Fine Arts, Boston. Edward Ingersoll Brown Fund 03.1033

painted a handkerchief in Mr. Laming's lap." The next day, he worked on the parrot (a rare South American variety, of the genus *Amazona*, with red tail feathers) and the fruit held by Mrs. Laming, and at one point spent a day composing a "view of part of Baltimore Town." By October 4 the portrait was nearly done, but it was not entirely to Peale's liking. He worked on it until month's end, listing in his accounts "Mr. & Mrs. Laming in one piece 5 feet by 3 feet 6 Inches" and a fee of thirty-five pounds sterling.

Part of Peale's dilemma was how to fit a big man and a petite woman comfortably into the same composition. Indeed, Peale had very little experience fitting figures of any size together, much less for a patron who so often checked in on the work. Over time, historians have tried to interpret Peale's ambition on behalf of the Lamings, especially his representation of their marital bond as one clearly based on romantic love, a rare concept in early America when so many marriages were arranged. There would have been few American pictorial precedents for what Peale wanted to deliver: Copley's portrait of the Mifflins (fig. 8)—in which their hands almost touch and he gazes at her while she makes fringe—was about as close to romance as one could get in colonial portraiture. Peale may not have known that, in 1775, while traveling in Italy, Copley had tried again, for Ralph Izard and his wife, Alice Delancey (fig. 13). In the Izard portrait, Copley's greater success in the overall expression of romance was in large measure owing to the glorious Roman setting. Otherwise, the painting revealed a still-slight connection between husband and wife, indicated by approving gazes, barely touching fingers, and a suggested conversation about a drawing.

The reiteration of polite accomplishments in portraiture had a subtle narrative effect. The story in a portrait often mirrored real-life parlor behavior. In Gilbert Stuart's rendering of two young women of the distinguished Foster family in Dublin (fig. 14), the apparent activity of embroidery is carefully calculated: that the older girl can sew is beside the real point, which is that she is ready for marriage.[28] It seems that sewing long described appropriate accomplishment for a young woman, and the emblem was still in use a century

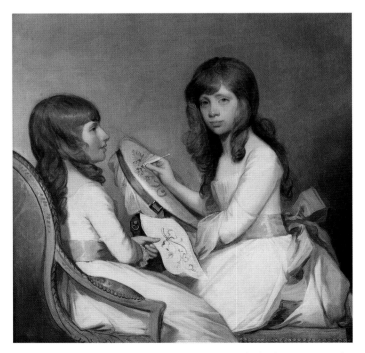

Fig. 14. Gilbert Stuart. *Anna Dorothea Foster and Charlotte Anna Dick*, 1790–91. Oil on canvas, 36 × 37 in. (91.4 × 94 cm). Philip and Charlotte Hanes

later, in Mary Cassatt's *Young Mother Sewing* (fig. 125), for example. The difference is that Stuart's assignment from the 1790s, to make a modern portrait of a marriageable aristocratic girl, required that the sewing carry the story. In other words, Stuart had to create narrative in his portrait in order to tell the story of a girl in want of a good match, perhaps even love, whereas Cassatt's work was a subject picture from the start. To fulfill his commission from Sir John Foster, Speaker in the Irish House of Lords, Stuart designed a scene that would appropriately but clearly put his teenage daughter, Anna Dorothea, on pretty show. In the portrait, Anna is shown full face, working on a tambour frame that indicates her skill: she has graduated from mere samplers to significant projects suitable for framing or upholstery. Her cousin Charlotte Anna Dick is in profile, as befitting a younger, not-yet-marriageable lass who serves as an accomplice to the dual tasks of embroidery and of finding a husband.

By contrast with the Mifflins, the Izards, and Anna Dorothea Foster, the Lamings have no need for devices of merit or pieces of art or sewing set forth for approval—they need only each other. Their parlor game begins with her gentle touch. That Benjamin leans toward Eleanor may have helped Peale solve the logistical problems of size and proportion in his composition—by elongating Laming's body, Peale accommodated the subject's full girth and still had room for the vista of Baltimore in the distance. But this rather astonishing solution also takes on considerable narrative effect, all the more so because Eleanor encourages her husband's closeness. More than fifty years ago, the Peale scholar Charles Coleman Sellers's analysis of the Laming portrait as indicative of "conjugal felicity" was considered risqué, yet his interpretation now seems timid compared to Margaretta Lovell's recent reading of Benjamin's "telescope and Eleanor's peaches as anatomical analogues" that clarify the precise nature of their happiness.[29]

The Lamings were Peale's most liberal patrons ever, obviously willing and perhaps desirous for much more than accurate likeness—although Peale certainly worked hard on that aspect as well—but not seeking personal biography either. The beauty of the Laming portrait lies in the exacting lack of particular details about the lives of Benjamin and Eleanor from Baltimore. They allowed Peale to connect them to a larger concept of love, and he came up with a narrative structure that both served their interests and flattered their circumstances. The art historians Ellen Miles and Leslie Reinhardt have found in Peale's "unorthodox composition" a reenactment of Rinaldo and Armida, the lovers in Torquato Tasso's *Gerusalemme liberata* (1581).[30] The story had a long history in paintings known to Peale—for instance in compositions by Domenichino and Annibale Carracci—and in Western literature. Specifically, Peale would have known his teacher Benjamin West's painting of the story (1766, Jane

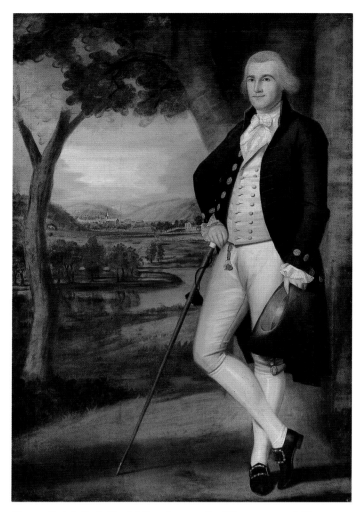

Fig. 15. Ralph Earl. *Daniel Boardman*, 1789. Oil on canvas, 81⅝ × 55¼ in. (207.4 × 140.4 cm). National Gallery of Art, Washington, D.C. Gift of Mrs. W. Murray Crane 1948.8.1

Voorhees Zimmerli Art Museum, Rutgers University, New Brunswick, New Jersey). Rinaldo was a Christian knight hopelessly distracted from his crusade by Armida, a Turkish enchantress who lured him into her lush, magic garden filled with exotic birds, fruits, and flowers. Benjamin Laming, as Rinaldo, is dressed in the armor of his time—a proper bespoke suit for a gentleman of business—while Eleanor, as the seductress nymph, is swathed in diaphanous drapery, with nary a pin, seam, or corset to constrict her desire.

The chance for upstanding American citizens like the Lamings to play at romantic dalliance, to be the illicit lovers in an epic Italian poem, could happen only in portraiture; masquerade and other costumed frivolities had not yet reached Baltimore in the late 1780s. Through Peale's brush, Benjamin and Eleanor became lovers, not merely in the marital sense, but also according to a tale rich in sensuality and forbidden desires. When displayed on the wall in their home, the Lamings' story would have captivated their guests and friends, the smartest of whom would have taken pleasure in identifying the literary reference and found amusement in the theatrics of their hosts.

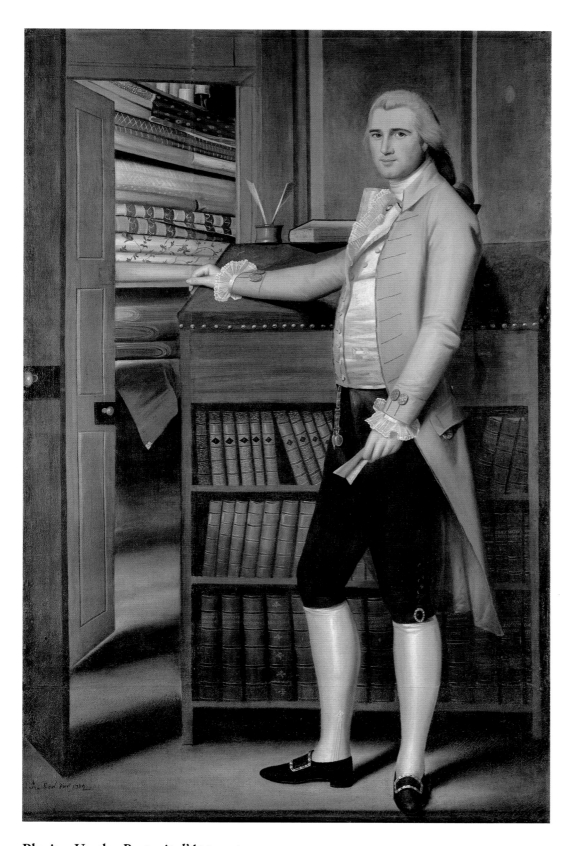

Fig. 16. Ralph Earl. *Elijah Boardman*, 1789. Oil on canvas, 83 × 51 in. (210.8 × 129.5 cm). The Metropolitan Museum of Art, New York. Bequest of Susan W. Tyler, 1979 1979.395

Playing Up the *Portrait d'Apparat*

To a considerable degree, the masterpieces of late eighteenth- and early nineteenth-century American painting have in common two basic elements: first, they are portraits, and second, they represent the complicity of a talented artist and a confident patron. The sum of their parts most often equals a likeness and a narrative embedded within it. Examples mentioned here include Smibert working with Reverend Berkeley; Copley and Watson; Peale and Laming; Neagle and Lyon. America's best painters of this period cultivated their patrons, encouraged them to want more in their pictures than they might have imagined, and then became expert at satisfying that desire. They created the demand and the supply.

The extraordinary American paintings from this era resulted not only from an understanding on both sides of the negotiation, a push and pull of decisive parties, but also from a knowledge of what the community at large could tolerate and absorb for the private and, occasionally, public display of paintings. They responded to and enhanced the most common activity in town: looking at and performing for one another, constantly evaluating each other's looks and behavior. Imagine the role of a painter in a society where self-consciousness was at such a heightened state that, as cultural historian Richard Bushman put it, "People were aware of watching and being watched," every day.[31] For skilled painters working with willing subjects in both town and country, this atmosphere offered distinct compositional possibilities, reaching beyond the norm of monotonous head-and-shoulder views on canvas to a realm of heroic, romantic, and commercial proportions.

For example, when the painter Ralph Earl returned home to Connecticut after several years in London (followed by a few years in a New York prison for debt), he respected the local tradition of showing subjects in their own peculiar environments, but he modernized his approach for clients disposed to perform in their portraits.[32] When Earl began work on full-length portraits for the prominent Boardman brothers, who were also dry-goods partners, he painted to suit each sibling. The younger, Elijah (fig. 16), received a far more legible image than did the elder, Daniel (fig. 15). Earl shows Daniel standing near a tree in a landscape with buildings identifying his hometown of New Milford; this sophisticated portrait conveys the man's station without revealing how he makes his money. The work evidences Earl's studies abroad and his ability to deploy the more painterly technique and muted palette that were preferred in London. In Elijah's portrait, by contrast, the artist dispenses with English technique in favor of high-key colors and crisp edges in accordance with the taste of local folk. Both brothers perform in their portraits. Daniel's is evocative of affluence and intelligence: it is a traditional representation of a self-effacing gentleman. Elijah's, however, tells the story, line by line, of how his wealth and wisdom were gained: it is a modern painting of an appealing salesman.

For Elijah, Earl deployed the traditional European *portrait d'apparat*, a term referring to the inclusion of props, particularly from everyday business, in the composition. The precise term usually applies to French rococo portraiture, specifically to a single figure with objects chosen to define his or her profession rather than as emblematic or suggestive attributes. In this regard, Copley's portrait of Revere (fig. 7) clearly represents the genre whereas Earl's picture of Boardman explodes its boundaries: the artist and sitter devised a tableau that would not merely define the man's trade but would also tell the story of his profession using an encyclopedia of specific objects and suggestive devices, very much the way a good story is constructed with facts and embellishing details. Boardman stands in his neatly appointed shop, at his felt-covered counting desk, outside the door of the storeroom for bolts of fabric and spools of thread. Just as the fabrics can be read for their content—iridescent taffetas, pretty calicoes, expensive imported textiles—one can also decipher the titles of the leather-bound books on the shelves of his desk. Elijah Boardman may keep the account ledgers on top, but his business sense is informed by a world of knowledge that includes Milton's *Paradise Lost*, Guthrie's *Geography*, Cook's *Voyages*, Moore's *Travels*, Johnson's *Dictionary*, and the *London Magazine*. His elegant attire, from his perfect coiffure to his satin waistcoat to his matching jeweled knee and shoe buckles, not only befits a man who sells such items but also inspires confidence that he will expertly guide customers in making the correct choices in his shop.

Add to this Boardman's direct and charming, almost seductive gaze, and it seems clear that Earl has created more than a story: the portrait is an advertisement for his patron's business as well as for his own. Both the shopkeeper and the artist operated in the market economy that burgeoned after the Revolution, creating commercial opportunities for second- and third-party merchants. A decade earlier, a country portraitist would have been itinerant and a rural dry-goods merchant would have been a huckster with a traveling wagon or an importer with a ship at sea.[33] The position of salesman captured in Boardman's portrait, not only as a purveyor in a shop but also as a man who cultivates consumer desire, was an entirely modern notion, the precedent of the nineteenth-century department store. Make no mistake, the door-to-door salesman remained a fixture throughout the country and made for amusing painted anecdotes during the next generations, as for example in Francis William Edmonds's *Image Pedlar* of 1844 (fig. 26), in which a traveling salesman sells small parian and plaster figurines to a rural family. Yet, in a prosperous community like New Milford, and certainly in the major metropolitan areas, a prominent shop owner like Boardman could cultivate and satisfy the local demand for high-end products such that the fly-by-night salesmen stayed away, unless they were visiting him to peddle their wholesale items for retail display in his posh shop.

If Earl scripted Boardman's story to separate his subject from the arena of outdoor salesmen parading their wares in conspicuous wagons, Charles Willson Peale created a tale to engage the latter constituency. In his full-length self-portrait titled *The Artist in His Museum* (fig. 17), Peale's highly theatrical gesture presents him as carnival barker, master of ceremonies, and salesman all at once. Just as Boardman in his portrait opens his shop door to display enticing goods for purchase, so Peale in his lifts a curtain to reveal the array of

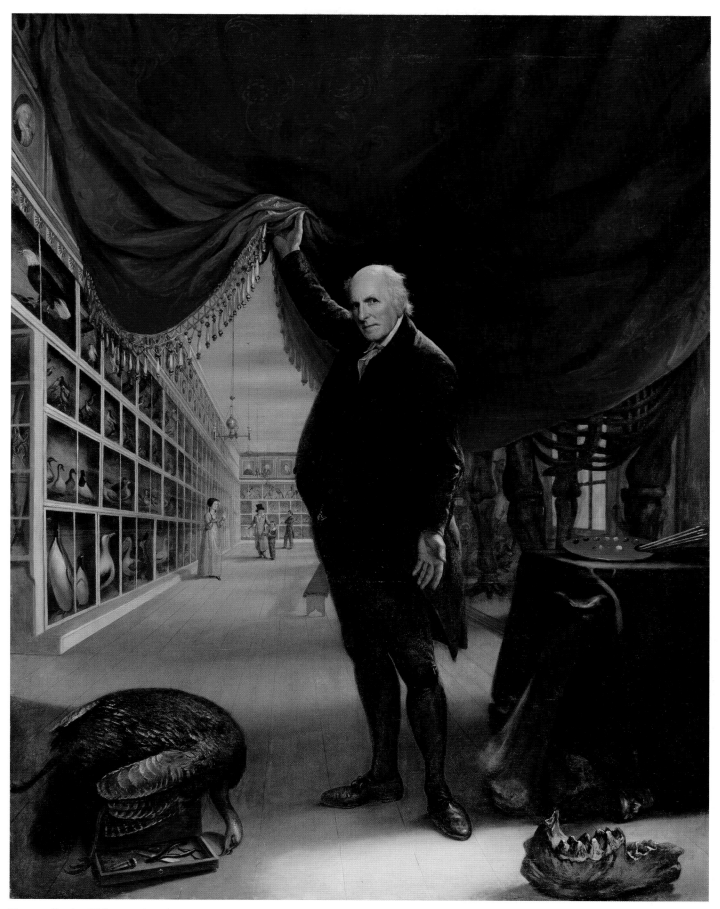

Fig. 17. Charles Willson Peale. *The Artist in His Museum*, 1822. Oil on canvas, 103¾ × 79⅞ in. (263.5 × 202.9 cm). Courtesy of the Pennsylvania Academy of the Fine Arts, Philadelphia. Gift of Mrs. Sarah Harrison (The Joseph Harrison Jr. Collection) 1878.1.2

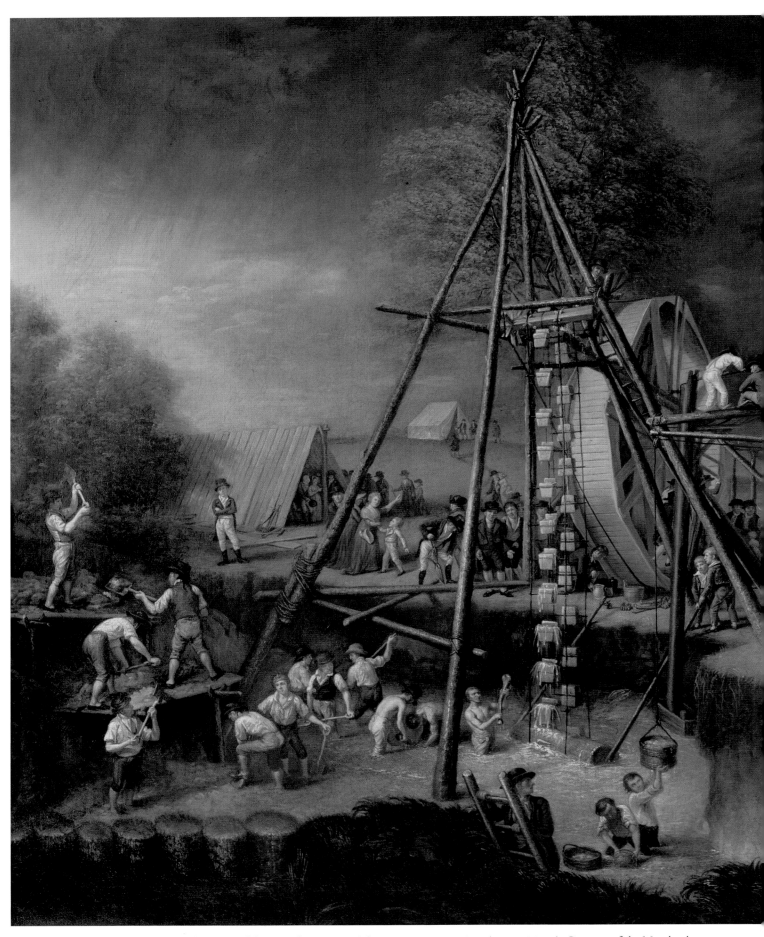

Fig. 18. Charles Willson Peale. *The Exhumation of the Mastodon*, 1805–8. Oil on canvas, 50 × 62½ in. (127 × 158.8 cm). Courtesy of the Maryland Historical Society BCLM-MA.5911

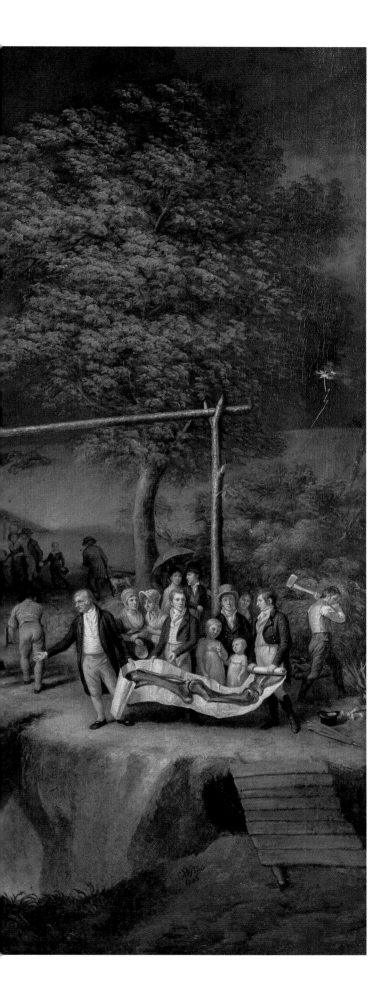

splendid stuff in his museum. Both Peale's Philadelphia Museum, founded in 1784, and the Boardman shop in New Milford from a few years earlier were based in concept and arrangement on Enlightenment principles that recommended systems of order designed to ensure harmony and virtue in the new republic.[34] Whereas Boardman created a shop that could manipulate the local economy—selectively retailing goods displayed in an organized and harmonious manner in order to encourage people to accede to his taste, thus curtailing errant consumer impulses—Peale sought to create a world in miniature, as he called it. His everyday work was to lure visitors into his museum in theatrical fashion and then educate them according to his precepts.

A Linnaean scientist and a Deist, Peale believed that a benevolent Creator had provided in nature all that was necessary to fulfill human life, if only man could gather, organize, and mold those resources. The scholar David Ward links this big portrait to Peale's contemporary painting *Noah and His Ark* (1819, Pennsylvania Academy of the Fine Arts, Philadelphia), suggesting that the artist had come to think of himself as a modern-day Noah, gathering natural resources in case of disaster, creating order, and ultimately providing salvation through the sanctified and secure display of educational artifacts.[35] In a long daylit room in the Philadelphia State House (later renamed Independence Hall), Peale designed a rational grid system of cabinet dioramas and cases for the display of wildlife specimens, above which he hung portraits of great men. As the curator Brandon Brame Fortune has explained, Peale painted the portraits of these so-called worthies in a reductive style—simplified and severe compared to that used in his private commissions—in order to maintain harmony in the display. He carefully selected his subjects, "as none but the virtuous deserve to be remembered."[36] His personal skills and hands-on approach to museum work are evidenced by the palette on the table just behind him and the taxidermy tools near the preserved turkey in front of him. Those implements not only define his profession—as in a classic *portrait d'apparat*—but also give him agency in the human activity behind him. In the portrait's collapsed narrative, Peale shows us his process and his product: he is the architect of the picture and all that can be seen in it. His work effectively creates the educational and emotional experience for his visitors, including the woman in the rear who raises her hands and cries out, quite losing her composure at the shocking sight of the great mammoth. In his museum, Peale has provided for her a cathartic experience, a potentially life-altering moment.

Lest there be any doubt that the man who made the museum really did excavate and reconstruct the beast, Peale painted and displayed a narrative scene of that episode. The *Exhumation of the Mastodon* (fig. 18) tells the story of how Peale, in the summer of 1801, found and excavated prehistoric

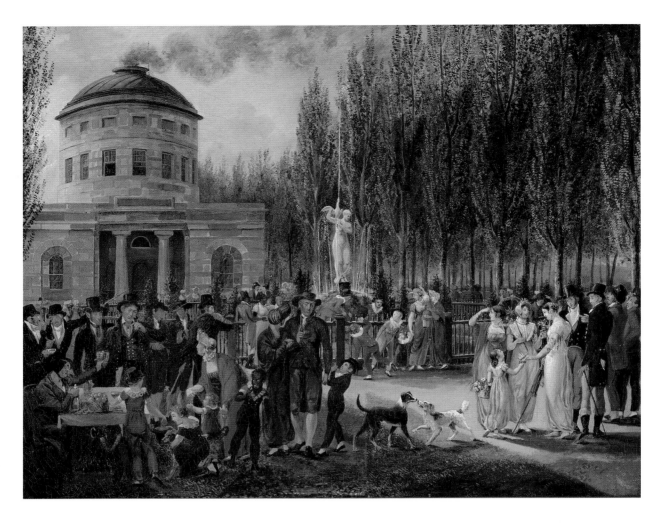

mammoth bones in marshes near Newburgh, New York. That year, on Christmas Eve, the skeleton was unveiled at the museum to much press and fanfare, providing the perfect defense of Peale's views on the primacy of the natural world.

At the time he founded his museum, Peale was one of many Americans obsessed with finding proof of prehistoric life on the North American continent. Thomas Jefferson, an avid collector of fossils, famously argued with the French naturalist Georges-Louis Leclerc, comte de Buffon, who claimed that life-forms in America had degenerated rather than evolved over time. Peale's discovery of the "Great American Incognitum" (as it was known before its identification as a mastodon) put the matter to rest and triggered President Jefferson's investment in the geological exploration of the western territories.[37]

In his autobiography, Peale described the discovery and excavation in minute detail, conveying his epic labor in the service of developing theories of cosmological history, life on earth, extinction, and the interdependence of species.[38] In his painting, Peale emphasized his principal role by depicting an ordinary day in the life of one of America's greatest artist-scientists. Peale holds his enormous and accurate drawing of the mastodon bone, not only providing an illustration but also representing the critical role of the artist in the production of scientific knowledge. He stands with his family, posed according to a hierarchy similar to the one he used in his museum; his family's presence at the pit reinforces their devotion and service to his leadership. In fact, only his son Rembrandt was actually involved in the excavation, but Peale bends the truth in order to include his second and third wives (Betsey DePeyster, to whom he was married during the

excavation but who died in 1804, and Hannah Moore, his wife by the time he finished the picture), as well as nine children, his brother James, various in-laws, unidentified kin, and other spectators. Indeed, Peale organized his family and his composition according to a strict taxonomy, with the well-dressed relatives at right, the shirtless and sodden workers in the pit, and the inattentive hoi polloi in the background. Hung at the museum near the mastodon skeleton, the painting reinforced the primacy and immediacy of Peale's educational and social agenda for an ideal republican state in which the classification and hierarchy of species was absolutely clear, everyone knew who was in charge, and human chaos was held at bay.

Peale endeavored in his daily work to eradicate the sort of atmosphere captured in paintings by the German immigrant John Lewis Krimmel, whose *Fourth of July in Centre Square* and *Quilting Frolic* (figs. 19 and 20) were shown at the Pennsylvania Academy of the Fine Arts in 1812 and 1813, respectively. Krimmel's festive scenes masked an underlying renegade quality, reflecting the popular prints made after paintings by the British satirical artists William Hogarth and David Wilkie (see fig. 21).[39] But jolly paintings of Philadelphians picnicking would have been quite different from amusing prints of the misbehaving British. In *Fourth of July in Centre Square*, various groups of like individuals celebrate the holiday near the Pump House in Philadelphia while keeping to themselves—Quakers on one side, the affluent on the other, with groups of lower classes in between. Yet everyone is, after all, enjoying the same space and celebration, thus signaling that the time-honored hierarchical system for social engagement was on the verge of collapse.

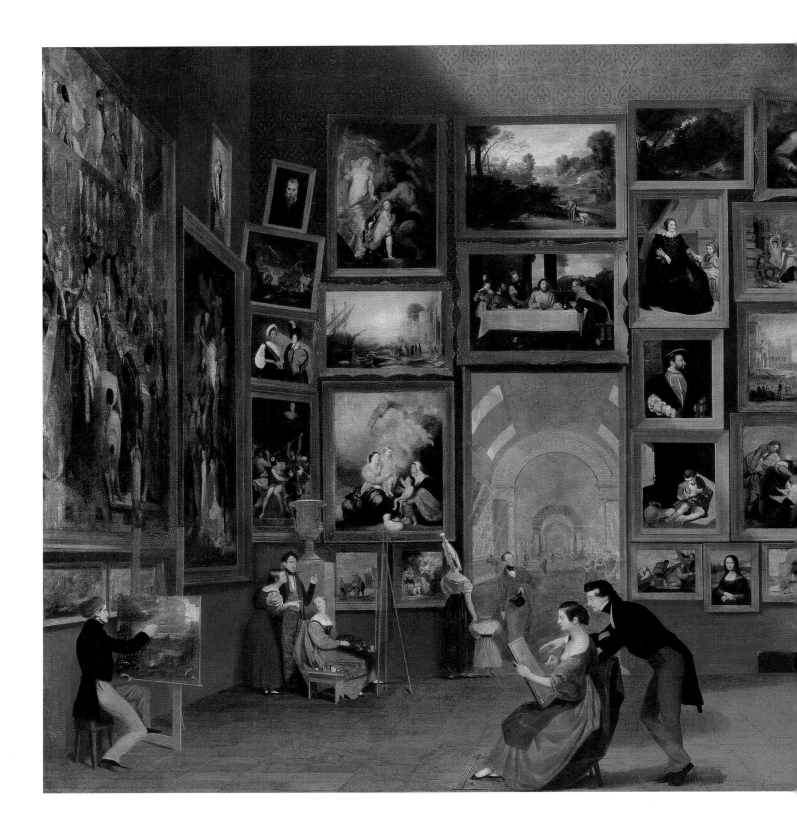

Krimmel gathered information for his paintings in the field, as it were, by observing local habits, rituals, and ceremonies, so that even while his pictures took their compositional format from British models, his subject matter was keyed to his potential audience at the Pennsylvania Academy. Similarly, Krimmel's *Quilting Frolic* would have been recognizable to contemporary viewers as a local translation of Wilkie's *Blind Fiddler* (fig. 21). In fact, Krimmel made the connection clear by painting a copy of the British print and submitting it to the academy as a companion piece for his quilting scene. In both works, enclosed rooms set the stage for the unfolding of revelry among various social and racial types, mixing work and pleasure, culture and folly. Krimmel's exploration of a new form of painting in America represented just the sort of lively, disorganized, democratic impulse that provoked in Peale a determination to solidify his museum for the new era.

Caviar to the Multitude

The creation in early nineteenth-century America of public venues for art exhibitions changed everything for artists working at the time. In New York, the American Academy of the Fine Arts, founded in 1802, began holding annual exhibitions of both contemporary art and old master paintings in 1816; the National Academy of Design followed in 1825 with a program aimed at promoting the works of living artists. In Philadelphia, Peale maintained his natural history museum, and the Pennsylvania Academy of the Fine Arts gathered modern paintings, sculpture, miniatures, and drawings for its annual juried show while, farther north, the Boston Athenaeum did the same. These institutions, along with the myriad galleries, shop exhibitions, and auctions that developed in the burgeoning capitalist environments of the major cities, effectively created an open market for art in various formats—from portraits to narrative scenes to landscapes. Only a small portion of the works displayed at exhibition sold, but the shows provided the impetus for artists to execute speculative works of their own choosing. Private clients continued to order portraits in droves, fostering successful careers for dedicated portraitists like Thomas Sully, Henry Inman, and the long-lived Gilbert Stuart. At the same time, however, a very few avant-garde patrons—Luman Reed in New York, Henry Carey in Philadelphia, and Robert Gilmor in Baltimore, for example—worked directly with certain artists on special projects. Adding to the mix was a flood of foreign paintings brought to these shores by entrepreneurs selling to both the knowledgeable and the unsuspecting, collectors who might have recognized a Titian or a Raphael if they spotted it on Broadway, but perhaps not.[40]

Fig. 22. Samuel F. B. Morse. *Gallery of the Louvre*, 1831–33. Oil on canvas, 73¾ × 108 in. (187.3 × 274.3 cm). Terra Foundation for American Art, Chicago. Daniel J. Terra Collection 1992.51

Fig. 23. Johann Zoffany. *The Tribuna of the Uffizi*, ca. 1772–77. Oil on canvas, 48⅝ × 61 in. (123.5 × 155 cm). The Royal Collection © 2008 Her Majesty Queen Elizabeth II RCIN 406983

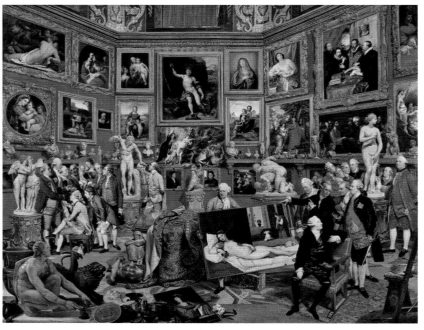

Fig. 24. Samuel F. B. Morse. *Susan Walker Morse (The Muse)*, ca. 1836–37. Oil on canvas, 73¾ × 57⅝ in. (187.3 × 146.4 cm). The Metropolitan Museum of Art, New York. Bequest of Herbert L. Pratt, 1945 45.62.1

In many ways, artists in 1825 struggled with the same issue that had confronted Matthew Pratt back in 1765: how to improve the public's perception of the painter. How could they get the local merchant elite to commission from them more than a mere likeness or convince them that the artists right in their own streets had talent worthy of their appreciation and business? For a brief moment in time, it looked as if Samuel F. B. Morse would save the day. A painter from the Boston suburbs, Morse studied in London with West from 1811 to 1815 and honed his portrait skills via travel in New England and South Carolina before taking New York by storm in 1824. A veritable unknown, he gained instant celebrity by winning the city's prize commission for a full-length portrait of the Marquis de Lafayette (1824–26, The City of New York). In swift and characteristic fashion, he converted his star turn into the means by which he rallied local artists—even most of those who were jealous of him—around him as a united community that would stimulate mutual support and individual opportunity. Morse and his merry band met privately in 1825 as the Drawing Association, which the following year became the National Academy of Design, the first artist-run fine-arts institution in the country. Yet even before the academy could mark its fifth anniversary, Morse

was restless. The institution had not created a thriving market for contemporary art; on the contrary, the city's affluent leaders were still more likely to buy an ersatz Leonardo than a bona-fide work by a talented artist in their midst. In 1829 he left for Europe, seeking inspiration and escape from the burden of portraiture.

Four years later, Morse returned from his travels in Italy and France with a large didactic painting, not for submission to the National Academy but for special exhibition in his New York studio, in the fall of 1833, and for a subsequent national tour. *Gallery of the Louvre* (fig. 22) confronted head-on the problems Morse perceived in the New York art scene: a flood of fake European masterpieces on the market along with a lack of faith in contemporary American artists had created a frenzied atmosphere that did nothing for the broader development of national culture, about which Morse remained passionate. In his new painting, which told the story of how things should be, he created an Americanized *Kunstkammer* featuring himself and others—including his friend the author James Fenimore Cooper—studying, making, and discussing art in a gallery. Morse had seen Johann Zoffany's *Tribuna of the Uffizi* (fig. 23) in the Royal Collection in London and would also have known versions of Giovanni Paolo Panini's paintings *Ancient Rome* and *Modern Rome* (1757, The Metropolitan Museum of Art) from their exhibition in New York at the American Academy in 1828. The format of these pictures inspired Morse, in effect, to bring home the collection of European paintings he thought most vital to the success of American art at large.

Morse began with the Salon Carré at the Louvre—the Grande Galerie is beyond—but rearranged it according to his own specifications. He mined the entire museum during 1831–32, toting his easel and paints along with him in order to record the works he would bring back to America on his large canvas. He scrubbed the Salon Carré of its installation of then-modern French paintings and re-curated it as a gallery of Italian old masters. Back in New York, he filled in the frames and finished the figures, including the centermost self-portrait. Morse, in profile, is, of course, helping an American student to see the world of art from his perspective. In the room are other students as well as patrons who, Morse knew, could also learn a thing or two about great painting. In case Americans failed to recognize each and every one of the masterpieces that Morse portrayed in miniature, he produced a graphic key for distribution to visitors to his studio.[41]

The highest praise for Morse's painting came from the *New-York Mirror*, whose critic enjoyed the show, returning again and again: "Most other pictures we have been able to grasp in a moment, or at least to satisfy ourselves after one or two visits. But this representation of the Louvre, although we have seen it perhaps twenty times, never tires."[42] Viewers

missed the seriousness of Morse's intent, finding the picture delightfully novel, a travelogue of sorts for those who had never been to and would never visit the Louvre. As the diarist and painter William Dunlap wrote, "Every artist and connoisseur was charmed with it, but it was 'caviare to the multitude.'"[43] Perhaps the problem was in Morse's delivery: when he should have told a story, he gave a lecture. The result was a chiding sermon on the capacity of American artists for greatness if only they had the freedom to study the correct models and the requisite financial support for advancement. *Gallery of the Louvre* is charged with exhortations "to raise the level of aesthetic discourse among artists and the public" and to recognize what one Morse biographer has called "American Providential destiny."[44] Like other wise men frustrated by the limited circumstances of their time and place, Morse would not see his dreams become reality until he was in his dotage. Long before then, he had given up painting, considering it an insufficient medium for telling tales or delivering lectures. His Morse code, and the technique of photography, which he brought to America from France, provided him clearer syntax. His last painting portrays his daughter, Susan, as a melancholic allegory of the arts of design (fig. 24). She is the muse of painting, her father's alter ego, with a sketchbook of blank pages that provoke her beseeching gaze up to the heavens. The beautiful portrait hints at Morse's tale of artistic woe but looks beyond for stories to be told by the next generation of artists.

1. For more on the painting, see Caldwell and Rodriguez Roque et al. 1994, pp. 57–60; and Rather 1993.
2. Rather 1993, p. 169.
3. Now officially the Republic of Suriname, it was spelled Surinam by the English, who founded the first colony, formerly known as Nederlands Guyana or Dutch Guiana.
4. John Greenwood, Diaries, 1752–58, New-York Historical Society.
5. Letter of June 6, 1878, from Edward A. Wild, and Kenny, "John Greenwood's Sea Captains Carousing in Surinam," n.d., both manuscripts in the curatorial files of the Saint Louis Art Museum.
6. Saunders 1995, pp. 61–86.
7. Staiti 1995–96b, p. 74.
8. Copley letter to Benjamin West or Captain R. G. Bruce, ca. 1767, in Copley and Pelham 1914, pp. 65–66; see also Rather 1997.
9. See Wood, G. 1992; Bushman 1992; Shalhope 1990; and Styles and Vickery 2006.
10. Lovell 2005, p. 10.
11. Harris 1982. See especially, chapter 3: "The Burden of Portraiture," pp. 55–88, 339–48.
12. Ibid., p. 56.
13. Revere Waste and Account Book, 1768, Revere Family Papers, Massachusetts Historical Society, Boston.
14. Lovell 2005, p. 104.
15. See Staiti 1995–96b, p. 57; and Bushman 1992, pp. 30–60.
16. For more on this topic, see Casper 1999.
17. Staiti 1995–96a, p. 47.
18. Stein, R. 1976; Abrams 1979; Boime 1989; Miles 1993; and Neff and Pressly 1995–96, pp. 102–3.
19. Burke, E. 1757.
20. See Hoock 2003; and Solkin, ed. 2001.
21. Neagle painted two versions of the picture. The earlier, from 1826, is owned by the Museum of Fine Arts, Boston. The work illustrated here and used for the present exhibition is the second, more elaborate version from 1829. See Torchia 1989b.
22. Lyon 1799.
23. Fitzgerald 1868, p. 480.
24. Ibid.
25. Griffin 1990, pp. 137–38. On the sketch of the Pythagorean theorem at bottom right, see Chambers 1976.
26. Retford 2006, p. 230.
27. See Peale's diary entries in Miller, L., ed. 1983, pp. 533–42, and p. 636 for the fees.
28. See Barratt 2004–5.
29. Sellers 1952, p. 120; Lovell 2005, p. 148.
30. Miles and Reinhardt 1996.
31. Bushman 1992, p. xiv.
32. Kornhauser et al. 1991–92.
33. See Kornhauser 1986; and Jaffee 1991.
34. On Peale's museum, see Ward 1996–97; Brigham 1995; and Yochelson 1992.
35. Ward 1996–97, p. 262; and Ward 2004. See also Stein, R. 1981.
36. See Fortune 1990, p. 309.
37. See Semonin 2004; and Semonin 2000.
38. Miller, L., ed. 2000.
39. On Krimmel, see Harding 2003; and Harding 1994.
40. On the development of art institutions in America during this period, see Barratt 2000–2001; Miller, L. 1982; and Wallach 1998.
41. Morse 1833.
42. *New-York Mirror* 1833.
43. Dunlap recorded Morse's lament in Dunlap 1834, vol. 2, p. 317.
44. Staiti 1989, pp. 202, 188. Staiti provides a thorough analysis of Morse's purpose in making this painting.

Stories for the Public, 1830–1860

BRUCE ROBERTSON

In *The Painter's Triumph*, William Sidney Mount depicts an artist unveiling his creation to the astonished delight of a farmer, his customer (fig. 25). Although we cannot see the canvas they gaze at, we know that the farmer and the artist really see themselves, reflecting the power of art to mirror and aggrandize one's own life.[1] The pleasure both take is a model of the reaction many viewers in the years before the Civil War had in front of such scenes of everyday life, beginning, more or less, with Mount's first efforts in the 1830s and continuing over the next two decades. The power of artists to capture the realities of everyday life in paintings occupied a middle ground, challenged both by the world of popular culture, which proffered cruder, more sensational entertainment, and by many within the realm of fine art who wanted art to elevate and refine the viewer by focusing on ideal beauty alone. Nonetheless, it was during these turbulent decades, from shortly after the election of Andrew Jackson to just before the Civil War, that such scenes thrived, changing and adapting to address contemporary concerns and crises but always embodying what it meant to be an American.[2]

Mount's rendering of an artist and his client was literally worlds away from Samuel F. B. Morse's impressive panorama of elevated cultural production, *Gallery of the Louvre* (fig. 22), exhibited only five years earlier, in 1833. The location of art making has moved from the Louvre, formerly a royal palace, to a rural farmhouse; from the distant banks of the Seine to the coast of Long Island; from a large, formal gallery to a small, bare room. The treatment of the figures in the two works is equally distinct. Mount reduces Morse's crowd of tourists, artists, and amateurs, all seen at a measured distance, to two energized men, so close that we can almost touch them. In Mount's painting, ideal forms and classical culture turn their back on the commonplace realism of the scene, as dramatized by the drawing of a bust of the Apollo Belvedere tacked to the wall and facing away from the artist; or perhaps we should say that Mount's Americans turn their backs on Apollo.

In one sense, the two paintings share the same subject: that of artists telling us how to look at and create art. Each constitutes an artist's statement about the nature and worth of art but with significant differences in form, in the specifics of the props, and in how a story is told. These differences are the subject of this essay, and they might be summed up by the artists' statements about their respective audiences. Morse declared in a speech in 1826, "The truth is, the Fine Arts are addressed not to the great mass of the community, but to the majority of the well educated and refined in Society." Mount, on the other hand, writing in his diary twenty years later, proposed to "paint scenes that come home to everybody. That every one can understand."[3] Even as Morse was painting *Gallery of the Louvre*, Americans had begun resisting efforts to develop a national culture by command from the top, preferring the bootstrapping efforts of individuals.

The Social Fabric

The nation's cultural politics were aligned with the civil politics of the day. The period inaugurated by President Andrew Jackson's first administration in 1829, often labeled the era of "Jacksonian Democracy," fundamentally changed American society: it was the first time that the elites who had founded the nation were no longer in power.[4]

Outwardly the United States grew much richer and more complex economically. Technological innovations transformed the experience of space and time for most Americans. The most radical of these innovations was the railroad, which soon brought the country together. Along with earlier developments, such as the steamboat and the Erie Canal, connecting New York City to the Great Lakes and the new western states, the railroad fostered a revolution in communications. The early 1830s brought the creation of the penny newspaper, which spread reading broadly throughout the country. (With one of the highest literacy rates in the world, the United States would become the first nation where as many

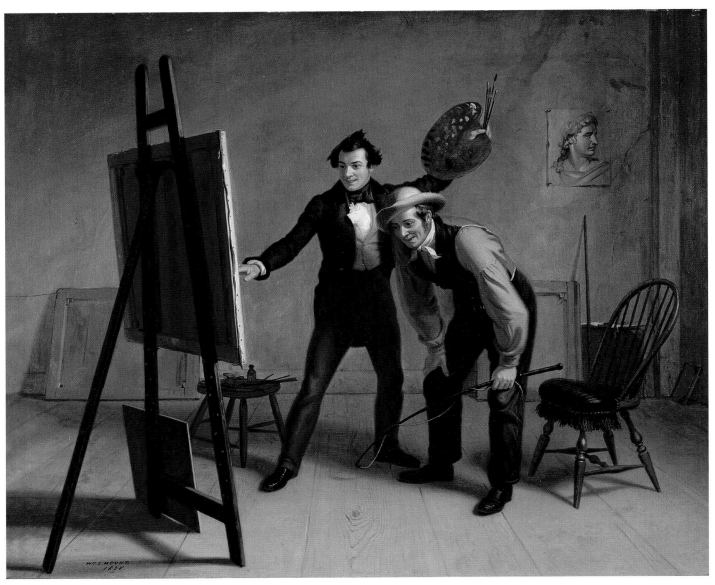

Fig. 25. William Sidney Mount. *The Painter's Triumph*, 1838. Oil on wood, 19½ × 23½ in. (49.5 × 59.7 cm). Courtesy of the Pennsylvania Academy of the Fine Arts, Philadelphia. Bequest of Henry C. Carey (The Carey Collection) 1879.8.18

women as men could read.) The author and publisher Samuel Goodrich recalled in 1856 how reading had changed since his youth, at the beginning of the century: "Books and newspapers . . . were read respectfully, and as if they were grave matters, demanding thought and attention. . . . Even the young approached a book with reverence, and a newspaper with awe. How the world has changed!"[5] The mass of reading material available to average Americans by the 1830s was unprecedented, comprising a flood of novels, gift books (glossy Christmas annuals), serials, and magazines of all kinds, a cornucopia of exciting, admonitory, emotional, and instructive stories for every taste. But newspapers, with their lurid stories and strong partisanship, were what most marked the age. Artists frequently included them in scenes of daily life, often as the fulcrum of the action (see figs. 45 and 46).

Another pivotal communications invention was the electric telegraph, which allowed the nearly instantaneous transmission of news (mostly political) and financial data from one end of the country to the other. Perfected by the artist and scientist Samuel F. B. Morse, it was perhaps a more consequential contribution than his painting of the Louvre. In 1848 former New York City mayor Philip Hone, a merchant and art collector and patron, observed that the *Milwaukee Sentinel* contained in its morning edition the previous afternoon's market news from New York. He noted this fact in his diary, adding, "I was once nine days on my voyage from New York to Albany."[6]

Perhaps the largest transformation of the country, however, was a physical one: with the annexation of Mexican territories (from present-day Texas to California and states in between) as well as Florida and Oregon, the United States by 1850 stretched from one ocean to another. The dramatic events surrounding this expansion—a war of imperial aggression against Mexico, the forced removal of Native Americans

from the East and the Old West to designated reservations, a gold rush in California, and the immigration of thousands to new regions—are central in the American imagination, fulfilling the national self-image of the archetypal American: a forceful individual and a frontiersman in all his manifestations.

Yet the most destabilizing physical change for many was the transition from rural to city life: during Mount's lifetime (1807–1868), New York City grew from just under one hundred thousand to nearly a million inhabitants, and while fewer than one in fifteen Americans lived in towns larger than twenty-five hundred before 1820, by the Civil War nearly half did.[7] During this period most Americans moved from a way of life comfortably ordered around the cycles of the seasons, around trading and selling real things in small communities where everybody knew everybody else and social relations were settled, to city life, where everything changed all the time, where stocks and bonds were worth more than tangible goods, where one never knew from one day to the next who one's neighbors might be, and where money determined power. Few Americans were prepared for these changes and many did not welcome them. The philosopher Ralph Waldo Emerson catalogued the upheaval he saw around him in the 1840s: "Our countrymen love intoxication of some sort. There is no repose in their character. All foreigners and we ourselves observe the sort of hunger, the voracity for excitement, which haunts us. Is it for food? Is it for news? Is it for money? Is it for stimulation in any form? . . . Our trade is wild and incalculable. Our people are wide travellers; our steamboats explode; our ships are known at sea by the quantity of canvass they carry; our people eat fast; our houses tumble; our enterprizes are rash; our legislation fluctuating."[8]

This ceaseless activity and change could easily lead to violence, often sparked by issues of race and class. Andrew Jackson's first inaugural turned into a brawl: when he invited "the people" to come to the White House, they did, overturning and breaking the furniture and leaving muddy footprints everywhere. It was a riot, and not an exceptional one in this age of "Mobocracy."[9] Strikes were frequent and often bloody, as workers resisted the tides of industrialization that threatened their autonomy and livelihoods. There were also riots against an Ursuline convent in Boston, against African Americans in New York, against Mormons, abolitionist editors, and immigrants. New York City's Astor Place Riot of 1849 pitted the partisans of two Shakespearean actors—one English, the other American—against each other. In this dispute between old elites and the nativist working class, a crowd of thousands threatened to destroy the Astor Place Opera House; twenty-five people died when troops fired on the crowd. The violence in the eastern cities was matched by violence on the frontier. Racial cleansing was practiced against Native Americans, as more than fifty thousand were uprooted from their homes and sent to the so-called Indian territories west of the Mississippi River. The era would end in the terrible bloodshed of the Civil War, a war in which more Americans died than in any other.

The fundamental cultural expression of the many changes in American society could be found in the increased tension between the active public sphere of politics and business, and the private arena of family life. Even as the public sphere grew more vociferous, the private one claimed greater and greater cultural power. As the architect Andrew Jackson Downing declaimed in 1850, "In America, not only is the distinct family the best social form, but those elementary forces which give rise to the highest genius and the finest character may, for the most part, be traced back to the farm-house and the rural cottage."[10] Americans conceptualized the destabilizing transformations of their day by fixing not on invisible economic forces but on changes in family relations as the cause of their new problems, and the place in which to solve them. Art was to have an important place in this effort, aided by the appearance of public venues for displaying and selling artworks. Among the most notable were the National Academy of Design, founded in 1825, which focused on exhibiting the work of living American artists, and the American Art-Union, founded in 1838 as the Apollo Gallery (the final name would be adopted two years later), which was a commercial venture for exhibiting, engraving, and selling paintings.[11] In an 1845 address on the Americanism of the American Art-Union, Joel Headley, an associate editor of the *New York Tribune*, declared:

> If ever there was a people on the face of the earth with peculiar and striking characteristics, it is the American people; and if we could only release ourselves from that strange infatuation about foreign arts and artists . . . we should soon have an *American* literature, an *American* school of art, as well as a peculiar form of self-government. . . . Give me the control of the *art* of a country, and you may have the management of its administrations. . . . The tariff, internal improvements, banks, political speeches and party measures are put paramount to them [our statesmen], and yet they all together do not so educate the soul of the nation.[12]

Telling Stories through Images

If art was so powerful, what role should it play in this new country? Americans looked to scenes everyone could feel and experience directly. In *The Image Pedlar* (fig. 26), Francis William Edmonds, an amateur painter and one of Mount's major rivals, imagined the way images interacted within an appropriately ordered family, which he divided along gender lines. The peddler in the center presents to the women—the mother with her baby and the grandmother (or perhaps mother-in-law)—a bowl of plaster fruit, modeled and painted to look

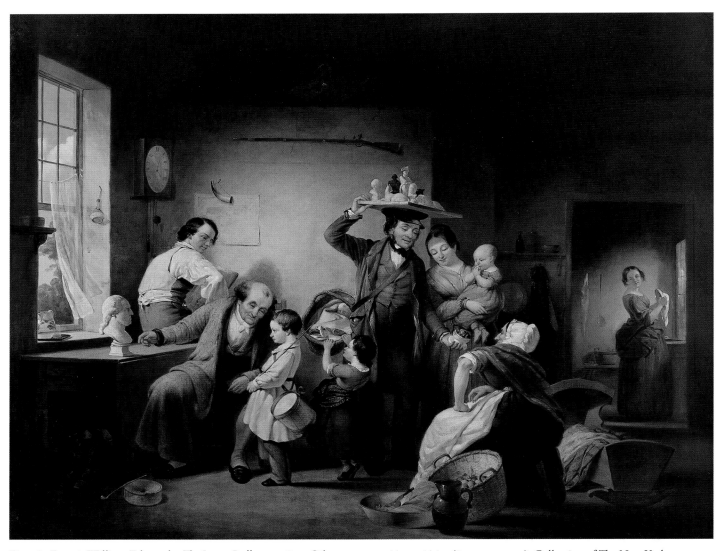

Fig. 26. Francis William Edmonds. *The Image Pedlar*, ca. 1844. Oil on canvas, 33¼ × 42¼ in. (84.5 × 107.3 cm). Collection of The New-York Historical Society. Gift of the New-York Gallery of the Fine Arts 1858.71

like the real thing. They admire it hugely. Gathered on the left side of the canvas are the menfolk—grandfather, son, and grandson. Resting on a table beside them, with sunlight streaming in benediction over it, sits a bust of George Washington; the grandfather instructs the grandson about this famous hero while the boy's father looks on. In Edmonds's scene, women are attracted to superficial illusionism while men respect and respond to meaningful substance. Most important, however, is that Edmonds shows us how a *family* responds to images, which for the artist and his audience were important tools in conceptualizing how Americans should naturally respond to their new nation and how they fit within its social framework.

Many oil paintings like Edmonds's *Image Pedlar* were intended to suppress dissent by envisioning a comfortable cultural center and enforcing an appropriate social order. Ironically, however, Edmonds's peddler sells not oil paintings but reproductive objects or multiples, a subtle reminder that this was the first period in American society where cheaply produced imagery, part of the great publishing explosion of

the 1830s and 1840s, surrounded ordinary people. It is also an indicator that the reach of oil paintings was conspicuously narrower than that of the lithographs, woodcuts, and other illustrations that appeared in everything from cheap pamphlets to expensive gift books put out by quality publishers.[13] The titillatingly crude and violent woodcuts in *Davy Crockett's Almanacks* (fig. 53), a series of pamphlets celebrating the deeds of the mythologized frontiersman, appealed to the young workingmen and their sympathizers who would wreck the Astor Place Opera House, whereas oil paintings were the province of the elites who would be attacked. Yet exhibitions of paintings, and printed copies of them, could cross such barriers, and sometimes did; the founders of the American Art-Union prided themselves on mounting exhibitions that attracted everyone "from the millionaire of the 5th Avenue, to the B'hoy of the 3rd—from the disdainful beauty of Fourteenth-street . . . to the belle of the Bowery," as they reported in the 1848 Art-Union *Bulletin*.[14] Thus, fine art occupied an uneasy high ground.

Oil paintings like Mount's and Edmonds's recall the didacticism of much contemporary improving and sentimental literature as well as advice and self-help manuals whose aim was to improve or at least change their middle-class readers. Further, because Mount and his colleagues were no longer bound by the narrative obliqueness required of the previous generation of artists, their works could be edifying or force emotion in ways that the narrative paintings before them—mostly portraits—could not. Intended as they were for a larger public audience, most of their compositions are explicitly readable, often from left to right, with actors whose gestures are both broad and distinct. Ambiguity, if present at all, is usually deliberate, with its meaning easily accessible rather than requiring deep learning or searching. The painting styles are generally precise and full of detail—resulting in comfortable, middle-class images that virtually all cultured Americans confessed to favoring. As Nathaniel Hawthorne remarked after visiting the Uffizi Gallery in Florence in 1858, "It is a sign, I presume, of a taste still very defective, that I take singular pleasures in the elaborate imitations of Van Mieris, Gerard Dou, and other old Dutch wizards who painted such brasspots that you can see your face in them, and such earthen jugs that will surely hold water."[15] Not for Hawthorne the abstract idealizations of the Apollo Belvedere when he, like Mount's farmer, could see himself in a Dutch painting.

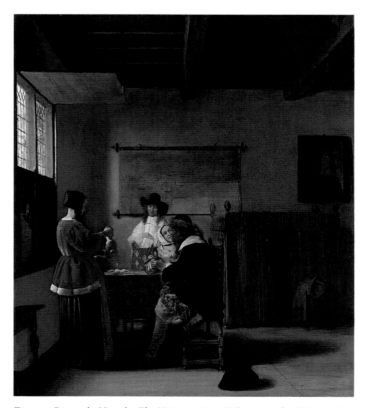

Fig. 27. Pieter de Hooch. *The Visit*, ca. 1657. Oil on wood, 26¾ × 23 in. (67.9 × 58.4 cm). The Metropolitan Museum of Art, New York. H. O. Havemeyer Collection, Bequest of Mrs. H. O. Havemeyer, 1929 29.100.7

The seventeenth-century Dutch paintings that Hawthorne preferred were, like Pieter de Hooch's *The Visit* (fig. 27), recognizable and deliberate transcriptions of normal lived experience, what art historians call genre scenes. Augmented by eighteenth-century examples by British (see fig. 5) and French successors to the Dutch, they provided the visual foundation on which mid-nineteenth-century American artists built their stories of everyday life.[16] Following this tradition, the audience for American genre paintings was middle class, and the painters themselves delighted in presenting lots of readily identifiable details. Like their earlier counterparts, American genre artists depicted stories and scenes that were not about leaders or heroes but that concerned the neighbors, at home, in a tavern, or at market. The subject matter was often didactic in its intent and generally meant to be comic. The essence of this comedy, as it was classically understood, was that it should be directed at those below the intended audience; thus, the figures represented were generally taken from the middle or lower class.[17] The New York author and editor William A. Jones, in an essay on American humor published in 1845 in the *Democratic Review*, catalogued the sources of comedy in everyday life as "the Camp meeting, the negro music, the auctioneers and orators, and fashionable clergy, life on the Mississippi and the Lakes, the history of every man's life, his shifts and expedients, and change of pursuits, newspaper controversies, fashions in dress, military trainings, public lectures, newspaper advertisements, placards, signs, names of children, man worship, razor-strop men. The trait creeps out in numberless ways. So far from being a dull people we are eminently cheerful."[18] These were the subjects artists painted, with plots and characters that were (and often are still) obvious and immediately recognizable; for example, the theme of boy-meets-girl and its endless permutations have satisfied every generation.

In adapting these genre traditions, American artists changed them in important ways. As Jones's list suggests, the range of American life, like the size of the country itself, was extraordinary and constantly broadening. While American audiences struggled with overwhelming change, the subject matter of American genre painting became increasingly nostalgic, delineating scenes and activities that were already out of date in the lively and very modern metropolises where the paintings themselves were displayed and acquired. As nostalgia became more central to the subject matter, the comic element was often de-emphasized, and many genre paintings came to serve as pleasant records of the recent past, reflecting, for example, the rustic background of the New York merchant, who could reminisce fondly in the comfort of his well-appointed study. Because the sheer size of the country required an act of imagination to keep it together, subjects never encountered in the staid parlors of Manhattan—savage Indians, intrepid trappers, rowdy

frontiersmen—could also be encompassed by genre scenes. While some artists did travel, staking their claims to authenticity by actually having seen what they depicted, most did not. Yet this did not matter much because, in truth, these themes could vividly be brought to life by a vast literature of novels, romances, newspaper reports, and prints. With images of Native Americans adorning everything from patent medicines to bank notes, such formerly exotic subjects appeared in even the most straitlaced parlors, becoming as familiar as the girl next door.[19]

The abundant visual details that drive these points home in most genre paintings summon up the illusion that the painting is part of the world already known to the viewer (Mount's farmer) and often allude to a greater meaning (as in the drawing of Apollo in the same painting). This meticulous version of life leads to the apprehension that we can see ourselves, that the painting and the people in it are real, like us. For example, the western newspaper critics who first viewed the scenes of George Caleb Bingham before they were sent to the East Coast for sale were thrilled to recognize themselves in them. The characters in *Shooting for the Beef* (fig. 50) were presented with "life-like fidelity," according to an anonymous author, who marveled, "It seems an incarnation rather than painting."[20] Even a more staid eastern critic, upon viewing Jerome B. Thompson's paintings in 1857, described them as "pictures which literally talk with reminiscences and life."[21]

The fact that genre paintings depicted the familiar meant that they could reach the viewer without the aid of any literary or historical knowledge. As Mount himself declared in 1850, "I must paint such pictures as speak at once to the spectator, scenes that are most popular—that will be understood on the instant."[22] Like Mount's farmer, one knew what one was looking at without having to be told what it was. In truth, however, genre paintings always existed within a verbal and written context. When these paintings were first put on public display, they were often accompanied by explanatory titles or even long descriptions that guided the viewer; sometimes (as with *The Painter's Triumph*) a story would be published in the press that laid out the scene even more fully.[23] And even those genre paintings that seemed entirely unrelated to pre-existing stories inevitably summoned up for the viewer already familiar narratives. The actors in them were often seen as specific individuals, and this may sometimes have been true,[24] but most were types: the old soldier, the dandy, the matronly widow, and so on. The art historian Elizabeth Johns, who has written eloquently about this aspect of American genre painting, has characterized the Yankee as one of the central actors of American art. Indeed, Mount's customer in *The Painter's Triumph* is a Yankee.[25]

The Painter of Yankees: William Sidney Mount

The Yankee was first represented as a recognizable type on the comic stage. The first American musical or comic opera, *The Sawmill: Or the Yankee Trick* (1824), written by Mount's own uncle, Micah Hawkins, a sometime composer, featured Yankees, but it is just one example among many that Mount and his customers would have seen.[26] The stage Yankee was a country bumpkin, often outlandishly dressed in either an old-fashioned farmer's smock or some exaggerated and uncouth version of city fashion, slouching and clumping his way across the boards. His manners were often boorish and as crude as his dress and posture, as seen in Tompkins H. Matteson's *Sugaring Off* (fig. 28), in which a Yankee farmer

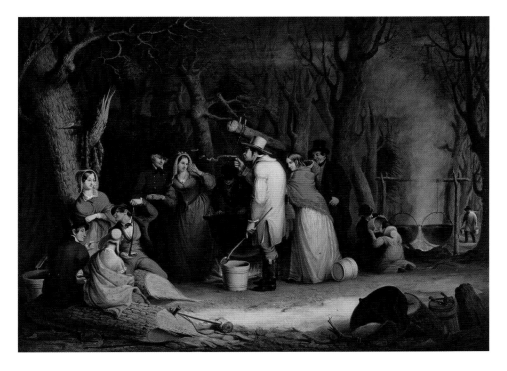

Fig. 28. Tompkins H. Matteson. *Sugaring Off*, 1845. Oil on canvas, 31 × 42 in. (78.7 × 106.7 cm). Carnegie Museum of Art, Pittsburgh. Bequest of Miss Rosalie Spang 32.2.1

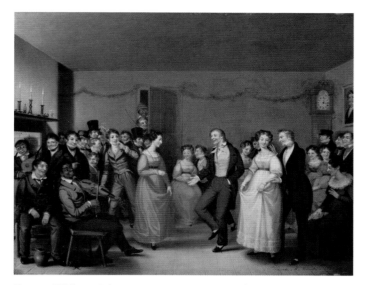

Fig. 29. William Sidney Mount. *Rustic Dance After a Sleigh Ride*, 1830. Oil on canvas, 22⅛ × 27⅛ in. (56.2 × 68.9 cm). Museum of Fine Arts, Boston. Bequest of Martha C. Karolik for the M. and M. Karolik Collection of American Paintings, 1815–1865 48.458

alarms the ladies by blowing maple-syrup bubbles at them. Underneath this rustic exterior, however, the Yankee was shrewd, calculating in all his dealings, and often inventive with dry puns and wordplay. The stereotype had a basis in reality known to most New Yorkers, who were themselves recent transplants from the country. The sympathetic mockery of the Yankee found in such plays, or in Mount's paintings, concealed both nostalgia for what the character represented and fear of what Americans were becoming.[27] The self-assertion and frankness of the Yankee encapsulated his republicanism, the leveling that made all men equal as ordained by the new nation. In this new order, men would now value plain, direct speech rather than elegant and pretentious language; rude manners, or no manners at all, rather than the false manners of a gentleman. As the author of one advice manual lamented in 1857, most Americans seemed to regard "*Rudeness* and *Republicanism* as synonymous terms."[28]

Mount is generally considered the first artist to transplant this stage creation successfully to canvas.[29] Certainly his first genre painting, *Rustic Dance After a Sleigh Ride* (fig. 29), exhibited at the National Academy of Design in 1830, marks both the onset of his fame and the conventional starting point for a discussion of American genre painting (and accounts for one of the chronological boundaries of this essay). Yet the figures in his rustic dance are no different from those in John Lewis Krimmel's scenes of Philadelphians dancing; in fact, Mount's work is closely based on a Krimmel painting from about 1813 with a similar subject and title.[30] Both Krimmel, in a related 1813 painting titled *Quilting Frolic* (fig. 20), and Mount stretch busy scenes filled with points of interest across the full widths of their canvases. Thus, the

narratives in these works evolve through cumulative incident: painting as novel rather than short story. This treatment derives directly from the work of the slightly older British artist David Wilkie, whose innovative scenes of everyday life—especially his *Blind Fiddler* (fig. 21), engraved in 1811—were circulated widely in engraved form.[31]

In contrast, Mount's first major mature painting, *Bargaining for a Horse (Farmers Bargaining)* (fig. 30), also one of his first to depict a Yankee, established a path for American genre painting through the intensity of the artist's characterizations and the force of his composition.[32] Mount based the scene on his close observation of his neighbors in Stony Brook, Long Island, where he had been born and always preferred to live. Here, as he had in *The Painter's Triumph*, and in contrast to both his *Rustic Dance* and Krimmel's *Quilting Frolic*, Mount eliminates the amusing secondary episodes to concentrate on a single idea. In *Bargaining*, the two farmers are engaged literally in horse-trading as they debate the merits and value of the horse in question. But they do so slyly, each ostensibly as interested in the slow progress of his whittling as he is in the deal. Neither wants to lose, and each is prepared to wait the other out. Seduced by the pursuit of profit, however, one farmer (in the top hat) has let his barn go to ruin—the crossbeam holding up the roof has cracked—and he ignores his wife in the background. With a subtle economy of detail and pose, Mount reminds his viewers that the Yankee can be too shrewd for his own good.

Despite the immediate success of his genre scenes, Mount worked virtually without competition in the 1830s; it was not until late in that decade and early in the next that genre paintings became more numerous. Nonetheless, Mount's innovations marked a decisive change in the way such paintings would tell stories and signaled the rapid shifts occurring in the art world and among its audiences. These changes came about as three forces converged. The first was a profound transformation, both in Europe and in the United States, in the understanding of what constituted history and historical narrative. The second was a great prolif-eration of venues for displaying and selling artworks, which led to the creation of a public art market. The third was the enormous change in American cultural and political life, as discussed earlier, which made genre painting a suitable vehicle for imagining a national community—an American society —able to transcend for a time the sectional divisions that would tear this country apart in 1861. It is no wonder that contemporaries hailed Mount as "the greatest artist this country has ever produced in that line of history painting," noting that his aim was not merely to tell familiar stories, nor even to be a "truly national painter"; rather, "his great aim is to tell history."[33]

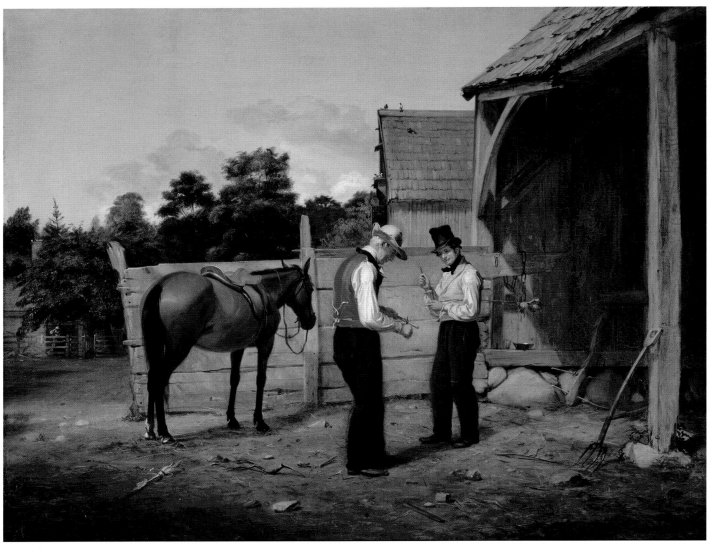

Fig. 30. William Sidney Mount. *Bargaining for a Horse (Farmers Bargaining)*, 1835. Oil on canvas, 24 × 30 in. (61 × 76.2 cm). Collection of The New-York Historical Society. Gift of The New-York Gallery of the Fine Arts 1858.59

Visual Stories and Their Publics

By the mid-nineteenth century, the distinction between historical and genre painting, like that between history and the novel, had become increasingly difficult to make. As the nature of historical writing and the understanding of history changed, so did the understanding of what was significant about a nation's character and past. The British historian Thomas Babington Macaulay wrote in 1828, "The circumstances which have most influence on the happiness of mankind, the changes of manners and morals, the transition of communities from poverty to wealth, from knowledge to ignorance, from ferocity to humanity—these are, for the most part, noiseless revolutions. Their progress is rarely indicated by what historians are pleased to call important events. . . . They are carried on in every school, in every church, behind ten thousand counters, at ten thousand firesides." He added, "A truly great historian would reclaim those materials which the novelist has appropriated. . . . The

perfect historian is he in whose work the character and spirit of an age is exhibited in miniature."[34]

Just as writers who aimed at recording the real—whether present or past—converged on the idea of the novel, artists turned to genre as a means of depicting reality "in miniature." As a reviewer for the American Art-Union noted, "[Bingham] has taken the simplest, most frequent occurrences on our rivers—such as every boatman will encounter in a season— such as would seem, even to the casual and careless observer, of very ordinary moment, but which are precisely those in which the full and undisguised character of the boatman is displayed."[35] Another critic, upon seeing Bingham's *County Election* (fig. 44), declared, "All who have ever seen a country election in Missouri, are struck with the powerful accumulation of incidents in so small a space, each one of which seems to be a perfect duplication from one of those momentous occasions in real life." Yet another viewer regretted that "the

Fig. 31. Junius Brutus Stearns. *The Marriage of Washington to Martha Custis*, 1849. Oil on canvas, 40½ × 55 in. (102.9 × 139.7 cm). Virginia Museum of Fine Arts, Richmond. Gift of Edgar William and Bernice Chrysler Garbisch 50.2.2

figures are not made of life size . . . for the subject has the full dignity and interest requisite for a great historical painting."[36]

The antebellum period was a prolific one for American history painters, who explored incidents from the nation's past, ranging from the marriage of Pocahontas to the Revolution, with Columbus and Cortés making appearances in turn.[37] But, unlike the post-Revolutionary history paintings of John Trumbull (enlarged versions of which were commissioned for the U.S. Capitol Rotunda in 1817), the most successful historical paintings, many based not on the most heroic deeds of the day but on characteristic sentimental and domestic anecdotes, were often hard to distinguish from genre scenes. Junius Brutus Stearns's series of paintings about the life of George Washington is an example. While a number of works show Washington engaged in heroic military or serious presidential activities, the heart of the series depicts him as either farmer or married man. When it was exhibited at the American Art-Union in 1850, Stearns's *Marriage of Washington to Martha Custis* (fig. 31) was accompanied by an account of the place and the moment portrayed: as Rev. Dr. Mossom is "about to pronounce the words, 'Wilt though take this woman.'" Details included the names of all attending as well as a luxuriant description of the white satin robe of the bride and Washington's "scarlet velvet coat."[38] Indeed, without the aid of explanatory titles or accompanying text, some viewers were hard put to distinguish between historical works and genre scenes, or between paintings that illustrated a literary text and those that did not. One critic, for example, interpreted an Indian scene by Thomas Hicks, unhelpfully titled *A Study* (1851, whereabouts unknown), as the story of the Good Samaritan, whereas his friend felt it merely illustrated Indians selling skins.[39]

Like Mount, Stearns was able to produce these paintings because he had access to markets and an audience, largely through exhibitions organized by the National Academy of Design and the American Art-Union. As they grew in size and variety, exhibitions at both venues were marked by a mixture of history and genre, which was always overwhelmed, however, by portraiture (at the National Academy of Design) and landscape painting (at the American Art-Union), with a surprising number of religious works thrown in. The American Revolutionary War did not dominate historical subjects until after 1845. Among literary sources, Shakespeare and popular poets like Robert Burns predominated. Of the American authors, James Fenimore Cooper played second fiddle to the popular Washington Irving. The first painted versions of scenes from Irving's stories of a legendary New York appeared as early as 1823, within a decade of their publication, in a work by Henry Inman, *Rip Van Winkle Awakening from His Long Sleep* (whereabouts unknown).[40] These literary paintings blended visually and iconographically with contemporary genre paintings, and even contemporary viewers often grouped them all together. Even the use of the term "genre" to describe painted scenes of everyday life in America did not become common until the 1840s—before then, they were often called "familiar" paintings or "cabinet pictures."[41]

Although Mount's works were the touchstone by which all American genre painting was measured into the 1850s, he was never a prolific painter, averaging only two or three works for exhibition per year for most of the 1830s, and then only one or two yearly for the rest of his career. A common pattern for many painters was to exhibit several genre works (usually done on speculation) at an early point in their careers, before turning to landscapes or portraiture, the bread and butter for

any artist. As a result, genre scenes were pervasive, although few artists could earn a living by painting them alone.

The most important venue where any American might see genre painting was the American Art-Union, which, unlike the National Academy of Design, actively encouraged art of a broadly democratic character. As proclaimed in its 1848 *Bulletin*, not only were the works displayed drawn from artists all over the country (and from Americans working abroad), but so also were its members, who represented every state and region, from small towns to large cities, and its visitors, who ranged from "a pair of moustaches and lemon-colored kids fresh from Europe . . . [to] . . . the poor working-woman who knows not oil-paint from water-colors, but who weeps when she looks upon 'The Mother's Prayer.'"[42] More important, the Art-Union bought the paintings it showed—more than three hundred a year by 1850—and distributed selected engravings of them to all its subscribers, whose number exceeded twelve thousand by 1850. Art-Union members everywhere, from New Orleans to Brooklyn to small towns in Ohio, could display in their parlors fine engravings of such scenes as Richard Caton Woodville's *War News from Mexico* (fig. 46) or Bingham's *Jolly Flatboatmen* (fig. 49), and a lucky few could own the actual canvases, which were offered by raffle to this same subscriber base (see fig. 32). Unfortunately, this ultimately led to the organization's downfall: in 1852 its operations were ruled an illegal lottery, and it was shut down. Until then, however, the Art-Union could trumpet its own success: "This association has now become truly national in its character and benefits. . . . It proposes to send into tens

of thousands of households the refining influences of art, in a truly republican way, and one suited to the moderate fortunes of our citizens."[43]

While it lasted, the American Art-Union combined many of the forces that made New York so powerful culturally: printmaking, moneymaking, and a national distribution system. With the Art-Union's insistence on "American subjects," the market for scenes of everyday life exploded. Moreover, because the Art-Union had a nationwide reach, it introduced this American imagery to the whole country in a way that transcended region and many other niches such as politics, religion, and gender.[44]

The engravings that the American Art-Union selected as particularly worthy of distribution to every member serve as a reminder that many of the paintings illustrated here were known to the public in multiple formats. Most of Mount's major paintings were engraved. *Bargaining for a Horse* appeared both as a handsome engraving suitable for framing and as an elegant illustration for a story in the publisher and collector Edward Carey's gift book. *The Gift* was representative of a class of stylish annuals combining literature and images that were favorite end-of-year souvenirs, especially among women. Indeed, it was Carey who commissioned Mount's *Painter's Triumph* in the first place, for *The Gift*.

The world of illustration grew enormously in the wake of the print explosion that high literacy rates, cheap production, and inadequate copyright enforcement created in the 1830s. (Today's practice of music and video downloading provides an apt analogy for the vividness and quantity of material

DISTRIBUTION OF THE AMERICAN ART-UNION PRIZES,

Fig. 32. Francis d'Avignon, after Tompkins H. Matteson. *Distribution of the American Art-Union Prizes, at the Tabernacle, Broadway, December 24, 1847*, 1847. Color lithograph printed by Sarony and Major and published by John P. Ridner, 24 × 29⅞ in. (61 × 75.9 cm). The Metropolitan Museum of Art, New York. The Edward W. C. Arnold Collection of New York Prints, Maps, and Pictures, Bequest of Edward W. C. Arnold, 1954 54.90.1056

suddenly available to everyone, and its impact.) A vital element of this explosion was the commercial development of lithography. Nathaniel Currier (later more famous as half of the duo of Currier and Ives) opened his first lithography business in New York City in 1835. The French firm Goupil, Vibert and Co., sensing opportunities in the new markets exposed by the American Art-Union, arrived in 1848: Mount's *Power of Music* (fig. 65) was the company's first American fine-art lithograph. The critic Henry T. Tuckerman commented in 1847 that many American artists had to become illustrators rather than painters in a country where "art necessarily takes a popular form, and cheap literature answers instead of public libraries." He also noted that "there is a tendency to make art and literature subservient to temporary ends, and render them popular agents. . . . It is no ignoble office to take an efficient part, either as a writer or an artist, in the education of the people."[45] William A. Jones, the author of one of the first appreciations of Mount, agreed. In his 1841 essay "The Culture of the Imagination," he commended cheap culture, declaring, "The numberless improvements in the art of engraving have brought the choicest works within the reach of even the laborer."[46] As a result, prints, like oil paintings, could be used for education and improvement. Unlike oil paintings, however, they were not restricted by exposure to public view in elite cultural arenas such as the National Academy of Design.

Thus, prints were often blunter in their messages, more melodramatic and lachrymose in their expression, and more cruelly violent than oil paintings. Historians have described this explosion of prints as part of the growing culture of sensation, which included the theater and other public entertainments.[47] Oil painting, in contrast, merely touched the margins of such exciting fare.

Growing Up in the Imperfect Family

The most popular subject among artists of this period, and the one most scrutinized, was the family. Every member, from baby to patriarch, was examined, weighed, and usually found wanting. The center of this attention increasingly became the mother. As one magazine editor declared in 1841, "It is an article of our creed that the American mother is the best mother in the world; and that the best elements of the American character, those which mark us as a peculiar people, and have most contributed to make us a great nation, were fashioned and moulded by the plastic hands of American mothers."[48] In Christian Friedrich Mayr's painting *The First Step in Life* (fig. 33), for example, the baby moves toward his mother, not his father. That first step is fraught with anxiety in the hearts of those watching: Where will it lead? How will the baby grow up and manage the transition to adulthood and responsible citizenship?

Fig. 33. Christian Friedrich Mayr. *The First Step in Life*, ca. 1847. Oil on canvas, 26¾ × 31⅞ in. (67.9 × 81 cm). Greenville County Museum of Art. Museum purchase with funds from the 1993 Museum Antiques Show, Elliott, Davis & Company, CPAs, sponsor; Corporate Benefactors: Alice Manufacturing Company, Inc.; Barker Air and Hydraulics, Inc.; BB&T; Carolina First Bank; The First Union Foundation; Greenville News-Piedmont Company; Hartness International; Insignia Financial Group, Inc.; KEMET Corporation; Liberty Life Insurance; Michelin North America; Odell Associates, Inc.; Pepsi-Cola Bottling Company of Greenville; Portman Marina, Inc.; Provence Printing, Inc.; Suitt Construction Company; Thoracic and Cardiovascular Associates 92.21.24

Americans fixated especially on the problem of physical and moral purity, a transference from the broad-scale changes occurring within the new market-oriented society. Sylvester Graham, one of the most prominent social commentators at the time (remembered today for his invention of the Graham cracker), advised young men that the key to success in life was to restrain from all sexual impulses, as any sexual stimulation outside the bounds of marriage would inexorably lead young men to "a shocking state of debility and excessive irritability," and even death.[49] Only through absolute temperance could a young man achieve happiness. Middle-class reformers relentlessly tried to shape family values as they witnessed anxiously the dramatic changes around them. But they were not unopposed, and these tensions created divisions in even the most well-ordered households.

Because they could not exercise the right to vote—and the sobering responsibility that went with it—women were considered especially vulnerable to material temptations. In *The New Bonnet* (fig. 34), Edmonds shows a young unmarried woman exulting in her purchase of a splashy new bonnet while her parents gasp at the cost. She is an image of unbridled consumerism, providing a classic warning for contemporary advice columnists, who argued that shopping produced "unnatural excitements" and worse.[50] In this scene, Edmonds

Fig. 34. Francis William Edmonds. *The New Bonnet*, 1858. Oil on canvas, 25 × 30⅛ in. (63.5 × 76.5 cm). The Metropolitan Museum of Art, New York. Purchase, Erving Wolf Foundation Gift and Gift of Hanson K. Corning, by exchange, 1975 1975.27.1

questions the wisdom of trying to acquire gentility and upward mobility through consumption. The daughter, who holds the frivolous bonnet, is deliberately positioned opposite her mother, whose attributes are the plain cooking utensils beside her.

Young men could look to better models for growing up properly. Richard Caton Woodville's *Old '76 and Young '48* (fig. 35), painted in 1849 in the immediate aftermath of the Mexican-American War, shows a young soldier who has internalized the lessons of George Washington and the Revolution.[51] The hero relates his exploits to his grandfather, a veteran of that earlier war, who sits beneath a portrait of himself as a young man and a bust of Washington on the mantel.

The most fraught relationship within families, however, lay in the path of their creation. Courting was the greatest trial in the lives of young men and women as they approached adulthood. Indeed, for most young people,

adulthood could not be fully achieved without marriage, which signified that one was settled in one's course of life, and a man could not contemplate marriage before he could be sure of supporting his wife; until then, one was still considered immature. Courting was further endowed with symbolic power because it was the moment in the arc of one's life story when conventional relations between men and women were inverted. Most of the time, the power of decision rested in men's hands: they had jobs, were expected to support their families, and were given the right to vote. Women, in contrast, were supposed to stay at home. While real life was never so neat, in idealized relations between men and women, the latter were most often acted upon rather than the ones who acted. In courting, however, it was always the woman's right to choose: men proposed, but it was women who said yes or no. Yet, as a young New England woman named Eliza Southgate had noted about

1800, "We have the liberty of refusing those we don't like, but not of selecting those we do."[52]

Unsurprisingly, people reacted very differently to these pressures. One young bachelor wrote in 1838 that he yearned to "taste the comforts and enjoyments of a home with the society of a bosom companion to solace a portion of [my] time at the domestic fireside and in the bosom of a family."[53] In contrast, however, another young man, Aaron Olmstead, invoked the daredevil Davy Crockett in his advice to a shy friend in 1836: "Depend upon it, a 'faint heart never won fair lady.' If you would make conquests instead of suffering your eyes to be dazzled by a false splendor and sculking [*sic*] away in the background you must take a monstrous dose of Col. Crockett's '*go-ahead*' [and] Bounce into the midst of the fair [ladies]."[54]

Set against the confusion was a persistent, even strident questioning of the traditional ways of doing things. Family and marital relations were being reconceived radically, even as evangelicals insisted on a return to older Christian values. It was during this period that Americans could enter into a half dozen or more very different marriage arrangements. The most radical was no marriage at all and complete celibacy, as exemplified by the Shakers, who, at their peak in the 1840s, consisted of some six thousand members spread over eighteen communities in six states. At the other extreme was the practice proposed in 1842 by the Mormon founder Joseph Smith: polygamy. In between was almost every conceivable version of marriage and/or sexual relations, as courting, matrimony, pregnancy, child rearing, and even the sexual act itself were reconceived and experimented with in innumerable utopian communities.[55] Against this backdrop, advice and self-help literature and popular culture strove mightily to enforce a middle-class ideal of conventional marital happiness to which all should aspire. Prints like Nathaniel Currier's *Courtship, The Happy Hour* (fig. 36) reinforced the message like a sledgehammer in comparison to more nuanced genre paintings.

Fig. 35. Richard Caton Woodville. *Old '76 and Young '48*, 1849. Oil on canvas, 21 × 26⅞ in. (53.3 × 68.2 cm). The Walters Art Museum, Baltimore, Maryland 37.2370

Fig. 36. Nathaniel Currier. *Courtship, The Happy Hour*, 1851. Lithograph with hand coloring, 14 × 10 in. (35.6 × 25.5 cm). Fine Arts Museums of San Francisco. Gift of Anne Hoopes in memory of Edgar M. Hoopes III 1989.1.76

Variations on courting themes were probably the most common subject for genre paintings.[56] In *The City and Country Beaux* (fig. 37), Edmonds is having fun with a young woman who must choose between an urban sophisticate and his rube rival: she stands closer to the well-mannered gentleman in black and seems to gesture with dismay at the boor in his loud clothes who slouches and smokes in her presence. The latter's position next to the door suggests that he is on his way out. The rivalry between city and country permeated genre painting, just as it did the theater that inspired it, with the conflict between city slicker and country cousin usually ending in the latter's favor (but not always, as in this case).

The courtship paintings of Jerome B. Thompson and Lilly Martin Spencer (the one distinguished woman genre painter of the period), made more than a decade after Edmonds's, are less explicitly comic; this difference marks the transition to what some historians have called a more sentimental, female-directed culture.[57] Thompson prospered throughout the 1850s with scenes of couples set in bucolic landscapes. They were termed "domestic landscape compositions," alluding to

the artist's success in achieving a balance between nature and familiar human relations. In *Apple Gathering* (fig. 38), a "city beau," recognizable by his formal costume, sits on a basket, and a much more casually dressed "country beau" lies on the ground. Thompson blankets the underlying theme of courtship with a general sense of fecundity and plenitude, suppressing any possible comic misunderstandings.[58] Thoughts of Eve's forbidden fruit are banished in favor of the Garden of the Hesperides, Hera's grove in which golden apples abounded. In his *Belated Party on Mansfield Mountain* (fig. 39) a group of young people, having ridden or walked to the top of Mount Mansfield in the Green Mountains of Vermont, are resting and enjoying the view. The sun is setting, however, and one young man holds up his watch to warn the others that they must soon depart. But, as youths do, the rest ignore him, seemingly unconcerned that their way down the mountain will soon become difficult, even perilous. They are enraptured by the beauties of nature and "the desire to wait and watch the sun disappear beyond the far distant dim line where earth and sky blend in the blaze of light," as a critic wrote in 1859.[59]

The atmosphere in Spencer's *Reading the Legend* (fig. 40), an early work, is more highly idealized than in Thompson's scenes. Transported by the novels they have been sharing, the young couple engages in a mutual tender reverie so intense that a romantic castle ruin emerges out of the landscape behind them: the age of chivalry has materialized. All three courtship paintings naturalize love by placing the couples in landscapes—love blossoms most easily in nature. Yet the city is never far away, particularly because the paintings were made for exhibition and sale to city dwellers.

Spencer's paintings of young women alone show considerably more spark than her sentimental images of couples. In *Kiss Me and You'll Kiss the 'Lasses* (fig. 41), the young woman is now in command; from her seat of power, the kitchen, she wards off romantic attention with the flirtatious threat of a spoonful of molasses, which promises a sweetness different from that of her kisses. The view of the kitchen is directed not toward the ovens or hearth but into the genteel parlor, and the young woman's dress makes it clear that she is not a servant to be trifled with but the daughter of the house. Unlike the flighty unmarried daughter in Edmonds's *New Bonnet*, this young woman is hard at work, making jams from the summer's fruits. One contemporary viewer found her "looking firm but full of mirth, [in a scene] replete with that mischievous and animated life which is one of Mrs. Spencer's distinguishing characteristics."[60] Fundamentally, the painting is a one-liner, but it is made delicious by an abundance of the luscious detail that most genre painters delighted in portraying and that Spencer described as "the best thing of the kind I have yet produced."[61]

Fig. 37. Francis William Edmonds. *The City and Country Beaux*, ca. 1838–40. Oil on canvas, 20⅛ × 24¼ in. (51.1 × 61.6 cm). Sterling and Francine Clark Art Institute, Williamstown, Massachusetts 1955.915

Fig. 38. Jerome B. Thompson. *Apple Gathering*, 1856. Oil on canvas, 39¾ × 49½ in. (100.9 × 125.8 cm). Brooklyn Museum. Dick S. Ramsay Fund and funds bequeathed by Laura L. Barnes 67.61

Fig. 39. Jerome B. Thompson. *The Belated Party on Mansfield Mountain*, 1858. Oil on canvas, 38 × 63⅛ in. (96.5 × 160.3 cm). The Metropolitan Museum of Art, New York. Rogers Fund, 1969 69.182

Fig. 40 . Lilly Martin Spencer. *Reading the Legend*,
1852. Oil on canvas, 50⅜ × 38 in. (128 × 96.5 cm).
Smith College Museum of Art, Northampton,
Massachusetts. Gift of Adeline Flint Wing, class of
1898, and Caroline Roberta Wing, class of 1896
SC 1954:69

Fig. 41. Lilly Martin Spencer. *Kiss Me and You'll
Kiss the 'Lasses*, 1856. Oil on canvas, 29⅞ ×
24⅞ in. (76 × 63.3 cm). Brooklyn Museum.
A. Augustus Healy Fund 70.26

Fig. 42. Lilly Martin Spencer. *Young Wife: First Stew*, 1854. Oil on canvas, 30 × 24 in. (76.2 × 61 cm). Susan and Bruce Lueck

Spencer's relatively unvarnished take on the realities of male-female relationships is made most explicit in a pair of paintings chronicling the travails of early married life: *Young Wife: First Stew* (fig. 42) and *Young Husband: First Marketing* (fig. 43). In these scenarios, the young wife is not in command of her kitchen and the young husband has been sent out to get the groceries as though he were a servant. As in so many of her genre paintings, Spencer underlines her humor with a pun: the wife is in a stew about her stew. With the husband, the artist achieves her comedy by assigning him a task outside his proper place and function.[62] Spencer was depicting a real social anxiety of the time, that of the complexity and difficulty in setting up a household and having it run efficiently, as addressed in manuals like Catherine Beecher's 1842 *Treatise on Domestic Economy, for the Use of Young Ladies at Home, and at School*. The works also have a larger goal: to question seriously the nature of genre painting and its relationship to its audience. Scenes such as Spencer's were created to be viewed in the parlor, the center of refinement in a house, a place where all evidence of labor and hardship was erased. But here Spencer has brought the back of the house—the part usually kept hidden from visitors so that nothing can mar the refined performance enacted in the parlor—to the front. She similarly brought the laborer to the fore in her other paintings of housewives, servants, and cooks. This effect is very different from that of a rustic interior, which

no visitor could mistake for the proud homemaker's own kitchen. *Young Husband* is perhaps even more transgressive in that both the man's gentility and his competence are parodied publicly. Spencer further breaches the decorum of genre painting by showing people only slightly lower on the social ladder, if at all, than the intended viewer. In doing this she breaks the first commandment of genre painting: comedy is about those below us.

In both *Young Wife* and *Young Husband*, the faults we laugh at lie with the woman—if things were running well in the kitchen, the maid would be doing the marketing. Yet the responsibility lies with the husband, and it is he who invites the greatest ridicule. His posture is so awkward that he appears to be falling apart, whereas the young wife is merely weeping. It was always the man's job to establish the defenses between the family at home and the larger world outside, and if he failed, catastrophe could ensue.

Voting and Arguing

Fundamental to the larger world that men inhabited was politics, exemplified both by the places where politics was enacted (coffee shops, oyster houses, and taverns) and by the institutions that embodied the practice (the parties, law courts, and assemblies). One would be hard put to find a corner that remained neutral in the face of the overwhelming pressure and saturation, the intensity and vividness of politics. Many coffee shops, theaters, and clubs were allied overtly with party sentiment, and even newspapers were not impartial. Indeed, the election of Andrew Jackson had brought with it the irreversible spread of party politics. No longer could Americans ignore the fact that the political process was now factionalized and could be managed only by separate parties. Moreover, this division was now seen more and more clearly as a matter of Northern versus Southern interests, and unifying national themes were increasingly hard to come by.

George Caleb Bingham's series celebrating elections as they took place in recently created states along the western frontier comprised the most explicitly political paintings by any American artist at the time. In *The County Election* (fig. 44), Bingham delights in the crowd of types that gather around the polling place. Bracketing the foreground are figures representing the alpha and omega of American politics: the happy drunk whose vote has been bought with liquor and the downcast loyalist whose candidate has lost and who bows his head with more than a hangover. This empowerment of the common man through an enlarged franchise reflects the fundamental process of Jacksonian democracy. In a development well under way even before Jackson's election, many states rewrote their constitutions to erase all property restrictions related to the vote—but the changes applied to white males

Fig. 43. Lilly Martin Spencer. *Young Husband: First Marketing*, 1854. Oil on canvas, 29½ × 24¾ in. (74.9 × 62.9 cm). Private collection

Fig. 44. George Caleb Bingham. *The County Election*, 1852. Oil on canvas, 38 × 52 in. (96.5 × 132.1 cm). Saint Louis Art Museum. Gift of Bank of America 44:2001

only. Typical of the outcome was the New York constitutional convention of 1821, which gave all white men the franchise while simultaneously making it more difficult for freed black men to vote. This was the paradox of Jacksonian democracy: even as rights were increased in one area they were decreased in another, so that the one African American in Bingham's scene stands far to the left, at the very edge of the canvas.

In between the extremes represented by the drunk and the loyalist, Bingham savors every type within American political culture. When the painting was being engraved in 1852, Bingham changed the title of the newspaper held by one figure from *Missouri Republican* to *The National Intelligencer*, so that "there will then be nothing left to mar the *general character* of the work, which I design to be as *national* as possible— applicable alike to every Section of the Union, and illustrative of the manners of a free people and free institutions."[63] Ironically, Bingham could find no East Coast exhibition venue for the painting before he had it engraved.

As Bingham implies, politics was considered a man's game, too rough for women. Bingham himself was a disappointed politician, denied election to the Missouri statehouse in

1846 by crooked dealing. He swore never to get involved in politics again but in the end found himself—like most Americans—addicted to the pursuit. Woodville's *Politics in an Oyster House* (fig. 45) acknowledges this kind of political zeal in its depiction of the start of the electoral process: the argument over candidates and policies. The young political enthusiast, his party newspaper in hand, berates his older friend as they huddle in the booth of a typical male eating establishment (it is too crude to be called a restaurant). The latter's disengagement—the fruit of experience?—is evident. Woodville's *War News from Mexico* (fig. 46) transfers this small scene to a larger stage, the porch of the "American Hotel." The head of the eagle and half of "American" on the hotel's signboard are cut off, perhaps a small note of warning that not all is well. The man in the center holds a newspaper and reads aloud the exciting news. The young dandy to the left and the old veteran to the right are equally engaged, as are the clerk, the salesman, and the others on the porch. Two groups are excluded, however, because they cannot vote: the black man on the steps and his child in front of the porch, and the old woman inside who cranes her head through the

Fig. 45. Richard Caton Woodville. *Politics in an Oyster House*, 1848. Oil on canvas, 16 × 13 in. (40.6 × 33 cm). The Walters Art Museum, Baltimore, Maryland. Gift of C. Morgan Marshall, 1945 37.1994

window to listen. The war with Mexico was as partisan as it was national, and Americans were fiercely divided about its propriety, its conduct, and its outcome. The war itself was over quickly, with a small army of Americans defeating the much larger Mexican army. Yet how would the nation assimilate the indigenous and Catholic Hispanic peoples living in the new territories? Indeed, race, or, more accurately, racial

differences, permeated every aspect of the war—and the presence of the black man and child in the foreground of Woodville's scene provides a silent commentary on the issue.

Throughout these decades it was very hard to avoid the subject of race in American politics. Although Congress, controlled by representatives from slaveholding states and their allies, rejected the annual antislavery petitions presented

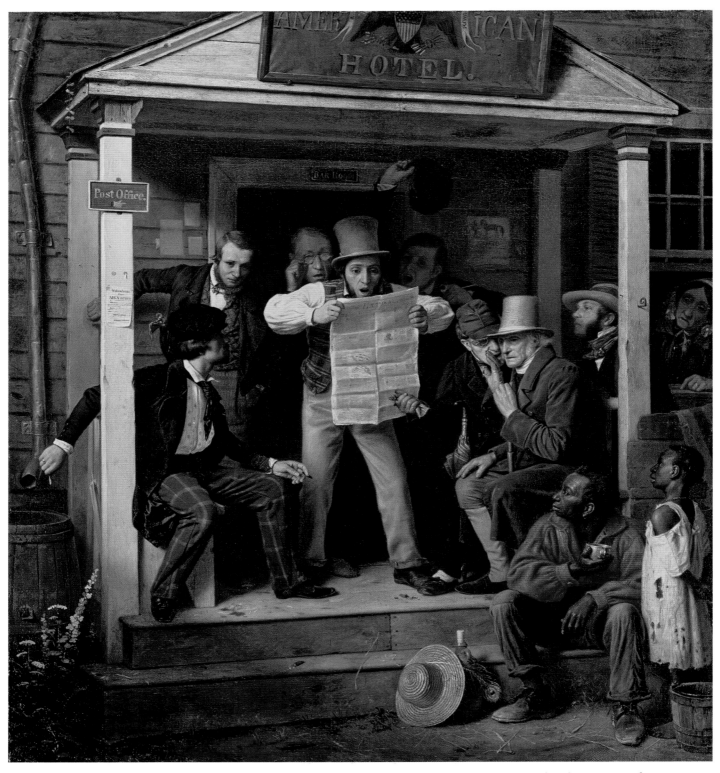

Fig. 46. Richard Caton Woodville. *War News from Mexico*, 1848. Oil on canvas, 27 × 25 in. (68.6 × 63.5 cm). Crystal Bridges Museum of American Art, Bentonville, Arkansas

by former president John Quincy Adams—imposing a gag rule that prohibited discussion of the issue from 1836 until 1844—the controversy never receded from public debate. Even when absent from view, race could be present, as in Mount's *Cider Making* (fig. 47), a more subtle comment on politics than the paintings of either Bingham or Woodville. In this instance, "cider making" refers to the symbols of

William Henry Harrison's presidential campaign of 1840: barrels of hard cider. A story published in connection with the painting explicated the details of the political allegory and the identities of the figures. For example, the old squire in the back is the Whig banker Nicholas Biddle; the young girl is Fanny Wright, who campaigned for women's rights; and the dog, Trim, is the newspaper editor Francis Preston Blair.[64]

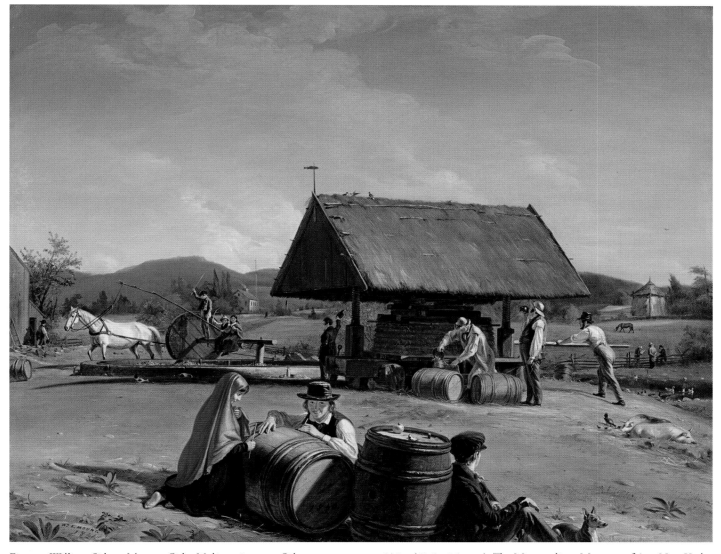

Fig. 47. William Sidney Mount. *Cider Making*, 1840–41. Oil on canvas, 27 × 34⅛ in. (68.6 × 86.7 cm). The Metropolitan Museum of Art, New York. Purchase, Bequest of Charles Allen Munn, by exchange, 1966 66.126

In this apparently benign image of a political society, the younger generation enjoys the fruits of the adults' labor. In order to achieve this harmony, however, Mount deliberately excluded from the painting the black workers who would have been part of any actual scene observable near his home in Stony Brook, Long Island, which, like many parts of New York State, had a significant African American population.

This exclusion heightens the artificiality of good cheer in *Cider Making*. By comparison, Mount's *Bargaining for a Horse* (fig. 30) is the more honest of the two paintings, revealing that sharp dealing and endless striving for advantage could take place even in a bucolic landscape far from Wall Street. The art historian Bryan J. Wolfe has commented perceptively on the way in which so many of these paintings strive to obscure this issue, creating "a cultural space, where ideology can be *realized*," where the divisions of politics can be made to seem natural, even organic, and thus nonthreatening.[65]

Going West: Settling and Fighting

The divisions of the nation were physical as well as political and cultural, and artists strove to harmonize these differences. In *Fur Traders Descending the Missouri* (fig. 48), Bingham addressed the great central north-south axis of the expanding country, the Missouri and Mississippi rivers. The artist also embedded within the painting's narrative of trade and settlement the issue of race. In doing so, he acknowledged that the wilderness had never been an empty vessel waiting for Americans to spill into it from the East; rather, Native Americans, French trappers, Hispanic ranchers, and others were already there. Yet Bingham used his smooth brushwork and controlled composition of the scene to repress conflict rather than bring it to the fore. *Fur Traders* can be read from left to right—against the flow—from the native bear cub chained to the prow to the "half-breed" son reclining on the furs to his French father at the stern, representing a line of transformation from pure nature to almost civilized

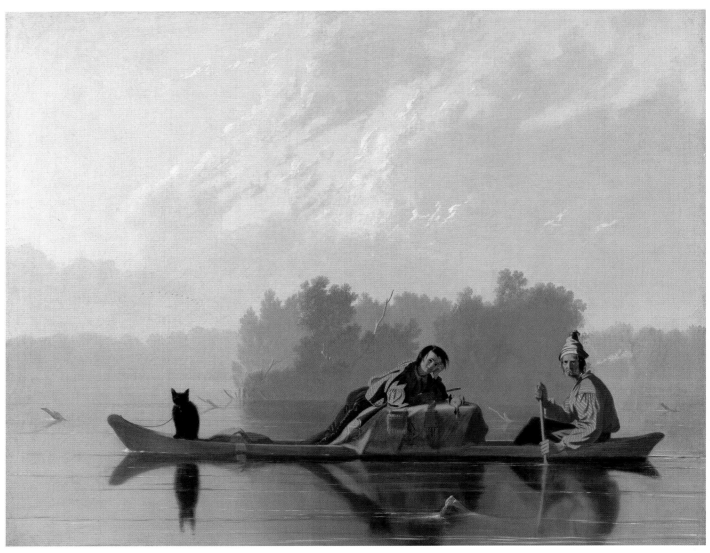

Fig. 48. George Caleb Bingham. *Fur Traders Descending the Missouri*, 1845. Oil on canvas, 29 × 36½ in. (73.7 × 92.7 cm). The Metropolitan Museum of Art, New York. Morris K. Jesup Fund, 1933 33.61

humanity. The "almost" is important, however: this is definitely not the East Coast. Bingham had first named the picture *French-Trader—Half breed Son*, emphasizing the racial exoticism of the image, but it was exhibited at the American Art-Union under its present title, which transformed the trader and his son into general western types. The scene is most remarkable for the quietness that pervades it, as non-American inhabitants along the upper reaches of the Missouri drift naturally toward the embrace of the modern, urbanized world.

A year later Bingham depicted a very different group of westerners. *The Jolly Flatboatmen* (fig. 49), his first painting to be engraved by the American Art-Union and distributed to its thousands of members, presented a national audience with an image of riverboat men engaged in a moment of relaxation: one man dances while another fiddles and a third sets the rhythm by beating on a cooking pan. Bingham emphasizes the scene's tranquillity by framing the musicians and

dancer with two seated men and, directly below the dancer, another man who stretches on his back and clasps his hands behind his raised head so that he can watch the high-stepping footwork. The artist subtly elevates the tone and mood through the flatness of his brushwork and the calmness of his setting—and with a (not-so-subtle) reference to the often-reproduced classical sculpture of a dancing satyr from the Casa del Fauno, Pompeii (Museo Nazionale, Naples).[66]

Yet Bingham's painting, for all its exotic appeal to an East Coast audience, is fully homogeneous, suppressing the presence of Native peoples as well as the "boatmen, draymen, and laborers, white and black; French, Irish, and German, drinking, singing, and lounging" observed in 1847 by the peripatetic Philip Hone while visiting the wharfs along the Mississippi in Saint Louis.[67] In erasing the tension of race and ethnicity, Bingham also translates the men into Arcadian figures. Like the shepherds in that mythical region of ancient Greece, these boatmen do not "work" in the same way that

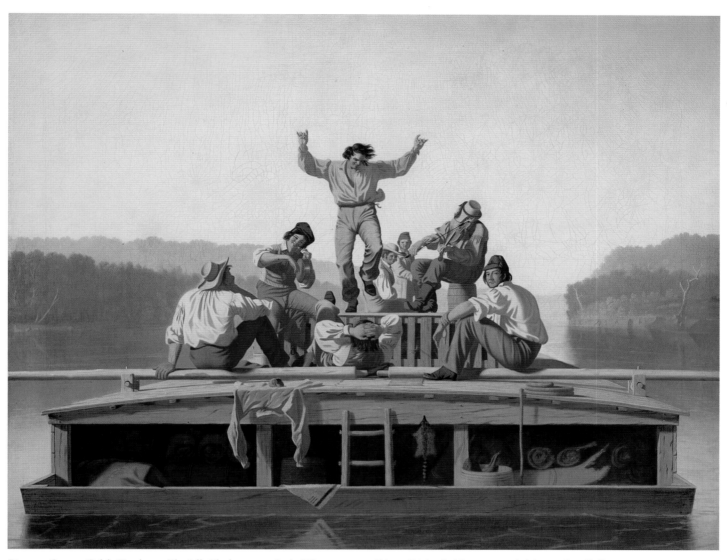

Fig. 49. George Caleb Bingham. *The Jolly Flatboatmen*, 1846. Oil on canvas, 38⅛ × 48½ in. (96.8 × 123.2 cm). Manoogian Collection

farmers, artisans, and factory workers do; rather, they spend their days drifting lazily on the river, waiting for the few moments when they are needed. The wild and dangerous frontier is thus reconceived as a white paradise, a realm of natural leisure in harmony with the strenuous efforts of national and state governments to create a "purified" United States. This was a West that Bingham's eastern audience could fantasize about being in, away from the hurly-burly of the East Coast, where the railroad had collapsed the distance between towns so miraculously and loudly.

In *Shooting for the Beef* (fig. 50), Bingham depicted yet another quintessentially western gathering, still all male, although this time in a slightly more settled region. The men are engaged in a contest of skill, each aiming at the nail holding a plank—emblazoned with the directions "To Boonesborough 14 Miles"—fixed to a dead tree in the distance. As described by a writer for the *Missouri Republican*, the prize is the "fat ox" to the left, in front of a rough "Post Office

Grocery" that serves as the community center.[68] Framed between prize and target are nearly a dozen men. On one level, Bingham presents it as a straightforward account, but it is also a sharp statement about the real skills needed in the West. No one is talking; they have been silenced by the possibility of gain. These men, however, do not engage in the haggling seen, for example, in Mount's *Bargaining for a Horse* (fig. 30), where the horse-trading may be silent but is still ongoing. In this sense, then, this western contest represents a purer transaction than that shown in Mount's painting of Yankees. In the Northeast the manipulation and negotiations of business and politics could be conflated; in Bingham's West they are fully separated—talking is reserved for electioneering, whereas in trading one concentrates on the task at hand.

The same local newspaper critic who lauded *Shooting for the Beef* as "an incarnation rather than painting" described the men portrayed in it as "backwoodsmen,"[69] a type that would continue to evolve and eventually have as much prominence

Fig. 50. George Caleb Bingham. *Shooting for the Beef*, 1850. Oil on canvas, 33⅜ × 49 in. (84.8 × 124.5 cm). Brooklyn Museum. Dick S. Ramsay Fund 40.342

in American culture as the Yankee. The term covered a lot of ground, encompassing characters ranging from squatters (the subject of an earlier painting by Bingham),[70] "crackers," and frontiersmen to mountain men, fur traders, prospectors, and, in the late nineteenth century, cowboys (see fig. 164). In its largest sense, it referred, like the word "peasant," to all those who lived far from the benefit of cities; but, unlike "peasant," which was still used disparagingly within American high culture, the term "backwoodsman" carried connotations that were more often neutral than negative and was a designation reserved for westerners. The class of men who were called squatters or crackers was looked down on, but many of the other backwoodsmen conjured up images of romance. As Herman Melville remarked in 1857, "The tide of emigration, let it roll as it will, never overwhelms the backwoodsman into itself. . . . He must depend upon himself; he must continually look to himself. Hence [his] self-reliance, to the degree of standing by his own judgment, though it stand alone."[71] Ralph Waldo Emerson's 1847 call to self-reliance may be seen, like Thoreau's performance as a backwoodsman at Walden Pond, as merely an eastern refinement of a basic American characteristic manifested most fully in the West.[72] This was the

heart of the region's attraction: out west, men were still men. Of course, exactly where the eastern states ended and the West began was a source of constant dispute. From the moment Daniel Boone marched through the Cumberland Gap into Kentucky in 1775 until the frontier was declared closed by the 1890 U.S. Census—as historian Frederick Jackson Turner famously reminded America in 1893—the West was a region receding farther and farther from the East Coast.[73]

The startling process of settling that wilderness, by which unformed nature became domesticated and Americanized, and which had been ongoing since the arrival of the first European settlers, now, for the first time, unfolded in front of the public's eyes through paintings and prints. Backwoods types were deployed in narratives that explicated how the frontier had been conquered and the West settled, first along the Oregon Trail in the 1840s and then along more southerly routes into California after the Gold Rush (1848–55). The figure of the fur trapper, in his red shirt, was the most popular; Charles Deas's *Long Jakes* (1844, Denver Art Museum) was the first representation in oil, and the most influential. Yet by 1852 some viewers were already sick of the omnipresence of the type, complaining that it had become "painfully

Fig. 51. William Tylee Ranney. *Advice on the Prairie*, ca. 1853. Oil on canvas, 38¾ × 55¼ in. (98.4 × 140.3 cm). Buffalo Bill Historical Center, Cody, Wyoming. Gift of Mrs. J. Maxwell Moran 10.91

conspicuous in our exhibitions and shop-windows, of which glaring red shirts, buckskin breeches, and very coarse prairie grass are the essential ingredients."[74] As Elizabeth Johns has pointed out, there were never more than a few thousand such men, and by 1830 they were already vanishing from the scene, as beavers became scarce and fashions changed. Just as it had been with the old-fashioned Yankee, nearly every American type that appeared in genre painting reflected what had already gone from the scene.

Most of Bingham's early genre paintings of western life were exhibited first in his native Missouri and then sent to the American Art-Union, where they were enthusiastically received as authentic images of the frontier. As art historians have explained, it was necessary to create the West as an identifiable region, something other than an extension of the East but still tied to it.[75] Thus one reviewer could write in 1853 that Bingham "is to the Western what Mount is to the eastern States, as a delineator of national customs and manners."[76] As early as 1851, however, Bingham's work was being criticized at the Art-Union, where Mount's Yankees were ranked ahead of Bingham's boatmen and backwoods-men as real Americans. As an Art-Union critic wrote, "Mount

is the only one of our figure painters who has thoroughly succeeded in delineating American life. . . . Bingham has made some good studies of western character, but so entirely undisciplined and yet mannered, and often mean in subject."[77] National politics had overtaken Bingham. In particular, the Compromise of 1850, which had sorted out the entrance of new states as either slave or free—but which had also permitted the taking of runaway slaves anywhere in the Union (through the Fugitive Slave Act)—brought the prospect of sectional division to every doorstep in the Northern states. The Northeast was now pitted politically against the West and South.

William Tylee Ranney's western paintings picked up where Bingham's left off but were far more sentimental and nostalgic, and thus more acceptable in the turbulent 1850s. In Ranney's *Advice on the Prairie* (fig. 51), a trapper comes across a wagon train and sits down at the campfire to give the group advice on how to move forward and what to expect along the way. As the British explorer and writer George Ruxton observed in 1848, "The rough conversation of the mountaineers, whose . . . narration of their everyday life is a tale of thrilling accidents and hairbreadth 'scapes," was a staple of settlers'

accounts.[78] The gesture of the buckskinned mountain man is a familiar one for such tall tales, but the position of his chief listener, who sits below him on the ground, seems to turn the gesture into a benediction. Between the two stands a young mother, holding her baby and looking attentively down at her husband. The painting documents one way in which the West was settled and also gently brings the adventure back within the comfortable fold of domestic expectations and family values. In Ranney's image, the West is not unknown territory but simply a stage in the normative process of civilization. Nearly twenty years earlier, while discussing the nature of American scenery, the landscape painter Thomas Cole had enunciated such domestication as the basic principle of the American experience: "Where the wolf roams, the plough shall glisten."[79] Yet Ranney's older man to the right, who sits with two boys, and the man standing behind him are without wives, providing a subtle reminder of the tragedies inherent in the passage through the West.

Danger often lurked beneath the surface of western paintings, and occasionally emerged. In Arthur Fitzwilliam Tait's *Life of a Hunter: A Tight Fix* (fig. 52), a large black bear has surprised a hunter, who has only his knife with which to defend himself. Fortunately his partner is aiming at the bear from the safety of a few trees just yards away, and no doubt he will save the day. The painting's imagined territory is an already mythic West (it is actually set in the Adirondacks), with the bear in Tait's painting as much a sign of the original inhabitants as the cub is in Bingham's *Fur Traders*. Tait's subject drew from the popular imagery surrounding the frontiersman Davy Crockett, perhaps the first manufactured celebrity in America, by way of *Davy Crockett's Almanacks*, a series of stories issued from 1835 through 1841 (see fig. 53). The extraordinary racism and violence in these pamphlets was aimed impartially at everyone who was not like Crockett, from Yankee peddlers to bears, but it was most vividly expressed when it was directed at Indians and blacks. In one story, Crockett and his pet bear, Death Hug, killed four Indians using only their teeth, and then "washed the injun juice from our paws, took a hug and a shake." In another, he "smashed number one into injun gravy with my foot, and spread it over number two, and made a dinner for me and my dog."[80]

Illustrated with very crude woodcuts, the *Almanacks* appealed to the type of young men who were not attracted to the sentimentalized didactic literature of self-help manuals. Indeed, the young men who bought the pamphlets were victims of the very forces such middle-class literature warned against. The stories spoke to these youths' desire to rebel against authority and to their repressed urge for violence. The images themselves provide a sense of the varied visual culture in which oil paintings also existed: within the same few New

York City blocks one could buy a crudely illustrated pamphlet or attend an exhibition of oil paintings at the American Art-Union or National Academy of Design. In the end, the audiences for both cultural arenas overlapped to a degree, as is evident from Tait's use of Davy Crockett imagery in his *Life of a Hunter*. It had, however, taken twenty years for this appropriation to become respectable. In turn, and almost inevitably, Tait reworked his painting for a lithograph issued in 1861 by Currier and Ives, returning the imagery to mass circulation.

Charles Deas's *Death Struggle* (fig. 54) is surely the most intense expression of violence in a mid-nineteenth-century American painting. Deas depicts a frontiersman—a white trapper with a beaver and trap still in his hand—and two Indians who have pursued him for the prized fur. The chase has been so extreme that both the trapper and one of the Indians have raced their horses past the point of safety and into disaster over the cliff edge: the two men, their horses, and the beaver all hang by a small dead tree limb as rocks cascade into the abyss below them (birds flying at their feet signal how high up they are) and the other Indian looks on. The trapper grasps the beaver, which, still alive, bites the Indian, who clings to the trapper. Naturally it is the white man who clasps the branch, staring out in horror as he realizes his predicament, and the Indian who fights on. One could see this as a parable of the consequences of being so single-mindedly caught up in the market (for beaver skins, in this case). As the trapper becomes conscious of his fate, Deas offers him redemption, or at least some self-awareness, which is denied the Indian.

This over-the-top image appears to have been based on two very different prototypes. The overall scene and the figures were inspired by the illustrator Felix Octavius Carr Darley's influential *Scenes in Indian Life* (fig. 55), a set of fifteen prints, sold as a pamphlet for a dollar, that included ferocious and elegant images of Indians warring among themselves, battling frontiersmen, killing animals, and so on. Deas's horses, by contrast, seem to be based on the same (as yet unidentified) fine-art prototype that informed the artist William Morris Hunt's near-contemporaneous designs for *The Horses of Anahita* (ca. 1847–50), which became one section of *The Flight of Night* (1878), a mural Hunt painted for the New York State Capitol at Albany.[81] Thus, in the same way that Tait could draw from the crude violence of *Davy Crockett's Almanacks* to create an oil painting and then refine that image for a Currier and Ives lithograph, Deas could take inspiration for his sensationalist painting both from violent Indian scenes and from the imagery later used in a sober-minded public mural.

Images of Native Americans had been popular, indeed essential, American subjects at least as early as 1840, when the

Fig. 52. Arthur Fitzwilliam Tait. *The Life of a Hunter: A Tight Fix*, 1856. Oil on canvas, 40 × 60 in. (101.6 × 152.4 cm). Crystal Bridges Museum of American Art, Bentonville, Arkansas

Fig. 53. "Fatal Bear Fight on the Banks of the Arkansaw," from *Davy Crockett's Almanack*, 1837. Woodcut, approx. 7⅞ × 8⅞ in. (20 × 22.5 cm). Library of Congress, Rare Book and Special Collections Division

Fig. 54. Charles Deas. *The Death Struggle*, 1845. Oil on canvas, 30 × 25 in. (76.2 × 63.5 cm). Collections of the Shelburne Museum, Shelburne, Vermont 27.1.5-018

National Academy of Design instituted a competition for the best American history painting, with the judges deciding that the most appropriate subject for this inaugural contest "should have reference to transactions between the 'first Lords of the Soil' and its present rulers." The story chosen was of Canonicus, chief of the Narragansetts, who planned to make war on the Pilgrims but was deterred by the strength of their response.[82]

In the recurring irony of genre painting, this great interest developed only after the Indian removals of the early 1830s, when the chances of encountering a real Indian were small.

The widespread idea that Native Americans were a race doomed to extinction prompted some artists, of whom George Catlin is the most famous, to travel west to document the appearance and activities of these dwindling peoples.[83]

Fig. 55. Thomas S. Sinclair, after Felix Octavius Carr Darley. *Scenes in Indian Life, No. 7*, 1843. Lithograph, 7¼ × 9⅛ in. (18.3 × 23 cm). Amon Carter Museum, Fort Worth, Texas 1981.54.7

This documentary impulse—aimed at recording human beings and their cultures rather than gathering natural-history specimens—fitted uneasily both into the conventions of "scientific" or "objective" visual observation and into the medium of oil painting itself. At the time, the two dominant modes for realizing multifigure compositions were either history or genre paintings—that is to say, the artist could either heroicize and classicize the bodies or render the scene as more domestic and sentimental than it may have been in reality. As a result, even artists working ostensibly as documentarians found it hard to avoid "genrefication," or the turning of actual scenes into pleasant stories.[84]

Seth Eastman, although primarily a military man (after the Civil War he retired at the rank of general), was also a semiprofessional artist who trained at West Point under Robert Weir and exhibited at the National Academy of Design. Most of his work consists of expansive views of characteristic Indian activities in landscape settings, or close-ups of a few figures doing something ethnographically exotic, but on occasion he depicted Native Americans engaged in activities that would be familiar to his New York audience. *Chippewa Indians Playing Checkers* (fig. 56) records a scene he often observed at Fort Snelling, Minnesota, where he was stationed for nearly a decade. In 1849 his wife described the subjects as "two Chippeway Indians who were kept for a long time in the Guard House at Fort Snelling. They passed away their time playing Cards, Checkers, and Smoking."[85] In rendering such a scene, Eastman combined an activity typical of genre paintings with details that were impressively foreign.

This balance was very rare, however. As with Yankees, the most important avenue for conceptualizing Native Americans was through literary texts, notably James Fenimore Cooper's series of novels about Natty Bumpo (also called

Leatherstocking or Hawkeye, as he was known to the Indians), published from 1823 to 1841. Because Cooper drew on the tradition of the noble savage as well as from contemporary accounts of Indian wars, his depiction of Indians was broad enough to accommodate both violence and nobility. Set within the conventions of the novel, Cooper's Indians also were allowed to show a domestic side. Imagined from the author's descriptions, painted Indians brooded on mountain

Fig. 56. Seth Eastman. *Chippewa Indians Playing Checkers*, 1848. Oil on canvas, 30 × 25 in. (76.2 × 63.5 cm). Courtesy of The Anschutz Collection

Fig. 57. Tompkins H. Matteson. *The Meeting of Hetty and Hist*, 1857. Oil on canvas, 24 × 19 in. (61 × 48.3 cm). Los Angeles County Museum of Art. Purchased with funds from the American Art Acquisition Fund M.2003.66

ledges or sat around in family groups; raised bloody hatchets or played games; and died tragic, romantic deaths. An example of a highly sentimentalized scene is Tompkins H. Matteson's *Meeting of Hetty and Hist* (fig. 57), which illustrates a passage from Cooper's *Deerslayer* (1841). Hetty Hutter is a "Christian fool," a simple-minded girl who attempts to save her father and the man she loves from the evil Mingo Indians who have captured them.[86] Walking into their camp, protected only by the love of Christ, she meets Hist, a captive maiden from another tribe; as the two become friends, Hetty tries to convert Hist to Christianity. The strained and sentimental intensity of the look each gives the other makes this image little different emotionally from a Yankee courting scene.

Laboring in the City

The dramas of the West, and the constant movement of settlers within its regions, was more than matched by the increased complexity and intensity of urban life between 1830 and 1860. Flooded with immigrants and wealthy merchants, New York City, the center of so much attention in this essay, was bursting at the seams. Philip Hone noted in the spring of 1836 that he was not alone in selling at an enormous profit the house he had lived in for decades. Using language that

could just as easily have described the movement of households to Utah or Oregon, he predicted that "the old downtown burgomasters . . . will be seen during the next summer in flocks, marching reluctantly north to pitch their tents in places which, in their time, were orchards, cornfields, or morasses a pretty smart distance from town."[87]

The artist Thomas Le Clear spent the early part of his career upstate, in Buffalo, New York, the thriving western terminus of the Erie Canal. His *Buffalo Newsboy* (fig. 58) presents a central icon of this new urban frontier. Acolytes of the communications revolution brought on by the penny paper, newsboys were an important recent feature of the city scene. As a critic of the day announced, "The nineteenth century, thirsting for information and excitement, finds its Ganymede in the newsboy. He is its walking idea, its symbol, its personification."[88] Taking a break from his labors, Le Clear's newsboy sits on a crate on a city sidewalk, eating an apple. Gazing directly at the viewer, he appears as an image of youthful confidence. Surrounding the boy is the material evidence of this new world of mass information. Plastered on the wall behind him are posters for the theater and other thrilling announcements, and the remains of more posters are visible on the fences across the street; the crate is lettered to advertise its original contents, and two newspapers lie at the boy's feet. The ephemeral quality of all this material becomes apparent when one realizes that Le Clear's deluge of print—torn and tattered, layered and half erased as it is—is very hard to read. According to one reviewer, the newsboy's product was "a mirror in which may be sometimes seen a rapid panoramic exhibition of Society, a sort of picture of the times."[89] One could just as easily have said that genre paintings mirrored the scenes newspapers captured.

For most visitors, the city was illegible and dense, requiring that they (and even residents, oftentimes) turn to guides that promised to "penetrate beneath the thick veil of night and lay bare the fearful mysteries of darkness in the metropolis."[90] The issue was one of trust: unlike the solid certainties of the countryside, the city was famous for its gaudy illusions and tricks. The term "confidence man" was coined in 1849 to describe the exploits of William Thompson, a small-time operator who asked strangers to trust him with their watches and then disappeared with them.[91] The whole experience of the city could be deeply intimidating and disorienting, as one New Yorker, a successful carpenter, remembered in 1833 of his first months there: "I became excessively nervous, so that I was continually full of apprehensions of danger, afraid of everything."[92] Under this barrage of confusion, one could even be brought to doubt oneself. In 1838 Emerson confessed that "if a man should accost me in Washington street [in downtown Boston] & call me a base fellow! I should not be sure that I could make him feel by my answer & behaviour

Fig. 58. Thomas Le Clear. *Buffalo Newsboy*, 1853. Oil on canvas, 24 × 20 in. (61 × 50.8 cm). Albright-Knox Art Gallery, Buffalo, New York. Charlotte A. Watson Fund, 1942 1942:3

that my ends were worthy & noble. If the same thing should occur in the country I should feel no doubt at all that I could justify myself to his conscience."[93]

Armed with this knowledge of the nineteenth-century city, and looking more closely at Le Clear's newsboy, one wonders if he is relaxing or loafing: he still has two papers to sell. Can we trust what we see, or should the apple be interpreted as the fruit of an opportunistic theft, and the boy's direct gaze one of defiance rather than confidence?[94] Newsboys might

begin as young icons of enterprise, but what would they grow up to be? Abundant novels and guidebooks, with dramatic titles such as *The Mysteries and Miseries of New York* (1848) or *New York by Gas-Light* (1850), featured youths fresh from the country—naive, green, trusting, and always from good, loving families—who walked into the city looking to make their fortunes and meet trouble instead. Advice literature abounded in heartrending tales of boys and young men corrupted by morally depraved scoundrels who introduced

Fig. 59. James Brown. *Dancing for eels: A scene from the new play of New-York as It Is, as played at the Chatham Theatre, N.Y.*, ca. 1848. Lithograph, with watercolor, 12⅜ × 16⅛ in. (31.4 × 41 cm). Library of Congress, Prints and Photographs Division LC-USZC4-4542

them, slowly and surely and in an ever-downward path, to the stink of smoking, drinking, gambling, and, ultimately, prostitution. From this there could be no recovery, and the young man who had been so corrupted would then himself seek fresh victims.

Almost as frightening was that the newsboy could become a B'hoy, or Bowery Boy, as seen in a popular print that memorialized the first appearance of Mose, portrayed by the actor Frank Chanfrau in the 1848 play *New York as It Is* (fig. 59).[95] The archetypal B'hoy, Mose poses on a barrel at the right while a group of merchants, or city beaux (who until now had been shown far from their natural haunts, competing for the hands of lovely rural maids), stand on the left, watching a black street performer dance the juba. Often Irish, the B'hoy swaggered down Broadway as if he owned it, dominated the fire companies, and was an active participant in riots and strikes. He was tall, wore his hair well greased, strutted with his G'hal on his arm, and was loud in his opinions. One author compared him to "the rowdy of Philadelphia, the Hoosier of the Mississippi, the trapper of the Rocky Mountains, and the gold-hunter of California." All these types expressed the "free development of Anglo-Saxon nature" in which, whether in city or country, the true American spirit of liberty could be found.[96]

B'hoys seldom appeared in paintings, unlike the Yankees who preceded them as stock figures on the stage or the westerners with whom they were compared. B'hoys represented something too real, the threat of ungoverned (or self-governing) workingmen. The issue of class, usually disguised in other terms (such as disagreement over who was the better Shakespearean actor), lay at the heart of the matter: how was the workingman to retain his self-sufficiency and self-respect in this newly wealthy America? The old ways of master and

apprentice handcrafting objects in the privately owned shop, working within the long-established patterns of artisanship and patronage, were disappearing fast, to be replaced by wage labor in factories, often deemed just another form of slavery. As a song from the 1830s put it: "For liberty our fathers fought/which with their blood they dearly bought, /the Fact'ry system sets at naught."[97]

As Mount wrote in his diary at the end of 1846, "New York is the place for an Artist if he can put up with the noise. Croton water and regular hours will help to preserve his health. To see a variety of character, and colours, the City is the place," but, he added sadly, "not without ending my love for the Country."[98] Like the young woman caught between the city and the country beaux, genre painting struggled to find the right balance between rural and urban subjects. Genre fulfilled most patrons' desires for sentiment and nostalgia, even when it engaged such real issues as courtship and consumerism. Because the city was generally too threatening, too real for comfort, even potentially universal subjects were insistently rusticated, or Yankeefied.

Cleveland-based artist Allen Smith Jr., like Le Clear or even Mount, found a delicate balance between reality and sentiment by depicting workers as children. The boys in *The Young Mechanic* (fig. 60) seem well behaved and engaged in appropriately boylike activity as they gather in a carpenter's shop that could be in either the city or country. Yet Smith still introduces a note of class division in the seated barefoot boy who whittles a mast for the well-dressed youth standing on the other side of the counter, holding his model boat. Smith's sympathies lie with the wood-carver, but the smallest boy, barefoot like the whittler and so young that he still wears a smock, is fascinated by the richer boy. His crossed hands pointing to both older boys suggest his difficulty: Which one should he emulate?[99]

Charles Cromwell Ingham based his *Flower Girl* (fig. 61) on earlier conventions of the so-called fancy picture (often of a single figure, usually a peasant or laborer, presented aesthetically rather than with didactic intent) in order to sentimentalize the urban realities for women. Ingham, an Irish artist who arrived in New York at the age of twenty, specialized in painting female portraits and was very much an establishment artist; he was a founder of the National Academy of Design and served as its vice president for many years. In his hands, the girl may be as poor as her black bonnet and brown dress suggest, but she is also as pretty as the flowers she holds. She addresses the viewer directly, offering a potted fuchsia for sale. With the painting's references to old master paintings, such as the Spanish artist Bartolomé Esteban Murillo's *Flower Girl* (ca. 1665–70, Dulwich Picture Gallery, London), and the goddess Flora, the suggestion that the girl might also be offering herself to her customers is very much

Fig. 60. Allen Smith Jr. *The Young Mechanic*, 1848. Oil on canvas, 40¼ × 32⅛ in. (102.2 × 81.6 cm). Los Angeles County Museum of Art. Gift of the American Art Council and Mr. and Mrs. J. Douglas Pardee M.81.179

suppressed. The image exists in that lovely realm of denial where the viewer can both have his fantasy and enjoy it without taint. And, indeed, the girls selling strawberries or flowers or plaiting straw baskets were never portrayed as ragged in the way the newsboys, match boys, bootblacks, and chimney sweeps were. The realities for single women in the city,

however, were very different from those of such images. Like young men from New England (70 percent of whom in this period emigrated from rural areas to the major East Coast cities and the Midwest), young women were forced to leave the fields in droves, migrating to the factory and mill towns of the Northeast and to the rapidly growing cities of the

Fig. 61. Charles Cromwell Ingham. *The Flower Girl*, 1846. Oil on canvas, 36 × 28⅞ in. (91.4 × 73.3 cm). The Metropolitan Museum of Art, New York. Gift of William Church Osborn, 1902 02.7.1

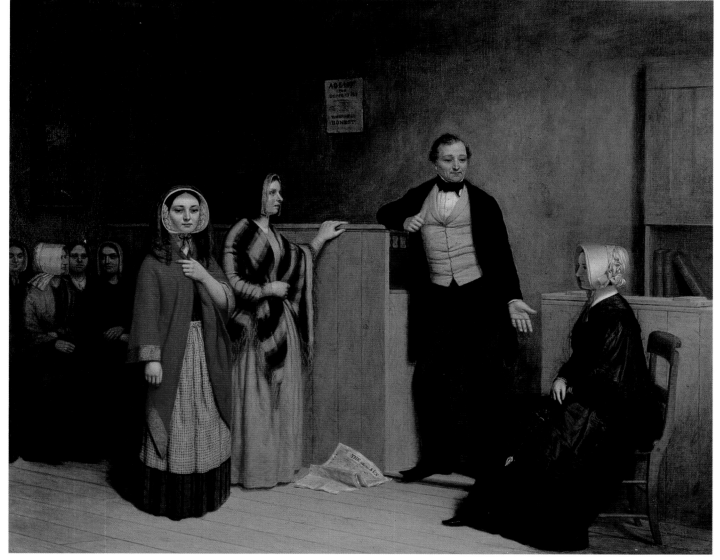

Fig. 62. William Henry Burr. *The Intelligence Office*, 1849. Oil on canvas, 22 × 27 in. (55.9 × 68.6 cm). Collection of The New-York Historical Society. Museum Purchase, Abbott-Lenox Fund, 1959 1959.46

Midwest to work as teachers, if they were lucky. By 1820 more than two hundred brothels could be found in New York; one statistic suggests that almost 10 percent of the women in the city had been or were engaged in prostitution.

William Henry Burr's *Intelligence Office* (fig. 62) takes a more clear-eyed view of the reality for women in the labor force. The young woman who stares out at us *is* selling her services—as a maid or housekeeper for the seated woman to the right. The scene is an employment office, and the rather self-satisfied proprietor is offering the lady a selection of his best candidates. Behind the two standing women is a group of plainer, and grimmer, candidates. The apparent objectivity of the scene is striking; the only display of emotion can be found in the way one woman grasps the rail while clutching her shawl close to her body, perhaps in desperation. There is also a hint of potential future discord: the lady who is hiring must surely be aware of the risk of admitting pretty servants

into a household. The sign on the back wall, which reads, "Agent for Domestics. Warranted Honest," further identifies this scene with the central dilemma of city life, the need to trust strangers, but are clients being asked to trust the agent or the domestics seeking work? Not surprisingly, given Burr's penchant for social realism, when he abandoned his career as an artist, he retrained as a stenographer and in 1854 became a journalist.

Charles Felix Blauvelt is perhaps the first American painter to address in a documentary fashion the other great feature of New York, its immigrant population; he was followed by a succession of artists whose treatment of this subject would reach its apex with the Ashcan painters half a century later (see, for example, fig. 175). In *A German Immigrant Inquiring His Way* (fig. 63), a new arrival addresses a laborer, engaging in a seemingly typical exchange between a recent immigrant and an American.[100] Yet by making the immigrant white and

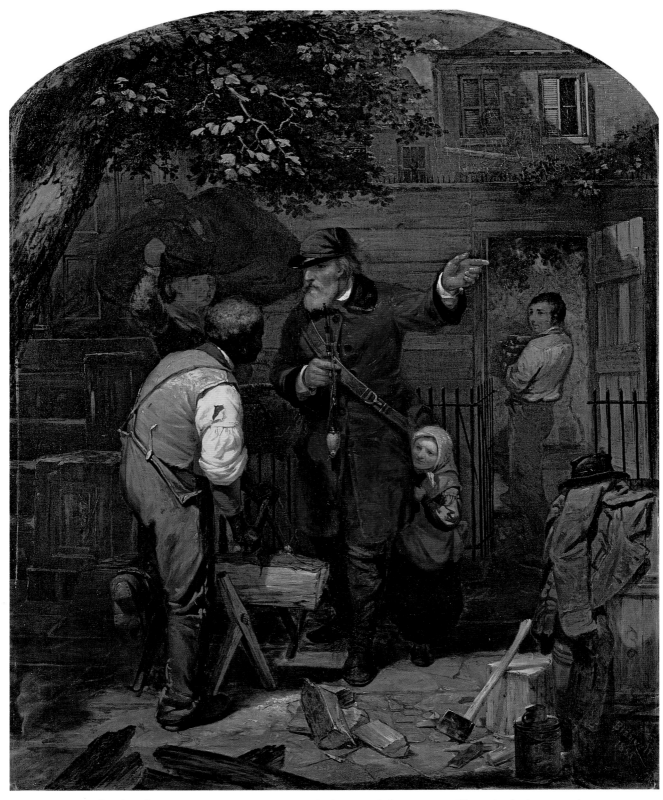

Fig. 63. Charles Felix Blauvelt. *A German Immigrant Inquiring His Way*, 1855. Oil on canvas, 36⅛ × 29 in. (91.8 × 73.7 cm). North Carolina Museum of Art, Raleigh. Purchased with funds from the State of North Carolina 52.9.2

the American black, Blauvelt tackled one of the most fraught issues of the day. Although some contemporaries maintained that European immigrants were not necessarily better than the black laborers with whom they were competing for work—they considered black servants cleaner and more submissive than the Irish[101]—the abolitionist and former slave Frederick Douglass perceived the reality: "Every hour sees the black man elbowed out of employment by some newly arrived immigrant, whose hunger and whose color are thought to give him better title."[102] The positions of the two men—the

German posed frontally in the center, with his shy daughter behind him, and the black man off to the side and slightly obscured—suggest that Blauvelt saw the issue equally clearly.

Placing Race

Despite his exclusion of African Americans from his take on presidential politics in the painting *Cider Making*, William Sidney Mount, more than any other artist of his day, revealed the contradictions and difficulties inherent in the position of blacks in American society. In Mount's *Eel Spearing at Setauket* (fig. 64), a strong black woman, very much in control, stands in front of a seated white boy in a small boat as she teaches him how to fish. Her unusual visually dominant position in the painting grows out of the work's roots, the childhood memories of both Mount and the patron who commissioned it, George Washington Strong. Strong's family came from Setauket, near Stony Brook, and was well known

to the artist as one of the oldest and most prominent families in the district. All the land in the distance, called Strong's Neck, belonged to the family manor seen faintly across the water. Like many Manhattanites in the first decades of the nineteenth century, George Washington Strong retained his country connections; it was a common practice to send some sons to the city to pursue business careers while other members of the family stayed behind, thereby keeping rural and urban families knitted together. Commissioned when Strong was sixty-two, the painting was intended to recall the aging man's happy days growing up in his ancestral haunts, and it was first exhibited with the neutral title *Recollections of Early Days: Fishing along Shore*. Mount's recollections of "an old Negro by the name of Hector [who] gave me the first lesson in spearing flat-fish, and eels" were also internalized in the painting, yet the artist softened the potential conflict of power between an older Negro man directing a young white boy by replacing Hector with Rachel Holland Hart, a member of a

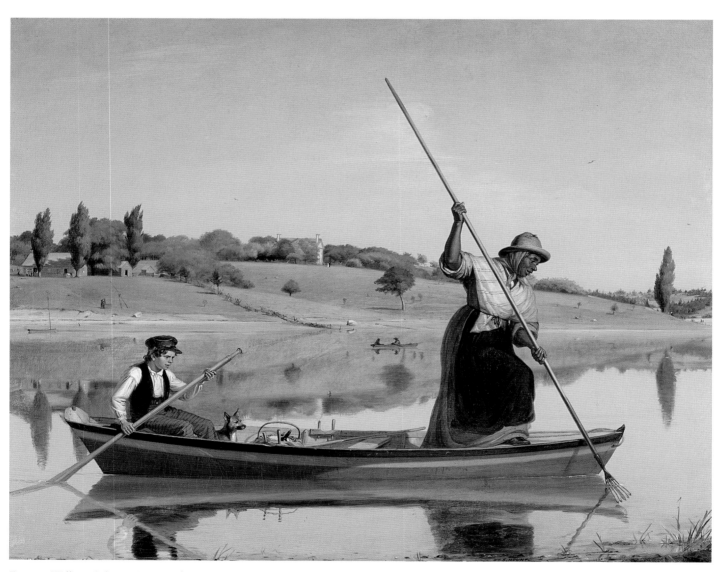

Fig. 64. William Sidney Mount. *Eel Spearing at Setauket*, 1845. Oil on canvas, 28½ × 36 in. (72.4 × 91.4 cm). Fenimore Art Museum, Cooperstown, New York N-395.55

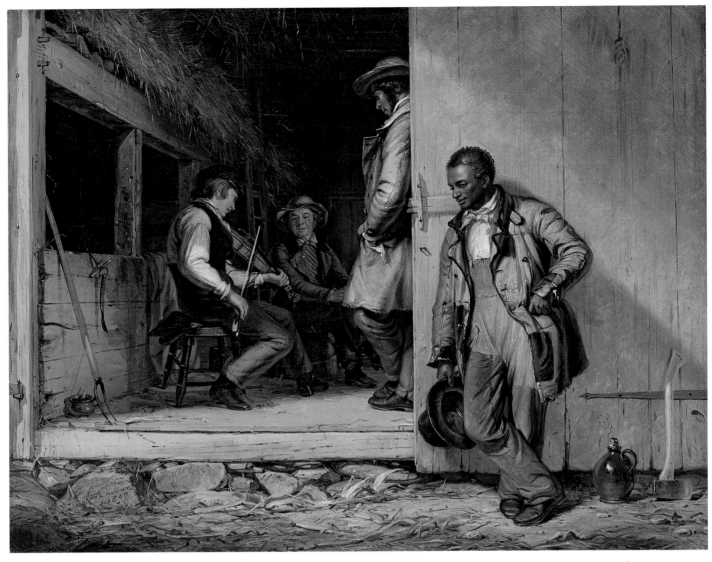

Fig. 65. William Sidney Mount. *The Power of Music*, 1847. Oil on canvas, 17⅛ × 21⅛ in. (43.4 × 53.5 cm). The Cleveland Museum of Art. Leonard C. Hanna Jr. Fund 1991.110

large African American family that had formerly been slaves on the Strong manor.[103] (In fact, Hart may not have been freed until 1827, the last date in the slow process of manumission in New York State, which had begun in 1799.) George Templeton Strong, the patron's son, who had been raised in Manhattan where racial politics trumped familial and neighborly ties, disliked the painting, which was never reviewed or engraved.[104]

In *The Power of Music* (fig. 65), Mount suggested a more conventionally structured set of racial relations. Two white men in a barn reflect calmly on their memories as they listen to a young white boy playing a touching, sentimental melody on his fiddle. The music has also captured the attention of a passing black man, who has put down his axe and jug to lean against the open barn door and listen. Mount clearly intended this as a scene of racial harmony achievable by "the force of music," as he first called the painting, if only for as long as the music lasted. Mount, after all, was a fiddle player himself

and firmly believed in the therapeutic power of music's harmonies. The painting was received rapturously when it was exhibited in New York City, which was experiencing the first flush of enthusiasm for blackface minstrelsy.[105]

Yet New York viewers were unsure how to place the work, even as they admired it.[106] The image proved difficult to read. Was it depicting the black man as lazy and easily seduced by the charms of music, or did it dignify him? Mount deliberately renders the issue ambiguous. The black man is represented fully in the foreground and, while the standing white man may have the advantage of height, he and his seated companions are set farther back and are partly obscured. Thus, the meaning of the painting is provided by the black man, not the three white men who, for once, are peripheral. Behind this ambiguity lay the social realities of Setauket and Stony Brook, where Mount painted the scene, and where African Americans, whether enslaved or free, had resided and worked alongside their white neighbors for

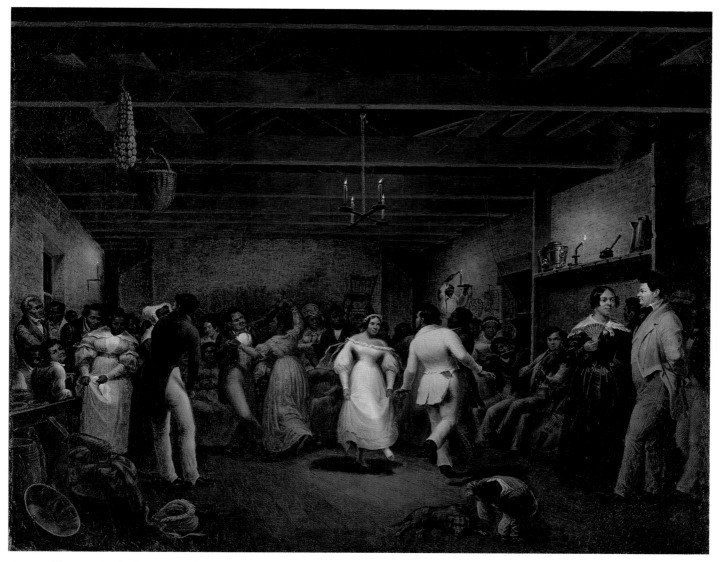

Fig. 66. Christian Friedrich Mayr. *Kitchen Ball at White Sulphur Springs, Virginia*, 1838. Oil on canvas, 24 × 29½ in. (61 × 74.9 cm). North Carolina Museum of Art, Raleigh. Purchased with funds from the State of North Carolina 52.9.23

centuries. All the models were well known to the artist: the boy playing the violin was Mount's nephew, Thomas Nelson Mount; the standing white man was his brother-in-law, Charles Seabury; and the older white man, seated in shadow at the back, was an English-born laborer named Reuben Merrill who worked for Mount's brother-in-law but had no social standing in the community. The black man, Robin Mills, one of the few African American landowners in Stony Brook, was literate and an elder of the local African Methodist Episcopal Zion Church.

Unlike Mount, very few American artists could even imagine a wholly functional black society. Christian Friedrich Mayr succeeded in *Kitchen Ball at White Sulphur Springs, Virginia* (fig. 66), perhaps because he was German born and trained and had arrived in the United States only in 1833, at the age of twenty-eight. A prolific genre painter, Mayr traveled in the South as an itinerant portraitist, periodically staying at the resort of White Sulphur Springs in what was then Virginia. A kitchen ball for slaves that he witnessed there

must have impressed him for its completeness as a social setting. The event may have been a wedding, given the central couple dressed in white, and the scene is lively and harmonious, with none of the caricatures that often intrude in images of blacks making music or dancing at their own parties. In many senses this is a black version of Mount's *Rustic Dance After a Sleigh Ride* (fig. 29). At the same time, as Elizabeth Johns points out, Mayr's painting reflects a subtle hierarchy of skin tone, with those lightest in complexion receiving the most attention, and the activities represented mirror those of the slave owners.[107]

In the mid-nineteenth century, the preferred place, visually, for black Americans was at the margins, unless they were being satirized or otherwise made comical, as in many of James Goodwyn Clonney's paintings.[108] As the sectional tensions over slavery and abolitionism grew more extreme throughout the 1850s, it became increasingly difficult for artists to depict African Americans positively. In the early 1850s,

Mount produced a set of genre portraits of black musicians for Goupil, Vibert and Co., which also commissioned images of black children from Lilly Martin Spencer.[109] After 1856, however, Mount, like many others, abstained from subjects that included black Americans. The activities of abolitionists and the efforts of Congress to clamp down on them and preserve the rights of slaveholders conspired to make even sympathetic viewers uneasy. A lot had occurred between 1834, when Philip Hone expressed concern for the fate of the "respectable pastor" of the African Methodist Episcopal Church during anti-abolitionist riots, and his reaction to the freeing of a slave boy in Manhattan twelve years later. After witnessing the "shouting and jostling, such peals of negro triumph, such uncovering of woolly heads in raising the greasy hats," he declared, "This is all very pretty; but how will it end? How long will the North and the South remain a united people?"[110]

The last major genre painting to address the place of African Americans before the Civil War is Eastman Johnson's *Negro Life at the South* (fig. 67), one of the most sophisticated artworks of the period just prior to the war. Set in a backyard of the nation's capital, Washington, D.C., it depicts African Americans in a socially convincing, uncaricatured, and complex way. In style, subject, and narrative, it is a transitional work, returning to an earlier format that owes more to David Wilkie's panoramic family scenes (to which it was explicitly compared by a critic for *The Crayon*) than to Mount's dramatic theater.[111] The "room" in which the blacks are gathered may be a tenement, but it is nonetheless a home that incorporates virtually every available trope of family life (except the evil of consumption): courtship and marriage, motherhood, training the young, listening to the old. Most astonishingly, in this image of black community, the white visitor is marginalized. Inverting the motif used in Mount's *Power of Music*, Johnson's painting depicts a black man playing and his white audience listening from outside.

The painting's euphoric reception testified to the degree to which Johnson was able to straddle the political tensions of his day.[112] The title is a perfect example of the artist's dissembling: it is an urban scene, as clearly indicated by the adjoining buildings, yet he called it *Negro Life at the South*, which cued viewers to see the tenements as outbuildings on a plantation. Even the music raises questions. Is the banjo player performing a fast tune, to which the boy in the foreground dances, or a slow love song, which envelops the courting couple to the left? Johnson's canvas demonstrates superbly the ability of genre painting to both depict and inspire a community, to address the tensions of contemporary life and, simultaneously, to paper over them. That it was almost immediately renamed *Old Kentucky Home*, after the Stephen Foster song of 1853, suggests the relative powerlessness of genre artists to dictate or

Fig. 67. Eastman Johnson. *Negro Life at the South*, 1859. Oil on canvas, 36 × 45¼ in. (91.4 × 114.9 cm). Collection of The New-York Historical Society. The Robert L. Stuart Collection, on permanent loan from The New York Public Library S-225

retain their messages.[113] The truths about slave life in the nation's capital were too difficult for most viewers to witness. Thus, while one viewer recalled the powerful abolitionist novel *Uncle Tom's Cabin* (1852), most preferred to see minstrel figures.[114] Indeed, another critic argued that it was now time to address the "strife" between the races by having "the cunning hand of the artist . . . strip [it] of all . . . bitterness."[115]

In other words, genre painters had to varnish harsh realities in order to render them acceptable and to preserve harmony. During this period of American history that saw the country reach its first maturity, artists strove forcefully and critically to create images that would bring audiences together, producing that enjoyable sensation that allowed them to see themselves in each other. Ultimately, these efforts to place a coherent image of America before the eyes of a united American public could not overcome the increasingly strong sectional divisions. Yet while the nation itself fractured, the anecdotes and tales told in paintings gave pleasure to viewers, exciting, reassuring, and even enlightening them. The works were not trivial in their effect, which was to consolidate and even aid in creating the self-reinforcing sense of identity that established Americans as citizens rather than strangers passing through. Future generations of American artists would build on this achievement as they painted their own stories of everyday life.

1. Oedel and Gernes, and the contemporary story they cite in *The Gift* (Edward Carey's annual; see also this essay, p. 38), suggest that the hidden painting is a landscape, not a portrait or genre scene, for good but different reasons. Chances are, given the preponderance of landscapes, they are right. The artist is certainly showing how he has turned a sketch into a finished work. Oedel and Gernes read this transformation as turning the real into the ideal, but the reverse has happened: the artistic sketch has been turned into life itself. See Oedel and Gernes 1988. The themes of Mount's *Painter's Triumph*—the relationship between the artist and his publics, and the nature of the viewer's response—appeared in many other artists' works, from the subtly comic to the fiercely satiric. See Sanford Thayer's *The Connoisseurs* (1845, Onondaga Historical Society, Syracuse, N.Y.), and Johannes Adam Simon Oertel's *The Country Connoisseurs* (1855, Shelburne Museum, Vt.). See also David Claypoole Johnston's *Veneration*, engraving from Plate 2 of *Phrenology Exemplified . . . Being Scraps No. 7* (Johnston, D. C. 1837), reproduced in Johnston, P., ed. 2006, p. 50.

2. Elizabeth Johns's book, *American Genre Painting: The Politics of Everyday Life* (Johns 1991), remains the classic and most influential discussion of the subject. She places genre paintings in the realm of the verbal, grounded in speech metaphors such as puns and jokes. These paintings are certainly rhetorical, but this essay emphasizes as well the visual devices used by the artists. Moreover, a central thesis of this exhibition and catalogue is that, while the nature of American paintings of everyday life certainly changed after the Civil War, such paintings did not decline in numbers or importance.

3. See Johnston, P. 2006, p. 53; Mount diary, August 29, 1846, published in Frankenstein 1975, p. 143.

4. Unless otherwise noted, for statistics and historical facts I have relied on Howe 2007; and McPherson 1988.

5. Samuel Goodrich (1793–1860) writing in 1856 and quoted in Kasson 1990, p. 39. See also Lehuu 2000; and Streeby 2002.

6. Hone 1936, vol. 2, pp. 851–52 (April 15, 1848).

7. Smith-Rosenberg 1985, pp. 79, 87–90.

8. Emerson 1843–44, 2005, p. 109.

9. Howe 2007, pp. 430–39.

10. Downing 1850, 1969, p. xix.

11. See Barratt 2000–2001; and Myers 2000–2001. The National Academy of Design today comprises the academy, a museum, and a school of fine arts.

12. Joel Headley, quoted in Widmer 1999, pp. 148–49.

13. For an overview of fine-art prints, see Davis, E. 2000–2001.

14. *Bulletin of the American Art-Union* 1848b, p. 44.

15. Quoted by Patricia Hills, in Carbone and Hills et al. 1999–2000, p. 21. Dutch paintings were well known to audiences in America, where they were collected and exhibited extensively. See Liedtke 1990–91.

16. At the first exhibition of the Apollo Association (the predecessor to the American Art-Union) in 1838, for example, copies of Jean-Baptiste Greuze's *Paternal Curse*, David Wilkie's *The Village Festival*, Caspar Netscher's *Singing Lesson*, and David Teniers's *Boors Drinking* provided a full synopsis of possible models.

17. The philosopher Aristotle, in the *Poetics*, famously defined tragedy as about people who are better than we are and comedy about those who are worse off. Aristotle 1984, vol. 2, p. 2317.

18. William A. Jones, quoted in Widmer 1999, p. 139.

19. Cawelti 1976, pp. 154–55.

20. A review in the *Missouri Republican* (1850) that was reprinted in *Bulletin of the American Art-Union* 1850a, p. 64; quoted in Carbone et al. 2006, vol. 1, p. 290.

21. From an 1857 review, quoted in Edwards 1982, p. 5.

22. Mount diary, July 1, 1850, in Frankenstein 1975, p. 241.

23. As just one example, see G. H. Brueskner's (or Brueskler's) description of his painting in the American Art-Union exhibition of 1849, which he labeled a "Kitchen Scene": "A laborer returns to his home expecting to find his dinner ready, but his wife having had a call from some of her neighbors, has allowed the time to pass without preparing it. The wife (aware of her power) simply states the reason of the delay, which appears to satisfy him, and he puffs off his disappointment in the smoke of his cigar." The painting is lost but it is hard to imagine how the viewer might have divined this scenario without the help of the text. *Bulletin of the American Art-Union* 1849, p. 46, no. 315.

24. See, for example, "Charles Cromwell Ingham, 1796–1863," in Caldwell and Rodriguez Roque et al. 1994, pp. 402–4; and Robertson 1992.

25. Johns 1991, pp. 24–59. See also Taylor 1976; and Burns 1989, pp. 99–236.

26. See Buckley 1984.

27. See Hodge, F. 1964.

28. Conkling 1857, p. 330, quoted in Kasson 1990, p. 59.

29. See Johns 1991, pp. 24, 28.

30. John Lewis Krimmel's *Country Frolic and Dance* (1819, private collection). See Keyes 1969, pp. 259–61; and Harding 1994, p. 223.

31. Chiego et al. 1987.

32. Johns (1991, p. 213 n. 9) has observed that the painting was first exhibited as *Farmer's Bargaining*; the placement of the apostrophe may be simple carelessness or a typographical mistake.

33. See reviews of *The Tough Story*, 1838, from undated clippings in a Mount family scrapbook, cited in Johnson, D., et al. 1998–99, pp. 99–100 n. 100.

34. Quoted in McCurdy 2005, p. 1. Much of this discussion of history painting is informed by McCurdy's work.

35. *Missouri Republican* (1847), quoted in McDermott 1959, p. 185.

36. *Evening Intelligencer* (1851), and *Daily Courier* (1853), quoted in McDermott 1959, pp. 92, 99.

37. Ayres, W., et al. 1993–94; Gerdts and Thistlethwaite 1988; Burnham and Giese, eds. 1995.

38. *Bulletin of the American Art-Union* 1850b, p. 168, no. 69.

39. *Bulletin of the American Art-Union* 1851b, p. 42.

40. See reproduction in Gerdts 1977, p. 29.

41. For example, in 1834 William Dunlap wrote, "That Hogarth was incomparably the best painter, is no argument for the supremacy of familiar painting over historic"; Washington Irving used the phrase "that branch

of historical painting peculiarly devoted to scenes of familiar life."
Dunlap 1834, 1969, vol. 2, p. 2, ll. 303–4.

42. *Bulletin of the American Art-Union* 1848a, p. 20.

43. *Bulletin of the American Art-Union* 1848c, p. 14. Of the paintings discussed in this essay painted during the existence of the American Art-Union (1839–51), slightly more than half were bought by the American Art-Union. Of the thirty-seven paintings discussed, all except four were exhibited at either the National Academy of Design or the American Art-Union, and nearly thirty percent were engraved.

44. As an Art-Union writer proclaimed in 1850, "More strongly than ever, in our opinion, may the Art-Union appeal to the public in this season of political agitation. It presents a field of work in which all may unite like brethren. It belongs to the *whole* people. It disregards all sectional differences. It is attached to no party." *Bulletin of the American Art-Union* 1850c, p. 2.

45. Tuckerman 1847, p. 149.

46. Jones 1841, p. 240, quoted in Widmer 1999, p. 149.

47. See, for example, Lehuu 2000; and Cohen, Gilfoyle, and Horowitz 2008.

48. Van Cott 1841, p. 185, quoted in Johns 1991, p. 153.

49. Sylvester Graham, "A Lecture to Young Men on Chastity…," Boston, 1833, quoted in Larkin, J. 1988, p. 201.

50. Upton 2000–2001, p. 24.

51. For Woodville, see Wolff 2002.

52. Eliza Southgate; quoted in Rothman 1984, p. 32.

53. Levi Lockling to Aaron Olmstead, September 28, 1838, quoted in Rotundo 1993, p. 115.

54. Aaron Olmstead to Adriel Ely, August 31, 1836, quoted in Rotundo 1993, p. 103.

55. See Howe 2007, pp. 292ff.; and Sutton, R. 2003; Sutton, R. 2004.

56. See especially Burns 1986.

57. See Johns 1991, p. 149; and Douglas 1977.

58. Review in *Knickerbocker* 1857, p. 316, quoted in Carbone et al. 2006, vol. 2, p. 1002.

59. See review in *Home Journal*, June 4, 1859, p. 2, quoted in Caldwell and Rodriguez Roque et al. 1994, p. 584.

60. *Cosmopolitan Art Journal* 1856, p. 50, partially quoted in Carbone et al. 2006, vol. 2, p. 967.

61. Carbone et al. 2006, vol. 2, p. 967.

62. Frances Trollope, the British tourist, noted that middle-class men in Cincinnati in 1830 did the grocery shopping for their wives, and Spencer may have witnessed a similar phenomenon decades later. But the painting was made for a New York audience, where such men did not shop for groceries, and the man's pose and figure undercut any notion that this is normal behavior. See Trollope 1832, 1949, p. 85.

63. George Caleb Bingham to John Sartain, October 4, 1852, cited in Miller, A. 1992, p. 14.

64. See Johns 1991, pp. 49–53.

65. Wolf 1995, p. 249.

66. Bloch 1967, figs. 55–57.

67. Hone 1936, vol. 2, p. 810 (1847).

68. *Missouri Republican* (1850), quoted in McDermott 1959, p. 74.

69. See *Bulletin of the American Art-Union* 1850a, p. 64, quoting from a "St. Louis newspaper."

70. The painting, titled *The Squatters* (1850), is in the Museum of Fine Arts, Boston.

71. Melville 1857, pp. 226, 225, quoted in Lubin 1994, p. 87.

72. Emerson 1847, 1983.

73. See Turner 1893, 1894.

74. *Literary World* 1852, p. 316, quoted in Johns 1991, p. 81.

75. For discussions of the functions of regionalism, see the work of Angela Miller, Bryan J. Wolf, and Elizabeth Johns.

76. *Daily Picayune* (1853), quoted in McDermott 1959, p. 97.

77. *Bulletin of the American Art-Union* 1851a, p. 139.

78. Ruxton 1848, quoted in Ayres, L. 1987–88, p. 90.

79. Cole 1835–36, 1965, p. 109.

80. *Davy Crockett's Almanacks* 1846, 1849, respectively, quoted in Smith-Rosenberg 1985, pp. 97–98. For a powerful analysis of this twinning

of race and violence in the creation of American identity, see also Morrison 1992.

81. An engraving of Deas's painting was published in 1846 and might well have been seen by Hunt in Paris in 1847. Hunt's first surviving sketch places a white horse to the right, with a black horse to the left, virtually copying Deas's painting. See Adams 1983b; and Clark 1987–88, p. 77 n. 42.

82. Dearinger et al. 2004, pp. 68–69.

83. See, for example, Viola, Crothers, and Hannan 1987–88, p. 131; see also George Catlin's conviction "of the rapid decline and certain extinction of the numerous tribes of the North American Indians," in Catlin 1840, p. 3.

84. A term invented, usefully, by Barbara Weinberg.

85. Mrs. Eastman to Col. Andrew Warner, June 27, 1849, in McDermott 1961, p. 58. See also the painting by Charles Deas, *Winnebagos Playing Checkers* (1842, private collection), painted in St. Louis.

86. For an analysis of Hetty as a "Christian fool," see for example House 1965, pp. 320–24.

87. Hone 1936, vol. 1, p. 202 (March 9, 1836).

88. Humorist Joseph C. Neal in Darley and Neal 1843, p. 105, quoted in Husch 2000, p. 42. See also N. Sarony, "One of the News B'Hoys. Sketches of N. York, No. 18," lithograph, 1847, in Husch 2000, p. 44.

89. *Episcopal Recorder* 1849, quoted in Husch 2000, pp. 40–41.

90. Foster, G. 1850, quoted in Kasson 1990, p. 78.

91. Kasson 1990, pp. 103–4.

92. Written in 1833; quoted in Kasson 1990, p. 113.

93. Emerson 1960–82, vol. 7, pp. 158–59, quoted in Kasson 1990, p. 113.

94. See Albert D. O. Browere's image of boys thieving, *Mrs. McCormick's General Store* (1844, New York State Historical Association, Cooperstown).

95. Mose first appeared in Benjamin Baker's play, *A Glance at New York* (Baker 1848). See Taylor 1976, pp. 64ff.

96. Foster, G. 1850, quoted in Upton 2000–2001, p. 33.

97. Quoted in McPherson 1988, p. 25.

98. Mount diary, December 29, 1846, in Frankenstein 1975, p. 147.

99. Machine tools were first developed in this country for woodworking industries. See McPherson 1988, p. 18.

100. Other works by Blauvelt depicting immigrants include *The Immigrants* (ca. 1850, Hunter Museum of Art, Chattanooga, Tenn.) and *Burnt Out* (1849, Detroit Institute of Arts). Most immigrants after the late 1840s were Irish Catholic or German; see McPherson 1988, p. 7.

101. See, for example, Pennington 1841, p. 79; and Marryat 1840, p. 50.

102. Douglass was writing in the 1850s; quoted by Johns 1991, p. 102.

103. William Sidney Mount to Charles Lanman, November 17, 1847, in Frankenstein 1975, p. 120; for Rachel Hart see Johnson, D., et al. 1998–99, p. 65.

104. For George Templeton Strong's reaction to his father's commission, see Strong 1952, vol. 1, p. 276 (April 17, 1846): "Mount's picture for my father is there. I like it no better than when it hung in the back parlor."

105. For a list of these reviews, see Robertson 1992, p. 60.

106. See Robertson 1998.

107. See Johns 1991, p. 114. Mayr exhibited this work seven years later with a companion painting, *Juba in the Kitchen, at the White Sulphur Springs, in Virginia* (NAD Exhibition Record [1826–60] 1943, vol. 2, p. 22, 1845, nos. 300 and 307, respectively), which presumably would have shown a livelier dance.

108. See Giese 1979.

109. The term "genre portrait" is a translation of *portrait de genre*. See, for example, Thomas Eakins's use of the term in a draft of a letter to his teacher Jean-Léon Gérôme, reproduced in Foster, K., et al. 1997, p. 264. See also Siegfried 2007.

110. Hone 1936, vol. 1, p. 135 (July 10, 1834); vol. 2, p. 777 (October 27, 1846).

111. See *Crayon* 1859b, p. 191, quoted in Carbone and Hills et al. 1999–2000, p. 128, and p. 161 n. 25.

112. See Davis, J. 1998, p. 70; and Koke et al. 1982, vol. 2, p. 234.

113. Although the painting was renamed almost immediately by the press, it was not exhibited under the new title until 1864. See Davis, J. 1998, p. 70.

114. See, for example, *Home Journal* 1859, quoted in Davis, J. 1998, p. 70, and p. 89 n. 17.

115. *Crayon* 1859a, p. 145, quoted in Davis, J. 1998, p. 84, and p. 91 n. 67.

Stories of War and Reconciliation, 1860–1877

MARGARET C. CONRADS

When Thomas Le Clear, the leading painter of Buffalo, moved to New York City in 1863, he must have had many things on his mind. Surely he was pleased to have been named a full academician at the National Academy of Design, a testament to his rising stature as an artist. He must have been delighted also that his daughter Caroline would soon marry William Holbrook Beard, a colleague from Buffalo who had encouraged Le Clear to establish his studio at New York's most prestigious artistic address, the Tenth Street Studio Building.[1] At the same time, however, the Civil War, which was supposed to have been short and without serious detriment to the general populace, was raging and getting bloodier by the minute. Painting in a time of such deep crisis, when the entire fabric of American ideology was being rent in two, must have been trying, especially as many basic premises of art were also coming under fire. In *Interior with Portraits* (fig. 68), Le Clear, who by the mid-1860s was dividing his efforts between portraiture and genre subjects, cleverly engaged these aesthetic battles, chief among them the nature of illusion and reality in art.[2] Indeed, the story Le Clear tells here is not the chronicle of a family's visit to a photographer's studio, but rather an outline of ideas about "truth" in art, which was heavily encumbered by the rise of photography. At a time when photography was considered the more truthful medium and was a strong competitor of painting for portrait commissions, Le Clear unmasked the illusion, even deception, in the mechanics of both media, as well as the complicity of painters and photographers in their creation.[3]

Le Clear's depiction of an artist's studio was, despite its convincing reality, completely fabricated. Not only is the photographic setup inaccurate but, more important, neither of the sitters, siblings Parnell and James Sidway of Buffalo, could have been photographed, or been painted being photographed, as children in 1865: Miss Sidway died in 1849 at age thirteen and her brother was killed in a fire in 1865 at the age of twenty-five.[4] Even so, the immediacy of the scene, enhanced by the placement of the photographer's carefully modeled rear end at the right, the dog just diagonally across the studio, and the casually arranged cane, umbrella, cloak, hat, purse, and rumpled newspaper in between, is perhaps the work's most prominent and captivating feature. Le Clear contrasts all these elements relating to the photographic moment against the rest of the studio, which is filled with examples of Western art traditions, such as old master paintings and classical and contemporary neoclassical sculpture, drawings, and prints. Even though they are relegated to the background and edges of the composition, they serve as reminders of the cornerstones of the painter's art. Le Clear's painted portrait of the Honorable Daniel S. Dickinson (1864, Buffalo & Erie County Historical Society) sits kitty-corner between the photographer and the posing children, inviting a comparison between that painted likeness, which was hailed by a writer for New York's *Evening Post* as both truthful and artistic, and the confected image of the dead siblings.[5] By painting the artifice of the photographer's craft, Le Clear exposed the fiction involved in image making as well as the layers of truths that constructed fictions can reveal. Like both William Sidney Mount in *The Painter's Triumph* of 1838 (fig. 25) and William Merritt Chase in depictions of his Tenth Street studio from the 1880s (see fig. 104), Le Clear in his studio painting offers a glimpse into the artist's world. He also exposes the artistic fictions that were used to reveal truths within the painted stories of everyday life in the 1860s and 1870s.

This essay looks at a small sampling of paintings that tell a variety of American stories spawned by the Civil War and Reconstruction and that still resonate with us today. Although *Interior with Portraits* ostensibly addresses issues of image making, it also demonstrates the interest that narrative subject matter commanded during this time. The unique and often overwhelming circumstances of the period challenged American artists as never before. Looking back on the war in 1882, Walt Whitman sagely observed in *Specimen Days*, "The real war will never get in the books. . . . Future years will never know

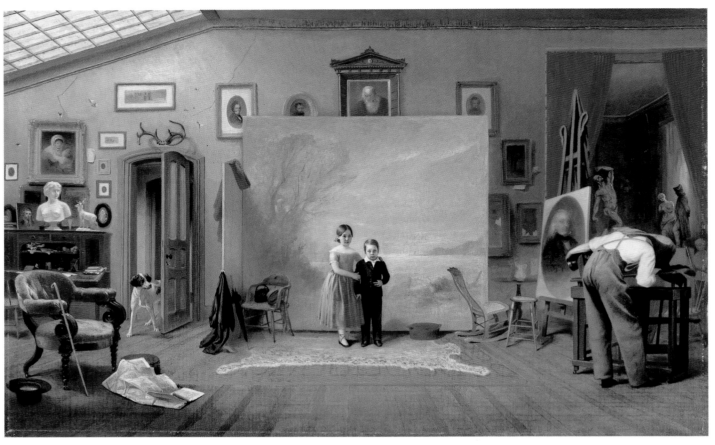

Fig. 68. Thomas Le Clear. *Interior with Portraits*, ca. 1865. Oil on canvas, 25⅞ × 40½ in. (65.7 × 102.9 cm). Smithsonian American Art Museum. Museum purchase made possible by the Pauline Edwards Bequest 1993.6

the seething hell . . . and it is best they should not."[6] In essence, the same can be said about paintings: artists resorted to a wide array of subjects and compositional schemes to help negotiate the horrors and impact of a war experience that could not be understood by those who had not lived through it. Likewise, the years of Reconstruction—which were marked not only by momentous congressional acts such as those that gave African American males suffrage and expanded liberties, but also by a financial crisis that began in 1873—created such turmoil amid cataclysmic change that artists relied mainly on examination of small slices of the human experience in order to suggest its broad and deep ramifications. The historian David Blight has astutely described Reconstruction as "one long referendum on the meaning and memory of the verdict at Appomattox."[7] The painters of the period recounted in oil on canvas many different stories that reflected their attempts to find meaning in the Civil War and its aftermath. Such stories helped to knit together a whole host of memories that contribute to the fabric of American society today.

With the artistic center of the period firmly anchored in New York, the great majority of painted narratives were told from a Northern perspective.[8] Even so, they touched on a wide range of subjects and attitudes. The situation of African Americans and its impact on every aspect of American life was a pervasive subject. Also part of the mix were the nation's economic and social order; the family, especially children; the home and domesticity; gender roles and relationships; politics; labor; immigration; westward expansion; and the status of Native Americans.

Many of these stories connect to basic narratives central to the human experience, although the upheaval and change particular to the years between the start of the Civil War in April 1861 and the public recognition of the failure of Reconstruction in 1877 often cast them in a unique light. New subjects or new twists on familiar ones appeared in established aesthetic molds, and toward the end of the period, time-tested themes provided opportunities for new stylistic approaches. At the root of all these subjects were two basic questions: What is America? Who is an American? Thus, nearly every story told by artists related in some way to concepts or concerns about national identity. The paintings addressed, even if by denying or erasing, the erratic nature of life and the overwhelming transformation of the nation during this period. The best topics for American art, therefore, remained close to home.[9]

No matter what subject an artist chose to picture throughout the years of the Civil War and Reconstruction, the situation of the black population lay under, if not on, the surface. In 1859, a full two years before the first shots were fired at Fort Sumter, Eastman Johnson beautifully articulated the challenge artists faced in reckoning with the topic. His *Negro Life at the South* (fig. 67), greatly admired for its careful attention to detail, harmony of subject and artistry, agreeable palette, use of light and shade, truthfulness, and grace and correctness of figure painting, was considered at the time completely successful in capturing the character of African American life.[10] Even so the painting engendered a wide assortment of interpretations, each representing a different viewpoint relative to emancipation on the eve of the Civil War. There was general agreement about the written stories that might be attached to the individual vignettes Johnson judiciously placed within the stagelike setting of his composition: most were aligned either with *Uncle Tom's Cabin* (1852) by Harriet Beecher Stowe or with stereotypical imagery from popular literature.

Yet, despite extensive research by numerous scholars, especially Patricia Hills and John Davis, the artist's ultimate intentions remain elusive.[11] A writer for the *New-York Semi-Weekly Tribune* astutely recognized two ways to consider Johnson's recently unveiled masterpiece, one as "a stirring speech from an anti-slavery platform," the other as the image of the "careless happiness of simple people . . . forgetful, perhaps ignorant . . . of how soon may come the rupture of all those natural ties in which lie the only happiness that life can give them."[12] Johnson's presentation of competing narratives, each a blend of fact and fiction, suggests his awareness that the painting's potential audience could subscribe to either of the two chief ideological camps of the day. Further, by coding his imagery to elicit positive reactions from viewers in either political group, Johnson incorporated real and idealized aspects of slavery throughout his vignettes. With his training in Düsseldorf, The Hague, and Paris guiding his brush, he presented the complex subject in a composition and style familiar and comfortable to potential patrons. As a writer for the *Crayon* noted in a complimentary review of the painting, "It is a mistake to suppose that artists are free to paint what pleases them best. . . . The Truth is that artists are compelled to meet the public by consulting its likes and dislikes."[13]

Whatever coding Johnson may have inserted in *Negro Life at the South*, it not only pleased his varied audience but also rang true as an essentially American image, even if it did not rank as the highest art, which, according to the writer for the *Crayon*, was defined as "the most beautiful thoughts" depicted "in the most beautiful forms."[14] By 1859 no image of slavery, regardless of how carefully presented, could be considered beautiful. Although Johnson would paint other

African American subjects, most notably *Ride for Liberty* (ca. 1862, Brooklyn Museum), he turned his attention at the outbreak of the Civil War to picturing the more overtly pastoral communities of rural New England.

Picturing Communities and Shifting Social Networks in Wartime

From 1861 to 1865, Johnson made more than twenty oil sketches on the theme of maple sugaring.[15] The entire group, especially *Sugaring Off* (fig. 69), the second-largest and likely penultimate canvas, reflected a set of ideals about American community and civic values to which Johnson and many of his patrons adhered. Central to the project was an image of New England identity that included its desire to be independent from Southern markets.

Sugaring Off refers to the celebratory gathering of both farmfolk and townspeople to mark the first sap of spring being boiled into maple sugar.[16] The theme was familiar to Johnson both from childhood and through the several trips he made to his hometown of Fryeburg, Maine, as he prepared these works. The sugar-boiling method depicted, already labeled old-fashioned though still in use in Fryeburg in the early 1860s, allowed the image to shift between past and present associations. The nostalgic memories of Johnson and the generation of rural New Englanders born in the 1820s likely resounded with recollections of enjoyable communal effort. Yet by featuring what some might have regarded as antiquated technology, the artist may also have intended, as the historian Anne Rose and the art historian Brian T. Allen have suggested, to insert a degree of disapproval. An article in the *Flag of Our Union* in early March 1862 noted that the year would be a banner one for New England's maple-sugar production, therefore making the "loyal States wholly independent of Louisiana crops."[17] The continued use of the less-efficient "Fryeburg method" may have raised the question of whether Johnson's boyhood community, perhaps even all of New England, was contributing enough to the war effort.[18]

In *Sugaring Off*, the multiple figures spilling forward in a V from the kettle depict numerous types of exchange that reflect a shared concept of New England, and generally Northern, identity. The kettle tender signifies hard work and, perhaps most notable during the war years, the use of free laborers, a source of pride for New Englanders. An older couple behind the kettle and the children in front of it underscore the broader subject's links to past, present, and future. The importance of being informed and educated, considered imperatives for civic order, is suggested in the seated man reading a newspaper. The only hint of corruption appears in the red-shirted man at the middle right who takes a swig from a bottle. The drinker may be a reminder of the Maine

Fig. 69. Eastman Johnson. *Sugaring Off*, ca. 1865. Oil on canvas, 34 × 54 in. (86.4 × 137.2 cm). The Huntington Library, Art Collections, and Botanical Gardens, San Marino. Gift of the Virginia Steele Scott Foundation 83.8.28

prohibition law of 1851 and the temperance movement overall.[19] Evidence of romance, a staple of sugaring-off events, appears at the left and right foreground of the canvas, where, rendered in the artist's characteristic energetic brushwork with bright patches of color and white, the men court the women. In the face of war, of which we are reminded by the scattered Union caps, this suggestion of continued regeneration was likely most welcome.

Despite the harmonious activity portrayed in *Sugaring Off*, tension pervades the image. A cold pall hovers above and around the figural group in the lowering gray light, as well as

in the surrounding bare trees and the remains of snow still piled to the sides. The entire center fore- and middle ground are marked by an emptiness that is at once inviting and menacing. Johnson soon abandoned his maple-sugaring canvases in favor of images like *The Pension Claim Agent* (fig. 70), which addressed more directly the challenges faced by society immediately after the war.[20]

David Gilmour Blythe took a markedly different path from Johnson's in his examinations of the social construction of Civil War–era America. Working in Pittsburgh, then still considered part of the West, he painted unique, pointed satires

of urban ills throughout the 1850s until his death in 1865. No group was spared by Blythe's brush as he expressed his own and much of educated society's discomfort with the impact of expanding city centers, especially the influx of immigrants following the European revolutions of the 1840s. Blythe's *Post Office* (fig. 71) offers an outline of real and perceived urban evils and growing concerns about civil disorder at a time when sectional strife and downward mobility were both increasing.[21]

Blythe situated the action under the imposing classically inspired stone arch of an urban post office, an institution where a "world of strangers" mingled in the years before free home delivery.[22] Post offices, especially, represented what many perceived as the problem of disagreeable social mixing, as decreases in postage prices in 1855 made the use of mail services broadly accessible. "Manners are the outward expression of internal character," noted an 1855 etiquette book. Appropriate behavior for women of the day rested on their reserve and protected privacy.[23] In contrast to Thomas P. Rossiter's *Rural Post Office* (fig. 72), where genteel society mixes agreeably in homogenous groups, Blythe's mail center displays a crush of people from recognizably different backgrounds. The woman in pink, whose colorful dress and large basket identify her as working class, pushes toward the dark rectangle of the General Delivery window in a clearly unacceptable manner. She and the drably dressed workman, who peers over his shoulder at the shady figure who rips his pants, are caricatured with exaggerations of shape that contrast strongly with the two well-dressed individuals calmly reading their mail on the fringes of the action. Reminiscent of characters in satirical prints by William Hogarth and Honoré Daumier, the figures in this central grouping fit together compactly like puzzle pieces, with their proximity to one another emphasizing their differences. Blythe extends his commentary on public behavior to the edges of the neoclassical archway, where, in vignettes to the right and left, men engrossed in reading letters are compromised, one by a

Fig. 70. Eastman Johnson. *The Pension Claim Agent*, 1867. Oil on canvas, 25¼ × 37⅜ in. (64.1 × 94.9 cm). Fine Arts Museums of San Francisco. Museum purchase, Mildred Anna Williams Collection 1943.6

Fig. 71. David Gilmour Blythe. *Post Office*, ca. 1859–63. Oil on canvas, 24 × 20⅛ in. (61 × 51.1 cm). Carnegie Museum of Art, Pittsburgh. Purchase 42.9

Fig. 72. Thomas P. Rossiter. *The Rural Post Office*, 1857. Oil on canvas, 19½ × 27½ in. (49.5 × 69.9 cm). Courtesy of Sotheby's, Inc., 1995.

pickpocket and the other by a carpetbag-toting snoop. Their self-absorption puts them personally at risk while also, Blythe perhaps contends, contributing to greater social disorder.[24]

Painting the Civil War at the Front and at Home

Not surprisingly, the Civil War itself posed a real challenge for artists, a number of whom served in the military. Patronage dropped off significantly, and critics were divided over the opportunities the war provided for art.[25] As one writer noted in 1861, "A period of civil war is not usually a harvest time for artists."[26] The art critic James Jackson Jarves, however, opined in 1863 that "the present period of civil war has proved the most auspicious for art and artists that America has seen."[27] Still others urged both artists and the public to rally around the necessity for American art, especially after the war's end. In 1861, when it was still hoped that

the conflict would be brief, the *Knickerbocker* contributor Mrs. J. H. Layton made an impassioned plea to American artists, writing, "Dare to be National!" Mrs. Layton felt that it was imperative for native artists to "depend upon your own identity" and "tell some story, record some sentiment which shall fix upon the page of immortality the date of your nativity." She called for scenes showing "the poesy of home, whose episodes shall warm the heart and thrill the nation," which she defined as subjects that were recognizably American and visually distinct from paintings that came from the brushes of such artists as the Frenchman Pierre-Édouard Frère and the German-born Johann Georg Meyer, both popular in New York City at the time. Subjects taken both from the past, such as colonial weavers, or the present, such as starving settlers in the Kansas Territory, were offered as appropriate alternatives.[28] Mrs. Layton would likely have applauded works such as George Henry Boughton's *Pilgrims Going to*

Fig. 73. George Henry Boughton. *Pilgrims Going to Church*, 1867. Oil on canvas, 29 × 52 in. (73.7 × 132.1 cm). Collection of the New-York Historical Society. The Robert L. Stuart Collection, on permanent loan from the New York Public Library S-117

Fig. 74. Thomas Le Clear. *Young America*, ca. 1863. Oil on canvas, 26½ × 34 in. (67.3 × 86.4 cm). Anonymous Loan

Church (fig. 73). In the end, nearly all the paintings produced during the conflict and in the decade that followed reflected the Civil War in some way.

In his *Young America* (fig. 74), Le Clear represented key issues surrounding the war, alluding to the racial, labor, political, and financial challenges facing most Northern urban dwellers, especially those in his original hometown of Buffalo and his recently adopted one of New York.[29] Using a series of attractive vignettes arranged across the canvas in a manner recalling the basic compositional format of Johnson's *Negro Life at the South*, Le Clear addresses harsh realities but softens potentially provocative themes by employing children, traditionally emblems of purity, as the purveyors of the narrative.[30] At the apex of his masterly composition, in which he positions the figural groups as a series of overlapping triangles, Le Clear highlights a plainly clothed boy making a speech as another in a military-type jacket, seated at his feet, gestures upward toward a handbill posted on the fence that reads, "Meeting Tomorrow/Young America." By 1860 the term "Young

America," familiar since the 1840s, implied a fresh and bold energy in contrast to the old order, but it was not uniformly identified with either Democratic or Republican politics. Amid sectional strife, Young Americans primarily promoted conciliation and supported the war for the sake of the Union's preservation, not emancipation (see fig. 75).[31] Alternately for some, as the historian Edward L. Widmer has noted, "Young America" was "a watchword . . . for a dangerously aggressive, unstable nationalism," a corruption of the democratic culture fostered by New York intellectuals, including those who had been associated with the American Art-Union in the 1840s.[32]

The impetus for Le Clear's meeting of motley boys was most likely "some stirring question of the day," as a critic for the *Evening Post* posited in 1863. To support his theory about the oration of the "precocious youth," the journalist identified the adult males depicted: an Irishman, a black man, and, "in deep meditation from the state house but a furlong off, a pompous legislator."[33] Indeed, these outlying figures point directly to the pervasive anti-immigrant sentiment

Fig. 75. John McLenan. *Young America politics*, from a page of illustrations in *Harper's Weekly* 4, no. 200 (October 27, 1860), p. 688. Wood engraving, 8¼ × 4⅝ in. (21 × 11.8 cm). Library of Congress, Prints and Photographs Division LC-USZ62-138448

Fig. 76. White and Baur. *The great fear of the period That Uncle Sam may be swallowed by foreigners: The problem solved*, ca. 1860–69. Lithograph, 24⅞ × 27⅝ in. (63.3 × 70 cm). Library of Congress, Prints and Photographs Division LC-DIG-pga-03047

(see fig. 76) and the hotly debated issue of emancipation early in the Civil War. During 1862, worker strikes in New York, often led by Irishmen, and the extreme tension between Irish and black laborers would erupt in the Draft Riots in the summer of 1863, soon after the closing of the National Academy of Design's annual exhibition, which included *Young America*.[34] Thousands of Irish immigrants and African Americans were staking their claim to citizenship through their significant participation as soldiers in the Civil War.[35] The country's struggles are further underscored in the vignette of the two wrestling boys, one in a blue jacket and the other wearing a white shirt and red vest. The boys in red, and the similarly dressed man at the far right, labeled by the *Evening Post* critic as a "pompous legislator," may symbolize the Republican-majority state legislature. Another red-vested boy draping a white ribbon around the girl standing beside the soapbox may refer to temperance reform and pro-abolition sentiment, both Republican causes.[36] The Irishman at far left and the fruit seller on the right, probably Irish as well, along with the boys in the striped vests or brown jackets standing close to them, could refer to the Democratic machine of Manhattan, which not only tended to be sympathetic toward the South

but also generally controlled the large immigrant Irish population and was famously at odds with upstate politics.[37] Yet, in the left foreground, ignoring the speaker, another red-vested boy receives a gold coin from a youth in working-class garb, a nod perhaps to the financial turmoil that wreaked havoc on wage labor and forged alliances outside of partisan politics, although sectional loyalties continued to hold.[38]

To the left of the young orator's proper right arm, the word "folly" is written on the fence in the same bright red paint used to write "Young America." To what is Le Clear calling attention? Is he satirizing the distracted legislator, as was proposed by the *Evening Post*; or the Democrats' extreme tendency toward rhetorical scare tactics; or the ideals of "Young America" itself, which Lincoln suggested were admirable but lacking in the balance offered by the wisdom of experience?[39] As with Johnson's *Negro Life at the South*, the full meaning of Le Clear's canvas eludes us. Yet just as Le Clear's overlapping figural groups wove together individual narratives to form a larger picture, the many challenges of the day were also integrally connected, and the unity of the nation was an issue that affected Americans of all ideological persuasions.[40]

Fig. 77. William de Hartburn Washington. *Jackson Entering the City of Winchester, Virginia*, ca. 1864. Oil on canvas, 48⅛ × 60⅛ in. (122.2 × 152.7 cm). Valentine Richmond History Center V.75.283

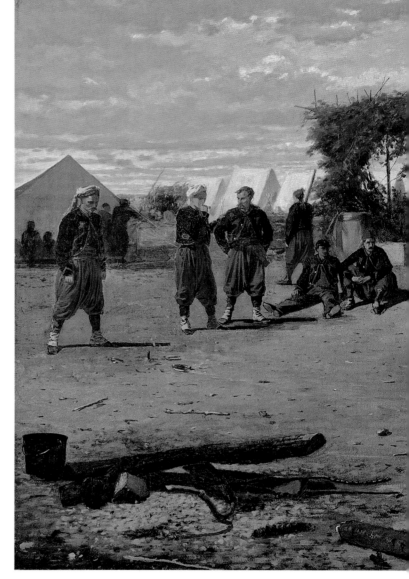

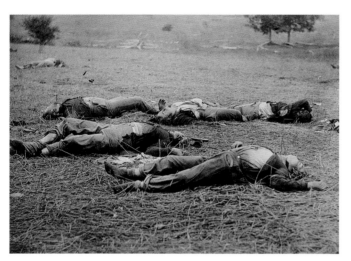

Fig. 78. Timothy O'Sullivan. *The Field Where General Reynolds Fell, Gettysburg*, 1863. Albumen print, 12¼ × 17¾ in. (31 × 45.1 cm). The Nelson-Atkins Museum of Art, Kansas City. Gift of Hallmark Cards, Inc. 2005.27.292

Fig. 79. Winslow Homer. *Pitching Quoits*, 1865. Oil on canvas, 26¾ × 53¾ in. (68 × 136.5 cm). Harvard University Art Museums, Fogg Art Museum. Gift of Mr. and Mrs. Frederic Haines Curtiss 1940.298

Indeed, the war's horrors and their effect on national and personal conditions, were almost unfathomable and unbearable. Not surprisingly, existing pictorial conventions, especially the grand-manner tradition usually employed for war imagery, failed to convey the current trauma. As the historian Steven Conn has outlined, the Civil War created artistic crises of both a pictorial and a narrative nature. Some artists, like William de Hartburn Washington in *Jackson Entering the City of Winchester, Virginia* (fig. 77), did adopt a version of the grand manner. Such images, composed using a classical vocabulary, tended to combine an individual hero with a universal moral in an incident that symbolized the larger narrative; however, the massive destruction of the Civil War and the contested ideology surrounding its cause often prevented

this approach from being successful.[41] The diverse attitudes toward the war added to the many different types of representation it engendered.

While numerous Civil War battle paintings were created, the most enduring scenes of the battlefields appeared in photographs (see fig. 78), the viewing of which, as the *New York Times* noted in 1862, brought home the gruesomeness of war with a "terrible reality and earnestness" analogous to having bodies of the dead left on one's doorstep.[42] By contrast, Boston native Winslow Homer, whose emergence as America's most famous nineteenth-century painter of everyday life coincided with the beginning of the war, primarily depicted camp life. Daring in subject and design, his war imagery, first seen in illustrations for *Harper's Weekly*, captured

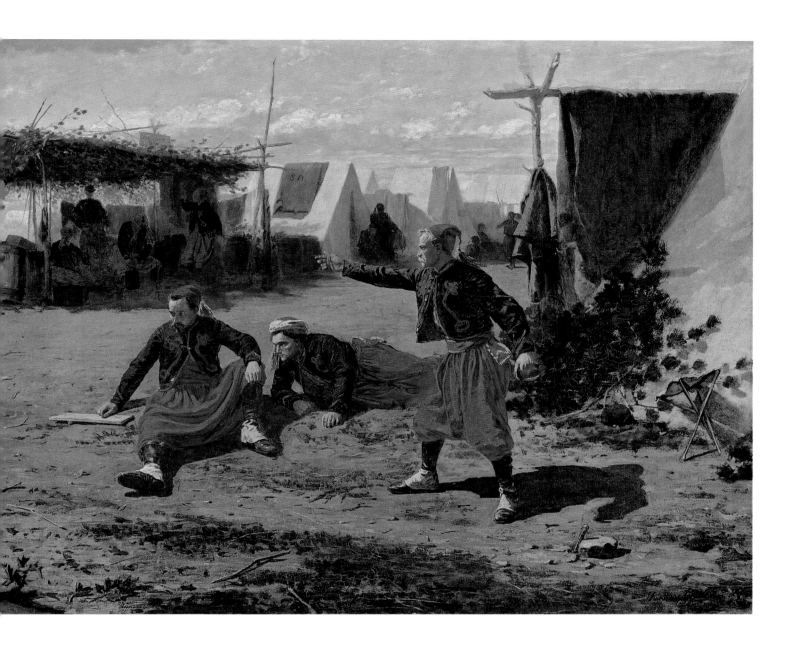

the hearts and minds of his audiences, who prized the honesty and thoughtfulness of his works.[43]

In his earliest illustrations, such as *The War for the Union—A Cavalry Charge*, published July 5, 1862, Homer employed a grand-manner format but quickly developed an original pictorial approach that incorporated historical precedent, popular contemporary European models, and his own experiences.[44] Having worked in oil for barely two years, Homer painted *Pitching Quoits* (fig. 79) during the last year of the conflict, soon after his return from a difficult visit to Virginia, when everyone, Northerner and Southerner alike, was war weary. His ostensible subject is a game of horseshoes, but the story Homer tells is less about a particular game played than about the broader experience of army life more than four years into

the conflict. In the artist's most ambitious canvas to that date, groupings of figures are bisected on the diagonal by the great sandy gulf of the hard-packed campground, which fills most of the pictorial space.[45] Accentuated by the bright light that falls evenly across it, the vacant expanse interrupts any possible active narrative connection between the near and far figures and contrasts with the signs of camp life arrayed around its edges. Seated or standing, the soldiers in Zouave uniforms, who were known as courageous special fighters with New York City ties, appear psychologically isolated. The lack of a single focal point and the downward or disengaged stares of those who nominally watch the horseshoe thrower further separate its participants from any apparent narrative, making the painting's true subject the loneliness and boredom that

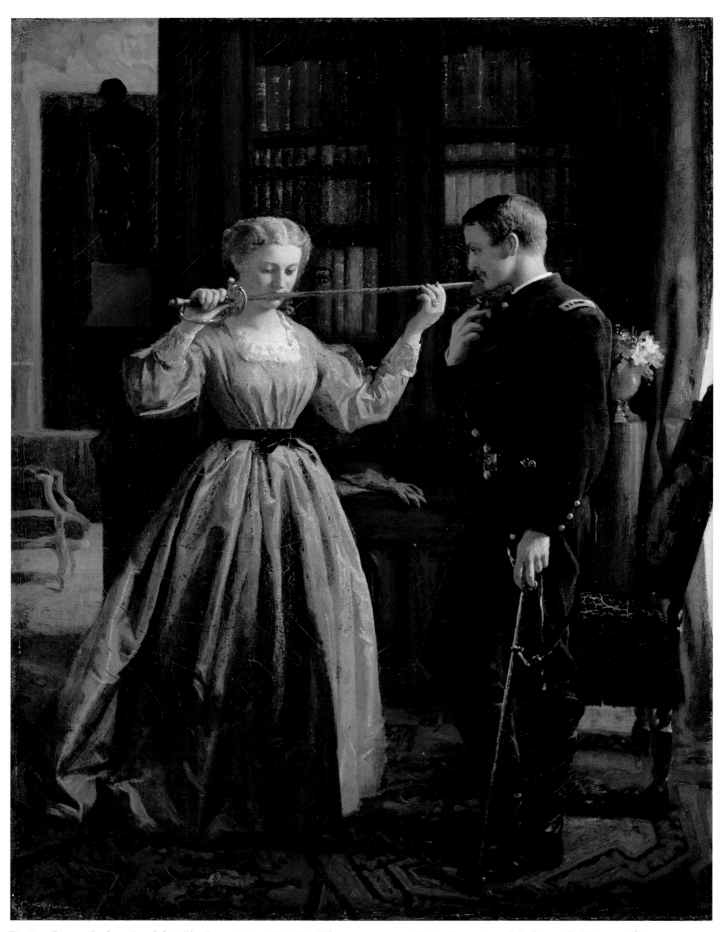

Fig. 80. George Cochran Lambdin. *The Consecration, 1861*, 1865. Oil on canvas, 24 × 18¼ in. (61 × 46.4 cm). Indianapolis Museum of Art. James E. Roberts Fund 71.179

Fig. 81. Currier and Ives. *Off for the War*, ca. 1861. Lithograph, 14 ×
10 in. (35.5 × 25.5 cm). Library of Congress, Prints and Photographs
Division LC-USZ62-17257

were facts of army camp life.[46] At the same time, in rendering
a scene without overt references to battle or lost lives, Homer
perhaps offered those at home a comforting connection to
soldiers' daily experiences at a time when many had not seen
their loved ones for several years.

In contrast to Homer's poignant psychological portrait of
camp life at the war front in *Pitching Quoits*, the Philadelphian
George Cochran Lambdin's *Consecration, 1861* (fig. 80) pro-
vided a rarely painted scene of a soldier at home.[47] Lambdin,
whose early reputation rested on his war-related imagery,
came from a family of strong Union supporters. He knew the
realities firsthand through his own visits to the front in 1864
and 1865 and through his brother's tales of his three years of
service.[48] In this canvas, however, the artist pictures the inner
sanctum of a comfortable home. In a library filled with law
books, a woman kisses the sword of a man who presumably
is her husband. Standing at a slight remove, he dreamily
smells a rose while observing her act of sacred declaration.
Following compositional and allegorical models drawn from
Pre-Raphaelite works like John Everett Millais's rendering of
Huguenot lovers (1852, private collection), Lambdin's tight

focus and close-up viewpoint may also have been influenced
by his interest in photography.[49]

The Consecration, 1861 focuses on a farewell ritual enacted
in multitudes of homes throughout the war. Rather than
depict the more typical clinging, tearful woman seen in
images such as Currier and Ives's lithograph *Off for the War*
(fig. 81), Lambdin portrays a woman who appears resolute,
embodying patriotism and a willingness to sacrifice personal
desires for the greater good of the country. Such a farewell
narrative was unusual so late in the war. Painted at a time
when the entire nation was exhausted from the extended
conflict, the picture evokes the zeal to serve that marked the
war's early days and thus could function as a memorial for
both the initial idealism surrounding the war and the many
soldiers who would not return.[50]

First shown as *Love and Loyalty*,[51] *The Consecration, 1861*,
may have harbored an additional metaphor, one referring to
the relationship of the North and South at the war's end. The
reconciliation of the two sides was commonly equated with
the institution of marriage, in which the North was the hus-
band and the South the wife.[52] Likewise, Lambdin's woman is
dressed in gray, in contrast to her husband's dark blue Union
uniform. Further, as the art historian Christine Bell has noted,
The Consecration, 1861 may have alluded to the challenges
inherent both in the reunion of long-separated spouses and
in the terms imposed by the North on the South.[53] The stiff-
ness of the woman's pose and the gap between the two figures
inject a tension into the scene that disturbs the fantasy of a
loving partnership and suggests mistrust on both sides, despite
the ultimate submission of the South.[54] Even so, by kissing
the sword, the woman takes an oath of loyalty, implying a
reunion of political and domestic relationships, both of
which would be imperative for the healing of the country
in the coming years.

"Society Is Suddenly Turned Bottomside Up"

Winslow Homer's *Veteran in a New Field* (fig. 82) brilliantly
coalesces the many and sometimes contradictory issues with
which the nation grappled immediately following Robert E.
Lee's surrender at Appomattox and President Lincoln's assas-
sination, both of which occurred in the second week of April
1865. In a deceptively simple image, wheat is being cut by a
farmer who is also a veteran of the Army of the Potomac, as
signified by his jacket and canteen discarded at the lower right.
As the Homer scholar Nicolai Cikovsky Jr. has pointed out,
the image comprises only three key elements—wheat field,
sky, and figure.[55] With this economy of means, which the
historian Benjamin T. Spencer compared to Walt Whitman's
"new language for a new world," Homer locates his subject
within a terrain of familiar symbols in order to blend several

Fig. 82. Winslow Homer. *The Veteran in a New Field*, 1865. Oil on canvas, 24⅛ × 38⅛ in. (61.3 × 96.8 cm). The Metropolitan Museum of Art, New York. Bequest of Miss Adelaide Milton de Groot (1876–1967), 1967 67.187.131

different but related narratives reflecting the contemporaneous American state of mind.[56] Its single anonymous yet iconic figure recalls the majority of soldiers who had been farmers before the war.[57] Those who returned to farming were especially esteemed for their acumen and work ethic, especially in the face of potentially unprecedented unemployment following the disbanding of massive military forces.[58] Farmers also elicited well-known associations with George Washington and the Roman hero Cincinnatus, thus securing for the common farmer-soldier an honored lineage in times of war as well as peace.[59]

Homer describes the wheat, which occupies a full two-thirds of the canvas, in dry, attenuated strokes of beautiful golds, browns, and burnt umber. Nearly half of the grass has been cut by Homer's farmer with a simple scythe, an implement already outdated by the 1860s.[60] With the scythe evoking the Grim Reaper, the scene stands as a reminder of the death that occurred on Civil War battlefields. Painted through the summer and fall of 1865, the image also surely serves, as Cikovsky has suggested, as an expression of grief upon the death of Lincoln. Alternately, the wheat conveys a positive message in its role as a Northern agricultural product, and its bountiful presence in the painting could be reflective of the Union victory.[61] With these opposing representations of

death and life, Homer offers in his economical composition a powerful meditation on the nation's immense sacrifice during the Civil War and the potential for regeneration afterward.

Moreover, the additional symbolic possibilities of the painting's title cannot be ignored. The veteran works in a *new* field. It may have been in the same location in which he had worked before, but much had changed, and would continue to change, since his last harvest.[62] Finally, Homer's veteran may have held meaning for the artist himself given that, at the end of the war, he hastened more fully into his own new field—that of painting.

Agriculture was only one of many aspects of American enterprise and society that faced upheaval after the Civil War. As the Northern journalist James Pike noted in 1868, "Society is suddenly turned bottomside up."[63] The Thirteenth Amendment, which in late 1865 removed race as a qualifier for the right of citizenship, and the Reconstruction Acts of 1866 and 1867, which incorporated black citizens into the social and political fabric of the country, were passed at the same time that Southern states were being reinstated into the Union. At the center of these endeavors were conflicting ideas about the meaning of the word "liberty" and the potential of emancipation.[64] Not surprisingly, the new state of the Union led to a reassessment of African American imagery,

which resulted, especially at first, in a reduction both in the number of depictions of the subject and in the use of biting stereotypes.[65] In *On to Liberty* (fig. 83), Theodor Kaufmann, a German émigré and veteran of the revolutions of 1848 and the art academies of Dresden and Munich,[66] offered a visual rendition of Northerners' general optimism regarding the situation of African Americans immediately following the war.[67] Mixing the classical academic figure tradition with anecdote, Kaufmann portrays a group of black women and children running out of the woods toward an open field punctuated by an American flag and the smoke of battle. The image may have derived from Kaufmann's own experiences as a Union soldier in the South, where retreating Confederate forces took adult male slaves with them, leaving the women and children to fend for themselves.[68] Employing carefully finished and sculptural figures arranged with the rhythms of an antique frieze, Kaufmann confers gravity on the scene, connecting the specific narrative of this small group's flight to the larger difficulties facing African Americans as they embraced emancipation. Ultimately, the image reflects Kaufmann's personal convictions of equality and liberty for all and the Northern hope that political and social freedoms would indeed become part of the African American experience. Even so, it was acknowledged that the transition from enslavement to citizenship would be full of challenges. Across a canvas in which the scene literally shifts from dark to light, Kaufmann deploys details with symbolic resonance to underscore his didactic purpose. Emblems of success and caution are worn around the necks of the painting's two central figures: in nineteenth-century African American folklore, red beads signified victory and blue beads were considered potent amulets of protection.[69] To ward off witches, slaves also used forked sticks like those carried prominently by three of the women.[70] The anxious expression on the face of the boy glancing back to the women, whose poses suggest a mix of resolve and hesitancy, acknowledges the uncertainty of this dangerous endeavor.[71] The landscape further adds to Kaufmann's program. At the right foreground, a ledge of boulders separates the rocky path underfoot from the smooth road leading to the Union forces. In 1867 there was no clear path to liberty or any guarantee of what it would bring to African Americans, who, on the whole, were ill prepared for their new status. Understanding this, Kaufmann arms those in flight with only their most basic personal belongings and traditional protections as they head toward the promise of the flag, which looms large yet remains frighteningly close to the ongoing battle.

Like images of African Americans, genre scenes that featured American Indians were rare immediately after the Civil

Fig. 83. Theodor Kaufmann. *On to Liberty*, 1867. Oil on canvas, 36 × 56 in. (91.4 × 142.2 cm). The Metropolitan Museum of Art, New York. Gift of Erving and Joyce Wolf, in memory of Diane R. Wolf, 1982 1982.443.3

Fig. 84. John Mix Stanley. *Gambling for the Buck*, 1867. Oil on canvas, 20 × 15⅞ in. (50.8 × 40.3 cm). Stark Museum of Art, Orange, Texas 31.23.11

Fig. 85. Albert Bierstadt. *Emigrants Crossing the Plains*, 1867. Oil on canvas, 67 × 102 in. (170.2 × 259.1 cm). National Cowboy and Western Heritage Museum, Oklahoma City 1972.019

War despite, or because of, the prominent position the situation of American Indian populations held in the American consciousness during the late 1860s. "Next to the Negro question, the one relating to the Indians claims the serious attention of the country. What ought we do with them, and for them?" asked the missionary T. S. Williamson in 1864 while considering the duty of the government in Indian matters.[72] From 1865 to 1867, a congressional committee devised the course for establishing treaties with various tribes that, in effect, would force them off their lands to reservations farther west. Key in these deliberations was the recognition that the completion of the Union Pacific Railroad's transcontinental line would open the way for tremendous national economic growth.[73] In 1867, when John Mix Stanley painted *Gambling for the Buck* (fig. 84), Indian wars raged throughout the Plains region from Iowa to Montana as the railroads and emigrants, such as those pictured in Albert Bierstadt's romanticized *Emigrants Crossing the Plains* (fig. 85), pushed farther and farther west of the Mississippi.

Specializing in Indian subjects, Stanley employed his deep knowledge of Native American cultures, which grew out of exchanges with the Iroquois of his upstate–New York childhood and with the many tribes, from the eastern Sioux to the Blackfeet, he encountered during his years traveling throughout the West, from 1842 to 1854.[74] Yet his paintings primarily present a pastiche of Indian life that nevertheless appears genuine, fulfilling his audience's desire for good stories that romanticized the Native American experience. *Gambling for the Buck* is an excellent example of his approach. The general narrative of the painting is easy to read. Three men play cards to determine which of them will be the owner of the dead buck in the foreground. Stanley invokes some well-known stereotypes associated with American Indians, such as a penchant for gambling and, as seen especially in the man stripped to his waist, the idea of the noble savage.[75] Missing is any

reference to the violence of the times, which was often attributed to Indian men, but Stanley dresses them up in clothing generally reserved for ceremonies and special meetings, adding both gravity and an exotic air to the otherwise quotidian scene.[76] For the thousands who knew this image through its chromolithograph, perhaps not coincidentally issued in 1869, the year the Union Pacific completed its rail line, *Gambling for the Buck* imparts an illusion of authenticity without revealing any hint of the terrible ongoing conflicts.

Yet Stanley may also have embedded more subtle references that reflected his own considerable anxiety over Indian removal.[77] The bright light streaming from the opening in the lodge roof focuses attention on the center of the canvas, where each man is frozen in action. As the Stanley scholar Julie Schimmel has observed, the moment appears portentous.[78] Playing perhaps on the word "buck," the artist may have equated the dead deer, the young Indian men, and monetary gain in the game of chance. Buck was a pejorative term for young American Indian (and African American) men, evoking the virile, animal nature of deer and other animals whose males are known as bucks.[79] Further, by 1850 the word "buck" was well-known slang for a dollar, the term having been derived from the late eighteenth-century frontier days when the value of one deerskin equaled a dollar.[80] This conflation of meanings and their association with gambling here may have been a way for Stanley to vent his personal distaste of the government's handling of Indian affairs while also catering to popular taste.

Home and Family

Artists and patrons sought subjects that suggested normalcy and promoted national values amid the hard work of reunion and reconciliation; reconstruction of the South; expansion of the West; and integration of emancipated African Americans

Fig. 86. Seymour Joseph Guy. *The Contest for the Bouquet: The Family of Robert Gordon in Their New York Dining-Room*, 1866. Oil on canvas, 24⅝ × 29½ in. (62.5 × 74.9 cm). The Metropolitan Museum of Art, New York. Purchase, Gift of William E. Dodge, by exchange, and Lila Acheson Wallace Gift, 1992 1992.128

into the political, economic, and social fabric of America. Although landscape paintings were prominent, home and family, often intermingled, were two of the most compelling subjects at the time.

A number of art patrons who had profited from the Civil War, and continued to prosper in the years following, commissioned portraits of their families at home.[81] These assignments often grew out of existing connections between artist and patron. Such was the case with the financier Robert Gordon and the painter Seymour Joseph Guy, both of whom were British-born members of New York's Century Club.[82] *The Contest for the Bouquet: The Family of Robert Gordon in Their New York Dining-Room* (fig. 86) pictures Gordon's wife, Frances, and their four children in their home at 7 West Thirty-third Street in Manhattan. Although Gordon himself is absent from the scene, his presence permeates it. As the art

historian John Davis has noted, the antlers, a massive sideboard on which sits a sculpture of a big cat clawing its prey, and an impressive collection of paintings all suggest the hunt, and in particular, the "hunter" Gordon's success in intellectual, financial, and physical arenas.[83] In Victorian America, the dining room was considered a male domain in contrast to the more feminine space of the parlor, and, indeed, this painting clearly elucidates Gordon's privileged position in society.[84] Central to the painting, however, are perhaps his most prized possessions: his children and wife.

The Contest for the Bouquet shows the eldest Gordon son snatching a bouquet from his sister. The work is painted in careful detail with a high degree of finish, both hallmarks of Guy's style, and the center of the narrative is amplified by the actions of the other siblings. A young boy, having adventurously climbed on a chair, mimics his older brother by also

Fig. 87. Eastman Johnson. *Not at Home (An Interior of the Artist's House)*, ca. 1873. Oil on laminated paperboard, 26½ × 22⅜ in. (67.1 × 56.7 cm). Brooklyn Museum. Gift of Gwendolyn O. L. Conkling 40.60

attempting to grab at the prized flowers. The youngest girl has climbed into her mother's lap, perhaps seeking safety from the commotion. Altogether, the scene reflects prevalent ideals in connection with the home, family, childhood, and gender roles while also presenting the success achieved by Gordon, and by association, America.

The family in Victorian America was exalted as a stabilizing force in the social order, and the home functioned as both a sanctuary from the outside world and a training ground for the rising generation.[85] With schoolbooks in hand but hat thrown off, the elder Master Gordon stands squarely, keeping both his eye on the prize and the prize out

Fig. 88. Henry Mosler. *Just Moved*, 1870. Oil on canvas, 29 × 36½ in. (73.7 × 92.7 cm). The Metropolitan Museum of Art, New York. Arthur Hoppock Hearn Fund, 1962 62.80

of his sister's reach. This exhibition of the forthright, dominant spirit so highly valued in male behavior suggests that this boy will be well prepared to follow in his father's footsteps. His sister, slightly off-balance, reaches for the bouquet but remains within the confines of feminine propriety. Their mother, observant but not a principal actor in the scene, signals the kind of watchful, maternal influence that was increasingly fashionable in parenting after the Civil War.[86]

In *Not at Home (An Interior of the Artist's House)* (fig. 87), Eastman Johnson tells a companion tale of family life that remarks not only on his personal success and the domestic harmony he enjoys but also on the division between the public and private spheres of contemporary experience.[87] Using as his setting his own residence at 65 West Fifty-fifth Street, he creates an intimate view of his wife, Elizabeth, ascending the staircase from their home's public spaces on the first floor. She had presumably received guests during the afternoon

visiting hours customarily kept by middle-class and affluent women in the nineteenth century.[88] The composition, which gives a glimpse from the shadows of the entry hall into the sunlit parlor, owes its design to Dutch masters such as Pieter de Hooch (see fig. 27) and Gerrit Dou. The well-appointed parlor, including the paintings on view to all visitors, testifies to Johnson's professional success. The beautifully rendered figure and details such as the stroller parked at the side of the parlor door both convey personal accomplishments and indicate Mrs. Johnson's key role in endeavors, both public and private, related to the home. Painted in warm tones and with descriptive brushwork that is neither too finicky nor too sloppy, Johnson's canvas is a loving portrait of his own domestic experience.

Although it features a much more humble abode than those portrayed by Guy or Johnson, Henry Mosler's *Just Moved* (fig. 88) also represents home as a haven in which the

perfect American family still presides, even when in modest surroundings and amid the jumble of unpacking after a move.[89] The tender and nurturing mother and the father providing sustenance signal the possibility of an intact, happy family regardless of one's station in life. At a time when cities struggled with increased crime and poverty as well as booming populations of foreign immigrants, an image like Mosler's obscured the seamier sides of urban life, providing to art patrons and viewers alike reassurance of the power of the family and the potential for a more diverse national character once the Union was solidified.[90]

Images of children—whether from elite families like the Gordons or from those on the lower rungs of the economic ladder like the one presented by Mosler in *Just Moved*— played key roles in the healing of post–Civil War America.[91] Not only were children considered free of the sins weighing on their parents, but they also embodied the promise of America's future.[92] Guy suggested this in his depiction of the Gordon boys, who are characterized as educated, aggressive enough to succeed, and, in the case of the youngest boy teetering on a chair, willing to take risks.

Homer also promoted boys as redeemers, but his paintings reflect a more nuanced narrative and artistic construction than did Guy's commissioned conversation pieces. Hailed for creating art that was "thoroughly national," Homer offered in paintings like *Snap the Whip* (fig. 89) an image of boyhood that combined a generation's nostalgia for the simple rural experiences of childhood with reflections on the hopes for and perceived challenges facing those coming of age in the more complex post–Civil War world.[93] Arrayed across the picture plane in a rhythmic cadence created through pose and the alternation of lights and darks, the string of boys is portrayed with an exuberant sense of freedom that characterizes child's play. Now outside the security of home and in the world of nineteenth-century schoolyard culture, the boys of *Snap the Whip* display the bare feet associated with the freedom of childhood as well as the suspenders that signify they are on the path to manhood and its responsibilities.[94] On the one hand, Homer implies that these country boys, playing a game that requires teamwork, strength, and calculation, symbolize the democratic reunited nation. On the other, he hints at the decisions fraught with anxiety that these boys will all too soon face in their lives. As the writer Charles Dudley Warner observed in 1877, "Just as you get used to being a boy, you have to be something else, with a good deal more work to do and not half as much fun."[95] Observed from right to left, Homer's boys in *Snap the Whip* hang on, strain to stay connected, run in perfect harmony, and fall away, representing

Fig. 89. Winslow Homer. *Snap the Whip*, 1872. Oil on canvas, 12 × 20 in. (30.5 × 50.8 cm). The Metropolitan Museum of Art. Gift of Christian A. Zabriskie, 1950 50.41

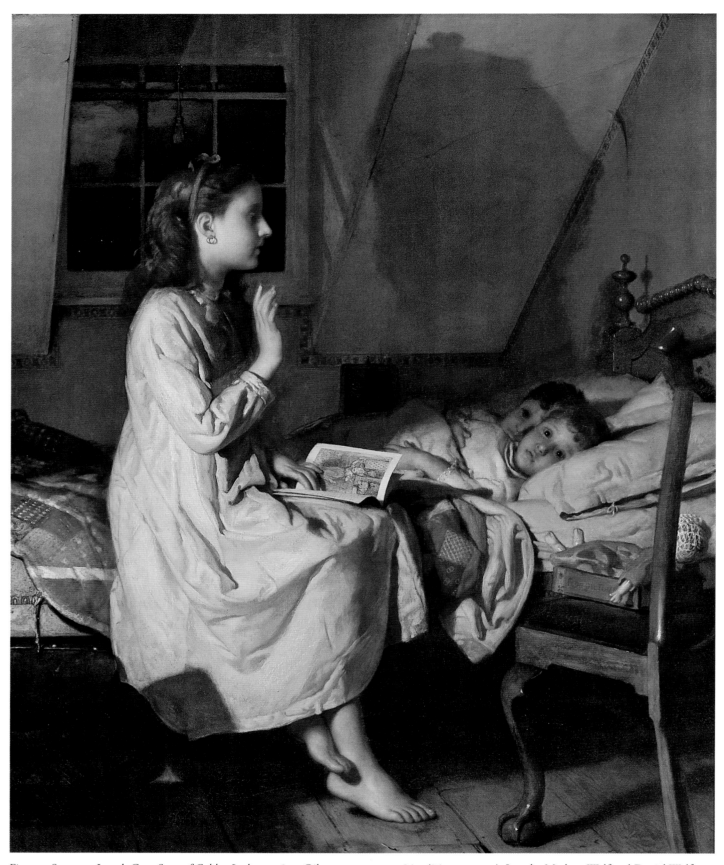

Fig. 90. Seymour Joseph Guy. *Story of Golden Locks*, ca. 1870. Oil on canvas, 34 × 28 in. (86.4 × 71.1 cm). Lent by Mathew Wolf and Daniel Wolf, in memory of Diane R. Wolf

Fig. 91. Seymour Joseph Guy. *Making a Train*, 1867. Oil on canvas, 18⅛ × 24⅛ in. (46 × 61.3 cm). Philadelphia Museum of Art. The George W. Elkins Collection, 1924 E1924-4-14

all the possible scenarios within the male experience after the Civil War.

Paintings of girls also forecast the future and the desires of the nation.[96] Guy specialized in sentimental narratives that frequently featured preadolescent girls and were incredibly popular. A writer for the *New York Evening Mail* remarked in 1869 that it took him several attempts to visit Guy's studio because the artist was "so completely smothered among lady visitors."[97] Canvases like *Story of Golden Locks* (fig. 90) contributed to Guy's success. Using a dramatic scheme of light and shadow reminiscent of the work of Georges de La Tour or Joseph Wright of Derby, the artist presents an older sister reading the titular story to two little boys tucked snugly into their bed. The girl, probably modeled after Guy's own daughter, plays the maternal role that likely will be hers someday. Her doll tucked in the box on the chair at right suggests that she is ready to put away childish games and take on more adult roles. The boys' wide eyes and their sister's menacing shadow projected on the attic bedroom's wall behind them indicate that the moment depicted is the story's most frightening.

Fairy tales remained well regarded for their moral content in the late 1860s, and the story of "Goldilocks and the Three Bears" was intended to warn children not to wander off on their own.[98] Later interpretations of the tale, including that of the psychologist Bruno Bettelheim, also considered the story important as a reflection of a girl's search for identity and her sense of alienation as she makes the transition from girlhood to womanhood.[99] Although Guy's girl, brightly lit in her white nightgown, is the source of the scary shadow that could reflect her own internal conflicts, she also exudes a sense of calm and purity that foretells her success as an American mother.[100]

Other paintings of preadolescent girls by Guy conjure up aspects of Victorian womanhood aside from the role of mother. Picturing the same attic room as the one seen in *Story of Golden Locks,* his *Making a Train* (fig. 91) turns a young girl's bedtime preparations into a flight of fancy, as she imagines herself in the womanly splendor of a long dress with a train. As the art historian David Lubin has outlined, the amiable charm of the image relates to the post–Civil War belief

Fig. 92. Currier and Ives. *The age of brass: Or the triumphs of woman's rights*, 1869. Lithograph, 11⅞ × 16⅞ in. (30.3 × 42.8 cm). Library of Congress, Prints and Photographs Division LC-USZC2-1921

that play and leisure time were good for children, in contrast to earlier ideas about the latent depravity of such activities. The painting also confirms gendered stereotypes within a male-dominated social order at a time when many perceived womanhood to be under attack by militant feminists fighting for suffrage and other freedoms (see fig. 92).[101] More broadly, the painting displays political cogency in its depiction of a clean, healthy, white girl in a modest home, in contrast to the dirty and delinquent street children that concerned reformers of the day such as Charles Loring Brace.[102] The red, white, and blue color scheme seen in the quilt—an early American craft born out of communities of women— and in the triad of the girl's dress, chemise, and headband, signals the subject's national implications as well.

At the same time, the girl's choice of amusement, in tandem with the doll half-stuffed into the cupboard at the left, suggests the popular subject of nascent womanhood and, as with *Story of Golden Locks*, the idea of vanishing childhood. *Making a Train* also perhaps exhibits a nostalgic slant toward lost innocence.[103] Although they were unarticulated in Guy's day, the erotic overtones of *Making a Train* are unavoidable. The viewer, apparently situated in the shadows of the foreground, secretly watches this private moment and, guided by Guy's signature dramatic illumination thrown from the lamp on the chair at right, focuses on the partially disrobed girl as light and shadow graze her prepubescent chest. Although such commingling of sexual allure and girlish innocence may cause considerable anxiety today, the convention was prevalent in both Victorian England and America and, as the historian James Kincaid has asserted, was considered less disturbing.[104] As seen in the photographs of Oscar Gustav Rejlander or Julia Margaret Cameron, sentiment and innocence trumped

overt erotic readings of images like *Making a Train*, even though to today's viewer salaciousness seems to lurk beneath the surface.[105]

In the 1860s and 1870s, John George Brown, like Guy, had a penchant for painting carefully rendered canvases of children engaged in play that underscored their innocence and often commented on or foreshadowed adult experiences. He also occasionally painted stories of young womanhood, the best known of which is *The Music Lesson* (fig. 93). Like Guy, Brown was British born and settled in Brooklyn in the mid-1850s.[106] Brown's debt to the English Pre-Raphaelite painters, especially John Everett Millais and Arthur Hughes, was rooted in his art studies in his native England and predisposed him toward both a tightly descriptive technique and moralizing tales. The scene in *The Music Lesson* is steeped in the period flavor of Victorian America, clearly rendered so that every element of middle-class prosperity can be enjoyed.[107] The wall covering, two layers of carpeting, heavy draperies, Renaissance Revival sofa, harp, paintings and prints, and brass plant holder perfectly set the stage for Brown's courtship narrative, which, according to the critic of the *Evening Mail*, could not fail to gain admirers because of its style and the tale it told. The writer outlined the story for his readers, describing the room and noting that the young man sitting close to the woman on the sofa aids her in playing the flute. He continued, "It is a charming duet, which we can fancy was followed by a solo from him. . . . 'Oh happy love, where love like this is found;/ Oh heartfelt rapture, bliss beyond compare.'"[108]

Brown's subject matter may have had personal associations as well as contemporary resonance: he would marry his second wife the year after he painted this canvas. More broadly, the

Fig. 93. John George Brown. *The Music Lesson*, 1870. Oil on canvas, 24 × 20 in. (61 × 50.8 cm). The Metropolitan Museum of Art, New York. Gift of Colonel Charles A. Fowler, 1921 21.115.3

role of women, especially as wives and mothers, had garnered increasing attention five years after the Civil War. In part, this interest was a result of the stabilization of a middle-class structure and the keystone women provided for it. Additionally, it was a time of concern that marriage was losing popularity, birthrates were dropping, and the rise of independent women would upset the delicate balance between genders being reestablished after the war, as was suggested by Thomas Nast in an illustration for *Harper's Weekly* (see fig. 94).[109]

The Music Lesson fully endorses, even idealizes, the status quo. The happy ending of the tale and its moral—that marriage is essential to civilization—are supported by

Fig. 94. Thomas Nast. *"Get thee behind me, (Mrs.) Satan!"*, illustrated in *Harper's Weekly* 16 (February 17, 1872), p. 140. Wood engraving, 15¾ × 10⅞ in. (40 × 27.5 cm). Library of Congress, Prints and Photographs Division LC-USZ62-74994

Brown's overall musical theme.[110] Not only was music considered both a universal language for expressing emotions and a sweet and refining influence, but music making was also an acceptable activity for courting couples.[111] All the remarkable details in the painting further add to the story, which reflects an accurate portrayal of 1870 domesticity and courting rituals. The high-minded associations inspired by the planter filled with ivy, a well-known symbol of fidelity, are amplified by the haloed figure at the center top of the canvas and the golden harp at right. Further, the couple's well-appointed and complementary attire, in warm brown, tan, and taupe tones, would have been familiar emblems of stability, security, domesticity, and compatibility at the time.[112] As the writer W. Howard Standish declared in 1908, "[Brown's] story is never obscure."[113] Another aspect of the narrative that would have been readily apparent to its contemporary viewers was the couple's obvious mutual admiration, which was highlighted by an engraving of the painting titled *A Game Two Can Play At*.[114] This coy label, the poses of the figures leaning into each other, and their shared handling

of the flute all play into the romantic pursuits of the day and speak to the social realignment that was well under way by 1870.

Modern Women and Men

Throughout the 1870s, the place of women in society hung in the balance between what were generally considered their only acceptable roles—as wives and mothers—and new alternatives born out of the nascent women's movement. Early feminists campaigned for expanded suffrage, educational opportunities, and control over their own lives.[115] As the historian Catherine Clinton has noted, the resulting collision of spheres—public and private, male and female, home and work—presented women with a myriad of possibilities.[116]

If Brown's *Music Lesson* embodies an ideal of middle-class values and gender harmony, Homer's images of women painted about the same time often suggest the tensions associated with these new choices. The game of croquet was a perfect subject, allowing Homer to explore the growing complexities of relations between the sexes right after the Civil War.[117] As a thirty-year-old bachelor in 1866, the year he painted *Croquet Scene* (fig. 95), the artist had become intrigued with this "eminently social" game. Croquet, which had gained tremendous popularity in the United States by 1864, was remarkable as an activity that allowed men and women to play, and compete, on equal terms. At the same time, contemporary observers applauded the sport for its promotion of good health and for the opportunity it provided men and women to visit and flirt with each other.[118]

In *Croquet Scene*, Homer employed his distinctive artistic style to touch on these aspects of the game, highlighting current societal transformations through visual rather than anecdotal means. In contrast to a painting like *The Music Lesson*, which Brown filled edge to edge with detailed renderings of accoutrements to the story, Homer populated his canvas sparsely, replacing extravagant detail with broader paint application and definition of shape and form. The entire painting comprises four figures and a modicum of croquet equipment, arranged on a lawn bordered by woods in the background. The image's cropped edges prohibit a contextual setting—there is no sign of either a home or other participants in the game—and there is barely any sky to relieve the primarily green and brown palette of the background. Although it unmistakably represents the outdoors, Homer's croquet lawn suffers somewhat from visual claustrophobia even as it wavers between the suggestion of an open space and the flatness of the canvas. Homer arranged the figures across this ambiguous stage so that, as the art historian Sarah Burns has recently noted, the man, shown following the expected courtesies of the day by assisting his companions with ball placement,

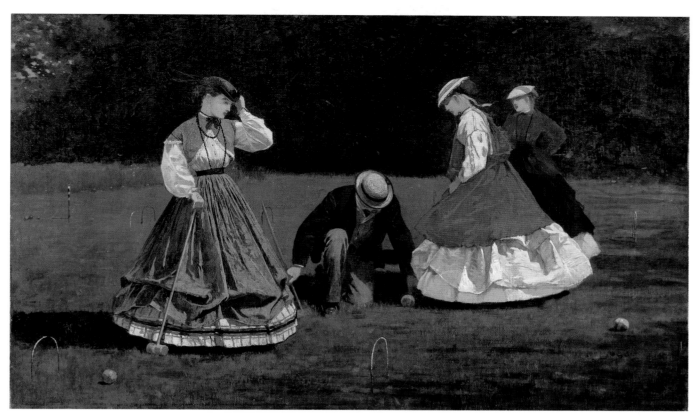

Fig. 95. Winslow Homer. *Croquet Scene*, 1866. Oil on canvas, 15⅞ × 26⅛ in. (40.3 × 66.2 cm). The Art Institute of Chicago. Friends of American Art Collection, Goodman Fund 1942.35

Fig. 96. Winslow Homer. *Eagle Head, Manchester, Massachusetts (High Tide)*, 1870. Oil on canvas, 26 × 38 in. (66 × 96.5 cm). The Metropolitan Museum of Art, New York. Gift of Mrs. William F. Milton, 1923 23.77.2

appears sandwiched between two women, wearing stylish dresses brightly colored in a patriotic palette, who tower over him.[119] Homer's composition, which gives no clues to a specific story, simultaneously tells of a passing moment during an afternoon of pleasant play and the changing, uncomfortable terrain of relationships between American men and women.

During the 1870s Homer frequently portrayed women engaged in outdoor activities that marked ongoing changes both in contemporary society and in art. *Eagle Head, Manchester, Massachusetts (High Tide)* (fig. 96), which shows three young women regrouping after a foray into the ocean, was the artist's most daring subject and composition to date. The painting's viewpoint and arrangement of figures insist that the viewer intrude into what feels like a very private moment. The focal point of the broadly painted canvas is the woman in the least decorous pose, en déshabillé, wringing out her bathing costume before doing the same with her hair. The sharp diagonals of the tide line and the disheveled girl's shadow, punctuated on the left end by an alarmed dog, neatly converge at her brightly illuminated figure. The resulting view replicates what one might see looking at the actual scene through binoculars, leading D. O'C. Townley of the *Evening Mail* to comment, "Other puppies are presumed to be on the beach with opera glasses."[120]

Always an anonymous and astute observer, Homer caused outrage with his beach scene only in part because of its borderline risqué subject. *Eagle Head* arrested viewers as much for its unconventional composition and loose brushwork as for its content. The 1870s saw a revived discussion about the nature of truth in art, with Homer's work at the center.[121] Verisimilitude such as that seen in the canvases of Guy and Brown was generally considered the best foundation for art. Homer's idea of verisimilitude was ostensibly different, however, producing, as Clarence Cook of the *New-York Daily Tribune* described, a realism that took "a direct, bold look into the face of things."[122] Homer's combination of modern subjects and unorthodox artistic practices was heralded for its Americanness, truthfulness, and originality even as it was condemned for its eccentricities and unconventionality.[123]

While Homer was painting contemporary women, Thomas Eakins, just back from three-and-a-half years in Europe, was focusing on images of men engaged in leisure activities in his native Philadelphia. *The Champion Single Sculls (Max Schmitt in a Single Scull)* (fig. 97), the first in a series of rowing scenes set on the Schuylkill River, depicts Eakins's high-school friend and champion rower Max Schmitt. As with women bathing in the sea, the subject of men rowing was a new one in American painting, and a reflection of contemporary life. Rowing was valued for its dual engagement of the mind and body as well as for the discipline it required. It also was affirmed as an egalitarian

activity and an antidote to the challenges and pressures faced by urban workingmen in post–Civil War America.[124]

Eakins, at only twenty-seven, displays in *The Champion Single Sculls* a highly personal aesthetic that systematically weaves together carefully chosen elements of observed nature. Drawing from the tradition of rowing prints and the lessons, notably about objective description, learned in Jean-Léon Gérôme's atelier in Paris, the artist created an extraordinary illusion of reality as opposed to literal representation. As the art historian Michael Leja has noted, Eakins enhanced the

Fig. 97. Thomas Eakins. *The Champion Single Sculls (Max Schmitt in a Single Scull)*, 1871. Oil on canvas, 32¼ × 46¼ in. (81.9 × 117.5 cm). The Metropolitan Museum of Art, New York. Purchase, The Alfred N. Punnett Endowment Fund and George D. Pratt Gift, 1934 34.92

narrative in paintings like *The Champion Single Sculls* by knitting together disconnected but carefully studied elements that enhance our perception of reality.[125] For example, Eakins shapes his space and his story from extraordinarily detailed considerations of Schmitt, the water, the bridge, and the sky, as well as from the other sculls on the river, including one in the middle distance containing the artist himself. Using calculated perspective, Eakins systematically conjures an image that appears to represent a particular moment, place, and experience. At the same time, the concentration

on these details focuses our attention on Schmitt as a kind of modern hero, a renewed Greek ideal of manhood represented as the winner of a specific competition owing to diligence and hard work. It also draws attention to the artist's and Schmitt's hometown of Philadelphia by including the Girard Avenue and Connecting Railroad bridges as well as a nearby group of Quaker rowers. It acknowledges, too, Eakins's hard work and diligence in his art.[126] Thus, *The Champion Single Sculls* tells multiple stories and exists simultaneously as a celebration of a friend and modern hero, a display of civic

Fig. 98. Enoch Wood Perry. *Talking It Over*, 1872. Oil on canvas, 22¼ × 29¼ in. (56.5 × 74.3 cm). The Metropolitan Museum of Art, New York. Gift of Erving and Joyce Wolf, in memory of Diane R. Wolf, 1980 1980.361

pride, a metaphor for the artist's own creativity, and an emblem of the male experience in the early 1870s by "mov[ing] parallel to nature, selecting and appropriating rather than transcribing a given whole," as the art historian Marc Simpson has cogently observed.[127]

Looking Back and Moving Forward

If Homer and Eakins boldly rendered the lives of modern men and women in the early 1870s, Enoch Wood Perry told stories of contemporary New England farm life that blended nostalgia and current events.[128] Perry's canvases, such as *Talking It Over* (fig. 98), were acclaimed because they conjured happy childhood memories for many wealthy urban New Yorkers and they celebrated a way of American life that was fast disappearing.[129] By the summer of 1871, when Perry traveled throughout New York State and New Hampshire to gather the raw material for his rural scenes, it was well understood that the region had been replaced as the seat of modern American agriculture by locales farther west. One-third of

the farming population in the United States now lived in the north-central United States, whereas only one-sixth remained in New England, and, for the first time, nonagricultural workers were more prevalent than farmers there.[130]

Talking It Over features two farmers either in discussion about some agricultural issue or bargaining, as most reviewers of the painting assumed when they saw it at the National Academy of Design in 1872.[131] The two protagonists of the story are seated in a barn surrounded by the tools and products of farm labor, with their horses, the one at left seen only in shadow, as the only spectators. In composing the scene, Perry drew on earlier American models such as William Sidney Mount's *Bargaining for a Horse* (fig. 30) or Eastman Johnson's *Corn Husking* (1860, Everson Museum, Syracuse) as well as the lessons he learned under Emanuel Gottlieb Leutze in Düsseldorf and Thomas Couture in Paris. His use of dramatic lighting casts the carefully painted figures in high relief, accentuating their generational and physical differences. As the art historian Dorothy Hesselman has convincingly proposed, the farmers may represent not only icons

Fig. 99. Eastman Johnson. *The New Bonnet*, 1876. Oil on academy board, 20¾ × 27 in. (52.7 × 68.6 cm). The Metropolitan Museum of Art, New York. Bequest of Collis P. Huntington, 1900 25.110.11

of ideal American citizenry but also personifications of George Washington and Abraham Lincoln, whose visages were very well known and often paired following Lincoln's assassination.[132] Perry may have desired to offer more than a comforting nostalgic reverie in *Talking It Over*. By setting protagonists who resemble America's two best-known and most-admired farmer-patriot citizens in a barnlike interior amid suggestions of a bountiful harvest, he also may have hoped to allude to the state of the "national" barn, which under President Ulysses S. Grant continued to experience massive immigration, a continued seismic shift of agriculture to the West, and the unprecedented economic growth that generated the powerful new industrial business class.[133]

While Perry mined the interior of New England and northeastern New York State for his farm subjects, Eastman Johnson found on Nantucket Island a new inspiration for his paintings that would last for a decade. *The New Bonnet* (fig. 99) is one of several interiors that exude the flavor of Johnson's island idyll, which came to stand for authentic America with roots in its colonial past.[134] In a Nantucket

kitchen, a young, fashionably dressed woman shows off a stylish new hat to her more plainly clothed sister.[135] Their father, having returned with the shopper, is hunched by the fireside, warming his hands and waiting for the drink being mixed by his more restrained daughter, who acts as a conduit between the other two figures and who, as Clarence Cook perceptively noted, underscores the division between the two generations and their interests.[136] Johnson's success lies in the details of the interior, which is outfitted like a carefully appointed stage set. Candlesticks on the mantel, lanterns and tools hanging against otherwise bare walls, a Windsor chair, and a large brick fireplace are all rendered with a documentarian's specificity using Johnson's best Dutch-inspired brushwork. The generally spare interior, exuding a sense of humbleness and respect for the past, and the older man, who is physically and psychologically isolated, are in sharp counterpoint to the fashionable daughter and her new purchase. The muted tones and quiet atmosphere of Johnson's canvas contrast markedly with Frances William Edmonds's more active and expressive 1858 painting of a similar story (see fig. 34).

Fig. 100. Winslow Homer. *Breezing Up (A Fair Wind)*, 1873–76. Oil on canvas, 24¼ × 38¼ in. (61.5 × 97 cm). National Gallery of Art, Washington, D.C. Gift of the W. L. and May T. Mellon Foundation 1943.13.1

In his narrative, Johnson not only revels in simpler times gone by, but he also points toward the rising consumer culture of the Gilded Age.

Painted early in America's Centennial year, *The New Bonnet* was the type of scene that contributed to the discussions about American art that so preoccupied art circles.[137] As the country assessed its first hundred years, all aspects of the American experience, including art, were evaluated, with comparisons between old and new, past and present abounding. In art, these conversations had increased dramatically during the previous year, as younger American artists studying in Munich and Paris made a notably strong showing at the National Academy of Design for the first time. Remarking on these new works, Clarence Cook exclaimed, "We are in the midst of an era of revolution."[138] Among artists, there was a widening divide between the young and old guard, with Johnson chief among the "old hands."[139] Homer represented the authentic New America, most expressly represented in *Breezing Up (A Fair Wind)* (fig. 100), which was displayed, as was *The New Bonnet*, at the 1876 exhibition of the National Academy of Design.

Homer labored for three years on the image that would become *Breezing Up*, and his hard work paid off.[140] The

painting was universally applauded at the Academy exhibition, where it was recognized for the complete package it presented, perfectly balancing subject and execution.[141] The scene features two generations of sailors in a boat heading into a strong wind toward the horizon. Originally, the older man had managed the sail while one of his three young companions held the tiller. Homer changed the first detail as he simplified the composition to focus on the vessel cutting through choppy waters. The anchor, a well-known symbol of hope, on the bow and the youth's hand on the tiller reinforce the story's subject, ostensibly the thrill of sailing, as a metaphor for the appropriate course for the country and, perhaps, for its artists. The work's exuberance can be attributed to the boat's strong diagonal position in relation to the picture plane, a reflection of Homer's growing interest in Japanese prints; the energetic descriptive brushwork; and the play of light and shadow across the entire canvas. The vitality conveyed by *Breezing Up* equaled that of America's boosters in the Centenntial year, despite the continued depression caused by the Panic of 1873 and the increasing failure of Reconstruction efforts. In addition, the noticeable freedom of Homer's brush, an aspect of his art in the early 1870s that had drawn criticism (see fig. 96), was now more consistently

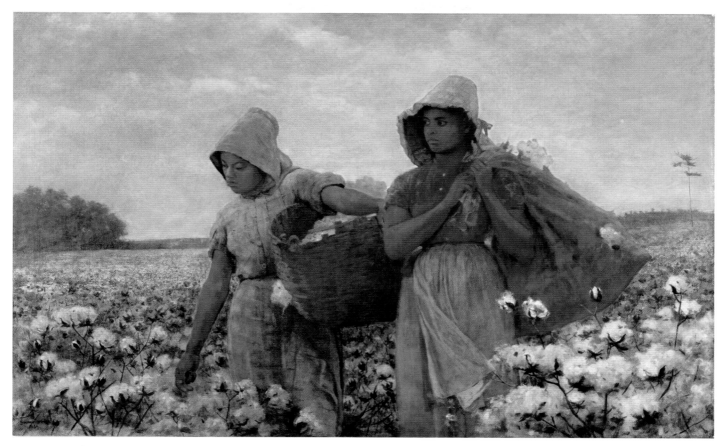

Fig. 101. Winslow Homer. *The Cotton Pickers*, 1876. Oil on canvas, 24⅛ × 38⅛ in. (61.1 × 96.8 cm). Los Angeles County Museum of Art. Acquisition made possible through Museum Trustees: Robert O. Anderson, R. Stanton Avery, B. Gerald Cantor, Edward W. Carter, Justin Dart, Charles E. Ducommun, Camilla Chandler Frost, Julian Ganz Jr., Dr. Armand Hammer, Harry Lenart, Dr. Franklin D. Murphy, Mrs. Joan Palevsky, Richard E. Sherwood, Maynard J. Toll, and Hal B. Wallis M.77.68

praised, a result of the familiarizing effect of new works by both Homer and younger American artists and the greater availability of European paintings, many of which were distinguished by expressive brushwork.

Homer, more than any other American artist, continued to answer the call for national subject matter. In 1875 he began a new series of African American images—chief among them *The Cotton Pickers* (fig. 101) and *Dressing for the Carnival* (fig. 102)—which managed to respond to the new trends in painting while also telling distinctive American stories. The painter F. Hopkinson Smith, reminiscing on the impact of *The Cotton Pickers* at first viewing, declared that the canvas revealed "the whole story of southern slavery."[142] Yet Homer's work contains none of the anecdote or incident that Johnson had included in *Negro Life at the South* seventeen years earlier. The two black women gracefully posed in a sea of cotton could be sisters of Jean-François Millet's French peasants.[143] Further mirroring contemporary French figure painting, Homer renders his figures large and close to the picture plane so that the incline of the women's heads, the expressions on their faces, and the slope of their shoulders silently convey the burden of more than a century of slavery. As a writer for the *Evening Post* said of the scene, "Its deep

meaning stares you in the face."[144] Beautifully painted in freely brushed strokes and muted but rich tones, *The Cotton Pickers* avoided overtly painful reminders of the larger story, past and present. Sadly, the next chapter would be marked by the end of Reconstruction and the encroachment of the sharecropping system that would prolong the exploitation of African American laborers.[145]

In the face of a radically changed country and art world, Homer combined his national themes with a sophisticated understanding of European and Asian aesthetics, as he had in *Breezing Up*. Yet he was disappointed with some of the consequences of this more cosmopolitan outlook. Homer felt these consequences first in his pocketbook. With the exception of *Cotton Pickers*, which was purchased in 1877 by an Englishman whose name is unknown today, few of his oil paintings sold in the years immediately following the Centennial. More important, as he noted in a conversation with Clarence Cook, "People seemed to have lost interest in the progress of artists in New-York,"[146] and within a few years he had distanced himself from that city. Residing in Maine by the mid-1880s, he forged his own new brand of telling stories.

Changes in attitudes about American art occurred at lightening speed over the course of 1876. Increasingly, the rising

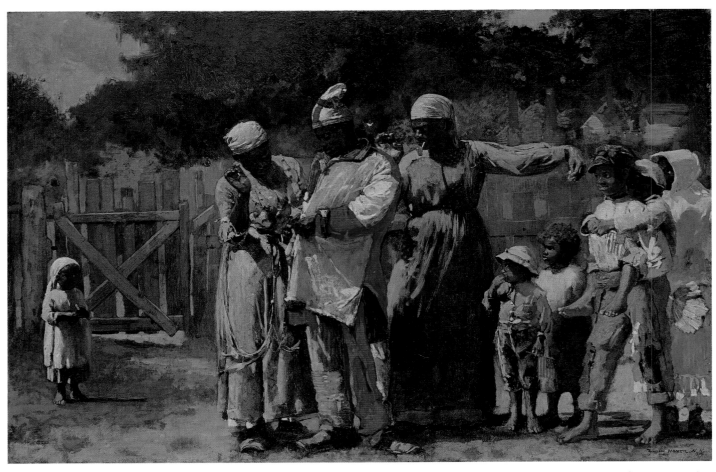

Fig. 102. Winslow Homer. *Dressing for the Carnival*, 1877. Oil on canvas, 20 × 30 in. (50.8 × 76.2 cm). The Metropolitan Museum of Art, New York. Amelia B. Lazarus Fund, 1922 22.220

generation of artists turned its back on the old, rejecting didactic description and anecdote. In 1876 the painter and critic Earl Shinn characterized the shift in his summation of contemporary art's three key concerns: color, lighting, and "its plastic difficulties."[147] Thus Homer, for example, saw his art moved from the camp of the avant-garde to that of the old guard,[148] a change in status that became apparent at the Centennial Exhibition, where his *Snap the Whip* appeared in striking contrast to canvases such as William Merritt Chase's *"Keying Up"—The Court Jester* (fig. 103). The national stories that artists had related during and after the war lost their primacy as citizens acknowledged the failure of Reconstruction and the need for another platform on which to promote America's continued healing and rebuilding. As the nation set its sights on a more global outlook, its artists would do the same, embracing the training, aesthetics, and pictorial content of Europe as they addressed themselves to stories of the next chapter in the American experience.

Fig. 103. William Merritt Chase. *"Keying Up"—The Court Jester*, 1875. Oil on canvas, 39¾ × 25 in. (101 × 63.5 cm). Courtesy of the Pennsylvania Academy of the Fine Arts, Philadelphia. Gift of the Chapellier Galleries 1969.37

1. I am indebted to Stephanie Fox Knappe for her invaluable research assistance and to William H. Gerdts for generous access to his library. For biographical information on Le Clear, see Viele 1962; and Krane et al. 1987, p. 101. On the Tenth Street Studio Building, see Blaugrund 1997.

2. For an excellent interpretation of the painting and the conflicts between photography and painting, see Miller, A. 2006.

3. Holmes 1861, pp. 14–15, noted photography's commonness and its supremacy to painting in delineating material particulars and expression.

4. I am grateful to my colleague Keith F. Davis, Curator of Photography, The Nelson-Atkins Museum of Art, for his analysis of the camera position and angle and the overall studio setup relative to those of photographers of the era. James Sidway's death may have prompted the commission that led to this painting. Viele 1999.

5. *Evening Post* 1864.

6. Walt Whitman, *Specimen Days* (1882), quoted in Conn 2002, p. 17.

7. Blight 2001, p. 31.

8. This was true of prints and illustrations as well as paintings. Brown, J. 2006, p. 50.

9. Trachtenburg 2007, p. 73.

10. As the writer for the *Albion* noted, "Negro life is before you." *Albion* 1859.

11. Hills 2006; and Davis, J. 1998.

12. *New-York Semi-Weekly Tribune* 1859.

13. *Crayon* 1859b, p. 190.

14. *Crayon* 1859b, p. 192.

15. The final and largest canvas (Museum of Art, Rhode Island School of Design) was never completed. For an overview of the maple-sugaring pictures, see Allen 2004. See also Carbone and Hills et al. 1999–2000 and Hills 1972. I thank Kevin Murphy of the Huntington Museum and Library for clarifying some of the details in *Sugaring Off*.

16. Maple sugar is the result of boiling all the water from the sap of sugar-maple trees. The condensed sap then hardened into blocks to be used like cane sugar, although it is significantly sweeter.

17. *Flag of Our Union* 1862.

18. Rose 1999–2000, p. 216; and Allen 2004, p. 34. During his 1862 visit, Johnson had found Fryeburg decidedly provincial and remote; at the same time, he greatly appreciated his rural Maine boyhood, its positive impact on his character, and its role as an emblem of the Union, especially in New England. Eastman Johnson to Jervis McEntee, June 28, 1862, quoted in Carbone and Hills et al. 1999–2000, pp. 243–44.

19. Rose 1999–2000, pp. 216, 219.

20. For a discussion of *The Pension Claim Agent* and its role in the artist's work, see Carbone 1999–2000, pp. 68–72.

21. Chambers 1980–81 remains the primary monograph on the artist. For a more in-depth reading of *Post Office*, see Burns 2004b. On the downward mobility of this period, see Smith-Rosenberg 1985, p. 169.

22. Henkin 2006, pp. 64–67.

23. The issue of courtesy was discussed with regard to both sides of the General Delivery window. See *United States Mail and Post Office Assistant* 1860.

24. Burns 2004b, p. 66.

25. Layton 1861, p. 48.

26. *Crayon* 1861.

27. Jarves 1863, p. 401.

28. Layton 1861, p. 49.

29. The most obvious references to Buffalo include the crumpled newspaper in the left foreground, whose partial title, "Buffalo," is legible, and the handbills posted on the fence that includes the names "Buffalo" and "Ontario."

30. Even so, it was acknowledged that children could not help but absorb the politically charged atmosphere and their parents' views and emotions during the Civil War. See Marten 1998, generally and especially chapter 5.

31. As Yonatan Eyal has written, "Young America" was "not so much a coherent group as a chorus of voices from various quarters collectively calling for policy change and partisan reorientation." In politics, it was associated with a faction of the Democrats as that party broke apart and reorganized in the face of the demise of the Whigs and the rise of the Republicans. Eyal 2007, pp. 10–14.

32. Widmer 1999, p. 185.

33. *Evening Post* 1863.

34. The Irish, who made up 25 percent of New York City's population and represented an equally sizable percentage in Le Clear's native Buffalo, were considered African Americans' greatest competitors for jobs. Although blacks often were hired as scabs, in late 1862 the heavily Irish carpenters union successfully struck for higher wages, indicating the growing strength of unions, which in New York City increased from thirty in 1861 to one hundred thirty-three by early 1863. Bayor and Meagher, eds. 1996, pp. 100–101, 107–8, 197–203; Burrows and Wallace 1999, pp. 854, 884.

35. Both groups made important contributions to the Union effort. The fine dress of the African American man, who listens at a farther remove from the group than the worker does, further suggests the complexity of the two outliers' relative positions in society. Bayor and Meagher, eds. 1996, p. 193; and Foner and Brown 2005, p. 53.

36. Henry T. Tuckerman later identified the man as "a well-known operator in stocks," Tuckerman 1867, p. 441. White ribbons have long been associated with temperance reform. See the entry "Temperance," in Cull, Culbert, and Welch, eds. 2003, p. 393; on temperance's connection to the Republican cause, see Snay 2001, pp. 96–97.

37. On Irish women as fruit sellers, see Bayor and Meagher, eds. 1996, p. 95.

38. I am grateful to Karl Gabosh for clarifying this detail for me. On the financial situation, see Burrows and Wallace 1999, pp. 866–86.

39. On the Democrats' tactics, see Silbey 1977, p. 79. On Lincoln and Young America, see Widmer 1999, p. 219.

40. Le Clear's politics are unknown. As someone from upstate New York who sold this painting to a Union soldier, he might be expected to sympathize with the Republicans. This incredibly rich painting deserves greater study than that allowed by this essay.

41. Conn 2002, pp. 20–23.

42. *New-York Times* 1862.

43. Cikovsky and Kelly et al. 1995–96, p. 24, and the "School of War" chapter generally.

44. Roger Fenton's Crimean War photographs may have provided both a general and a specific influence for Homer's new compositional mode, as may have also been the case with French academic paintings like Jean-Léon Gérôme's *Death of Caesar*. On Fenton, see Baldwin, Daniel, and Greenough et al. 2004–5, pp. 17–24, and photographs in the Library of Congress, Prints and Photographs Division, especially such images as *Zouaves and Soldiers of the Line*, 1855 (LC-USZ62-2451). On the connections with Gérôme, see Cikovsky and Kelly et al. 1995–96, p. 52.

45. Mills 1988–89.

46. Even the horseshoe that falls short of its mark seems less a function of the game being played than a symbol of the pervading sense that the war was "falling short" of expectations. On the boredom of camp life, see Williams, H. 1961–62, pp. 63–68.

47. Stories and songs about farewells to soldiers were more common than visual imagery. On the abundance of these, see Fahs 2001.

48. *Round Table* 1864; and *Round Table* 1865. The first owner of the painting, George Whitney, was also a staunch Union supporter. For an overview of Lambdin's art and life, see Weidner 2003 and Weidner 2002.

49. The formal title of Millais's painting, *A Huguenot, on St. Bartholomew's Day, Refusing to Shield Himself from Danger by Wearing the Roman Catholic Badge*, is often shortened to *A Huguenot*. Lambdin would have been familiar with Millais and other Pre-Raphaelite artists from an 1858 exhibition in Philadelphia for which his father, artist James Reid Lambdin, was partially responsible. See Casteras 1985.

50. David Blight has noted that the memorialization of the Civil War began before the end of the conflict. See Blight 2001, p. 6.

51. The painting was titled *Love and Loyalty* when it appeared at the National Academy annual exhibition in 1865 [NAD Exhibition Record (1861–1900) 1973, vol. 1, p. 537] and was referred to as such by the writers for the *Albion, Leader,* and *New-York Times*. See *Albion* 1865, p. 249; Arnold 1865; and *New-York Times* 1865a, p. 4. It acquired the title *Consecrated, 1861* when it was shown in 1866 at the Pennsylvania Academy of the Fine Arts. See Falk, ed. 1988, p. 119. The painting had acquired its present title by 1867, when it was exhibited at the Exposition Universelle in Paris. See *New-York Times* 1867.

52. At the end of the war, metaphors that used family relationships to explain the sectional conflict abounded in literature and appeared in some popular imagery. See Mitchell, R. 1993, pp. 127–33.

53. By 1863, as it became clear that the war would be prolonged, women's loyalty was frequently questioned from all sides. This metaphorical reading has been enriched by Bell 1996, chapter 4 generally, and pp. 134–39, 293–95.

54. The commentary of the handful of critics who saw the painting at the 1865 National Academy of Design annual exhibition expressed an edgy dissatisfaction that seemed to go beyond general complaints about the artist's overly sentimental approach and may have reflected the then-unspeakable underpinnings of the image, especially given that Lincoln had recently been assassinated. See, for example, *New-York Times* 1865b, p. 4, and Arnold 1865. Interestingly, in the same exhibition Thomas C. Farrer, a close colleague of Lambdin's, displayed a painting called *April, 1861* (unlocated), which also confounded the critics. See Cook 1865.

55. Any interpreter of this painting is indebted, as I am, to Nicolai Cikovsky's essays on its meaning, especially Cikovsky 1988–89. Also informing my work is Wilson 1985.

56. Spencer 1957, p. 226.

57. On soldiers' occupations before the war, see Volo and Volo 2007, p. 182.

58. Between May and October 1865, when Homer likely was painting this canvas, the U.S. Army shrank from 1,000,516 to 210,000 soldiers. On the virtues of farmers with military experience in the face of this concern, see Volo and Volo 2007, pp. 191–92. See also Griffin 2006, pp. 35–38.

59. Cikovsky 1988–89, p. 86, recounts the immediate recognition of these references by the popular press. Also inescapable was the allusion to the famous Old Testament verse about swords being beaten into plough-shares, which foretold peace (Isaiah 2:4).

60. Pentimenti indicate that, after first painting a cradled scythe, Homer intentionally changed it to represent a single-bladed one.

61. On the associations of wheat to the Northern victory, see Rash 1995.

62. Agriculture specifically, and the nation more generally, were just beginning to acculturate to the new opportunities for African Americans to become landowners and free farmers. Foner and Brown 2005, pp. 82, 92.

63. Quoted in Hahn 2003, p. 219.

64. Blight 2001, p. 43. See also Foner and Brown 2005, pp. 78–99.

65. Pohl 1994, pp. 163–64.

66. For Kaufmann's biography see Zucker 1950; and Hoffmann 1977.

67. Northern optimism peaked in 1867, the year this canvas was painted. See Richardson 2001, chapter 1.

68. Honour 1989, pt. 1, p. 238.

69. Stine, Cabak, and Groover 1996, pp. 61, 63–64.

70. Singleton 1991–92, p. 157.

71. *On to Liberty* is not, however, completely devoid of old stereotypes of blacks. Kaufmann included a touch of humor in the older boy pulling the younger ones in their long-tailed shirts. In revealing the shoulders and upper chests of the central trio and the breasts of the woman at the left, he perhaps suggested contemporary ideas about the primitive state of Africans while also being salacious and flaunting his talent for painting the female body.

72. Williamson 1864, p. 587.

73. It was at this time that the western landscape replaced the American Indian as the national symbol of the West. See Truettner 1991, p. 48. See also Foner 1988, pp. 462–63; and Paxson 1928, pp. 286–96.

74. In 1864 Stanley moved to Detroit after a decade of living in various residences on the East Coast and out west. The next year a catastrophic fire at the Smithsonian Institution, where the majority of Stanley's Indian portraits and scenes were on deposit, destroyed more than 150 paintings. The authoritative treatment of Stanley is Schimmel 1983. See also Viola, Crothers, and Hannan 1987–88, pp. 137–44.

75. On Indian gambling, see Schwartz 2006, pp. 136–37. On the image of the Native American as noble savage, see Parry 1974; and Schimmel 1991–92, pp. 162–68.

76. Gaylord Torrence, Fred and Virginia Merrill Curator of American Indian Art, The Nelson-Atkins Museum of Art, most generously explained to me the types of dress, lodges, and objects in the painting. Similar objects,

such as the shirt, leggings, and burden strap, can be found in the John Mix Stanley Collection at the National Museum of the American Indian, Washington, D.C. I thank Dr. Patricia Nietfeld for her assistance in locating them.

77. Stanley's discomfort with U.S. government policy toward American Indians is apparent in paintings such as *Last of Their Race* (1857, Buffalo Bill Historical Center, Cody, Wyoming). See also Hodge, F. W. 1929.

78. Schimmel 1983, pp. 188–89.

79. Blevins 2001, p. 47.

80. Green 2005, p. 192, and Lighter 1997.

81. Both during and, especially, after the Civil War, Northern industry boomed, making the men who controlled it much wealthier. See Nevins 1971, pp. 31–34. On the increase in demand for family portraits, see Davis, J. 1996, p. 52.

82. Guy was English and Gordon was Scottish. For biographical information on Guy, see Carbone et al. 2006, vol. 1, pp. 574–75. For more on Gordon, who was also an early patron and founder of The Metropolitan Museum of Art, see *MMA Bulletin* 1918. For factual information on the painting and its patron, see object curatorial file, The Metropolitan Museum of Art.

83. Davis, J. 1996, pp. 72–73.

84. Plante 1997, p. 36.

85. Boettger 1992, p. 50.

86. Volo and Volo 2007, pp. 219, 258.

87. Plante 1997, pp. 36, 49–51.

88. For a cogent essay on this painting, to which the comments in this essay are indebted, see Carbone et al. 2006, vol. 2, pp. 711–12.

89. The primary biographical source on Mosler is Gilbert 1995–96.

90. Spencer 1957, p. 293. This canvas also must have resonated personally for Mosler, who had recently become a father and was on the verge of moving from Cincinnati to New York when he painted it. Gilbert 1995–96, pp. 34, 36.

91. For an overview of the subject, see Perry 2006–7.

92. Wishy 1968, p. 85.

93. On Homer and the response to *Snap the Whip* and other paintings as quintessentially American, see Conrads 2001–2, pp. 40–47.

94. On the symbolic meanings of suspenders, see Perry 2006–7, p. 29.

95. On nineteenth-century boyhood culture, see Rotundo 1993, chapter 2; for Warner's quote, p. 54.

96. Perry 2006–7, p. 13.

97. *New York Evening Mail* 1869. Despite his popularity, Guy did not always receive positive critical acclaim, primarily because many critics felt his compositions appeared too calculated and his subject choices were considered too middle class. See, for example, *American Art Journal* 1866, p. 244; and Benson, E. 1870.

98. On the development of the story of Goldilocks and its meanings, see Tatar, ed. 2002, pp. 245–46.

99. Bettelheim 1976, p. 218.

100. For a reading of this that focuses on the girl's alienation, see Lubin 1994, chapter 5, especially pp. 238–40.

101. On female suffrage, see Cooper, S. 1870. The painting's alternate title, *Votary of Fashion*, suggests not only a critique of women's consumerism but also a girl studying for her upcoming role in life. See Lubin 1994, pp. 244–47.

102. Lubin 1994, pp. 210, 214–15. See also Brace 1872, 1973.

103. Mitchell, M. 2002, p. 389.

104. Kincaid 1992, p. 275.

105. In the case of *Making the Train*, as Lubin has noted, innocence gone astray may be suggested by the dangling image of Joshua Reynolds's *Little Samuel*, a favorite image in Victorian nurseries. Lubin 1994, pp. 220, 223, 242.

106. For biographical information on Brown, see Hoppin 1989; *New York Herald* 1913; and Standish 1908.

107. Brown's interior conforms closely to the dictates of Charles Eastlake's 1868 book, *Hints on Household Taste* (Eastlake 1868). See Plante 1997, pp. 49–51, 63–65.

108. *New York Evening Mail* 1870.

109. On marriage, see Santley 1871; and *Nation* 1868. Falling birthrates were of such grave concern after the Civil War that in 1868 contraception was outlawed in New York State. See Kleinberg 1999, p. 140.

110. On the essential value of marriage, see Santley 1871, p. 395.

111. Hale 1868, 1972, p. 51. Edwards, Ramirez, and Burgard 1986, p. 22.

112. Lurie 1981, unnumbered plate between pp. 181 and 182.

113. Standish 1908.

114. A short story in the November 1872 issue of *Peterson's Magazine* translated the painted image precisely into prose. Benedict 1872.

115. Smith-Rosenberg 1985, p. 213. Articles on the "Woman Question" and the mysterious nature of women abounded. See, for example, "Woman a Mystery" (Gage 1876). Caricatures of women perceived as against domesticity appeared frequently; see, for example, "Girls of the Period—Club Life," *Harper's Bazaar*, January 30, 1869, illustrated in Burns 2006–7, p. 62.

116. Clinton 1984, p. 20.

117. For a thorough overview of Homer's croquet pictures, see Curry 1984–85.

118. See *Circular* 1866, and *Littell's Living Age* 1864; Vernon 1864; and *American Educational Monthly* 1866. The necessity of flirting for women was outlined in articles such as "The Nemesis of Flirtation" (*Littell's Living Age* 1870); and "Young Womanhood in America" (Glyndon 1870).

119. Burns 2006–7, p. 71.

120. Townley 1870.

121. On general reactions to Homer's images in the 1870s, see Conrads 2001–2; for responses to his work in 1870, see especially pp. 27–34.

122. Cook 1870.

123. On the response to Homer as original and American, see Conrads 2001–2, pp. 29 and 30–34, passim.

124. The scholarship on Eakins is voluminous. For the discussion of this painting I am especially indebted to Johns 1983; Cooper, H. et al. 1996–97; Simpson 2001–2a; and Leja 2004, pp. 59–92, 256–65.

125. Leja 2004, pp. 61–63, 257.

126. Johns 1983, pp. 26, 39.

127. Simpson 2001–2a, p. 29. Simpson's observation relates broadly to Eakins's work in the 1870s.

128. The sole monographic study of Perry remains Gibbs 1981.

129. *Commercial Advertiser* 1871; *Appleton's Journal* 1872, p. 579.

130. Nevins 1971, p. 154; and Foner 1988, p. 461. See also Brown, D., and Nissenbaum 1999, pp. 1–3.

131. See, for example, *New York Evening Telegram* 1872; and *Independent* 1872.

132. Hesselman 1998, pp. 298–301. My further interpretation of the painting relies on Hesselman's.

133. Foner 1988, chapter 10, especially pp. 460–61 and 488–510.

134. Carbone 1999–2000, pp. 78–105; and Carbone 1999.

135. The hat being shown is of the most recent fashion at the time. For descriptions of hats of the day, see Severa 1995, pp. 311–13; and *Chicago Daily News* 1876.

136. Cook 1876a. The narrative was outlined in, among others, *New York Herald* 1876; and *New-York Times* 1876b. See also Spassky et al. 1985, p. 229.

137. On American art at the Centennial and the discussions surrounding it, see Orcutt 2005.

138. Cook 1875.

139. For Johnson's status among artists, see, for example, *New-York Times* 1876a, p. 6.

140. The development of *Breezing Up* is recounted by Nicolai Cikovsky Jr. in Kelly et al. 1996, pp. 315–16. See also Cikovsky and Kelly et al. 1995–96, pp. 143–44.

141. For a comprehensive survey of the responses to *Breezing Up*, see Conrads 2001–2, pp. 95–99.

142. F. Hopkinson Smith, 1894, quoted in Cikovsky and Kelly et al. 1995–96, p. 149.

143. In the context of discussing Millet in the early 1870s, Homer's friend the critic Eugene Benson likened American blacks to French peasants. Benson, E. 1872. Susanna Gold's more didactic reading of *The Cotton Pickers* includes the assertion that the figures are of mixed race. See Gold 2002.

144. *Evening Post* 1877.

145. On the issue of labor, wages, and land for freed blacks in the early years of tenancy, see Ferrell 2003, pp. 70–73.

146. Cook 1876b.

147. Shinn 1876, p. 193.

148. Conrads 2001–2, pp. 104–5.

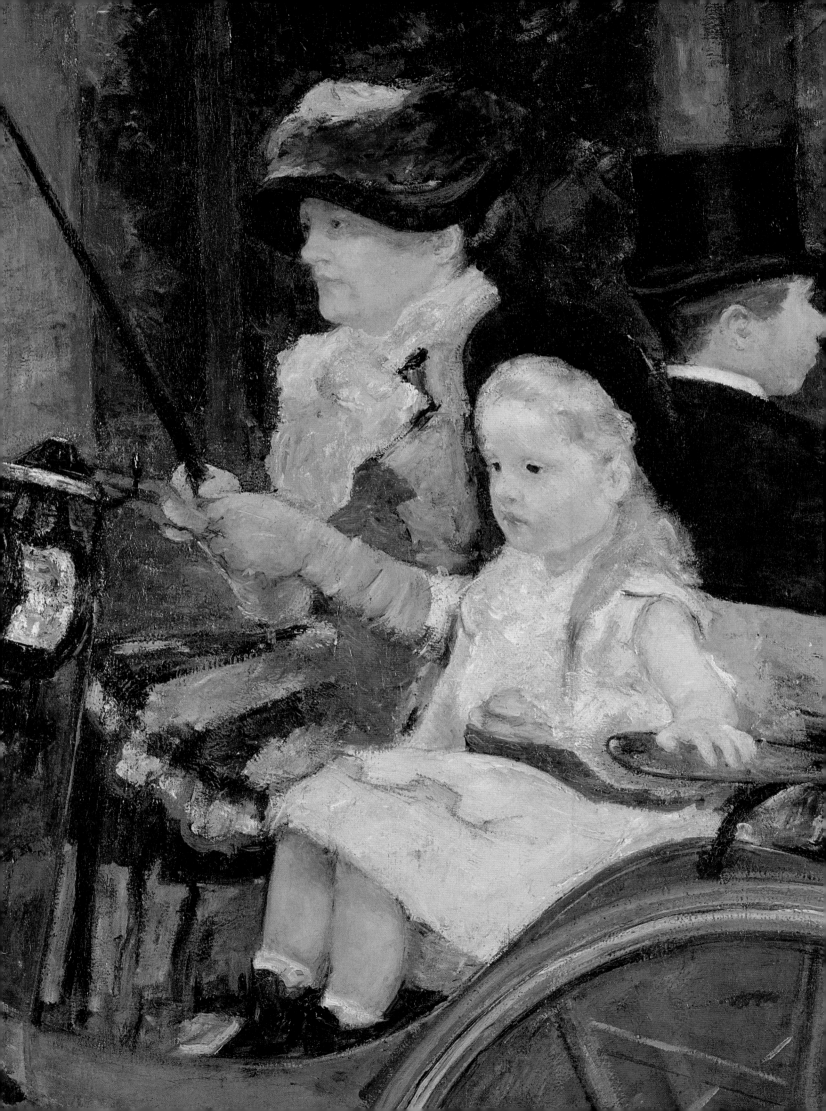

Cosmopolitan and Candid Stories, 1877–1915

H. Barbara Weinberg

My God, I'd rather go to Europe than go to heaven," William Merritt Chase is said to have exclaimed to a group of Saint Louis businessmen who in 1872 offered to finance his studies abroad.[1] Chase epitomizes the cosmopolitan American artists whose styles were formed by instruction in European schools and by association with foreign colleagues during the late nineteenth century. From his lessons in Munich's Academy of Fine Arts, his travels, and his friendship with the German realist Wilhelm Leibl, Chase acquired a fluent technique, an appreciation of deep, saturated colors, and a command of dramatic chiaroscuro (see fig. 103). He returned to New York in 1878 to launch his career as a painter and as a teacher at the new Art Students League, and to establish himself in the Tenth Street Studio Building, America's artistic citadel.[2]

To Chase and his American contemporaries, going abroad and gathering objects there were interdependent, equally appealing activities. Emulating their European mentors, they displayed souvenirs of travel and their own pictures in their studios, where they hosted exhibitions, receptions, and private viewings for critics, potential patrons, and other guests. Chase filled his quarters on Tenth Street with bric-a-brac, paintings, and furniture that recalled the Old World's accumulated artistic achievements and announced his own ties to them.[3] He also portrayed his studio in compositions that invited appreciation of his splendid professional surroundings by those who could not visit and provided mementos for collectors who could.

In Chase's *Tenth Street Studio* (fig. 104), one of the earliest and most ambitious of many such canvases, a fashionably dressed young woman lounges in a blue armchair, casually studying a print or drawing and chatting with the artist, who is almost lost in the shadows at the right. Although Chase shows himself holding his palette, as if caught in a pause from work, he leaves the narrative and the young woman's role vague. She could be a model for a portrait, a patron, or merely a friend.[4] The artist and his lovely companion are engulfed by opulent decorations—an oriental rug; a carved cabinet crammed with props and objets d'art; and rich silks, tapestries, paintings, plates, and prints displayed on the background wall. Chase enlivens the scene by placing the young woman off center, enticing the viewer's eye with her bright white gown. Using the napping dog as a fulcrum, he creates a droll balance between the figure's slender vertical shape and the broad framed landscape at the left.

By comparison with spartan midcentury workshops like the one described by William Sidney Mount in *The Painter's Triumph* of 1838 (fig. 25), Chase's luxurious studio was a showcase for his refinement and his association with artistic tradition, a place for aesthetic display and contemplation, a retreat from urban confusion, and a paradigm of his period's internationalist taste. In such an elegant setting, he could be a far more subtle "image pedlar" than the protagonist in Francis William Edmonds's 1844 scene (see fig. 26). Chase's portrayal of his studio is also typical of his generation's preference for newly sophisticated subjects and variously more subtle, candid, and euphemistic descriptions of everyday life. This essay considers how such paintings reflect some of the epochal changes, and the new artistic imperatives that developed alongside them, in late nineteenth- and early twentieth-century America.

Between the Centennial and World War I, the United States was thrust into the modern era by immense industrial and corporate expansion, a huge increase in wealth, the emergence of easier and faster transportation, and unprecedented participation in international political, economic, scientific, commercial, and social affairs. Other momentous developments included the growth of cities in response to an upsurge in immigration and domestic migrations from rural areas; the expansion of the railroad to 259,000 miles of track by 1900 and 391,000 miles of track by 1915; and the introduction of automobiles, airplanes, electric lightbulbs, telephones, phonographs, and moving pictures. Noting the nation's self-confidence and sophistication as well as its pessimism and

Fig. 104. William Merritt Chase. *The Tenth Street Studio*, 1880. Oil on canvas, 40⅜ × 52½ in. (102.6 × 133.4 cm). Saint Louis Art Museum. Bequest of Albert Blair 48:1933

anxiety during this complex age, historians have chronicled the "incorporation" and "search for order" of this "land of contrasts" as it underwent "transformations in everyday life."[5]

Having long endeavored to distinguish itself from Europe, the United States—particularly the industrial Northeast—now aspired to rival Europe, at least as far as amassing objects of high culture was concerned. Collectors came to believe that they were entitled, even obliged, to gather the best that the world had to offer. Equipped with ample financial resources and assisted by luxurious steamers that by the 1880s had shortened an ocean crossing to six or seven days, many of them visited Europe, especially Paris, which had become the world's artistic epicenter after 1850. They acquired works of fine and decorative arts from established collections and contemporary artists' studios and shipped them home to fill grand new houses designed in assorted revival styles.[6] Some collectors also relied on enterprising art dealers and advisers who prospered in New York and other cities. By 1876, Henry James could rightfully boast: "One takes . . . an acute satisfaction in seeing America stretch out her long arm and rake

in, across the green cloth of the wide Atlantic, the highest prizes of the game of civilization."[7]

In order to serve potential patrons' new cosmopolitan taste and to compete with their foreign rivals, American artists of the late nineteenth century needed to expand their subjects and update their styles. Unlike their antebellum predecessors, who made the Grand Tour and absorbed lessons from antiquity and the old masters but eschewed European training, they traveled abroad often, mingled with foreign artists, and actively sought instruction. During this period, they weaned themselves from British conventions; recovered from a brief midcentury flirtation with Düsseldorf (the artists who worked there during the 1840s and 1850s included George Caleb Bingham, Eastman Johnson, and Richard Caton Woodville); occasionally studied in Munich; and developed a serious crush on France, crowding into Parisian academies and private ateliers, spending summers in rural art colonies, and participating in international exhibitions. Some lived as expatriates; others returned home to adapt new subjects and styles to the American scene.

The intense enthusiasm for European—particularly French—artistic standards and advantages altered cultural life back in the United States, inspiring the formation of the Society of American Artists in 1877 and other professional organizations. Art schools were founded or restructured in emulation of Parisian models, and purpose-built artists' quarters such as New York's Tenth Street Studio Building flourished. Another outcome of this enthusiasm was the burgeoning of a newly serious and prestigious art press.[8] Discernible in American art by the 1870s, cosmopolitanism—especially as influenced by France—peaked during the 1880s. As Henry James noted in 1887: "It sounds like a paradox, but it is a very simple truth, that when to-day we look for 'American art' we find it mainly in Paris. When we find it out of Paris, we at least find a great deal of Paris in it."[9] So French were the subjects and styles represented on the walls of the American display at the 1889 Paris Exposition Universelle that only the words *États-Unis* posted over the entrance announced the exhibitors' nationality.

Generalizations about American painting between the Centennial and World War I are abetted by the fact that artists regularly measured their accomplishments at the world's fairs so popular at the time. Three of the most notable—the 1889 and 1900 Paris Expositions Universelles and the 1893 World's Columbian Exposition, held in Chicago—have been re-created by scholars in the last twenty years.[10] These displays illuminate the effect of foreign influence, not only on the subjects chosen by American narrative painters, but also on the painters' approaches to recounting them. By the 1840s, European academics such as Paul Delaroche and realists such as Gustave Courbet had renounced heroic and didactic texts in favor of looking at the past and recording the present without invention or exaggeration. The French Impressionists expanded this preference for journalistic description of modern life, focusing on prosaic experiences and transcribing them quickly in informal compositions with rapid brushwork and casual finish. Emulating these antinarrative impulses, American painters tended to abstain from instructing viewers, stirring their emotions, or telling tales with a clear beginning, middle, and end. They offered instead candid, uninflected, often vague stories from a broad range of sources, especially everyday life, and allowed viewers considerable latitude in interpreting them.

During the 1890s, which were marked by great economic uncertainty and labor unrest as well as a consolidation of federal power, there emerged an increased focus on American identity and a well-placed fear that the national artistic voice was being muted or lost entirely. In response, painters—especially the American Impressionists, who by then constituted the artistic mainstream—enlisted their foreign methods to express national ideals. The ascendancy of American

Impressionism notwithstanding, some American academics such as William McGregor Paxton and George de Forest Brush continued to thrive, even into the twentieth century, though with diminishing relevance and vigor.

About 1900, a group of New York realists known as the Ashcan School distanced themselves from their Impressionist and academic colleagues. Their leader and mentor, Robert Henri, had studied in Paris, but the others—like most painters of their generation—had gained an understanding of French artistic principles without leaving home. While the realists disdained cosmopolitanism and gentility, they made no revolutionary break from the status quo in either their choice of stories to tell or their approach to telling them. It was also between about 1900 and World War I that some American painters were attracted to European modernism. Absorbing ideas from the Post-Impressionists and Nabis in Paris and the German Expressionists in Berlin, painters such as Marsden Hartley, Arthur Dove, and Max Weber repudiated narrative to focus on formal concerns. Having been inspired by the work of European modernists in New York's landmark Armory Show in early 1913, even the Ashcan realist John Sloan began to favor formal experiment over storytelling. After 1910, other leading realists also modified the interest in narrative on which they had built their reputations and attended more to modernist issues.

Cosmopolitanism, Candor, and Mere Compositions

After the Civil War, many Americans made themselves at home in Europe as expatriates, long-term residents, or frequent visitors. Canvases from the late 1870s by three American expatriates—Henry Bacon, John Singer Sargent, and James McNeill Whistler—embody the cosmopolitan subjects, varied styles, and preference for candor and narrative ambiguity that marked late nineteenth-century art.

Having served in the Civil War and exhausted Boston's limited resources for art instruction, Bacon went to Paris to study in April 1864, in advance of the great wave of Americans who would soon flock there.[11] Enrolled six months later as the second American in Alexandre Cabanel's atelier at the recently reorganized École des Beaux-Arts, the French government school, he mastered anatomy, physiognomy, and other academic standards and technical skills. He also worked for two years under the painter Pierre-Édouard Frère at nearby Écouen before establishing his headquarters in Paris, where he painted, chronicled the cultural scene, and showed regularly in the Salons.

Bacon made the first of his several trips back to the United States in 1875 and his second the following year—possibly in Sargent's company—to see one of his paintings displayed in Philadelphia's Centennial International Exhibition.[12] Although

Fig. 105. James-Jacques-Joseph Tissot. *The Gallery of HMS Calcutta (Portsmouth)*, ca. 1876. Oil on canvas, 27 × 36⅛ in. (68.6 × 91.8 cm). Tate Gallery, London N04847

he would also paint historical and orientalist scenes, his most ingratiating works are fourteen known paintings prompted by his Atlantic crossings. They portray shipboard life and reflect Americans' increasing familiarity with modern tourism, which was abetted by regular transatlantic routes as well as faster, more comfortable vessels and lower fares. Precedents for Bacon's shipboard scenes were magazine illustrations by Whistler and Winslow Homer and paintings by the popular French artist James-Jacques-Joseph Tissot, such as *The Gallery of HMS Calcutta (Portsmouth)* (fig. 105).[13] Bacon sent to the 1877 Salon *On the Open Sea—The Transatlantic Steamship "Péreire"* (fig. 106), which shows fifteen passengers—along

with a crewman, at right, who carries a telescope—on a luxurious French mail steamer.[14] Attired in the deck wear recommended for sensible travelers, the passengers while away time by reading, napping, socializing, playing ring toss, or, like the recumbent woman at the left holding a lemon, trying to ward off seasickness.[15]

Bacon depicted the *Péreire* again in *First Sight of Land* (fig. 107), moving the mast from the left to the composition's center, where it proclaims that, even after the triumph of steam, ocean liners still used auxiliary sails to take advantage of good winds and reduce fuel consumption.[16] At the base of the mast stands a young brunette woman whose prominence in the scene and lack of visible companionship signal the fact that women ventured abroad in greater numbers during the 1870s than ever before. "The transatlantic experience . . . became a much sought-after means of finishing off a young lady's education to prepare her for marriage," as the scholar Judy Bullington has observed.[17] How-to books such as May Alcott Nieriker's *Studying Art Abroad, and How to Do It Cheaply* (1879) offered tips, and etiquette experts advised on demeanor aboard ship and in foreign settings.[18] American women's adventures and their encounters, as New World innocents with Old World social conventions, inspired contemporary fiction—including Henry James's *Daisy Miller* (1878) and William Dean Howells's *Lady of the Aroostook* (1879)—and social commentary by writers such as Mayo W. Hazeltine.[19]

The protagonist in *First Sight of Land*, garbed in a bright blue dress and beige overcoat, has cast aside her tartan lap robe and book and risen from her steamer chair to join two fellow passengers—mere staffage figures—in catching sight

Fig. 106. Henry Bacon. *On the Open Sea—The Transatlantic Steamship "Péreire,"* 1877. Oil on canvas, 19¾ × 29⅛ in. (50.2 × 74 cm). Museum of Fine Arts, Boston. Gift of Mrs. Edward Livingston Davis 13.1692

Fig. 107. Henry Bacon. *First Sight of Land*, 1877. Oil on canvas, 28¾ × 19⅞ in. (73 × 50.5 cm). In the collection of Art and Elaine Baur

Fig. 108. Julius LeBlanc Stewart. *On the Yacht "Namouna," Venice*, 1890. Oil on canvas, 56 × 77 in. (142.2 × 195.6 cm). Wadsworth Atheneum Museum of Art, Hartford, Connecticut. The Ella Gallup Sumner and Mary Catlin Sumner Collection Fund 1965.32

of the shore. Her large scale, solid form, and proximity to the picture plane recall Cabanel's society portraits. Her lost-profile pose, elegant stance, and simple yet detailed costume echo those of her counterpart in Tissot's *L'Escalier* (1869, Colección Perez Simón, Mexico), as the scholar Sara Caldwell Junkin has observed.[20] Like Cabanel, Tissot, and other academics, Bacon specialized in genteel subjects and espoused a refined finish, meticulous anecdotal detail, and, when appropriate, subtle outdoor light.

Bacon also manifested in his works the new narrative imprecision that characterized academic painting by the 1840s. The critic Richard Whiteing noted in 1882 that Bacon's views of shipboard recreation, flirtations, departures and arrivals, and even a burial at sea were a series of vignettes, not a continuous chronicle: "By arranging his works in a certain order, we might have a perfect pictorial history of the ocean-trip from the 'Bidding Good-by' on the one side to the 'Land! land!' on the other."[21] Bacon also illustrated each event only in part, merely implying his characters' responses and leaving the story open ended. For example, because the book that the woman discards in *First Sight of Land* is a salmon-covered paperback associated with French publishers such as Hachette and likely purchased in Paris, her gesture hints that she is returning to America. Her excitement, however, suggests her arrival in Europe. A midcentury foil to Bacon's account is Richard Caton Woodville's *War News from Mexico* of 1848 (fig. 46), in which artfully stage-managed, stereotypical characters, who are also involved in a story tied to reading, respond to a revelation with theatrical gestures, and the painting's narrative is declaimed, not whispered.

On the Open Sea—The Transatlantic Steamship "Péreire" and *On the Yacht "Namouna," Venice* (fig. 108), by Bacon's equally academic compatriot Julius LeBlanc Stewart, exploit

oblique views and dispersed narrative focus. The French Impressionists had amplified this new pictorial candor beginning in the mid-1860s. Their casually constructed, rapidly executed paintings, featuring loose brushwork and broken color, encode more fully than those of their academic colleagues the era's dynamic spirit as the pace of life accelerated, experience seemed fragmented, technologies emerged faster than people could comprehend them, and bewildering change defied synopsis. Sargent's *In the Luxembourg Gardens* (fig. 109) reveals the peripatetic young American's sympathy for the Impressionists' formal and expressive agenda, which he readily embraced in the late 1870s, after having also learned Diego Velázquez's fluent style from his teacher, the fashionable Parisian portraitist Carolus-Duran, and having become friendly with Claude Monet.

As cities were the epoch's most distinctive phenomena, the urban scene was the quintessential modern subject and an ideal arena for Impressionist experiments. Moreover, Paris, which had been transformed during the Second Empire (1852–70), was a consummate modern city and the world's cultural capital.[22] Its parks, including the Luxembourg Gardens, had been built or reconfigured in response to urban growth and overcrowding, thus epitomizing the French capital's new energy. In his freely rendered, asymmetrical, seemingly accidental view of the great basin at the heart of this popular promenade, Sargent features a gravel pathway that suggests the dominance of stone and concrete over nature in French parks.[23] The surrounding stone railings, statuary, and urns are evidence of the radical 1866 redesign, which elaborated the park's architecture while preserving it as the Left Bank's most extensive open green space.[24] Sargent captures the Parisian twilight with an extraordinary opalescent, grayed-lavender palette, recording the dusky sky's fleeting glow and, through the park visitors' attire and unhurried pace, signaling summer's endless evenings. He adds brilliant touches of color in the mass of crimson and pink flowers to the left and in the moon's reflection off the pool to the right, on which children sail toy boats.

By presenting a wedge of open pavement in the right foreground and banishing distracting details, Sargent focuses the viewer's attention on two young urbanites who stroll toward the left. Accompanied by a stylish young woman, the dark-suited man is the consummate flâneur, the impartial Baudelaireian observer of the modern city, whose cigarette confirms his sophistication.[25] Devoted to seeing and being seen, this fashionable couple ignores all observers and resists association with any narrative. As the Sargent scholar Elaine Kilmurray has noted: "In the disconnectedness of the experience it portrays, it is a modern picture, beautiful and purposeless. There is no implied narrative: the couple drift[s] through the scene, the children play in their own world and

Fig. 109. John Singer Sargent. *In the Luxembourg Gardens*, 1879. Oil on canvas, 25⅞ × 36⅜ in. (65.7 × 92.4 cm). Philadelphia Museum of Art. John G. Johnson Collection, 1917 Cat. 1080

one man sits isolated on a bench while another is absorbed in his newspaper."[26] John Lewis Krimmel's *Fourth of July in Centre Square* (fig. 19), a stagelike, painstakingly literal Philadelphia park scene from about 1812, illuminates by contrast the stylistic and expressive candor as well as the cosmopolitanism and narrative ambiguity of Sargent's cityscape.

Concurrent with Bacon's records of modern life in an academic style and Sargent's Impressionist efforts were the experiments of Whistler, who occupies a unique and influential place in the late nineteenth-century artistic firmament. In Paris in the late 1850s, Whistler had ignored Charles Gleyre's academic lessons in favor of emulating Courbet's realism. Settling in London in 1859, he created a highly original amalgam of numerous influences, including, among others, the decorative style of his friend Henri Fantin-Latour, the allusive paintings of Albert Moore and the Pre-Raphaelites, the painterly tradition of Velázquez, and the formal conventions of Japanese prints. By 1865, Whistler was distilling rather than depicting the visible world, painting cityscapes, landscapes, and marine scenes that responded to aesthetic rather than descriptive dictates, going around Impressionism—which

was then just developing—to arrive at a distinctive version of Post-Impressionism almost fifteen years earlier than the mature styles of Paul Cézanne or Georges Seurat. By the early 1870s, he was also producing figural works, including the archetypal *Arrangement in Grey and Black, No. 1: The Artist's Mother* (1871, Musée d'Orsay, Paris), that stress abstract values over visible facts.

Between about 1872 and 1877, Whistler painted seven known oils featuring Cremorne Gardens, a popular London amusement park just a few blocks from his house on Lindsey Row (now Cheyne Walk) in Chelsea.[27] Open to the public from 1845 to 1877 and expanded from twelve to sixteen acres in 1857, the park attracted festive crowds, which by the 1870s were predominantly working class. Entertainments included music, dancing, colored-light shows, and spectacular fireworks that could be viewed on foot or from a boat on the Thames. *Cremorne Gardens, No. 2* (fig. 110), the second canvas in the series, presents what the art critic Denys Sutton called "a sort of *fête galante*, in contemporary terms,"[28] evocative of Jean-Antoine Watteau's *Assembly in a Park* (fig. 111). Édouard Manet, Pierre-Auguste Renoir, and other painters associated

with Impressionism, along with Tissot, would also update rococo subjects by portraying the leisurely, pleasure-seeking mood of outdoor entertainments at the Tuileries Gardens, the Moulin de la Galette, and other Parisian venues.[29] Whistler's London scene differs from theirs in being allusive and proto-abstract, based more on a desire to create a harmonious world on the canvas than to reconstruct the mundane world of appearances.

Working with what he called his "sauce"—pigments diluted to the consistency of thin washes—Whistler suggests a group of brilliantly colored, attenuated figures in *Cremorne Gardens, No. 2*.[30] The curator David Park Curry acknowledged that by the 1860s, the site had "acquired a reputation as the territory of the demimonde." He noted, however, that Whistler's characters "are difficult or impossible to make out," reflecting the artist's wish, later expressed in his lecture titled *Ten O'Clock* (1885), to ignore local or personal interests and offer merely "a glimpse of the anonymity of modern life."[31] Most art historians agree that Whistler's ghostlike forms communicate little more than the ephemeral charm of an evening's gathering in the veiled atmosphere of an indistinct setting. Richard Dorment, however, presented an exceptional reading of *Cremorne Gardens, No. 2*, highlighting the site's association with prostitution in the 1870s and proposing the following narrative:

> In the faceless group of a man and four women [standing] at the centre of the picture, Whistler uses body language to depict an encounter between four prostitutes and a potential customer. . . . Meanwhile, an unescorted woman just to [the] left turns back to eye this fellow, a movement which invites him to turn away from the women he has just approached. A fourth woman with her crimson fan open in a gesture which signifies her availability moves in from the right. Whether these women circle their prey like so many vultures, or whether the male is simply confronted with a sexual *embarras de richesse* Whistler leaves . . . to the viewer to decide.[32]

Even if the figures in *Cremorne Gardens, No. 2* enact an encounter between prostitutes and a client, Whistler's expressive devices respond more to aesthetic demands than to anecdote. Dorment conceded: "In all his depictions of Cremorne, Whistler emphasizes the mystery of the Gardens. . . . In his painting technique, with thin glazes of paint and flecks of pigment suggesting fairy lights or sparks of fire, it is as though Whistler is trying to preserve the mood of Cremorne by not attempting to describe it too literally."[33]

The fall 1877 exhibition at the Grosvenor Gallery of Whistler's most radical Cremorne canvas, *Nocturne in Black and Gold: The Falling Rocket* (1875, Detroit Institute of Arts), provoked the scorn of the aging critic John Ruskin. In the

retaliatory libel suit that Whistler brought against Ruskin the following year, "the concept of abstract painting was the real defendant," as Curry has observed.[34] Winning only a Pyrrhic victory—the award of one farthing in damages—and suffering financial setbacks, Whistler fled to Venice in 1879. There, and later back in London, he attracted to his orbit many Americans who knew of his work, the lawsuit, and its ensuing uproar.[35] For his contemporaries, Whistler was a model of creative independence, the inventor of a new visual language compounded from diverse stylistic vocabularies, and an exemplar of painting softly, subtly, and in response to perceived pictorial necessities, not natural appearances. Whereas academic artists detached their works from serious historical, mythological, religious, or propagandistic narrative, and Impressionists painted candid scenes unburdened by explicit stories, Whistler rejected narrative almost entirely. Thus, as he himself realized, he was obliged to give to his paintings abstract titles derived from their predominant colors or from music—compositions, arrangements, nocturnes, notes—rather than label them with reference to particular sites, individuals, or anecdotes.

Fig. 110. James McNeill
Whistler. *Cremorne Gardens,
No. 2*, 1872–77. Oil on canvas,
27 × 53⅛ in. (68.6 × 134.9 cm).
The Metropolitan Museum of
Art, New York. John Stewart
Kennedy Fund, 1912 12.32

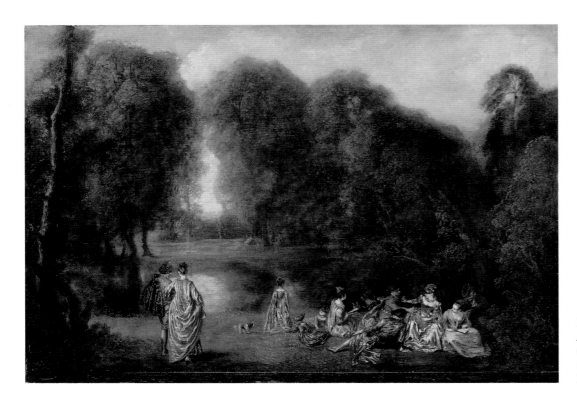

Fig. 111. Jean-Antoine Watteau.
Assembly in a Park, ca. 1716–17.
Oil on wood, 12⅝ × 18⅛ in.
(32 × 46 cm). Musée du Louvre,
Paris MI 1124

Fig. 112. John Singer Sargent. *A Street in Venice*, ca. 1880–82. Oil on canvas, 29⅝ × 20⅝ in. (75.1 × 52.4 cm). Sterling and Francine Clark Art Institute, Williamstown, Massachusetts 1955.575

Fig. 113. John Singer Sargent. *An Interior in Venice*, 1899. Oil on canvas, 26 × 32⅞ in. (66 × 83.5 cm). Royal Academy of Arts, London 03/1387

Traveling and Living Abroad

As Paris succeeded London as the principal magnet for aspiring American art students during this period, so Venice supplanted Rome and Florence as their favorite haunt in Italy.[36] Venice's exoticism, isolation from modern developments, and unhurried pace appealed to artists—and others—seeking escape from contemporary hurly-burly. Its watery byways, enhanced by reflections on textured architecture, fostered painters' experiments in capturing evanescent color and light, concerns that replaced the wish to study the art of antiquity and the old masters, which had earlier drawn them to Rome.

Born in Florence, Sargent had led a nomadic life since childhood. In 1879–80, having completed his studies in Paris, he visited Madrid to work in the Prado, nourished his long-standing interest in the picturesque in Andalusia and Morocco, and journeyed to Holland before moving on to Venice. There from September 1880 to January or February 1881 and again in August 1882, he captured the city's cool,

murky tonalities and the peculiar perspectives of its secluded courtyards and narrow *calli* (lanes) in watercolors and oils, including *A Street in Venice* (fig. 112). Sargent's modern emphasis on mundane experience and casual vision is palpable in a comparison of his painting with John Singleton Copley's 1775 portrait of Mr. and Mrs. Ralph Izard (fig. 13). That expansive double likeness, which commemorated the Izards' sojourn in Rome, proclaims the Charleston couple's wealth, intellect, and good taste with elegant attire, handsome furnishings, antique artifacts, and a distant view of the Colosseum. By contrast, Sargent quickly records on a narrow vertical canvas two members of the Venetian demimonde fleetingly encountered outside a wine shop in a dim, shabby side street. The gulf of wealth, class, and presumed virtue between the Izards and Sargent's pair is suggested by the differences in their demeanor. While Izard's demure wife trains her attention on him, the woman in Sargent's scene turns away from her

Fig. 114. Mary Cassatt. *Little Girl in a Blue Armchair*, 1878. Oil on canvas, 35½ × 51⅛ in. (89.5 × 129.8 cm). National Gallery of Art, Washington, D.C. Collection of Mr. and Mrs. Paul Mellon 1983.1.18

companion to meet a passing stranger's gaze. Copley describes an entire Grand Tour, attending equally to every detail. By contrast, Sargent—perhaps influenced by photography—acknowledges the dispersed focus of instantaneous vision, blurring the confining plaster walls and terminating the vista in a sunlit slice of wall as opposed to a major monument.

The quintessential cosmopolite, Sargent moved his headquarters from Paris to London in September 1886. He continued to travel widely, enjoying the hospitality of a large circle of urbane friends in Europe and America, and he made many paintings that embody his era's internationalist spirit. His *Interior in Venice* (fig. 113) reflects the continuing infatuation of late nineteenth-century Americans with the picturesque and evocative city. Now addressing himself to the most refined end of Venice's social spectrum, Sargent invites the viewer to visit two generations of the Curtis family in their grand residence.[37] These Boston expatriates—prominent members of Venice's Anglo-American community, as well as Sargent's distant cousins, dear friends, and frequent hosts—are shown taking tea in their apartments in the fifteenth-century Palazzo Barbaro, where they had lived since 1881. The dark, atmospheric *salone*, the palazzo's principal room, is

filled with ornate stuccowork, immense Baroque canvases in ornate frames, Venetian glass chandeliers, and handsome furniture. Dazzling sunlight from the unseen windows overlooking the Grand Canal flickers over the furnishings and the four figures: Ralph Wormeley Curtis, Sargent's classmate in Carolus-Duran's studio, perches on the edge of a gilded rococo console table while his wife pours tea; seventy-three-year-old Daniel Sargent Curtis and his wife sit in the right foreground.

By comparison with an earlier, more traditional conversation piece (a group portrait with genre or narrative elements) such as Seymour Joseph Guy's animated *Contest for the Bouquet: The Family of Robert Gordon in Their New York Dining-Room* from 1866 (fig. 86), which also portrays a tasteful, well-furnished home, *An Interior in Venice* appears experimental. Sargent captures the elegantly attired figures and their splendid setting with such vivacious brushwork that Whistler was moved to dismiss "the little picture" as "smudge everywhere."[38] Only the imposing Mrs. Curtis senior, whom Sargent affectionately called the "Dogaressa," responds to his presence. In fact, she was so offended by Sargent's frank description of her age and her small size in the vast space that

she declined his gift of the canvas, which he instead presented to the Royal Academy of Arts as his diploma piece. It is more than coincidental that Sargent's scene resembles a painted counterpart of a novel by Henry James, who stayed at the Palazzo Barbaro in 1899 and re-created it as the Palazzo Leporelli in his novel *The Wings of the Dove* (1902).[39] The Palazzo Barbaro also inspired Isabella Stewart Gardner's Fenway Court (1899–1903), in which she imported Venice's charm to Boston.

Like Bacon, Sargent, and Whistler, Mary Cassatt was a leading expatriate and an archetypal late nineteenth-century American cosmopolite. Having traveled through Europe as a child and studied art in Philadelphia, she continued her instruction in Paris in 1865, working privately with several teachers, including Frère and Thomas Couture, and receiving private criticism from the leading academic master, Jean-Léon Gérôme, Thomas Eakins's principal teacher. After journeying home during the Franco-Prussian War, she settled in 1874 in Paris, where her parents and older sister, Lydia, joined her three years later. Inspired by Edgar Degas, who admired her 1877 Salon contribution, and other members of the

Impressionist circle, Cassatt embraced their style and became the only American to show with them, doing so four times between 1879 and 1886.

Little Girl in a Blue Armchair (fig. 114) exemplifies Cassatt's commitment to Impressionist principles. With Degas's advice and his help with the background, she represents a room illuminated by a series of French doors and crammed with haphazardly arranged upholstered furniture, all of which she crops with the edges of the canvas.[40] The daughter of friends of Degas sprawls, bored or exhausted, on one of the over-stuffed chairs, with her arms akimbo, her skirt drawn up, and her bloomers showing, while Cassatt's Brussels griffon rests on a chair at the left. This unusual composition repudiates the decorum of traditional children's portraits, including English pictures of innocent girls with faithful little dogs such as Sir Joshua Reynolds's charming *Miss Jane Bowles* (fig. 115) or George Romney's *Marianne Holbech* (ca. 1781–82, Philadelphia Museum of Art). Comparison with a contemporary image—the Belgian painter Alfred Jean André Cluysenaar's *Vocation (Portrait of André Cluysenaar, Son of the Painter)* (fig. 116)—underscores Cassatt's transgressive

Fig. 115. Sir Joshua Reynolds. *Miss Jane Bowles*, ca. 1775. Oil on canvas, 35¾ × 27⅞ in. (91 × 70.9 cm). © By kind permission of the Trustees of the Wallace Collection, London P36

Fig. 116. Alfred Jean André Cluysenaar. *A Vocation (Portrait of André Cluysenaar, Son of the Painter)*, 1875. Oil on canvas, 43⅝ × 32⅛ in. (111 × 81.5 cm). Musées royaux des Beaux-Arts de Belgique, Bruxelles—Koninklijke Musea voor Schone Kunsten van België, Brussel Inv. 2647

Fig. 117. Theodore Robinson. *The Wedding March*, 1892. Oil on canvas, 22¼ × 26½ in. (56.7 × 67.3 cm). Terra Foundation for American Art, Chicago. Daniel J. Terra Collection 1999.127

frankness.[41] Although Cluysenaar's disheveled little boy rests awkwardly on a chair with his bare legs outspread, the artist realizes volumetric forms in detail and uses a more conventional viewpoint that allows the boy to meet the observer's gaze. Enraged by the American jury's rejection of *Little Girl in a Blue Armchair* for display at the 1878 Exposition Universelle, Cassatt showed it—as an emblem of her conversion to the "new painting"—in her debut with the Impressionists the following year.

American residents in and visitors to Paris often enjoyed excursions and holidays outside the city. "In May, with the appearance of balmy weather, the American colony begin talking of dispersing for the summer. . . . 'Where shall we go?' and 'Where we are going,' are the overruling questions and topics of conversation," Bacon noted in his 1882 account of an artist's year in Paris.[42] Artists often responded to a keen

desire to spend summers in old-fashioned villages and picturesque art colonies, enjoying the company of colleagues and recording nature and scenes of everyday provincial life.[43] Between 1885 and about 1915, many American painters were drawn to Giverny, the ancient Norman farming hamlet on the Seine, approximately fifty miles northwest of Paris, where Monet had settled in April 1883. Sargent visited as early as 1885 and, by 1887, Willard Metcalf, Theodore Earl Butler, Theodore Robinson, and others had established an art colony there, using the old Hôtel Baudy as their headquarters.[44] So quickly did the Americans adopt Monet's methods that a writer for *Art Amateur* marveled in October 1887: "Quite an American colony has gathered, I am told, at Givernay [*sic*]. . . . A few pictures just received from these young men show that they have all got the blue-green color of Monet's impressionism and 'got it bad.'"[45]

Of the Americans at Giverny, Robinson enjoyed the warmest relationship with Monet. Although he had studied with academics in Paris, including Henri Lehmann and Gérôme, his work with Carolus-Duran and in art colonies at Barbizon and Grez-sur-Loing predisposed him to experiment with Impressionism. Robinson visited Giverny briefly in 1885, when he may have met Monet. He made his first long stay in the village in 1887, summered there in 1888, and spent more than half of each year there from 1889 to 1892. His *Wedding March* (fig. 117), a unique visual record of the links between Monet and Giverny's American colony, commemorates Butler's marriage on July 20, 1892, to Monet's stepdaughter Suzanne Hoschedé, a match that the French master opposed. The civil ceremony took place at the town hall, which appears at the upper right, and was followed by a procession to the church of Sainte Radégonde, where the religious vows were exchanged.[46] Robinson began the painting two weeks after the wedding, describing the sun-drenched scene from memory.[47] One of his last Giverny canvases, *The Wedding March* reveals in its brilliant palette, dynamic compositional diagonals, and active figures the artist's most facile Impressionist technique. In the only known picture in which Robinson responded to a specific event, he carries Impressionist fluency so far that he obscures the identity of all the participants other than the bride, thereby creating not a factual document but an enigmatic wedding souvenir.

The New Woman

The woman who emerged after the Civil War assumed many roles in American stories—steadfast keeper of culture, devoted mother, dedicated household manager, participant in genteel feminine rituals—and engaged many painters' interest. In Chase's 1880 studio scene (fig. 104), the woman's lassitude and immersion in an aesthetic interior make her seem like a precious object, a trope embraced by many artists of the period and their patrons. Her association with art also reflects the simultaneous assumption that women were consumers and keepers of culture and arbiters of taste. Like Chase's painting and Bacon's *First Sight of Land* (fig. 107), the latter of which alludes to women as international travelers and readers of fiction, Frank Waller's *Interior View of the Metropolitan Museum of Art when in Fourteenth Street* (fig. 118) expresses the association of women with civilizing pastimes. After studying art in Rome in the early 1870s and traveling in Egypt, Waller became a founder in 1875 of New York's Art Students League, for which he evaluated European academies that might be worth emulating.[48] Convinced that tradition should shape artists' skills and patrons' standards, Waller welcomed the advent of museums such as the Metropolitan, founded in 1870 and emblematic of Americans' desire to

gather works of art from abroad. Waller sets his scene in the Douglas Mansion on West Fourteenth Street, which served from 1873 to 1879 as the Metropolitan's second home. He portrays two second-floor galleries as they appeared in 1879, when the portrait—then attributed to Leonardo—on view in the far room was on loan to the Museum. To the left of the doorway in the near gallery are a portrait by Cornelis de Vos and a religious picture by Anthony van Dyck; above the doorway is Henry Peters Gray's *Wages of War* (1848), the Metropolitan's first American acquisition. By obscuring the face of the young woman who scrutinizes an unidentified small landscape, Waller presents her as the archetypal female devotee of art and culture.

Thomas Eakins also appreciated the lessons of Europe. Upon his return to Philadelphia in 1870, after almost four years of foreign study and travel, he enlisted friends, family members, and accomplished local citizens, rather than professional models, to pose for his paintings. In them, he condensed the essence of any activity or individual he depicted, elevating his accounts of specific events to a more universal plane. *Singing a Pathetic Song* (fig. 119) culminates a series of canvases in which Eakins showed women and girls pursuing quiet indoor pastimes during the 1870s, a decade in which he also celebrated men's athletic endeavors outdoors.[49] For this, his most ambitious domestic scene and one of many pictures that communicate his enduring love of music, Eakins invited two of his Pennsylvania Academy students to act out a home musicale.[50] Margaret Alexina Harrison sings and Susan Hannah Macdowell (whom the artist would marry in 1884) plays the piano in a nondescript parlor, where they are joined by the accomplished Philadelphia cellist Charles Stolte. One reviewer praised Eakins's ability to "bring good results from the most unpromising materials . . . —even, as in this case, out of three homely figures with ugly clothes in an 'undecorative' interior."[51]

Although, as usual, Eakins investigated every component of the scene—for example, there are at least eleven photographs of Harrison in costume—he sacrificed actualities to pictorial necessities. Here, he enlarges the pianist and places the cellist behind her, where he cannot make eye contact with his fellow performers. This arrangement, which would handicap an actual chamber ensemble, simplifies the composition and directs attention to the singer, whom Eakins renders more precisely than her companions, as if in relief. He shows her holding a note, apparently of a "pathetic song," the sort of popular ballad that could move a listener to tears.[52] The painting invites comparison with John George Brown's *Music Lesson* of 1870 (fig. 93), which beguiles the eye with elements of interior decor and uses the occasion to offer a sexually suggestive account of relations between the two figures depicted. Eakins, by contrast, describes particular individuals, but then

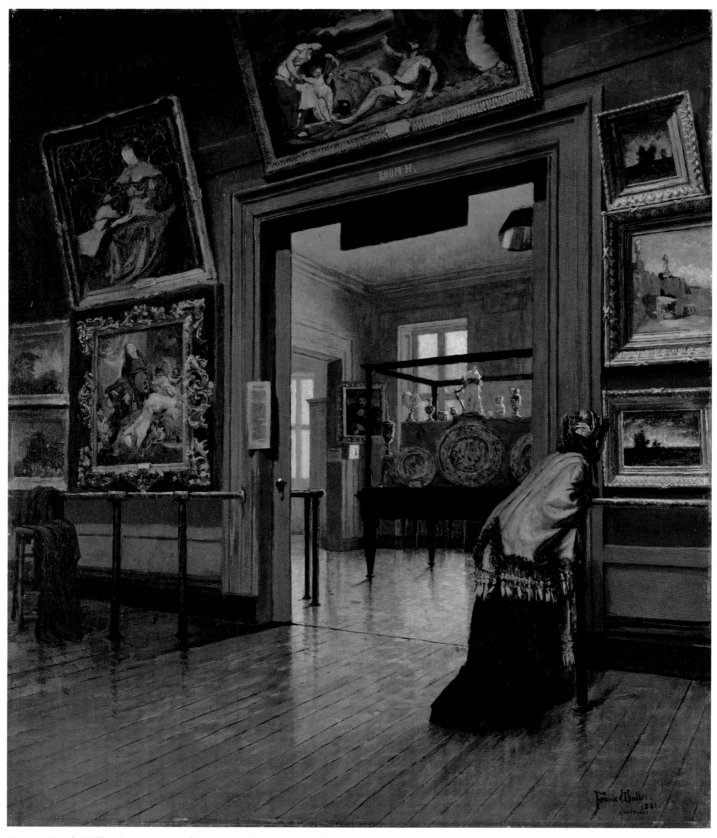

Fig. 118. Frank Waller. *Interior View of the Metropolitan Museum of Art when in Fourteenth Street*, 1881. Oil on canvas, 24 × 20 in. (61 × 50.8 cm). The Metropolitan Museum of Art, New York. Purchase, 1895 95.29

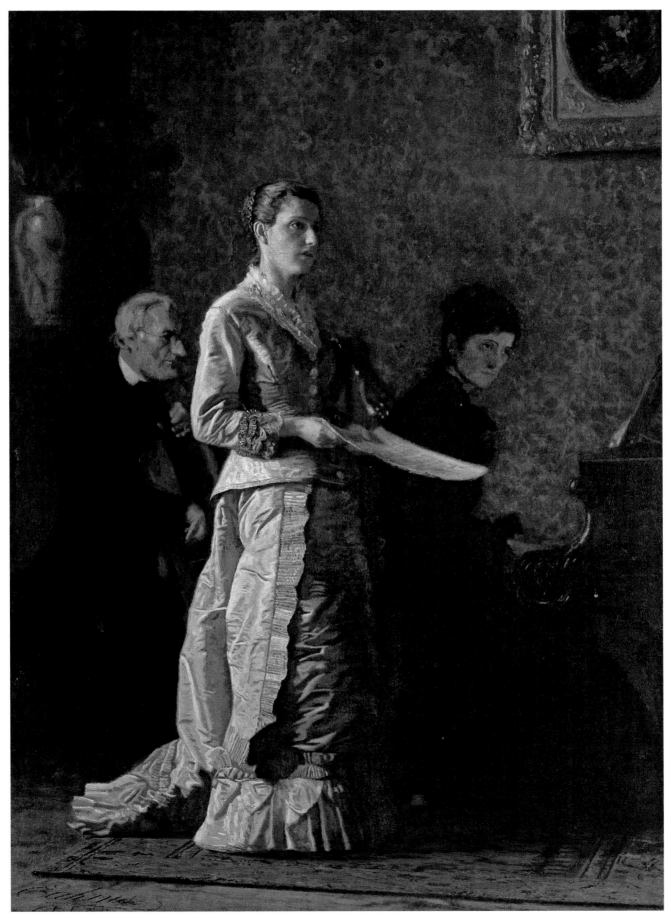

Fig. 119. Thomas Eakins. *Singing a Pathetic Song*, 1881. Oil on canvas, 45 × 32¼ in. (114.3 × 81.8 cm). Corcoran Gallery of Art, Washington, D.C. Museum Purchase, Gallery Fund 19.26

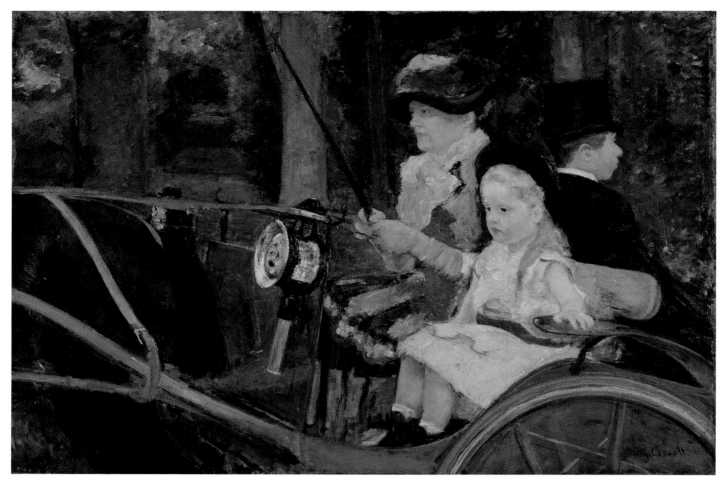

Fig. 120. Mary Cassatt. *A Woman and a Girl Driving*, 1881. Oil on canvas, 35¼ × 51⅜ in. (89.7 × 130.5 cm). Philadelphia Museum of Art. Purchased with the W. P. Wilstach Fund, 1921 W1921-1-1

engages the viewer's deeper connection with the principal music maker, her absorption in her score, her companions' concentration, and the moment's subdued mood. Although both artists respond to intimate performances, Brown adheres to midcentury explicitness while Eakins prefers the subtle storytelling more typical of his era. Transcending a specific moment in a particular parlor, Eakins sums up the power of music and women's association with art and sentiment.[53] *Singing a Pathetic Song* apparently embodied virtues admired by the Pennsylvania Academy trustee Edward Hornor Coates, who accepted it instead of *Swimming* (fig. 157), the painting Eakins had originally intended for him.[54]

Cassatt, who specialized in portraying women's activities, signals in *A Woman and a Girl Driving* (fig. 120) the comfortable existence of women in her circle and her support of female empowerment. Accompanied by Odile Fèvre, Degas's niece, Cassatt's sister, Lydia, is seen driving a small carriage in the Bois de Boulogne, thereby enjoying a familiar outing and taking charge of her own path, actually and symbolically. Her independence and determined concentration are in contrast to the family's passive young groom, who observes from the backward-facing seat only where the carriage has been, not

where it is going. Cassatt's use of an asymmetrical composition with compressed space, cropped forms, and conspicuous brushwork to convey an everyday subject announces her commitment to Impressionism and her close association with Degas. Yet Cassatt's message is distinctive, as the art historian Norma Broude has observed: "The woman's position—in the driver's seat—is one that metaphorically departs from the normal social order and may even carry a veiled challenge to that order; but at the same time, it is courageously normalized here by the slice-of-life point of view from which Cassatt chose to present it."[55]

Taking tea, a feminine ritual in Cassatt's genteel upper-middle-class Parisian milieu, inspired several of her paintings of about 1880. In *The Cup of Tea* (fig. 121), for which Lydia also posed, the artist displays Impressionist devices even more fully than in the driving scene. In addition to an asymmetrical composition, she amplifies spontaneity with vivacious brushstroke, reserved areas of unpainted canvas, and a high-keyed palette based on complementary colors (opposite each other on the color wheel). Cassatt showed the painting (as *Le Thé*) along with ten other works in the 1881 Impressionist exhibition, where the critic and novelist Joris-Karl Huysmans

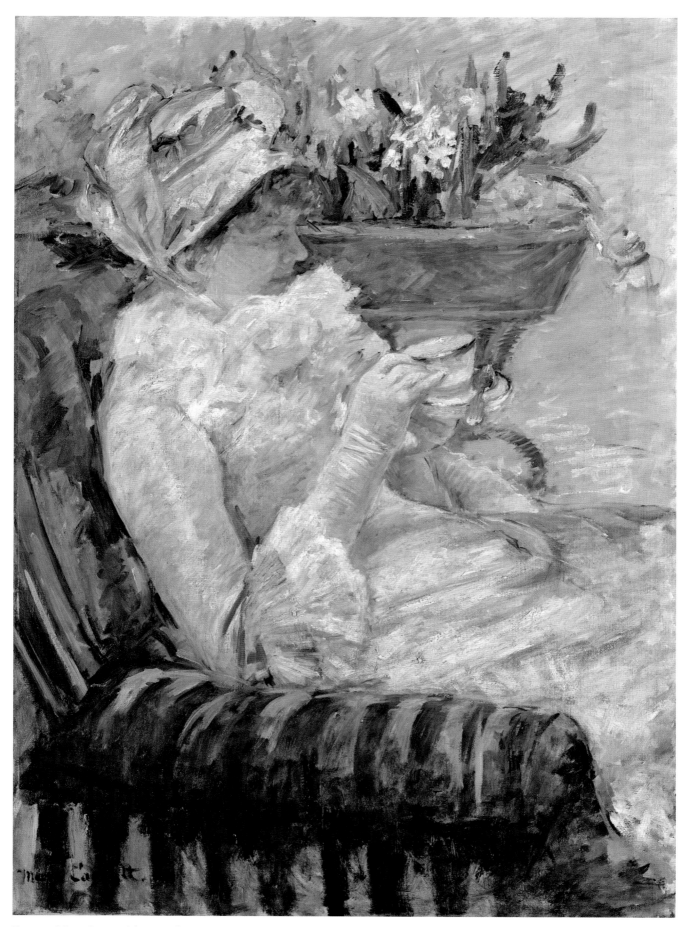

Fig. 121. Mary Cassatt. *The Cup of Tea*, ca. 1880–81. Oil on canvas, 36⅜ × 25¾ in. (92.4 × 65.4 cm). The Metropolitan Museum of Art, New York. From the Collection of James Stillman, Gift of Dr. Ernest G. Stillman, 1922 22.16.17

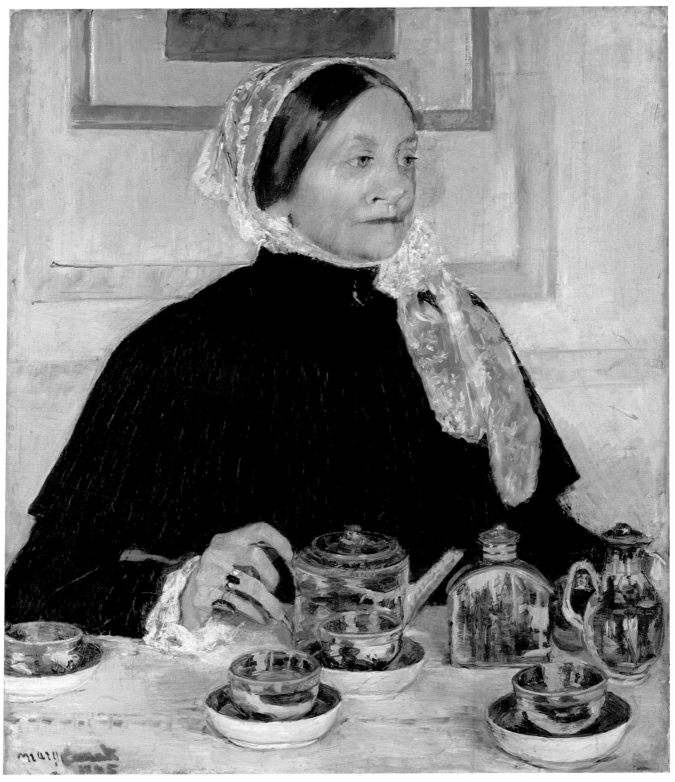

Fig. 122. Mary Cassatt. *Lady at the Tea Table*, 1883–85. Oil on canvas, 29 × 24 in. (73.7 × 61 cm). The Metropolitan Museum of Art, New York. Gift of the artist, 1923 23.101

praised her for "expressing, as none of our own painters have managed to do, the joyful peace, the tranquil friendliness of the domestic interior."[56]

Cassatt's monumental *Lady at the Tea Table* (fig. 122) is an emblem of authoritative conspicuous consumption.[57] The artist shows her mother's first cousin, Mary Dickinson Riddle (Mrs. Robert Moore Riddle), pinned between a gilt-framed picture and a crowded tabletop. Her ring-laden fingers hold a teapot, part of a gilded blue-and-white Canton porcelain service that Mrs. Riddle's daughter, Anna Riddle Scott, had

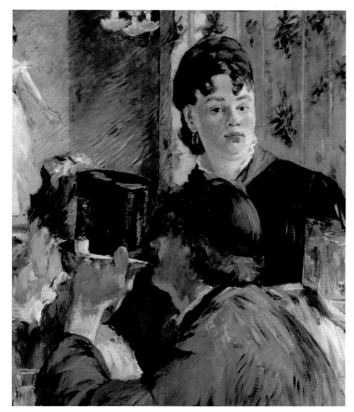

Fig. 123. Édouard Manet. *The Beer Waitress*, 1878–79. Oil on canvas, 30½ × 25⅝ in. (77.5 × 65 cm). Musée d'Orsay, Paris RF 1959-4

purchased in London and given to Cassatt's family. In response to the gift, Cassatt began the portrait in 1883 but Mrs. Scott disliked it, objecting to the size of her mother's nose. Irritated, disappointed, and later protesting, "You may be sure it was like her,"[58] Cassatt put the canvas into storage until June 1914, when she sent it for display at Durand-Ruel's Paris gallery. A sensation there, it appeared again in an April 1915 exhibition in New York that Cassatt's friend Louisine W. Havemeyer helped organize to benefit women's suffrage. At Mrs. Havemeyer's urging, the artist lent and then gave the painting to the Metropolitan in 1923. By comparison with an earlier American narrative portrait—Copley's *Paul Revere* from 1768 (fig. 7)—*Lady at the Tea Table* demonstrates Cassatt's adoption of Impressionist principles in its casual handling of anatomy, notably the hand; its rapid brushwork and sketch-like finish; and the sitter's indifference to the viewer's presence. By flattening space and forms, emphasizing silhouette, and restricting her palette, Cassatt also signals her debt to Japanese prints and the paintings of Manet. A comparison with Manet's frankly staring *Beer Waitress* (fig. 123), however, reveals the propriety that Cassatt's gender obliged her to observe as she sought commonplace subjects for her Impressionist initiative in fashionable parlors rather than in plebeian cafés.

During the 1870s and 1880s, Cassatt most frequently depicted women out and about in Paris—often as stylish spectators at social events—or engaged in quiet domestic

activities like taking tea. During the 1890s, she narrowed the focus of her paintings, pastels, and prints to mothers or nurses caring for children and to children alone. These themes, representing almost a third of her oeuvre, would elicit critical praise and find a favorable market. They also reflected both the prominence of motherhood and child rearing as concerns of many of Cassatt's contemporaries and the artist's affection for her nieces and nephews and her friends' children. Cassatt announced her interest in maternal imagery in 1880 with *Mother About to Wash Her Sleepy Child* (fig. 124), in which she portrays an infant, perhaps just awakening from a nap, gazing at his mother, who cradles him in her lap and returns his gaze as she dips a washcloth into a basin. Women washing children provided Cassatt with decorous equivalents of nude women bathing themselves, favorite subjects of Degas, Renoir, and her other male colleagues, and, like other acts of maternal solicitude, permitted her to celebrate the singular character of women's lives. The flat, quickly painted forms, casual poses, and unaffected spirit of *Mother About to Wash Her Sleepy Child* typify Impressionist candor and distinguish the painting from earlier, more contrived and conservatively rendered stories of maternal care such as Guy's *Contest for the Bouquet* (fig. 86) and Henry Mosler's *Just Moved* of 1870 (fig. 88).

As seen in *Mother About to Wash Her Sleepy Child*, Cassatt usually confined narrative interaction to the woman and child she portrayed, thereby emphasizing their self-contained relationship and minimizing any suggestion of staged performance. *Young Mother Sewing* (fig. 125) is exceptional in acknowledging the viewer. For this painting, Cassatt cast two of her frequent models—Reine Lefebvre, a woman from Le Mesnil-Théribus, Oise, the village near Cassatt's seventeenth-century manor house, Château de Beaufresne, and Margot Lux, a spirited little girl of the village—and depicts them in the château's glass-walled conservatory. The mother is absorbed in sewing while the child, chin in hand, leans against her knee and gazes intently at the viewer. In 1927 Mrs. Havemeyer, who had purchased the painting in 1901 from Durand-Ruel, applauded its candor and truth to experience: "Look at that little child that has just thrown herself against her mother's knee, regardless of the result and oblivious to the fact that she could disturb 'her mamma.' And she is quite right, she does not disturb her mother. Mamma simply draws back a bit and continues to sew, while little daughter rests her elbows upon mamma's knee. Such a movement never could have been except just between mother and little daughter."[59]

As cities grew and the industrialized workplace became more impersonal, the home became increasingly important as a private sphere for retreat and relaxation. Many painters recounted the pleasures of domestic life for collectors who might cherish both the real and the ideal aspects of such

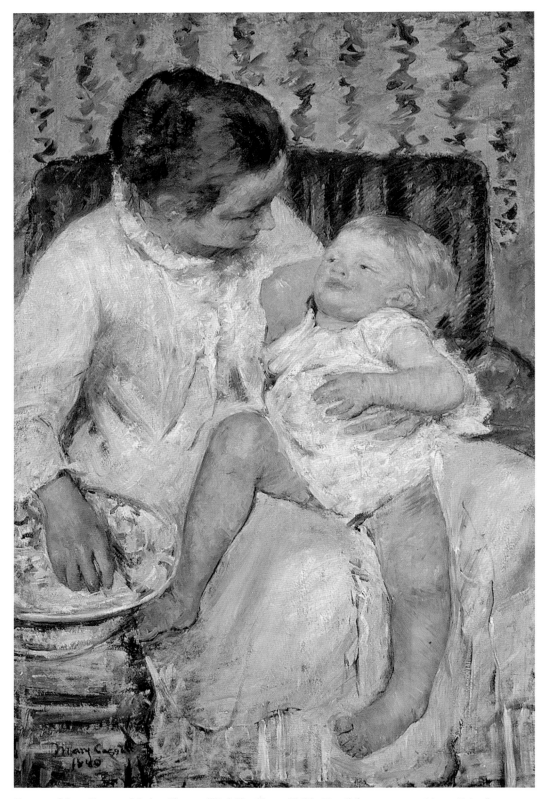

Fig. 124. Mary Cassatt. *Mother About to Wash Her Sleepy Child*, 1880. Oil on canvas, 39½ × 25⅞ in. (100.3 × 65.8 cm). Los Angeles County Museum of Art. Mrs. Fred Hathaway Bixby Bequest M.62.8.14

imagery. Eakins confined women and children to dim Philadelphia parlors and Cassatt showed them in comfortable surroundings in and around Paris, while Chase recorded them in agreeable settings in the New York area. Having moved with his new bride to his parents' residence on Marcy Avenue in Brooklyn shortly after his marriage in February

1887, Chase painted a series of small, brightly hued views of the neighborhood, including nearby Tompkins and Prospect parks. His largest Brooklyn canvas is *The Open Air Breakfast* (fig. 126), which shows a private rather than a public space. This work offers a masterly depiction of members of Chase's family at an alfresco summer meal in their secluded backyard,

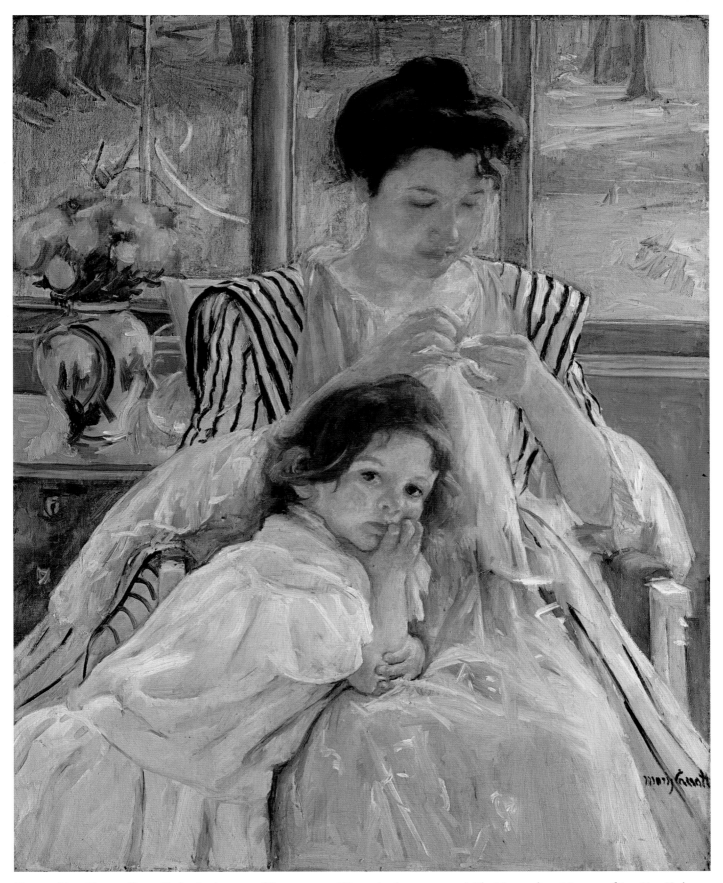

Fig. 125. Mary Cassatt. *Young Mother Sewing*, 1900. Oil on canvas, 36⅜ × 29 in. (92.4 × 73.7 cm). The Metropolitan Museum of Art, New York. H. O. Havemeyer Collection, Bequest of Mrs. H. O. Havemeyer, 1929 29.100.48

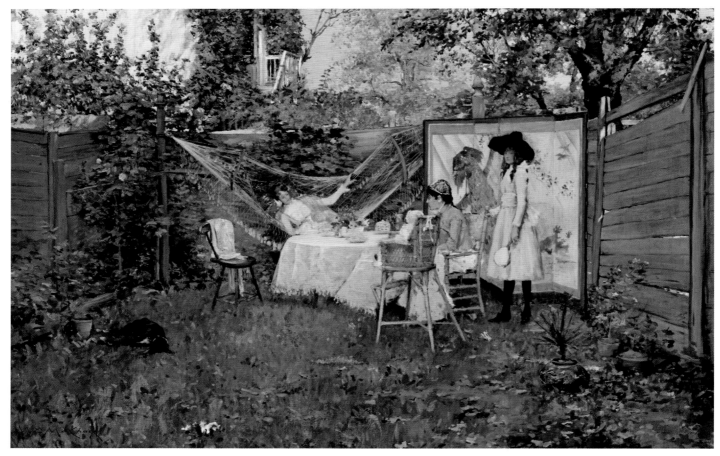

Fig. 126. William Merritt Chase. *The Open Air Breakfast*, ca. 1887. Oil on canvas, 37½ × 56¾ in. (95.3 × 144.1 cm). Toledo Museum of Art, Ohio. Purchased with funds from the Florence Scott Libbey Bequest in Memory of her Father, Maurice A. Scott 1953.136

protected from urban tumult by a high wooden fence, climbing roses, a stand of hollyhocks, and an arching tree. Although Chase does not render them precisely, almost all the characters portrayed are identifiable. His wife, Alice

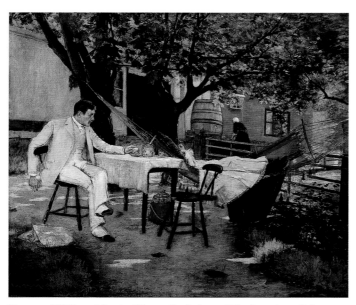

Fig. 127. William Merritt Chase. *Sunlight and Shadow*, 1884. Oil on canvas, 65¼ × 76½ in. (165.7 × 194.3 cm). Joslyn Art Museum, Omaha, Nebraska. Gift of the Friends of Art Collection JAM1932.4

Gerson Chase, wearing a morning cap and a short jacket, sits in profile at the breakfast table, next to baby Alice (known as Cosy)—then five or six months old—in a wicker high chair.[60] Behind Alice stands Chase's sister Hattie wearing a seventeenth-century Dutch burgher's hat, white dress, and black stockings, holding a battledore, and gazing out at the viewer. Behind the table, one of Alice's sisters—Virginia or Minnie—reclines in a hammock, and at the left, one of Chase's wolfhounds naps on the grass. That Chase intended this painting as a family memento is suggested by the fact that, despite its ambitious scale, he did not exhibit it until 1915 and it was in his possession when he died the following year.[61]

In *The Open Air Breakfast*, a turned bamboo side chair, a Japanese screen, Asian porcelains, potted plants, and a cashmere shawl draped over a Windsor chair suggest that Chase re-created outdoors the effect of his aesthetically cluttered studio on Tenth Street (see fig. 104). Noting that the artist invites the viewer "into a magical secret garden in which the picturesque furnishings, the geraniums and roses, the sparkling harmonies of color and texture, and the decoratively posed figures are all part of a poetic, make-believe world," the scholar Carol Troyen also observed the narrative vacuum: "All obvious anecdote and psychological interchange have

been eliminated."[62] Minimizing portraiture and storytelling, Chase revises the traditional formula for a conversation piece, a formula honored, for example, by Guy in *The Contest for the Bouquet* (fig. 86). Three years earlier, during a visit to his painter friend Robert Blum in Zandvoort, Holland, Chase had painted a prototype for *The Open Air Breakfast. Sunlight and Shadow* (fig. 127), which shows Blum in a garden, fiddling with a teacup and trying to engage the interest of a young woman who is turned away from him in a hammock, is more psychologically charged, evoking its original title, *The Tiff*.[63] By comparison, *The Open Air Breakfast* resists narrative reading; any literal conversation in this modern conversation piece is completely inaudible.

In *The Open Air Breakfast*, Chase enlists the bravura brushwork he had first learned in Munich and then enlivened by his work in pastel and his adoption of French Impressionism; yet he restrains his palette and excludes brilliant light and all shadows. Chase would mature as an Impressionist only in the early 1890s, when he took his interest in genteel outdoor genre subjects to Shinnecock, at the western edge of Southampton, Long Island, which had only recently been made accessible by improvements in suburban rail service.[64]

A charismatic teacher at New York's Art Students League, Chase was offered the directorship of the Shinnecock Hills Summer School of Art, founded and underwritten by collectors who spent summers there. At Shinnecock Chase found an ideal spot for painting, one lauded in contemporary guidebooks as suffused with American traditions and a perfect place for recreation. Southampton's luxurious tone—conspicuous then as now—also appealed to the socially striving Chase. Between 1891, when he was appointed director, and 1902, he offered criticism and gave demonstrations two days each week. He passed the rest of his time painting, often *en plein air*, and enjoying his family's company in and around a colonial-style house designed for him by Stanford White. In his Shinnecock works, as in his park scenes, he conducted dialogues with artists whose accomplishments he knew and admired, including the French Impressionists, who were attracting American patronage.

At Shinnecock Chase painted some of his liveliest, freshest, and boldest compositions, including *Idle Hours* (fig. 128), one of his largest outdoor scenes. This Shinnecock masterpiece showcases Chase's mature Impressionist technique more fully than his *Open Air Breakfast* does, and it constitutes the

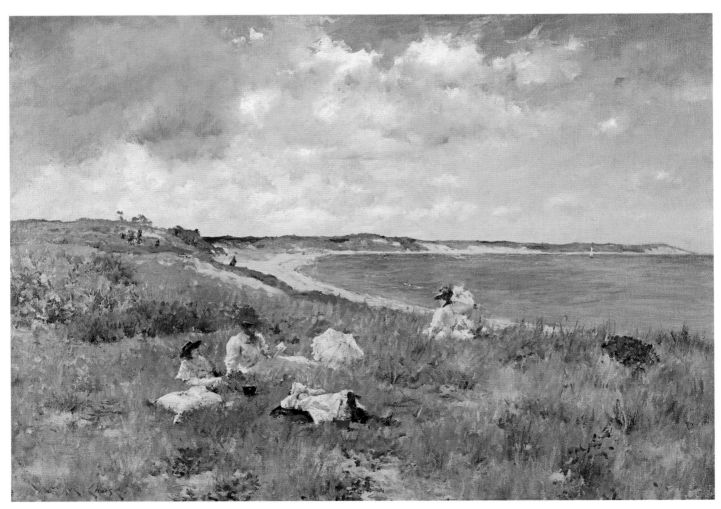

Fig. 128. William Merritt Chase. *Idle Hours*, ca. 1894. Oil on canvas, 39 × 48⅝ in. (99.1 × 123.5 cm). Amon Carter Museum, Fort Worth, Texas 1982.1

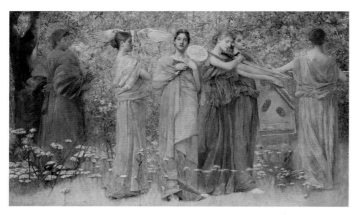

Fig. 129. Thomas Wilmer Dewing. *The Days*, 1884–86. Oil on canvas, 43¼ × 72 in. (109.9 × 182.9 cm). Wadsworth Atheneum Museum of Art, Hartford, Connecticut. Gift of the estates of Louise Cheney and Anne W. Cheney 1944.328

perfect Impressionist foil to Homer's 1870 seaside scene *Eagle Head, Manchester, Massachusetts (High Tide)* (fig. 96). The setting is the scrubby dunes along Shinnecock Bay, not far from Chase's house and studio, from which a few pillows may have been carried. The brilliant blue water is contained within the shoreline's bend and the sunny afternoon invites idling, despite the passing cloud. Inhabiting the scene are four females who often posed for Chase: a woman in a red bonnet—probably

his wife—reads aloud to two of her daughters; another woman—perhaps one of Mrs. Chase's sisters—enjoys her surroundings. The viewer's eye and mind are invited to fill in the picture's sketchy forms and elusive narrative. *Idle Hours* incorporates several subtexts: the growth of leisure time, suburban resorts, and country retreats in response to urbanization and industrialization; the ensuing displacement of images of country folks at play—Homer's *Snap the Whip* from 1872 (fig. 89), for example—by pictures of urbanites enjoying rural recreation; the predominance of women in resorts that were beyond commuting distance of cities where men worked all week; and unaccompanied women's preference for safe, quiet seaside pastimes. The painting's text, however, may be as simple as Henry James's remark: "Summer afternoon—summer afternoon; to me those have always been the two most beautiful words in the English language."[65]

Responding to the taste of affluent—principally male—collectors from about 1900, American painters of every stylistic tendency depicted women as exquisite, passive objects associated with aesthetic pursuits. Some of their pictures hint at the popular precepts of Dr. S. Weir Mitchell, an influential Philadelphia neurologist, who prescribed enforced confinement and absolute inactivity as a remedy for women's nervous disorders.[66] One such painter was Thomas Wilmer Dewing.

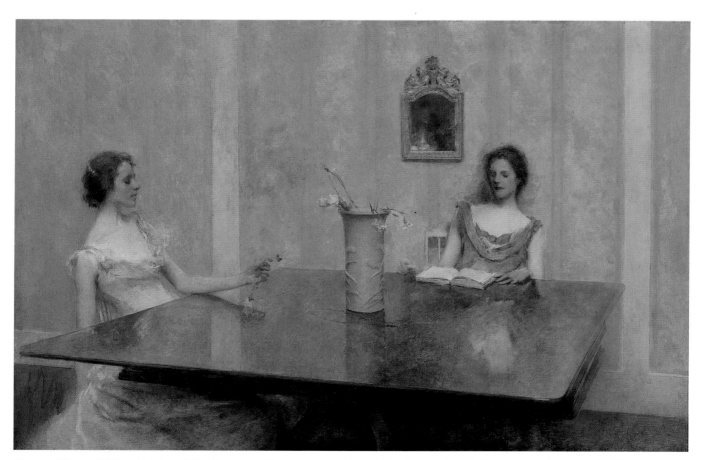

Fig. 130. Thomas Wilmer Dewing. *A Reading*, 1897. Oil on canvas, 20¼ × 30¼ in. (51.3 × 76.8 cm). Smithsonian American Art Museum. Bequest of Henry Ward Ranger through the National Academy of Design 1948.10.5

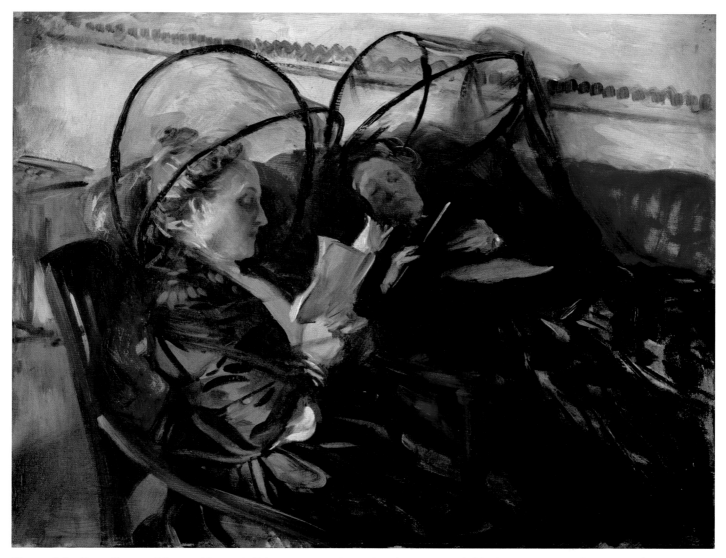

Fig. 131. John Singer Sargent. *Mosquito Nets*, 1908. Oil on canvas, 22½ × 28¼ in. (57.2 × 71.8 cm). The Detroit Institute of Arts. Founders Society Purchase, Robert H. Tannahill Foundation Fund, and Founders Society Acquisition Funds 1993.18

After exhausting Boston's then-limited instructional resources, Dewing worked from 1876 to 1879 in Paris at the Académie Julian, the leading private competitor to the École des Beaux-Arts. He deployed his academic skills during his years of study and after he settled in New York in 1880. In canvases such as *The Days* (fig. 129), he showed women in classical dress but detached them from explicit historical, religious, or mythological texts and from any narrative beyond the display of the female form.

In the 1890s, under Whistler's influence, Dewing put aside academic precision and further reduced narrative content, displaying an evocative tonalist style in works such as *A Reading* (fig. 130). Women, seen either outdoors or in silent interiors, appear mysterious and otherworldly, signaling the desire for escape from modern tumult into transcendent realms of beauty and contemplation. *A Reading* is set in a room, designed by Stanford White and recently added to Dewing's summer home in Cornish, New Hampshire, that is

dominated by a huge Empire-style mahogany table acquired from an 1896 auction of the contents of Chase's Tenth Street studio. Pressed toward the windowless walls by the immense tabletop, two elegantly clad women contemplate a text lying on the table. An autoradiograph discloses that Dewing had originally shown the listener, at left, gesturing toward the reader, who responded with a gaze. He later modified that hint of interaction, increasing the scene's ambiguity and inviting the viewer to meditate on two enervated women confined in a lovely but claustrophobic domestic sanctuary and lost in thoughts evoked by the text.[67]

Sargent's conversation piece *Mosquito Nets* (fig. 131) situates the subject of women reading in an exotic foreign locale and amplifies Dewing's emphasis on self-containment. Having essentially abandoned portrait painting in about 1900, Sargent traveled extensively, usually in the company of family members and close friends. In September 1908, he made his second visit to Majorca, the largest of the Balearic Islands off

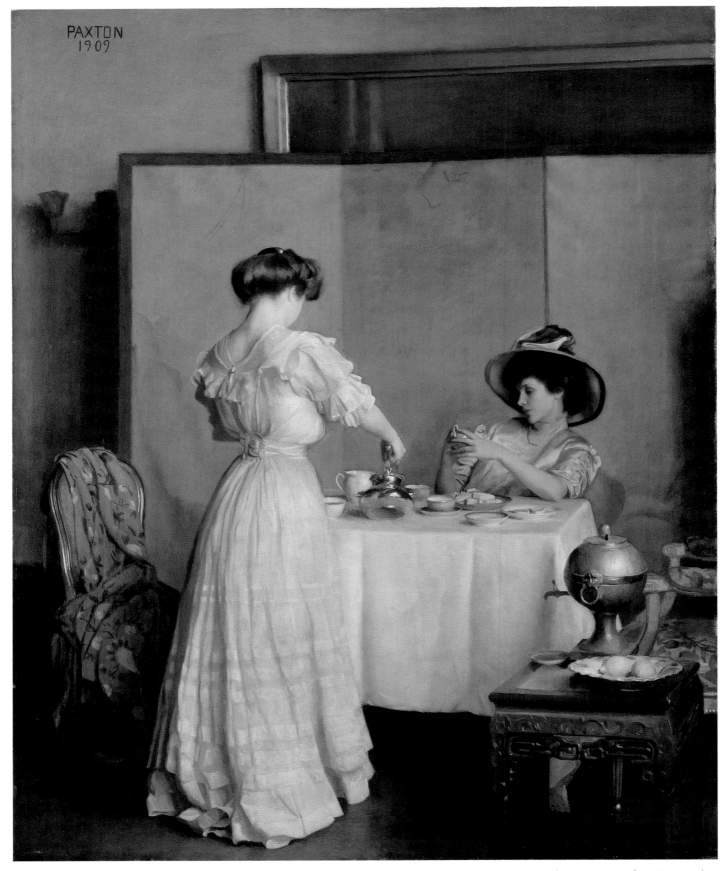

Fig. 132. William McGregor Paxton. *Tea Leaves*, 1909. Oil on canvas, 36⅛ × 28¾ in. (91.6 × 71.9 cm). The Metropolitan Museum of Art, New York. Gift of George A. Hearn, 1910 10.64.8

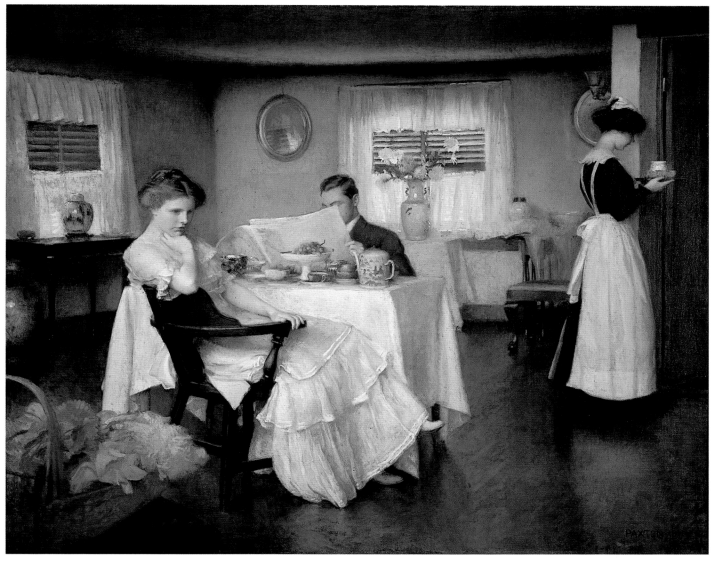

Fig. 133. William McGregor Paxton. *The Breakfast*, 1911. Oil on canvas, 28¼ × 35¼ in. (71.8 × 89.5 cm). Ted Slavin

the eastern coast of Spain, a place not yet touched by tourism.[68] There, in the dim interior of their rented apartment in a villa in Valldemosa, he portrays his older sister Emily sitting in a cushioned wooden chair and their friend Eliza Wedgwood reclining on a sofa. Absorbed in their texts, both women are further sheltered by contraptions that Sargent labeled *"garde mangers"*—mosquito nets that Emily had contrived from large hoops and black netting.[69] Sargent's high and close vantage point and the women's indifference to his presence imply an accidental glimpse into their private world.

Dewing and Sargent portray reading as a private feminine pastime and a means of escape from quotidian experience into the realm of the imagination. They feature settings—a cloistered parlor and a remote island villa—that are perfect habitats for contemplation. In spirit as well as in structure, their enigmatic, intimate, informally constructed, and seemingly timeless scenes are a world apart from the declamatory mid-century depictions of men reading in pursuit of information,

such as Woodville's *Politics in an Oyster House* (fig. 45) and *War News from Mexico* (fig. 46).

William McGregor Paxton, who from 1887 to 1893 had studied in leading Boston and Paris art schools and who would always espouse traditional artistic values, exemplifies the academic extreme among American artists active about 1900. His scenes of everyday life such as *Tea Leaves* (fig. 132) and *The Breakfast* (fig. 133) announce his appreciation of works by Johannes Vermeer and Jean-Auguste-Dominique Ingres and recapitulate the photographic accuracy achieved by Jean-Léon Gérôme, one of his Parisian masters. Paxton often depicted refined, elegantly attired upper-class women—like his patrons' wives and daughters—at leisure in handsome Boston interiors that they, as keepers of culture, would have decorated and occupied. Moreover, "by treating women in the same polished, precise, neutral way as their setting, and bathing them in the same gentle light, the artist equated the figures and the props, as precious aesthetic objects," as the

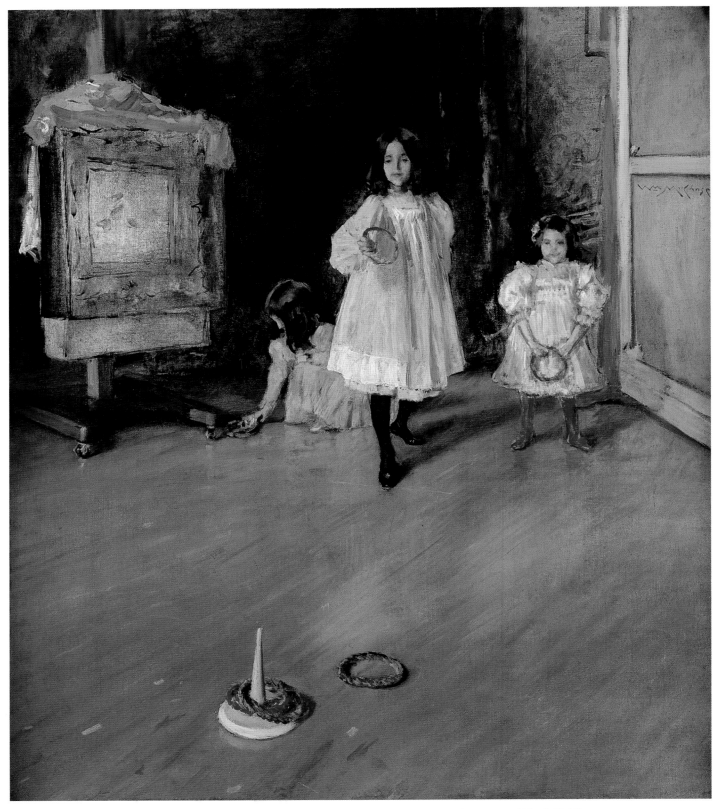

Fig. 134. William Merritt Chase. *Ring Toss*, 1896. Oil on canvas, 40⅜ × 35⅛ in. (102.6 × 89.2 cm). Marie and Hugh Halff

art historian Bailey Van Hook observed.[70] Paxton's women are thus counterparts to those who are portrayed as collectible objects in novels by Henry James. In *The American* (1877), Christopher Newman seeks as a wife "the best article on the market," envisioning "a beautiful woman perched on the pile" of his financial success "like a statue on a monument." In *Portrait of a Lady* (1881), Gilbert Osmond contemplates acquiring Isabel Archer, an independent American girl: "He was fond of originals, of rarities; of the superior and the exquisite; and now that he had seen Lord Warburton, whom

he thought a very fine example of his race and order, he perceived a new attraction in the idea of taking to himself a young lady who had qualified herself to figure in his collection of choice objects by declining so noble a hand."[71] Paxton's women personify the sociologist Thorstein Veblen's proposition, expressed in his *Theory of the Leisure Class* (1899), that a woman's "conspicuous leisure" signaled the wealth of her father or husband—men whose commitment to earning a living kept them from enjoying leisure themselves—and that a woman was expected not only to beautify her home but also to be its "chief ornament."[72] Like other Boston School painters about 1900, Paxton reflected the city's role as a bastion of refinement, elegance, aristocratic family connections, and conservative social and aesthetic standards in the face of modern developments, and in contrast to livelier and more heterogeneous and meritocratic cities like New York.[73]

In *Tea Leaves*, a slender young hostess with upswept hair turns away, excluding the viewer from the private moment she shares with her visitor. Clad in a ruffled white day dress that announces her decorum and implies her virtue, she pours water or tea from a silver kettle—probably a handy studio prop that substituted for the teapot a proper Boston hostess would have used.[74] Her languid guest, who wears a fashionable dog-collar necklace and a string of coral beads, reads her fortune in tea leaves at the bottom of her porcelain cup. As Dewing had done in a more painterly style in *A Reading*, Paxton portrays a windowless interior permeated by soft light, a dreamy atmosphere, and the sounds of silence, capturing elegant women's grace and lassitude as they pass time by doing very little or nothing at all. Although the artist hints at a narrative, he asks that the viewer invent it, echoing the ambiguity of Vermeer's paintings. Paxton also invokes the Dutch masters in his artfully creased linen table covering; framed background devices (here, a doorway or large painting and a paneled screen, instead of Vermeer's usual maps and paintings); and a foreground still life of luxury objects, including a Chinese-style table on which rest a large silver-plated hot-water urn from about 1800 and a blue-and-white ceramic plate. These imported goods signal Boston's history and its long-standing participation in the China trade. Although Paxton's illusionistic style announces his reliance on tradition, his preference for implying—rather than declaiming—narrative is modern.

In *The Breakfast*, Paxton again parades his academic skills well after most leading artists had abandoned them, at the same time adding humor to a genteel interior scene. He shows a beautifully attired young woman sulking at the breakfast table while her husband reads the newspaper, a symbol of his engagement with the modern world outside. She is excluded from that world both intellectually, by the inaccessibility of the morning news, and physically, by the multilayered

window treatments that incorporate visually confining venetian blinds. Recording what one critic called the "newspaper-at-breakfast stage" of marriage, *The Breakfast* suggests that the domestic sphere was a cozy trap for some women, as opposed to the "sweet home fireside" where "dear ones" gathered, as extolled by the social commentator Sereno Edwards Todd in 1870 and portrayed by Guy in 1866 and Mosler in 1870 (see figs. 86 and 88).[75] Paxton's disgruntled young wife is the "bird in a gilded cage" that Arthur J. Lamb celebrated in his popular song of 1900.[76]

Charming Children

When he depicted children at Shinnecock, Chase often enlisted as models his many offspring, showing them relaxing on stretches of sand or in groves of scrub pines and bayberry bushes, listening to stories, or playing in his studio.[77] Having traveled in spring 1896 with his wife and two eldest daughters to Madrid, where he admired works by Velázquez, copied *Las Meninas* (1656) in the Prado, and was even likened to the Spanish master by one observer, Chase returned to Shinnecock in June to teach. It was presumably in response to Velázquez's magnum opus, as curator Eleanor Jones Harvey noted, that he then painted *Ring Toss* (fig. 134).[78] Chase's canvas portrays three of his daughters engaged in a popular parlor game—an indoor version of pitching quoits (see figs. 79 and 106)—throwing colored rope or rattan rings over a target post set on a portable base.[79] Echoing *Las Meninas* are the studio setting; the

Fig. 135. John Singer Sargent. *The Daughters of Edward Darley Boit*, 1882. Oil on canvas, 87⅜ × 87⅝ in. (221.9 × 222.6 cm). Museum of Fine Arts, Boston. Gift of Mary Louisa Boit, Julia Overing Boit, Jane Hubbard Boit, and Florence D. Boit in memory of their father Edward Darley Boit 19.124

back of a large canvas, which serves as a *repoussoir;* the vivacious brushwork; and the youngest girl's interaction with the viewer.

In a 1909 review, the critic William Howe Downes commented that in *Ring Toss* "there is the element of portraiture, but without any of the formality or literalness usually associated with it."[80] This "element of portraiture" permits identification of the three girls. Nine-year-old Alice (Cosy), the eldest, wearing a yellow dress with a white pinafore, toes a chalked line on the polished hardwood studio floor while aiming her red ring; Koto Robertine, dressed in pale blue, crouches at left to retrieve a blue ring from under a rolling easel; and the youngest child, probably Dorothy, wearing a smocked white dress, waits her turn. Like Sargent's *Daughters of Edward Darley Boit* (fig. 135)—another modern variation on *Las Meninas* and a likely inspiration to Chase—*Ring Toss* employs an informal composition, compressed space, sketchlike rendering, and dispersed focus. These traits reflect not only Chase's appreciation for candor and trifling narrative, but also his sense that they are perfectly suited to "rendering the passing incident of child life," as a newspaper critic applauded in 1910.[81]

Comparing *Ring Toss* with earlier paintings of children at play—for example, Thomas Le Clear's *Young America* of about 1863 (fig. 74); Guy's *Contest for the Bouquet* of 1866 (fig. 86); or Homer's *Snap the Whip* of 1872 (fig. 89)—underscores its artfully accidental composition and free brushwork. Seeing it in relation to Cassatt's *Little Girl in a Blue Armchair* (fig. 114) points up Chase's reliance on the Impressionists' technique and their preference for minimal anecdote. Further, studying it alongside John George Brown's *Card Trick* (fig. 136) illuminates the distance between Chase's fresh technical and expressive candor and Brown's literalism, which was slipping from favor by the 1880s.

Born in Durham, England, in 1831 and schooled at Edinburgh's Royal Scottish Academy and New York's National Academy of Design, Brown was older than most of the artists who flourished in late nineteenth-century America, and he adhered to an English Victorian style typified by even older artists such as Le Clear (b. 1818) and Guy (b. 1824). One of the few American genre painters to deal with the subject of the urban poor, Brown specialized in sentimental depictions of industrious immigrants, especially youthful newsboys, bootblacks, and other street urchins who projected optimism and good cheer despite the hardships of city life—and were counterparts of Le Clear's 1853 *Buffalo Newsboy* (fig. 58), Horatio Alger's homeless fourteen-year-old bootblack, Ragged Dick, and other resourceful characters.[82] These ragamuffins flourished, and inspired Brown, until compulsory public education laws ended their enterprise.[83] *The Card Trick* is typical of Brown's paintings. In it,

three bootblacks, sitting on or leaning against their boxes, watch a skillful black youth perform a card trick. Avoiding the most offensive racial stereotypes such as the "darky minstrel," Brown ascribes street smarts and a gamesman's skills to this clever character.[84]

American appreciation of French art put Brown and other English-trained artists at an increasing disadvantage in the late nineteenth century. Chase and Brown, in fact, were considered avatars of their respective stylistic positions in a dispute about the New York jury's selection of paintings for display at the 1893 World's Columbian Exposition. Chase represented "modern French notions," which the jury greatly preferred; Brown, Frederic Remington, and their allies challenged that prejudice.[85] Yet, despite clinging to an outdated style, the long-lived, prolific Brown succeeded with patrons who gladly acquired his euphemistic genre scenes and the chromolithographs based on them. At the Chicago fair, for example, two of his paintings—*The Stump Speech* (early 1880s, private collection) and *The Card Trick*—sold for $2,500 and $1,200, respectively. As the curator Carolyn Kinder Carr concluded, "Clearly, those who believed that American art influenced by 'French method' would rule the day had nothing to fear when it came to sales."[86]

Avoiding Harsher Realities

The need to make their paintings marketable—particularly in competition with more serious, sometimes dour European works—may have encouraged American artists to temper candor with euphemism, emphasizing the positive aspects of the scenes they chose to paint rather than the disquieting transformations in modern life. They romanticized fading rural traditions and evaded the most emotive recent developments—industrialization, urbanization, and immigration—and the associated discord and civic disturbances. Ambivalent about change in a time of political and economic anxiety, they, like their patrons, preferred comfort to confrontation. Novelists also looked at their bewildering era through rose-colored glasses, reflecting Howells's recommendation in *Criticism and Fiction* (1891) that writers should "concern themselves with the more smiling aspects of life, which are the more American."[87] Neither Stephen Crane's account of a prostitute, *Maggie: A Girl of the Streets* (1893), nor Theodore Dreiser's story of hard times, *Sister Carrie* (1900)—both controversial when they were published—approaches in frankness the depressing drama of class struggle, urban malaise, and bleak poverty that Émile Zola described in *Nana* (1880).[88] The increasing feminization of culture also inflected American stories, as artists and writers strove to please female audiences and to reassure male patrons who preferred portrayals of genteel women, especially in the face of the suffrage

Fig. 136. John George Brown. *The Card Trick*, 1880–89. Oil on canvas mounted on panel, 26 × 31 in. (66 × 78.7 cm). Joslyn Art Museum, Omaha, Nebraska. Gift of the Estate of Sarah Joslyn JAM1944.14

movement and women's enhanced opportunities to work outside the home. Finally, artists' optimistic outlook in response to modern challenges expressed the nation's founding on faith in newness and rejection of Old World pessimism. The spirit of renewal that followed the Civil War was reflected in the popular metaphor that in America the streets were paved with gold. Even after 1900 when the Ashcan artists turned their attention to new urban realities, they rarely depicted hardship or degradation (see, for example, fig. 175).

Only a few mid- to late nineteenth-century painters—usually immigrants themselves—told stories about immigration, as did Charles Felix Blauvelt in *A German Immigrant Inquiring His Way* of 1855 (fig. 63); Henry Mosler in *Just Moved* of 1870 (fig. 88); John George Brown in *The Card Trick* and *Longshoremen's Noon* (fig. 155); and, perhaps most notably, Charles Ulrich in the ambitious *In the Land of Promise, Castle*

Garden (fig. 137). Thomas Hovenden's *Breaking Home Ties* (fig. 138), voted the most popular painting at the 1893 Chicago world's fair, is unusual in describing the era's epochal domestic migrations from country to city, or, perhaps, the departure of émigrés from Ireland, the artist's birthplace.[89]

Similarly, few painters of this period addressed the new labor conditions engendered by burgeoning industrialization. Industrial life had played a modest role in early nineteenth-century American art.[90] About 1815 the portraitist Bass Otis, the son of a blacksmith, had produced the monumental *Interior of a Smithy* (Pennsylvania Academy of the Fine Arts, Philadelphia); in 1829 John Neagle had celebrated the Philadelphia blacksmith Pat Lyon's labors (see fig. 11); and in 1848 Allen Smith Jr. had noted a young mechanic's achievements (see fig. 60). During the Civil War, John Ferguson Weir dramatically commemorated the casting of a Parrott

Fig. 137. Charles Ulrich. *In the Land of Promise, Castle Garden*, 1884. Oil on wood panel, 28⅜ × 35¾ in. (72.1 × 90.8 cm). Corcoran Gallery of Art, Washington, D.C. Museum Purchase, Gallery Fund 00.2

Gun for the Union army in *The Gun Foundry* (1864–66, Putnam County Historical Society, Cold Spring, New York). His peacetime pendant, *Forging the Shaft* (fig. 139), shows the fabrication of an ocean liner's propeller shaft. Weir's unusual industrial subjects translated into modern actualities the stories of Vulcan at the forge, the labors of Hercules, and other traditional pretexts for depicting heroic work.

Most late nineteenth-century artists skirted the themes of modern labor and industry by describing preindustrial toil, especially by European peasants. Associated with strength, resilience, piety, and discipline in the face of hardship,

peasants embodied time-honored rural values and were role models for industrial laborers. Peasants were chronicled at work or worship by scores of foreign masters such as Léon Bonnat, William Bouguereau, and Jules Breton, along with American expatriates and long-term European residents such as Walter Gay, Daniel Ridgway Knight, Walter MacEwen, Hovenden, and Henry Ossawa Tanner. Jules Bastien-Lepage's *Haymaking* (fig. 146) and *Peines de Coeur (Heartbreak)* (fig. 140) by Charles Sprague Pearce exemplify such images. Paintings of picturesque laborers who drew their livelihood from the soil and the sea in France, Holland, Germany,

Fig. 138. Thomas Hovenden. *Breaking Home Ties*, 1890. Oil on canvas, 52⅛ × 72¼ in. (132.4 × 183.5 cm). Philadelphia Museum of Art. Gift of Ellen Harrison McMichael in memory of C. Emory McMichael, 1942 1942-60-1

Fig. 139. John Ferguson Weir. *Forging the Shaft*, 1874–77. Oil on canvas, 52 × 73¼ in. (132.1 × 186.1 cm). The Metropolitan Museum of Art, New York. Purchase, Lyman G. Bloomingdale Gift, 1901 01.7.1

Spain, and England graced the walls of Americans whose new fortunes derived from mechanized farming and other modern production methods.

Even Winslow Homer, who eschewed cosmopolitanism, pursued picturesque subjects associated with foreign pre-industrial labor. Unlike most of his American contemporaries, who studied extensively at home and abroad, Homer had little formal training. Having only briefly visited Paris in 1866–67—to see two of his paintings displayed at the Exposition Universelle—he traveled in 1881 to England on his second and final transatlantic journey. After passing through London, he settled in Cullercoats, a village on the North Sea, remaining there from the spring of 1881 to November 1882. Cullercoats was a fishing community, which, like nearby Tynemouth, attracted artists and photographers in search of rustic surroundings and fisherfolk who preserved old customs, including regional costumes, folklore, and manual labor, and were willing to pose for artists. Working almost exclusively in watercolor, Homer responded to the strenuous and courageous lives of the inhabitants, especially the women whom he showed hauling and cleaning fish, mending nets, or standing at the water's edge, awaiting the return of their men.

Back in New York, Homer began work on a large canvas that embodied the theme of people in conflict with the sea that he had explored in England. The painting depicted a Cullercoats woman with a baby strapped to her back striding into the wind. In the background appeared the Life Brigade House, several men in foul-weather gear, and a large boat pulled up on the shore. Shown at the National Academy of Design in April 1883 as *The Coming Away of the Gale* (fig. 141), the picture disappointed most critics, including the writer for

Fig. 140. Charles Sprague Pearce. *Peines de Coeur (Heartbreak)*, ca. 1884. Oil on canvas, 61⅝ × 47⅜ in. (156.5 × 120.3 cm). Virginia Museum of Fine Arts, Richmond. The J. Harwood and Louise B. Cochrane Fund for American Art 2007.17

Fig. 141. Winslow Homer. *The Coming Away of the Gale*, ca. 1883. Albumen print, 4⅞ × 8⅝ in. (12.4 × 22.1 cm). Bowdoin College Museum of Art, Brunswick, Maine. Gift of the Homer Family 1964.69.176.1

The Nation, who complained about the monotonous palette and called the woman "conspicuously out of proportion and ill-drawn."[91]

Homer reworked the painting after settling in Prout's Neck, Maine, in the summer of 1883. He removed background details (although traces of the Life Brigade House remain visible under the white spray at the left), changed the sea's color from warm gray to light bluish green, and adjusted

the woman's proportions. In early spring 1893, the leading collector of American art, Thomas B. Clarke, purchased the canvas in its more harmonious, less explicit incarnation and submitted it as *A Great Gale* to the 1893 World's Columbian Exposition, where it was awarded a medal.[92]

This final version of the painting, now titled *The Gale* (fig. 142), exemplifies Homer's long-standing tendency to reconsider, minimize, or obscure narrative. Early in his career Homer had painted journalistic pictures such as *Pitching Quoits* from 1865 (fig. 79), but he was soon inclined to restrain specificity to create more subtle, iconic images. In *The Veteran in a New Field*, also from 1865 (fig. 82), he ignores agricultural technology, replacing a cradled scythe, which he had first depicted, with a single-bladed scythe that invokes the productive harvester's opposite: the Grim Reaper. In *Undertow* (fig. 143), he describes obliquely the rescue of two women who have been struggling in the surf. The bare-chested man at left drags ropes that have no perceptible function in relation to the victims. The woman at left—more like a Sleeping Ariadne than a drowning victim—seems to cup her chignon calmly.[93] The fisherman at right, wearing waders and a sou'wester hat, does not appear in any of Homer's preliminary drawings; in the painting he seems to limit his assistance to gripping the hem of the second victim's bathing

Fig. 142. Winslow Homer. *The Gale*, 1883–93. Oil on canvas, 30¼ × 48¼ in. (76.8 × 122.7 cm). Worcester Art Museum, Massachusetts. Museum Purchase 1916.48

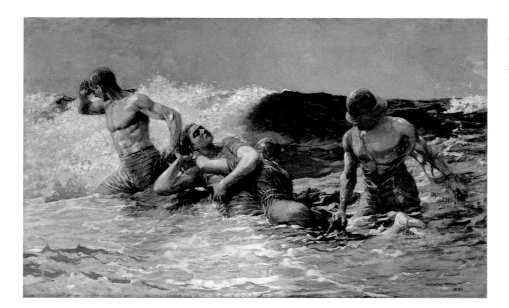

Fig. 143. Winslow Homer. *Undertow*, ca. 1886. Oil on canvas, 29¾ × 47⅝ in. (75.7 × 121 cm). Sterling and Francine Clark Art Institute, Williamstown, Massachusetts 1955.4

Fig. 144. Winslow Homer. *Northeaster*, 1895. Oil on canvas, 34½ × 50 in. (87.6 × 127 cm). The Metropolitan Museum of Art, New York. Gift of George A. Hearn, 1910 10.64.5

dress.[94] Such challenges to "absolute truth of fact," for which one critic commended *Undertow*, suggest that the picture—like *The Veteran in a New Field*—is more symbolic than documentary.[95]

Of Homer's revisions to *The Gale*, the curator Franklin Kelly remarked: "The result was a remarkable hybrid in which a sturdy Cullercoats fisherwoman was transported to the ledges of Prout's Neck, her forceful demeanor placed in opposition to the ocean's power."[96] The fisherwoman was also transported from the realm of Homer's subtle 1880s narratives to that of his silent 1890s narratives, like the final version of *Northeaster* (fig. 144), which captures a furious storm at Prout's Neck, where—except for vacation trips to the Adirondacks, Canada, Florida, and the Caribbean—he would live until his death. When this painting appeared on exhibition at the Pennsylvania Academy of the Fine Arts in 1895–96, shortly

Fig. 145. Winslow Homer's *Northeaster*, as exhibited in Philadelphia, before changes. From *Harper's Weekly* 40 (February 15, 1896), p. 149

Fig. 146. Jules Bastien-Lepage. *Haymaking*, 1877. Oil on canvas, 63 × 76¾ in. (160 × 195 cm). Musée d'Orsay, Paris, France RF 2748

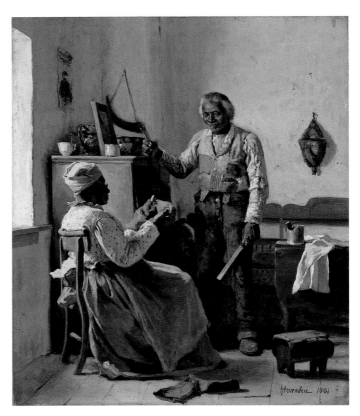

Fig. 147. Thomas Hovenden. *Sunday Morning*, 1881. Oil on canvas, 18¼ × 15½ in. (46.4 × 39.4 cm). Fine Arts Museums of San Francisco. Museum purchase, Mildred Anna Williams Collection 1943.1

after its completion and its purchase by Clarke, it included two men in foul-weather gear crouched below the column of spray, which was less massive (fig. 145).[97] Although *Northeaster* was well received, Homer reworked it before December 1900 with Clarke's permission. Painting over the figures, he limited the scene to "three fundamental facts, the rugged strength of the rocks, the weighty, majestic movement of the sea and the large atmosphere of great natural spaces unmarked by the presence of puny man," as a critic applauded in 1901.[98] Thus purged of "puny man" and, thereby, of a human story, *Northeaster* typifies Homer's monumental late seascapes and, like *The Gale*, suggests how he shared his era's indifference to obvious narrative.

Lacking peasants as subjects, Americans painting in the United States portrayed rural workers who embodied nostalgic recollections of small farms and old country ways as modern farming developed into big business. Eastman Johnson had recorded cranberry harvesters, cornhuskers, maple-sugar makers—as in *Sugaring Off* of about 1865 (fig. 69)—and other nationally distinctive white agricultural laborers,

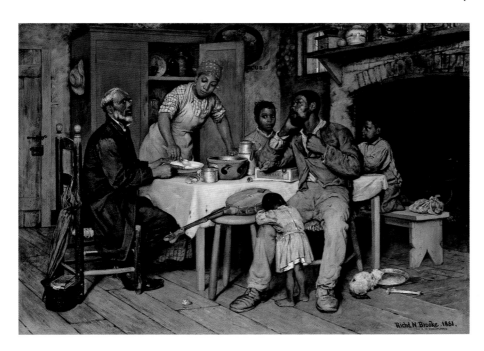

Fig. 148. Richard Norris Brooke. *A Pastoral Visit*, 1881. Oil on canvas, 47¾ × 65¾ in. (121.3 × 167 cm). Corcoran Gallery of Art, Washington, D.C. Museum Purchase, Gallery Fund 81.8

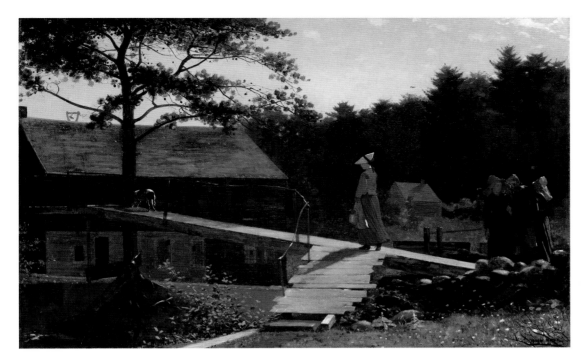

showing them as exemplars of the beauty of work in harmony with nature. Other artists turned to emancipated African Americans, usually casting a positive light upon them and their lives. Although the free blacks in Homer's *Cotton Pickers* of 1876 (fig. 101) and Thomas Anshutz's *The Way They Live* (1879, The Metropolitan Museum of Art) labor as they had as slaves, their demeanor is less dispirited than that of the French peasants who inhabit Bastien-Lepage's *Haymaking* (fig. 146). Home from studying in Paris and chronicling rustic types in Pont-Aven, Brittany, Hovenden painted *Sunday Morning* (fig. 147), as well as *Dat Possum Smell Pow'ful Good* (1881, Fleming Museum at the University of Vermont, Burlington) and similar canvases that portray rural African Americans respectfully despite his use of racially stereotyped titles. Richard Norris Brooke, a veteran of Bonnat's Paris studio, similarly dignified the lives of rustic black Americans in *A Pastoral Visit* (fig. 148), and Tanner—like Hovenden and Brooke, a painter of European peasant subjects—signaled the virtue of an African American man and a child who ask a blessing before a frugal meal in *The Thankful Poor* (1894, William H. and Camille O. Cosby).[99]

As early as 1871, Homer had noted industry's incursion into the countryside with *Old Mill (The Morning Bell)* (fig. 149), in which the bell atop a dark, dilapidated mill summons to work a young woman who crosses a precarious ramp from a sunny meadow. The scene thus suggests the mixed blessings of the nation's transformation from an agrarian to an industrialized society and the emergence of new opportunities for women. As industrialization accelerated, American artists celebrated craftspeople who preserved manual skills learned by family instruction, apprenticeship, and workshop cooperation. Scenes of craft genre (showing artisans at work) embody the nostalgic spirit of the Art and Crafts movement, which arose from aversion to mechanization and was reinforced by displays of handicraft at Philadelphia's Centennial exhibition.[100] Images of hand manufacture also anticipate the American Renaissance, a movement that matured in the

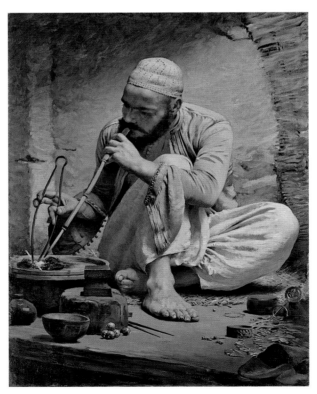

Fig. 150. Charles Sprague Pearce. *The Arab Jeweler*, ca. 1882. Oil on canvas, 46 × 35⅜ in. (116.8 × 89.9 cm). The Metropolitan Museum of Art, New York. Gift of Edward D. Adams, 1922 22.69

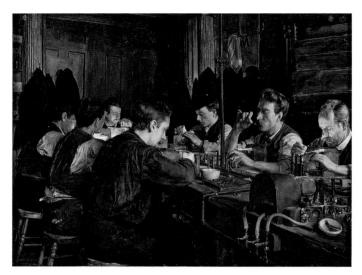

Fig. 151. Charles Ulrich. *The Glass Blowers*, 1883. Oil on panel, 17¾ × 22⅝ in. (45 × 57.5 cm). Museo de Arte de Ponce. The Luis A. Ferré Foundation, Inc., Ponce, Puerto Rico 58.0034

artisan and a detailed record of his physiognomy, clothing, and tools. Ulrich documents workers in glass, from New Yorkers producing glass eyes in *The Glass Blowers* (fig. 151) to Venetians following traditional practices in *Glass Blowers of Murano* (1886, The Metropolitan Museum of Art).[101] Some painters register time-honored women's skills, such as lace making, fashioning artificial flowers, or other piecework that allowed them to eke out a living at home while fulfilling their domestic obligations.[102] Others portray genteel women crocheting, sewing, or knitting, handicrafts that ignored the shift to factory work and machine manufacture by less privileged women.

Depictions of painters and sculptors at work are related to scenes of craft genre. George de Forest Brush's *Picture Writer's Story* (fig. 152) merges the traditional studio theme with ethnography. Brush had received two years of instruction at New York's National Academy of Design under Lemuel Wilmarth, Gérôme's first American student, before studying under the French master himself in 1873. Returning to the United States in 1880, he sought his subjects in the American Indian tribes he lived among in the early 1880s, and in Canadian tribes, whom he observed between 1886 and 1888. Native Americans offered Brush an excuse to paint the nude, the fundamental Beaux-Arts exercise, and provided subjects

1890s and valued Italian Renaissance studio procedures and collaboration among architects, painters, sculptors, and artisans in various decorative media. In *The Arab Jeweler* (fig. 150), an ambitious example of craft genre and of the era's cosmopolitan interests, Pearce offers a dramatic close-up of an exotic

Fig. 152. George de Forest Brush. *The Picture Writer's Story*, ca. 1884. Oil on canvas, 23 × 36 in. (58.4 × 91.4 cm). Courtesy of The Anschutz Collection

analogous to the exotic North Africans whom Gérôme had depicted. Like Gérôme, Brush sketched during his travels and collected artifacts and, possibly, photographs for reference; he also worked from models in his studio. *The Picture Writer's Story* portrays the interior of a Mandan lodge, where a painter describes to two younger tribesmen the battle he has documented on a buffalo hide, thereby passing down in picture and oral narrative his tribe's history and cultural heritage.[103] Brush's scene thus encodes the ideal of age instructing youth, which appears in many pedagogical narratives of the period, such as Eakins's *Negro Boy Dancing* (1878, The Metropolitan Museum of Art) as well as Tanner's *Banjo Lesson* (fig. 153) and *Young Sabot Maker* (1895, Nelson-Atkins Museum of Art, Kansas City).

As Brush explained in a May 1885 article in *Century Magazine*, which reproduced a full-page engraving of *The Picture Writer's Story*, he wished to express the universality of human experience in his paintings of American Indians: "I do not care to represent them in any curious habits which could not be comprehended by us; I am interested in those habits and deeds in which we have feelings in common."[104] To suggest universality, he quotes figures from Michelangelo's Sistine Chapel ceiling (1508–12). *The Libyan Sibyl*, seen in reverse, becomes the picture writer, and Adam, from the *Creation of Adam*, is cast as the torpid young man at the right, who might be energized by hearing and seeing the picture writer's story.[105] Brush's interest in Native Americans coincided with the field research of the Smithsonian's Bureau of American Ethnology, founded under John Wesley Powell's direction in 1879, and the work of ethnographers such as William Henry Holmes. Brush was sympathetic to Native Americans in an era marked by extremes of belief, from the opinion—attributed to General Philip Sheridan—that "the only good Indian is a dead Indian," to Helen Hunt Jackson's outrage at the federal government's dishonorable treatment of them.[106]

The few late nineteenth-century American painters who grappled with contemporary industry tended to minimize the inherent drama and hardship. Exceptions included Weir's ambitious efforts of the 1860s and 1870s. In *The Strike* (fig. 154), the German-born, Munich-trained, Minneapolis-based academic Robert Koehler depicts labor unrest, an unusual subject for artists despite the frequent and brutal disputes that arose between large militant unions and management. This monumental canvas dismayed viewers at the National Academy of Design, New York, in April 1886. Ironically, it was a year of extreme conflict marked by Chicago's bloody Haymarket Square riot on May 4. A *New York Times* critic, apparently troubled by Koehler's directness, tried to dissociate *The Strike* from American ways by emphasizing its ethnic references: "The angry mechanics, grouped in irregular fashion behind their spokesman, offer a

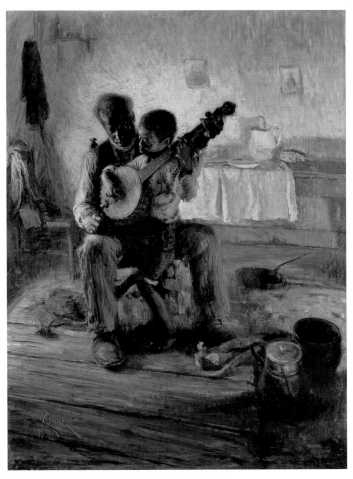

Fig. 153. Henry Ossawa Tanner. *The Banjo Lesson*, 1893. Oil on canvas, 49 × 35½ in. (124.5 × 94.2 cm). Hampton University Museum, Hampton, Virginia

remarkable series of workman types both German and Irish; their figures are natural, their gestures generally expressive, and their faces neither too furious nor too shiny nor too much begrimed." He was particularly irked by the portrayal of a beggar woman and her children in the foreground, protesting that "American workmen are not beggars, nor do their women become so through the fault of capitalists."[107] Koehler himself defensively underscored his painting's foreign connections, claiming that although he was inspired by an 1877 Pittsburgh railroad strike, he painted the canvas later in Munich from studies of workers he had made in England.[108] Thereafter, he avoided melodramatic or moralizing subjects and concentrated on portraits and landscapes.

Although frank accounts of contemporary laborers appeared in the popular press, the few painters who depicted them usually highlighted "the more smiling aspects" of their lives and work, rarely hinting at class struggles, wage disputes, competition for jobs, or other economic hardships faced by immigrants and black migrants to northern cities.[109] Brown's *Longshoremen's Noon* (fig. 155), the period's most ambitious representation of adult male workers, is typical of

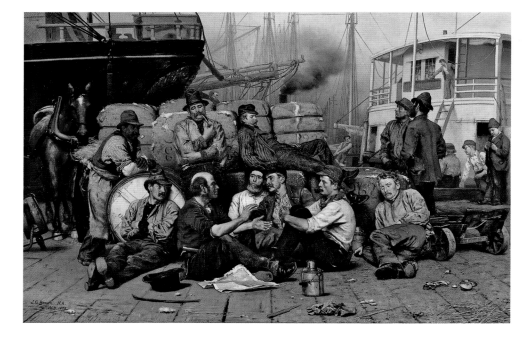

this trend. On a waterfront stage detailed down to a scattering of debris, Brown deploys a circle of carefully described and costumed types, "with the different nationalities and characters well observed and discriminated," as the critic Samuel Isham later applauded.[110] Brown's canvas emphasizes rest, recreation, and camaraderie despite the characters' differing ages and ethnic backgrounds. The literary historian Thomas H. Pauly has concluded that "his longshoremen are derivative from George Caleb Bingham's merry boatman [see, for example, fig. 49]. . . . They work the old-fashioned sailing ships clustered in the background. Even though he duly records a smoking chimney, Brown has shaped his material so that it is purged of disruptive industrial implications—or, for that matter, all negative implications."[111]

Brown's well-known picture may have prompted Anshutz to paint *The Ironworkers' Noontime* (fig. 156)—which also depicts a lunch break—the following year. On a canvas about half the size of *Longshoremen's Noon*, Anshutz challenged Brown's sentimental, English-Victorian approach to storytelling, demonstrating instead Parisian academic principles that he had absorbed beginning in 1878 under Eakins at the Pennsylvania Academy.[112] Born in Newport, Kentucky, Anshutz had moved with his family to Wheeling, West Virginia, at age twelve and was familiar with the factories along the Ohio River. During one of his annual trips back to Wheeling to visit his mother and his wife's family, he sketched workers in successive poses, preparing to depict them in the yard of an iron-nail factory at midday. Even more so than

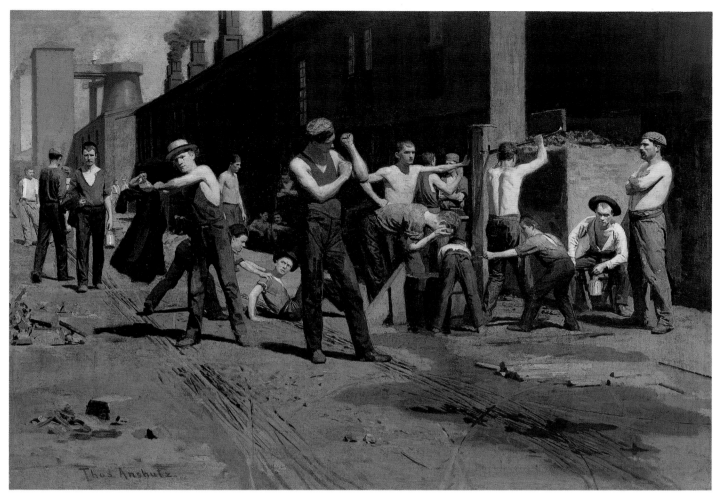

Fig. 156. Thomas Anshutz. *The Ironworkers' Noontime*, 1880. Oil on canvas, 17 × 23⅞ in. (43.2 × 60.6 cm). Fine Arts Museums of San Francisco. Gift of Mr. and Mrs. John D. Rockefeller 3rd 1979.7.4

Brown's carefully detailed dock, this yard, with its bleak factory buildings, belching smoke, and rusting iron bars, is the sort of dreary industrial setting from which most other late nineteenth-century American painters averted their eyes.

Anshutz focuses on the twenty-five muscular puddlers (metal workers) of differing ages—several stripped to the waist—who stretch, eat, or sit in the sun. The figures appear frozen in a series of classical poses derived from life-drawing instruction, much like the figures Eakins would portray five years later in *Swimming* (fig. 157). "The men stretch and bend as if they were the idealized, youthful athletes represented in Greek and Roman sculpture, spread across a commemorative frieze," the curator Daniell Cornell observed of Anshutz's scene.[113] In Brown's *Longshoremen's Noon*, the narrative of workers passing time in jovial banter is simple and clear. By contrast, most of the puddlers in *The Ironworkers' Noontime* are lost in private thoughts, and the narrative is open to multiple interpretations. It was probably in 1884 that the Strobridge Lithography Company of Cincinnati, Ohio, adapted *The Ironworkers' Noontime* for a large outdoor poster to market Procter & Gamble's recently introduced Ivory Soap,

adding to the right foreground tubs in which the puddlers could wash up.[114] Alternatively, a commentator describing the painting in the catalogue for an 1891 exhibition of the Clarke collection emphasized labor's toll upon the men: "At the stroke of noon the toilers at forges and furnaces emerge into the cinderous outer precincts of the foundry, for a brief respite from labor, and refreshment against labor yet to come. Utter weariness and the robust strength of abundant manhood are seen in contrast. One young giant stretches his powerful limbs, as if shaking off his chains. Others exhaust their superfluous vitality in a mock battle. Some seek refreshment in drenching their hot and grimy bodies with water, and others sink listlessly into supine repose."[115] In 1939 *The Ironworkers' Noontime* was read as a celebration of the relations between American workers and employers, and in 1994 it became a representation of evolving labor conditions.[116]

In an insightful 2005 account, Cornell proposed that Anshutz's painting encodes nostalgia for such labor by portraying nail making as it would have been conducted during the artist's youth in Wheeling. Noting that the highly adept puddlers were charged with making the metal sheets from

which nails would be cut, Cornell suggested that they could be read as quiet heroes in an era when factories diminished the role of skilled workers. In the context of feminized late nineteenth-century American culture, they could also be esteemed for their "rugged manliness" and their association with "an earlier definition of masculinity that was clearer and more traditional."[117] In its dependence upon French rather than English stylistic and expressive formulas, and its susceptibility to various readings, Anshutz's painting is much more typical of its period than Brown's, which, although painted only a year earlier, clings to midcentury expressive and compositional strategies. Although Anshutz's canvas was awarded a prize as the best work of art exhibited at the Philadelphia Sketch Club in winter 1880–81, it was not sold until Thomas B. Clarke purchased it in late summer 1883.[118]

Models of Masculinity

Anshutz's *Ironworkers' Noontime* signals the legacy of Eakins, who painted nearly nude men in convincing modern settings; adhered to narrative reticence; and based his teaching on study from life. Eakins's *Swimming* (fig. 157) has been the focus of more scholarly scrutiny and speculation than, perhaps, any other work in our exhibition. Thus, it provides an object lesson in a painted story's ability to provoke diverse readings and a cautionary example to any interpreter. Eakins began work on *Swimming* in summer 1884 in response to a lucrative commission from Edward Hornor Coates, a Pennsylvania Academy of the Fine Arts trustee who was named head of the Committee on Instruction in 1883. It is likely that Coates's interest would have motivated Eakins to paint a manifesto of his teaching principles and to expect that the resulting canvas would someday enter the Academy's collection. On a summer's day at Dove Lake, near Bryn Mawr, Pennsylvania, Eakins sketched and photographed his students taking a break from their schoolwork. While he based *Swimming* on these studies, he also signaled in it his own involvement with motion photography and that of Eadweard Muybridge, who was working at the University of Pennsylvania under the scrutiny of a committee that included Eakins. In *Swimming* Eakins portrays six men in a sequence of action and repose—swimming, climbing out, drying off, stretching, standing, and diving in again. The artist shows himself as the swimmer at the lower right who follows his setter dog, Harry, toward an old stone foundation around which the action unfolds.

While the figures' sequential movements reflect modern motion photography, their individual poses pertain to traditional life studies from the human nude (*académies*), exercises that were central to the curriculum at the École des Beaux-Arts, where Eakins had studied from 1866 to 1869, and the

Pennsylvania Academy, where he had taught since 1876 (see fig. 158). Eakins's positioning of typical *académies* within the outline of a classical temple pediment also refers to Beaux-Arts tradition. By thus combining up-to-date and long-established artistic practices, Eakins summed up in *Swimming* his distinctive approach to pictorial construction.

Eakins also demonstrated in *Swimming* his long-standing subject interests and his characteristic narrative reticence. From the beginning of his career, he had portrayed nearly nude male figures in personally significant modern settings, and he had done so with narrative subtlety. His emotionally reserved, enigmatic *Champion Single Sculls (Max Schmitt in a Single Scull)* of 1871 (fig. 97) is a case in point, especially by comparison with analogous earlier images such as Bingham's ebullient, unambiguous *Jolly Flatboatmen* of 1846 (fig. 49). Eakins's expository restraint peaked in *Swimming*. Describing self-contained figures in a silent world, he evokes a scene from antiquity—as he does in his contemporaneous Arcadian pictures—but he avoids legible narrative. Accordingly, *Swimming* has invited various interpretations, many of which the scholar Marc Simpson summarized in the catalogue of an exhibition devoted to the canvas.[119] Simpson observed that after an "inauspicious debut" and decades of neglect of both Eakins himself and the painting, *Swimming* was esteemed by mid-twentieth-century writers as "a veristic depiction of a real event manipulated by the artist's will and sensibility."[120] He continued: "Since the 1970s, most (but by no means all) writers have conceded the quality of *Swimming* and claimed for it a high place within any consideration of Eakins's career. They have then proceeded to use the work to explore at least one of three different themes: the Americanness of the painting and its subject, the role of photography in its development, or its apparent invitation to speculate on the sexuality of the artist."[121] Summarizing those interpretations, Simpson concluded that the image remains inscrutable: "The final words have not yet been—and probably never will be—spoken. The taut balances and enigmatic oppositions that Eakins so skillfully developed, consciously or no, in *Swimming* promise that the work's fascination will continue to prompt diverse readings and discordant assessments, allowing the painting to play many roles in different personal, cultural, and art-historical narratives."[122] As we read American scenes of everyday life—especially the subtle or silent ones that predominated between the Centennial and World War I—we realize that the stories told depend upon who is listening, and we concede that our own interpretations may be reconsidered and challenged.

By the mid-1880s, discontent had arisen at the Pennsylvania Academy concerning Eakins's emphasis on studying the nude. In January 1886, while lecturing about the pelvis to a class that included women, he removed a loincloth from a male model so that he could trace the course of a muscle.

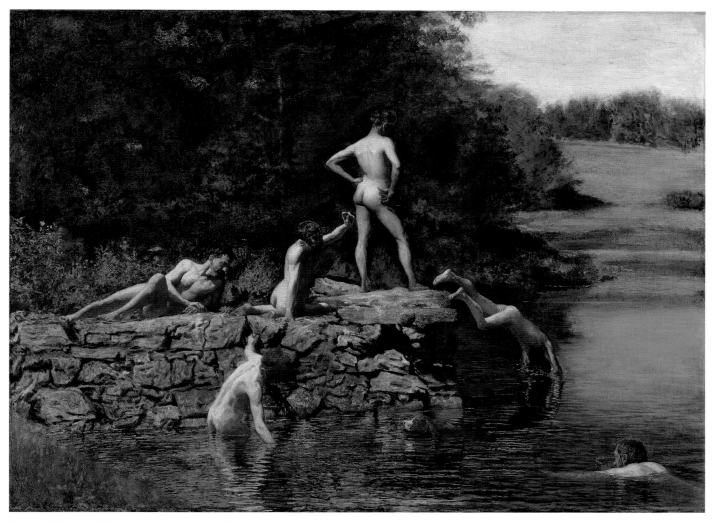

Fig. 157. Thomas Eakins. *Swimming*, 1885. Oil on canvas, 27⅜ × 36⅜ in. (69.5 × 92.4 cm). Amon Carter Museum, Fort Worth, Texas. Purchased by the Friends of Art, Fort Worth Art Association, 1925; acquired by the Amon Carter Museum, 1990, from the Modern Art Museum of Fort Worth through grants and donations from the Amon G. Carter Foundation, the Sid W. Richardson Foundation, the Anne Burnett and Charles Tandy Foundation, Capital Cities/ABC Foundation, Fort Worth Star-Telegram, The R. D. and Joan Dale Hubbard Foundation and the people of Fort Worth 1990.19.1

Angry protests by parents and students forced the trustees to request his resignation as the Academy's director. As his status declined, Eakins's art also changed: he shifted his attention from multifigure or narrative compositions to probing individual portraits, usually of friends and acquaintances. An exception was an 1898–99 series devoted to boxing and wrestling, in which he returned to male athletics, his groundbreaking theme of the early 1870s. Like his early rowing pictures (see fig. 97), his boxing and wrestling scenes reflect his enthusiasm for those pastimes, but they are even more transgressive in their subject matter. While the popular press of about 1900 featured prizefighting images, and boxers such as John L. Sullivan and James John "Gentleman Jim" Corbett commanded national headlines, most artists ignored the topic of ring sports in their work.

Fig. 158. J. Alden Weir. *Study of a Male Nude Leaning on a Staff*, 1876. Oil on canvas, 25½ × 31½ in. (64.8 × 80 cm). Yale University Art Gallery. Gift of Julian Alden Weir 1914.13

Fig. 159. Thomas Eakins. *Between Rounds*, 1898–99. Oil on canvas, 50⅛ × 39⅞ in. (127.3 × 101.3 cm). Philadelphia Museum of Art. Gift of Mrs. Thomas Eakins and Miss Mary Adeline Williams, 1929 1929-184-16

Having made photographs of his students boxing and wrestling in 1883–84, and having attended prizefights with his student and friend the sculptor Samuel Murray, Eakins painted these activities with his usual investigative zeal.[123] *Between Rounds* (fig. 159), his most complex interior scene, is set in the Arena, a Philadelphia venue for boxing from 1892 until May 1899.[124] Although the Arena, erected in 1886, was located on the northeast corner of Broad and Cherry streets, diagonally across from the Pennsylvania Academy, it was a world away culturally. As Simpson observed, "The moral and legal questions concerning prize-fighting, its sanctioned violence, and the indulgence in gambling and alcohol that took place around it separated its adherents from the more genteel elements of the city."[125] In *Between Rounds*, Eakins provides the viewer with a ringside seat in the Arena's large, circular space, hung with theatrical posters. As he had done in *Singing a Pathetic Song* (fig. 119), *Swimming*, and many other paintings, here he fabricates a pictorially harmonious reality from carefully studied individual elements. He invited Billy Smith, a Philadelphia featherweight, to pose for the boxer; added other figures from the boxing world—the timekeeper, varied journalists in the press box, seconds, and a uniformed policeman—who reenacted their real-life roles in his Chestnut Street studio; and enlisted friends and relatives to pose for the spectators.[126] As usual, he ignores no fact—the fighter's soft leather ankle-high boots, the timekeeper's shiny leather shoes, the creases on the young second's blue shirt, and the turnings of the wooden chair, table, and stool—to make his detailed diorama utterly convincing.

The placard at the upper left announces the program for April 22, 1898, in which Smith's bout closed the evening. As Eakins had done when he depicted Max Schmitt in a quiet late-afternoon practice session on the Schuylkill rather than in his epochal championship race, he minimizes drama here, showing Smith catching his breath rather than struggling against Timothy Callahan, his unseen—and ultimately successful—opponent. Spotlighted in the smoke-filled Arena, Smith's face and neck are ruddy, but his slender, muscular body is pale to the point of ghostliness; his white briefs, worn without the usual colored sash, make him appear nearly nude at first glance.[127] He rests on a stool, awaiting the timekeeper's signal. His impending activity is signaled only by his flexed arms, his taut grip on the ropes, and by the towel—the painting's most activated form—that the young handler waves over him. Eakins's most developed genre scene, *Between Rounds* exemplifies his preference for narrative understatement.

The exhausted Billy Smith seems charged with energy, however, by comparison with the torpid protagonist of Homer's *Gulf Stream* (fig. 160). In December 1884, in response to a commission from *Century Magazine* for illustrations to accompany an article on Nassau, the capital of the Bahamas, Homer had made his first of many trips to tropical locations. From December 1898 to February 1899, he was again in the Bahamas, where, in one of the most productive periods of his later years, he painted at least twenty-five splendid watercolors. Infused with the dazzling light of southern latitudes, these large sheets are perfect counterparts to his contemporaneous Prout's Neck seascapes such as *Northeaster* (fig. 144). Although most of Homer's tropical watercolors record everyday life among the islands' black population, a few, such as *After the Hurricane, Bahamas* (1899, The Art Institute of Chicago), explore the irony of tragedy in the face of brilliant sunshine.

On his visits to the tropics, including that in the winter of 1898–99, Homer often crossed the Gulf Stream, a warm Atlantic current running from the Gulf of Mexico to the Arctic, known for its dark blue waters, rough waves, and furious storms. In *The Gulf Stream*, painted back in the artist's Prout's Neck studio in 1899, a muscular Bahamian man with a vacant gaze awaits his fate on a dismasted, rudderless fishing boat. Sustained by a few stalks of sugarcane scattered on the deck and threatened by sharks churning up a choppy, blood red sea, he seems oblivious to the waterspout on the horizon at the right and the distant schooner on the horizon at the left. The painting sums up many of Homer's earlier interests, including the lives of people of color, whom he had painted in the 1860s and 1870s—as in *The Cotton Pickers* (fig. 101) and *Dressing for the Carnival* (fig. 102). He also revives the subject of the perils of the sea, which had preoccupied him in the 1880s in works such as his initial iteration of *The Gale* (fig. 142) and in *Undertow* (fig. 143).

Having reduced narrative in paintings of the 1890s, as exemplified by *Northeaster*, Homer reversed course in *The Gulf Stream*, tempting the viewer to become involved in a story and then amplifying it as he developed the painting over time. As the canvas appeared on Homer's easel in a photograph taken in his Prout's Neck studio in 1899, and in the catalogue of the annual exhibition at the Pennsylvania Academy of the Fine Arts in January 1900, the vessel had no name, the starboard gunwale was intact, and the horizon on the left was empty (see fig. 161).[128] After the exhibition closed, Homer inscribed the vessel "Annie—Key West," broke the starboard gunwale, placed a sail over it, and added the schooner, which offers hope of deliverance. In 1900 and 1901, Homer showed *The Gulf Stream* at the Carnegie Institute, Pittsburgh, at Knoedler and Company in New York, and in an exhibition in Venice. The Worcester Art Museum considered purchasing it in early 1902, but two women on the museum's board objected to its "unpleasantness." When asked for an explanation, Homer mocked their pursuit of a literal interpretation: "You can tell these ladies that the unfortunate negro who now is so dazed & parboiled, will be rescued & returned to his friends and home, & ever

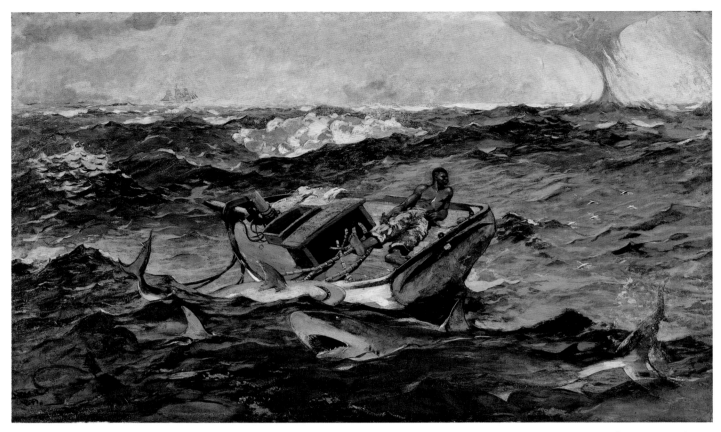

Fig. 160. Winslow Homer. *The Gulf Stream*, 1899. Oil on canvas, 28⅛ × 49⅛ in. (71.4 × 124.8 cm). The Metropolitan Museum of Art, New York. Catharine Lorillard Wolfe Collection, Wolfe Fund, 1906 06.1234

after live happily."[129] In 1906, The Metropolitan Museum of Art acquired *The Gulf Stream*—its first painting by Homer—from the 1906–7 winter exhibition at New York's National Academy of Design.

Homer's sarcastic rejoinder to "these ladies" implied, probably disingenuously, that in *The Gulf Stream* he was merely recounting a tropical fisherman's unfortunate fate. In announcing the purchase, Bryson Burroughs, the Metropolitan Museum's curator, suggested that a more profound message was latent in the canvas: "This is a story-telling picture, and the story assumes the proportion of a great allegory if one chooses."[130] Homer had hinted at allegory in 1865 when he minimized agricultural technology in *The Veteran in a New Field* (fig. 82). Perhaps in pursuit of deeper meanings, he again

Fig. 161. Winslow Homer's *The Gulf Stream* as exhibited in Philadelphia, before changes. From the *Pennsylvania Academy of the Fine Arts Catalogue of the Sixty-ninth Annual Exhibition, January 15 to February 24, 1900.* Courtesy of the Pennsylvania Academy of the Fine Arts, Philadelphia

seems to have flouted actualities in *The Gulf Stream*. The man's passivity despite his powerful physique, the fact that he dwarfs his tiny boat and miraculously remains in place on the pitching deck without cleats against which to anchor himself, and the almost cartoonish sharks suggest that Homer intended an emblematic rather than a factual statement.[131]

Just as they have gone beyond a straightforward reading of Melville's *Moby-Dick* (1851) as the tale of men pursuing a whale to consider its more complex content, scholars—including just a few cited here—have tried to sort out *The Gulf Stream's* larger implications. Concentrating on art historical references, the curator Natalie Spassky viewed the painting in relation to the Romantic tradition, including the "celebrated epic treatments of maritime disasters," such as Copley's *Watson and the Shark* from 1778 (fig. 10), and its European successors, including Théodore Géricault's *Raft of the Medusa* (1818–19, Musée du Louvre, Paris) and J. M. W. Turner's *Slave Ship* (1840, Museum of Fine Arts, Boston), all of which Homer would have known.[132] Subsequent observers have read *The Gulf Stream* in relation to the American social, political, and cultural milieu of about 1900. The art historian Albert Boime claimed that "Homer's besieged fisherman is an allegory of black people's victimization at the end of the nineteenth century." He linked the painting to the Spanish-American War, which forced the United States to "reconcile its institutionalized racism with multiracial societies in Cuba and Puerto Rico," and to the period's Social Darwinism and the "unparalleled outburst of racist speculation on the impending disappearance of the American Negro."[133] The curator Nicolai Cikovsky Jr. considered the painting in relation to the artist's biography: "Homer painted *The Gulf Stream* when he was sixty-three years old, in the year following the death of his father, his one surviving parent, and in the last year of the century—a confluence of circumstances, despite Homer's advanced age, that might all too easily have caused him to feel, as never before, alone, abandoned, and mortally vulnerable."[134] The art historian Paul Staiti studied *The Gulf Stream* in light of contemporary race relations and in terms of thermodynamic physics and its cultural applications at the turn of the century. He summarized the painting's narrative thus: "Nature is a death machine with a black man in its maw, consuming matter thoughtlessly, much as the industrial colossus blindly consumes iron, wheat, and bodies."[135] The historian Peter H. Wood pursued additional connotations of *The Gulf Stream* by examining it against the legacy of the slave trade, the emergence of Jim Crow practices in the South, the Spanish-American War and American imperialism in the Caribbean, and the publication of Rudyard Kipling's poem "The White Man's Burden" (1899).[136] As is the case with other paintings that seem to ask as many questions as they answer, what *The Gulf Stream* represents depends upon who is noticing.

Between the Centennial and World War I, cowboys and cavalrymen emerged as stars of fiction, art, the burgeoning popular press—newspapers, magazines, dime novels—and motion pictures.[137] While Albert Bierstadt, Thomas Moran, and Thomas Hill continued to produce awesome landscape panoramas of the West, as they had done since the 1860s, figure painters transferred their attention from the trans-Allegheny "buckskin brigade"—Daniel Boone, Davy Crockett, and other scouts, fur trappers, mountain men, and pioneers (see figs. 51–54, for example)—to cowboys and cavalrymen, who became the new folk heroes of the West and avatars of mythic national ideals.[138] This shift grew out of complex and overlapping developments and provoked sometimes paradoxical sentiments. The closing of the frontier, announced by the U.S. Bureau of the Census in 1890, triggered anxiety that a cornerstone of the American character had vanished, leading to the romanticization of the trans-Mississippi West and the desire to glorify its remnants.[139] Four transcontinental railroad lines, completed between 1869 and 1883, and four government-sponsored "Great Surveys," undertaken between 1869 and 1879, brought further attention to the West and increased its accessibility. Explorers, journalists, and other visitors arrived in force; physicians even prescribed "camp cures" for physical and emotional rejuvenation.[140] By 1890, cattle were being raised on ranches in pastures fenced with barbed wire (patented in 1873 and 1874) and sent to market on new railroad trunk lines.

These changes elicited nostalgia for the open range and for the great cattle drives along the Chisholm Trail from Texas to the Kansas stockyards. The government's slaughter of the buffalo herds and the ensuing starvation and decimation of native peoples—with the survivors' confinement to restricted lands—freed whites, who had earlier applauded bloody cavalry battles, to memorialize Native Americans as a noble, doomed race that had lived in harmony with nature. Growing industrialization and urbanization underscored by contrast the value of virgin wilderness and rural ideals, including the cowboy's independence, hard-work ethic, self-reliance, and freedom from social restraint. American culture's saturation with genteel domesticity, sentiment, and feminine taste inspired a yearning for authentic masculine heroes, rugged Anglo-Saxons with true grit who tested their manhood in dangerous lands inhabited by savage beasts and barbarous Indians. Easterners who had instigated the region's commercial development welcomed accounts of the winning of the West in the hope of attracting settlers, visitors, and investors and of assuaging fears that railroad construction, mining, clear-cutting, and predatory capitalism had despoiled it.

Curious and resourceful writers, painters, and sculptors—and, by 1903, with the debut of Edwin S. Porter's *Great Train Robbery*, filmmakers—fed the cult of the cowboy and cavalryman and, ultimately, the outlaw, sheriff, and posse. They

Fig. 162. Charles Schreyvogel. *My Bunkie*, 1899. Oil on canvas, 25⅛ × 34 in. (64 × 86.4 cm). The Metropolitan Museum of Art, New York. Gift of friends of the artist, by subscription, 1912 12.227

traveled west, absorbed frontier history, collected western paraphernalia, and later—usually in New York studies or studios—wrote, painted, sculpted, and drew their stories. Improved technology stimulated the growth of *Harper's Weekly*, *Collier's Weekly*, *Outing*, and other magazines that served a national audience eager to experience the adventurous but harsh and sometimes violent lives of cowboys and cavalrymen. Between 1883 and 1916, Buffalo Bill Cody—Civil War veteran, bison hunter, and hugely successful impresario—organized Wild West shows, sometimes featuring as many as eight hundred actors and five hundred animals, that displayed for international spectators cowboy skills such as riding, roping, and shooting, as well as whooping and hollering. Anthropological exhibits and photographs included in the Philadelphia Centennial and the expositions in Chicago in 1893 and Saint Louis in 1904 also stirred interest. Cowboys published their memoirs. Theodore Roosevelt, a New York–born patrician who, as president of the United States (1901–9), would become the West's greatest spokesman, described his own North Dakota retreat in *Ranch Life and the Hunting-Trail*,

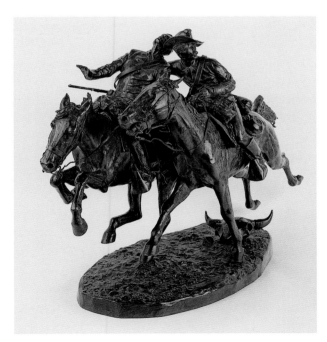

Fig. 163. Frederic Remington. *The Wounded Bunkie*, 1896. Bronze, 20¼ × 31 × 13 in. (51.4 × 78.7 × 33 cm). Gilcrease Museum, Tulsa, Oklahoma 0826.35

illustrated by Frederic Remington and published in 1888. Owen Wister's 1902 novel, *The Virginian: A Horseman of the Plains,* "would establish the range-riding horseman as the standard western hero in hundreds of western novels and films," as the historian Marilynn S. Johnson observed. Johnson also proffered the principal rationale for this glorification of the West: "As Americans faced a growing tide of immigration, a burgeoning factory system, labor unrest, and the proliferation of urban poverty and decay, the artists' image of the Old West as a repository of traditional American values of independence and individualism was a reassuring message."[141] The art historian Bradley A. Finson offered a positive spin on the phenomenon: "Images of a past long gone regenerated hope in an American nation that looked to its phantom heroes for inspiration as it strode into a new century."[142] In sum, between the Centennial and World War I, Americans turned to the West to reset their compasses.

The artists Charles Schreyvogel and Remington helped to engineer the masculine escapist fantasy of the cowboy and the cavalryman that flourished about 1900. Apprenticed to a commercial lithographer in New York and then trained in Munich by academics, including the American expatriate

Carl Marr, Schreyvogel set up his studio in Hoboken, New Jersey, in 1890.[143] Reading popular books and sketching Buffalo Bill's Wild West shows inspired his interest in the frontier. Beginning in 1893, he made many visits to Colorado, Arizona, and other western locales, collecting Indian, cowboy, and military artifacts for reference in his works. His first great success was *My Bunkie* (fig. 162), an emblematic record of a soldier's life in the West, which in 1900 won the Thomas B. Clarke Prize for figure painting at New York's National Academy of Design and brought the then-unknown Schreyvogel overnight attention. Seen in relief, a cavalry trooper rescues a barracks bunkmate who has lost his mount in a battle with unseen Indians. Two more mounted soldiers, one of whom aims his rifle at the viewer, provide protective firepower. Supposedly inspired by an actual incident, *My Bunkie* is packed with the energy of a Wild West show. It also responds to another iconic representation of cavalrymen's death-defying courage and camaraderie, Remington's bronze sculpture *The Wounded Bunkie* (fig. 163), in which a soldier shot in his saddle topples onto the arm of a comrade riding beside him. Moreover, as the art historian Diane P. Fischer has noted, "*My Bunkie* could easily pass for a caricature of

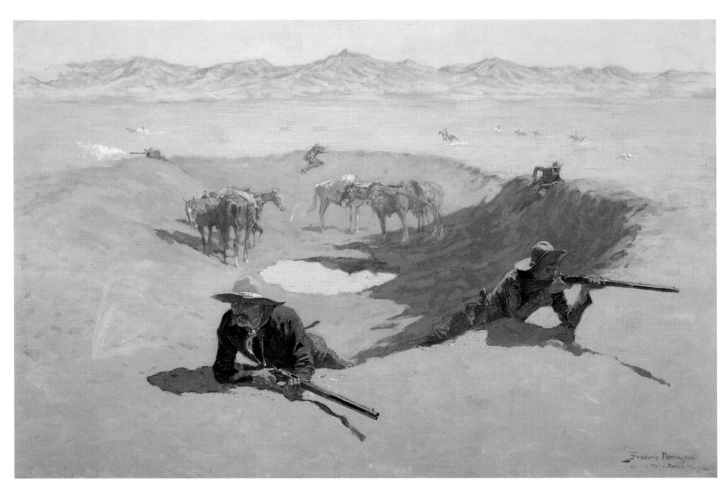

Fig. 164. Frederic Remington. *Fight for the Water Hole*, 1903. Oil on canvas, 27¼ × 40⅛ in. (69.2 × 102 cm). The Museum of Fine Arts, Houston. The Hogg Brothers Collection, gift of Miss Ima Hogg 43.25

Theodore Roosevelt's 'Rough Riders' who had charged up San Juan Hill just two years earlier. Roosevelt, who was the vice president in 1900, had become the incarnation of American manliness and imperialism."[144]

The most prolific and successful artist of the West, Remington established the standard by which Schreyvogel and other rivals were measured and codified the image of the cowboy and the cavalryman, as was noted by a critic in March 1892: "Eastern people have formed their conceptions of what the Far-Western life is like, more from what they have seen in Mr. Remington's pictures than from any other source, and if they went to the West or to Mexico they would expect to see men and places looking exactly as Mr. Remington has drawn them."[145] Trained in academic principles at the Yale School of Fine Arts and briefly at New York's Art Students League, Remington made his first trip west in 1881, invested in a Kansas ranch in 1883, and worked in Kansas City, Missouri, until 1885. Returning to New York, he enjoyed a lucrative career as a magazine and book illustrator, painter, and sculptor, concentrating on western subjects that he had observed during his travels and later developed in the studio he kept in suburban New Rochelle from 1890 until his premature death in 1909. The art historian Alexander Nemerov described the source of the artist's expressive agenda: "Like many people living in the turn-of-the-century industrialized East, Remington was obsessed with the difference between his own modern era, with its sprawling cities, rumbling machinery, and foreign immigrants, and an idealized, sentimentalized 'Old America' left in its wake. It was from this obsession, virtually the central drama in Remington's life, that his vision of the West emerged."[146]

Fight for the Water Hole (fig. 164) was one of Remington's most celebrated canvases. Having signed a four-year contract with *Collier's Weekly* in 1903 to produce twelve paintings a year that would appear monthly in double-page, full-color reproductions, Remington was free to choose his own subjects and to focus on formal issues, especially light and color, rather than on the basics of traditional commercial illustration. He selected this as the second picture to be featured. In an astute analysis of the painting, the curator Emily Ballew Neff described the parched setting and the action, which involves five armed cowboys (with a sixth cowboy—implied by the presence of six horses—presumably cropped out of the scene at the left) fighting to defend a shrinking water hole against marauding Indians, some of whom occupy the viewer's space and draw the gaze of the gunman in the foreground. Neff underscored the fact that "Remington's art invites multiple narrative and symbolic interpretations—that its meaning is, in short, elastic."[147] For example, when the canvas was first shown in New York in 1903 as *A Water-Hole in the Arizona Desert*, the title implied that violence could occur at

any Arizona desert water hole. When it reappeared in the Christmas 1903 issue of *Collier's Weekly*, its altered title—*Fight for the Water Hole*—expanded the narrative, emphasizing the cowboys' need to defend their meager water source and linking the scene to a storied 1874 firefight in the Texas Panhandle.

Neff also reviewed recent commentaries on Remington's paintings that reject the long-standing notion of them as literal records of western life.[148] The most vivid of these was offered by Nemerov in the catalogue for a controversial 1991 exhibition, *The West as America*. Featuring *Fight for the Water Hole* as the keynote of his essay, Nemerov described it as a symbol of the "last stand"; he also linked it to nativism and to Remington's own xenophobia, and read the gunmen fighting Native Americans as Anglo-Saxons defending their country against waves of foreign invaders.[149] Endorsing Nemerov's reading, the exhibition's principal curator, William H. Truettner, concluded: "This image transposes the anxieties of eastern industrialists, who purchased such works, onto a mock western landscape. . . . Substitute laborers or immigrants for Indians in *Fight for the Water Hole* and one comes closer to understanding Remington's paintings than any analysis of the artist's short and infrequent encounters with the West will provide."[150]

Tales of the City

The shift away from farming and toward urbanization was the epochal development of the nineteenth century, and it defined the modern era. Whereas the United States recorded 6 million farm workers and 4 million nonfarm workers in 1860, those numbers had reached 11 million and 18 million, respectively, by 1900. An observer summarized the phenomenon in 1887: "We live in the age of great cities. It began to be so named nearly half a century ago, and every year since then has added fitness to the title. For size, for number, and for influence, the cities of our time have never been approached."[151] Painters of modern life, especially American Impressionists abroad and at home, portrayed major cities, enlisting their new style to suggest the energy and fragmentation of contemporary experience. They often focused on parks, which, having been engendered by unprecedented municipal growth, symbolized the transformation of Paris, New York, Boston, and other cities. Sources of national and local pride, parks had social, moral, aesthetic, educational, and health-promoting significance for city dwellers. The best of them were also artistic phenomena, carefully arranged accumulations of eye-pleasing natural features that provided city dwellers substitutes for rural surroundings.

In his *Lake for Miniature Yachts* (fig. 165), Chase depicts the Ornamental Water, a small pond just inside the Fifth Avenue boundary of New York's Central Park, at Seventy-third Street. The artist usually stressed the pastoral charm of

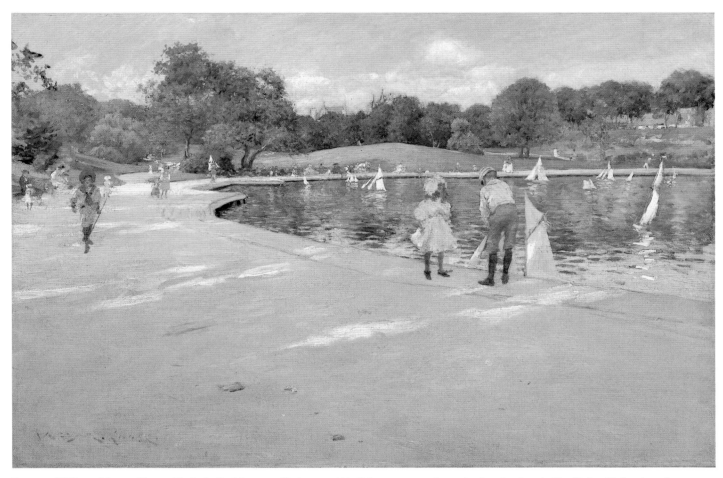

Fig. 165. William Merritt Chase. *The Lake for Miniature Yachts*, ca. 1888. Oil on canvas, 16 × 24 in. (40.6 × 61 cm). The Terian Collection of American Art

parks and their function as refuges from urban hurly-burly. Here, however, he allows Fifth Avenue's housetops to invade the screen of trees with which Frederick Law Olmsted and Calvert Vaux insulated the park from the city, and to have pavement dominate the scene, as it does the Luxembourg Gardens in Sargent's view (see fig. 109). Sargent's canvas, which was well known in the New York art market in the mid-1880s, when it was exhibited and sold, may have prompted Chase to undertake park subjects and may have inspired this asymmetrical composition. As if magnifying the children who appear at the small pool in the right background of Sargent's Luxembourg scene, Chase focuses on a boy and a girl playing with boats, while a youthful urban flâneur wearing a sailor suit strides along the pavement at the left. Chase also seems to echo Sargent's indifference to narrative, matching his Impressionist technique with an impression of meaning. Unlike the children at play in earlier and more obviously contrived scenes—Guy's *Contest for the Bouquet* (fig. 86) and Homer's *Snap the Whip* (fig. 89), for example—those in Chase's picture appear as if glimpsed in an instant, and they pursue their quiet tasks without any concern for the viewer. Kilmurray's comment on Sargent's Luxembourg image applies equally to

Chase's Central Park view: "In the disconnectedness of the experience it portrays, it is a modern picture, beautiful and purposeless. There is no implied narrative . . . the children play in their own world."[152]

About 1900, a group of New York realists departed from the American Impressionists in both style and choice of subject matter. The most extensively trained member of this group was Robert Henri, who, after studying under Hovenden and Anshutz, Eakins's successors at the Pennsylvania Academy, and then in Paris, in 1892 became mentor to four Philadelphia illustrators—William Glackens, George Luks, Everett Shinn, and John Sloan. These artists worked together at several local newspapers and gathered to exchange ideas, share studios, and travel. Between late 1896 and 1904, they all moved to New York, where Henri himself settled in 1900, taking with them the democratic vision and experience in rapidly rendering everyday life that they had cultivated as newspaper illustrators. Henri and his associates constituted the first generation of what became known as the Ashcan School. (A second generation consisted of Henri's students, of whom George Bellows was his mentor's most devoted acolyte.)[153] Despite the name, Ashcan artists were not an organized "school," and although they

espoused varied styles and subjects, they were all urban realists who supported Henri's credo—"art for life's sake," rather than "art for art's sake"—and who showed together in several significant early twentieth-century New York exhibitions.[154]

In their paintings as in their illustrations, etchings, and lithographs, the Ashcan artists rejected the American Impressionists' preference for sunny rural or quasirural settings and insistently positive accounts of modern life.[155] They concentrated instead on portraying New York's vitality and recording its seamier side. In so doing, they expanded the canon of everyday scenes to include new venues for dining, shopping, and entertainment and kept an eye on current events and their era's social and political rhetoric. Stylistically, they rejected the inspiration that the American Impressionists had found in the high-keyed canvases of Monet and his associates and depended instead upon the darker palette and gestural brushwork of Velázquez, Frans Hals, Francisco de Goya y Lucientes, Honoré Daumier, and modern realists such as Leibl, Manet, and Degas. They preferred broad, calligraphic forms, which they could render from quick sketches made on the run or from memory. The scholar Rowland Elzea described the method as Sloan practiced it: "A day or two of the idea lying fallow in his mind, followed by a few days of relatively effortless execution of the fully developed mental image."[156]

Although the Ashcan artists immersed themselves in mundane, disorderly, and even sordid subjects of modern life, they were neither social critics nor reformers and they did not paint radical propaganda. While they were contemporaries of leading muckrakers such as Frank Norris, Lincoln Steffens, Upton Sinclair, and Ida M. Tarbell, they were distant from them in spirit. Despite the fact that the Ashcan artists championed the vitality of the working class and sought to record the dreary aspects of urban existence, they themselves led pleasant middle-class lives, frequenting New York's restaurants and bars, its theaters and vaudeville houses, and making seasonal outings to its popular nearby resorts. Further, because they avoided civil unease, class tensions, and the shabbiest streets, their works are never as unsettling as the reformist images by contemporary American photographers such as Jacob Riis or Lewis Hine. And although they relaxed some taboos of subject matter, their approach is only gently transgressive and never as direct as that of their European counterparts. Sloan, for example, may have portrayed a prostitute in his *Chinese Restaurant* (fig. 166), but she is a "hooker with a heart of gold," not a hardened type represented by Degas or Henri de Toulouse-Lautrec.

Sloan's painting describes relations between men and women in a characteristic modern urban venue. Whereas dining had earlier been confined to private homes, clubs, and exclusive establishments such as Delmonico's or Sherry's in New York, the growing middle class, expanded opportunities for women to work outside the home, and the influx of immigrants supported the growth of ethnic eateries, which altered the city's restaurant culture.[157] Proclaiming in 1909 that "New York has more good restaurants than any other city in the world, save Paris," *Good Housekeeping* noted that "for from forty to seventy-five cents, one may lunch or dine in the atmosphere of foreign cookery, with a little music thrown in for good measure."[158] On February 23, 1909, Sloan recorded in his diary a visit to an eating place on Sixth Avenue at about Thirtieth Street, near his apartment on West Twenty-third Street: "Felt restless so went to the Chinese restaurant and was glad I did for I saw a strikingly gotten up girl with dashing red feathers in her hat playing with the restaurant's fat cat. It would be a good thing to paint." On March 15, he jotted: "I started a memory painting of the Chinese Restaurant girl I saw some four weeks ago." He returned for dinner on March 18 "to refresh my memory of the place," and had the painting "just about finished" on April 12.[159]

Honoring his recollection, Sloan focuses on the "strikingly gotten up girl" at the center of his composition, emphasizing her pale neck and chest with a lacy white collar, framing her with red-lacquer paneling, and letting her hat's "dashing red feathers" draw the viewer's eye and serve as the hinge of the action. While her rude companion hunches over a large bowl, she gives a treat to the more attentive cat that sits at her feet; two men at the right enjoy the droll performance. Sloan later summarized his narrative: "The girl is feeding her boy friend, before taking him home, in one of the many Chinese restaurants of that day where only Chinese food was served. Graphic expression and resonant in color."[160] His image evokes the description of a Chinese restaurant that appeared in *Once a Week* in 1893: "Some of the patrons have before them huge bowls of steaming rice, which they eat by bringing the dish to their lips, and then literally shoveling the food into the open mouth. . . . A greedy cat munches away under one of the tables. Were it not for the red banners on the walls, the eating-house would be as bare as a barn; and, assuredly, it is as uninviting as a pig-sty. . . . The 'slummers' eat, drink and are merry in their new experience with strange dishes."[161]

In Sloan's *Chinese Restaurant,* "we may be observing a woman of easy virtue," as the curators of the Metropolitan Museum's 1994 exhibition on American Impressionism and realism suggested.[162] The art historian Rebecca Zurier echoed their commentary but was more definitive: "Turn-of-the-century New Yorkers regarded Chinese restaurants as places of dubious respectability, and the central figure's flamboyantly feathered hat and heavy makeup probably marked her as a prostitute." But, Zurier concluded, "Rather than condemn the prostitute, as an earlier generation would have

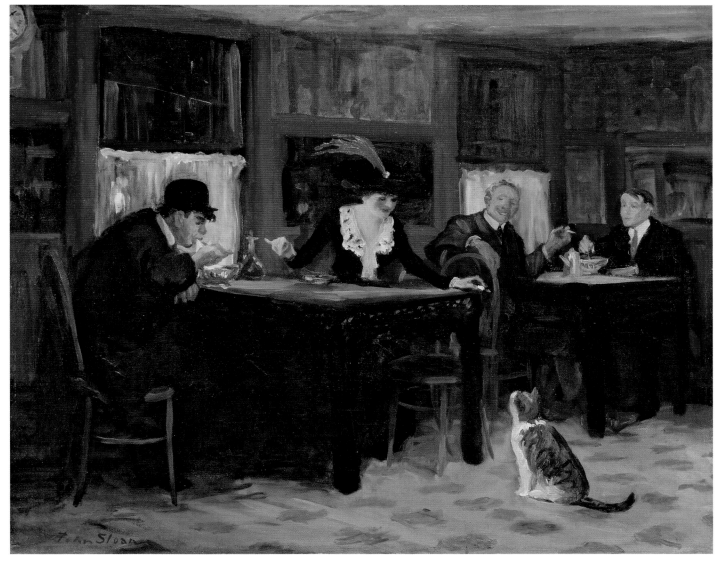

Fig. 166. John Sloan. *Chinese Restaurant*, 1909. Oil on canvas, 26 × 32¼ in. (66 × 81.9 cm). Memorial Art Gallery of the University of Rochester. Marion Stratton Gould Fund 51.12

done, or regard her as either the victim or the symptom of a social problem, the casual tone of the image presents its subject in a matter-of-fact way, then implicates both the viewer and artist as admiring onlookers." Zurier also explored the narratives that Sloan's painting implies, observing the painting's relationship to the realist fiction and movies that Sloan enjoyed. She further posited that "the picture encourages viewers to invent their own interpretations of the scene."[163]

The Picnic Grounds (fig. 167) also exemplifies the frank, good-natured urban comedies of manners on which Sloan's reputation rests. The setting is a public park in Bayonne, New Jersey, across the Kill Van Kull from New York City. Sloan's diary for Wednesday, May 30, 1906—then called "Decoration Day" and now known as Memorial Day—records his visit there with his wife: "Then we went to the Newark bay side and watched picnic grounds, dancing pavilion, young girls of the healthy lusty type with white caps

jauntily perched on their heads." Revealing his characteristic method, Sloan noted three days later: "Started painting a memory of the little Picnic Grounds at Bayonne and think I have a good 'go' at it."[164] He showed *The Picnic Grounds* at the Pennsylvania Academy in fall 1906 and worked on it again for exhibition in February 1907. In 1942, the year after he sold it to Gertrude Vanderbilt Whitney, he described it in a letter to a reporter: "Adolescent boys and girls playing like bear cubs. The white washed tree trunks were a device used to enable visitors to stroll about at night—when the grounds were used by numbers of guests."[165]

The jagged forms, vigorous brushwork, and informal composition in *The Picnic Grounds* express the youngsters' raucous energy. Against a background that shows a bunting-draped bandstand and three people at a picnic table, three girls "of the healthy lusty type" frolic with a grinning gold-toothed young man who ducks behind the central tree.

Fig. 167. John Sloan. *The Picnic Grounds*, 1906–7. Oil on canvas, 24 × 36 in. (61 × 91.4 cm). Whitney Museum of American Art, New York. Purchase 41.34

The girls' shirtwaist dresses, unrestrained gaiety, and garish makeup identify them as working class; their short skirts mark their age as no more than fifteen; and their cricket caps hint that their flirtation is merely a game. As the curator Patterson Sims observed: "By comparison with the conventional, contemporary depictions of women—perceived as silent, confined, and inactive—Sloan's females are communicative, joyous, and lively. *The Picnic Grounds* was conceived in a democratic spirit: whether talking or at play, the men and women are treated as equal beings, co-workers delighting in a special day off."[166] The painting represents a radical departure in its style and urban subject from earlier rural genre scenes such as Jerome B. Thompson's *Belated Party on Mansfield Mountain* of 1858 (fig. 39) or Eastman Johnson's *Sugaring Off* of about 1865 (fig. 69). It also challenges more decorous American Impressionist city scenes such as Sargent's *In the Luxembourg Gardens* (fig. 109) and Chase's *Lake for Miniature Yachts* (fig. 165).

Sloan's "strikingly gotten up girl" in *Chinese Restaurant,* the "healthy lusty" girls in *The Picnic Grounds,* and the other vulgar women he portrays out and about in mixed company are distant in spirit, style, and subject from Paxton's account

of a married couple seen at home in *The Breakfast* (fig. 133). Postdating Sloan's restaurant and picnic scenes, Paxton's 1911 canvas manifests the desire of some artists and their patrons to preserve gentility and tradition in the face of the daunting social change that the Ashcan artists embraced.

Sloan's images of women in the company of other women show them as liberated from the sheltered surroundings and polite behavior that Cassatt, Chase, and Dewing had assigned to them (see, for example, figs. 125, 126, and 130) and that Sargent and Paxton continued to describe after 1900 (see figs. 131 and 132). In *Sunday, Women Drying Their Hair* (fig. 168), Sloan features working women grooming themselves on a city rooftop during time off from their labors in sweatshops or department stores.[167] Rather than engaging in polite rituals in the seclusion of elegant or exotic private habitats, these lightly clad Three Graces share their easy camaraderie with the viewer. As if caught unaware, they display their chests and bare arms as they perform their toilette. Their hair is freed from the decorous buns, "psyche knots," or other coiffures required for their appearance in public (and seen in Paxton's *Tea Leaves,* fig. 132). Sloan later described these women as unself-conscious performers in

"another of the human comedies which were regularly staged for my enjoyment by the humble roof-top players of Cornelia Street," referring to the view from the loft building on Sixth Avenue at West Fourth Street, overlooking Cornelia Street, to which he had moved his studio in May 1912.[168]

The sort of shopgirl—to use the period's parlance—that Sloan might have glimpsed on a Greenwich Village rooftop appears in William Glackens's *Shoppers* (fig. 169), at the left, serving customers.[169] The canvas, one of Glackens's largest, records a slice of modern New York life: shopping for apparel in one of the grand department stores that began to flourish after 1846, when the dry-goods merchant A. T. Stewart opened his Marble Palace at 280 Broadway. Like the corporations that redefined the era's agriculture and industry—from meatpackers like Armour and Swift to manufacturers like U.S. Steel—department stores reinvented merchandising.[170] *The Shoppers* is probably set in Wanamaker's New York branch,

which combined Stewart's second store—the 1862 Cast Iron Palace—acquired by Philadelphia native John Wanamaker in 1896, with a thirteen-story annex designed by Daniel Burnham that opened in 1907. Occupying the southern end of Ladies' Mile near Glackens's residence at 3 Washington Square North, Wanamaker's comprised twenty-five acres of floor space, employed five thousand people, and welcomed thousands of customers every day.[171] Born in Philadelphia himself, Glackens would have had reason to salute Wanamaker's success, but in terms that acknowledged Wanamaker's distance from the sales counter—unlike the obvious association of Elijah Boardman with his tantalizing inventory in Ralph Earl's 1789 portrait (see fig. 16).[172]

As Wanamaker's showed off its goods, so Glackens shows off several well-dressed customers in *The Shoppers*. At center is his wife, the former Edith Dimock, the daughter of a well-to-do textile manufacturer. Wearing a luxuriant fur coat, she

Fig. 168. John Sloan. *Sunday, Women Drying Their Hair*, 1912. Oil on canvas, 26⅛ × 32⅛ in. (66.4 × 81.6 cm). Addison Gallery of American Art, Phillips Academy, Andover, Massachusetts 1938.67

Fig. 169. William Glackens. *The Shoppers*, 1907–8. Oil on canvas, 60 × 60 in. (152.4 × 152.4 cm). Chrysler Museum of Art, Norfolk, Virginia. Gift of Walter P. Chrysler Jr. 71.651

assesses a garment—perhaps an article of lingerie—that the saleswoman offers. Seated at left with her back to the picture plane is her former Art Students League classmate Lillian Gelston Travis. To the right stands Florence "Flossie" Scovel Shinn, the Ashcan painter's wife, a distant relative of the Philadelphia Biddles and herself a successful illustrator. In the shadows behind them appears an unidentified veiled woman waiting to be served. In 1858 and 1876, respectively, Edmonds and Johnson had depicted women as consumers, noting the acquisition of hats that were probably crafted in

modest local manufactories and sold in small shops (see figs. 34 and 99). Glackens, by contrast, responded to the twentieth century's new material abundance and sophisticated marketing trends by setting his scene in a huge, impersonal urban department store that encouraged middle-class women to enjoy shopping as a group experience.[173] Invoking the spirit of Veblen's conspicuous consumers, Mrs. Glackens and her expensively dressed companions also recall Edith Wharton's Lily Bart, who in *The House of Mirth* (1905) famously lamented: "If I were shabby no one would have me:

Fig. 170. Edgar Degas. *At the Milliner's*, 1882. Pastel on pale gray wove paper, laid down on silk bolting, 30 × 34 in. (76.2 × 86.4 cm). The Metropolitan Museum of Art, New York. H. O. Havemeyer Collection, Bequest of Mrs. H. O. Havemeyer, 1929 29.100.38

a woman is asked out as much for her clothes as for herself. The clothes are the background, the frame, if you like: they don't make success, but they are a part of it. Who wants a dingy woman? We are expected to be pretty and well-dressed till we drop."[174]

Glackens eschews the stagelike composition that Edmonds and Johnson had adopted from Dutch and English genre paintings and echoes instead candid arrangements used by Degas, Manet, and other French realists, whose works he would have seen in New York or during his visits to Paris in 1895–96 and 1906. He also quotes Manet's broad brushwork and somber palette and Degas's interest in portraying saleswomen and their customers. Yet a comparison between Degas's shopping scenes such as *At the Milliner's* (fig. 170)—in which he cropped the employee and declined to flatter the customer (actually, Mary Cassatt)—and Glackens's appealing portraits underscores the Ashcan artists' gentle brand of realism. Glackens also ignores the hardship that accompanied manufacture of the luxury goods that his shoppers examine and wear. The garment industry in New York, America's fashion capital, was beset by conflict, including a five-month strike by 20,000 shirtwaist workers in 1909–10, and by tragedy, notably the death of 146 young immigrant workers in a fire at the Triangle Shirtwaist Factory, four blocks from Wanamaker's, on March 25, 1911.

Glackens's characters ignore the viewer, with the exception of Florence Shinn, who plays the interlocutor. She brings to mind several similar figures—including Velázquez himself—in *Las Meninas* (1656), which Glackens had admired in the Prado in 1906, a year before he began painting *The Shoppers*.

Mrs. Shinn's accessibility to the viewer also signals the element of spectacle in modern consumer culture, whose denizens wish to see and be seen. Despite the gracious demeanor of all the women in *The Shoppers*, the figure of Mrs. Glackens irritated the critic Joseph Edgar Chamberlin, who viewed the painting in the landmark exhibition of The Eight at the Macbeth Galleries, New York, in February 1908, and far preferred the amiable Mrs. Shinn: "The ugly woman in the foreground is the essence of the disagreeable shopper," he grumbled, whereas "the pretty lady to the right . . . is all that is appealing and poetic." The reviewer James Huneker, however, had no complaints, finding *The Shoppers* "contemporary with a vengeance. It breathes of to-day, of to-morrow, and of Macy's every morning."[175]

In addition to a wide array of goods, modern department stores offered amenities such as restaurants, ladies' lounges, and reading rooms, inviting long, leisurely shopping excursions. They also recognized culture by including art galleries and large auditoriums—the one in Wanamaker's, New York, seated fifteen hundred—in which lectures and free recitals by in-house orchestras were presented. Other popular commercial performance venues—theaters, music- and dance halls, vaudeville and movie houses—abounded in New York at the

Fig. 171. William Glackens. *At Mouquin's*, 1905. Oil on canvas, 48⅛ × 36¼ in. (122.4 × 92.1 cm). The Art Institute of Chicago. Friends of American Art Collection 1925.295

Fig. 172. Everett Shinn. *The Orchestra Pit, Old Proctor's Fifth Avenue Theatre*, 1906–7. Oil on canvas, 17½ × 19½ in. (44.3 × 49.5 cm). Yale University Art Gallery. Bequest of Arthur G. Altschul, B.A. 1943 2002.132.1

time and attracted the Ashcan artists' patronage and professional interest. By recording such new urban subjects, these painters expanded the scope of American stories of everyday life. Glackens created iconic images of amusements such as *Hammerstein's Roof Garden* (ca. 1901, Whitney Museum of American Art, New York) and *At Mouquin's* (fig. 171); Sloan acknowledged the revolutionary new storytelling medium in *Movies, Five Cents* (1907, private collection); and Shinn specialized in portraying performers and spectators.[176]

Shinn's interest in theater began in his boyhood, when he made posters for the opera house his brother ran in Woodstown, New Jersey, and continued with his participation in amateur theatricals and burlesques in Henri's Philadelphia studio. It crested when he added to his Greenwich Village home a

fifty-five-seat amateur theater, for which he served as playwright, director, set designer, and producer.[177] Shinn was later commissioned to decorate the Belasco and Stuyvesant theaters in New York with murals. He also made theater the subject of many drawings and easel paintings. His *Orchestra Pit, Old Proctor's Fifth Avenue Theatre* (fig. 172) was among eight theater scenes that he showed at the 1908 exhibition of The Eight.[178] The extended title, which has long been attached to the painting, identifies the setting as the popular vaudeville house opened at Broadway and Twenty-eighth Street, near Madison Square, by the impresario F. F. Proctor in May 1900, and reopened in partnership with his former rival B. F. Keith in October 1906, after a major interior renovation.[179] The ensuing publicity, including a laudatory

Fig. 173. Edgar Degas. *The Orchestra of the Opera*, ca. 1868–69. Oil on canvas, 22¼ × 18¼ in. (56.5 × 46.2 cm). Musée d'Orsay, Paris RF 2417

description in the *New York Times* of its sumptuous features— including "draperies . . . of heavy velvet and silk, crimson in color"—may have attracted Shinn to the venue and to its value as a subject.[180] Proctor's invention and specialty was "continuous vaudeville," which began with the "milkman's matinee" and ended with the "supper show." The extravaganza was trumpeted in the slogan "After Breakfast Go to Proctor's, After Proctor's Go to Bed."[181] A typical show included eight to fourteen acts, or "turns," featuring magic and song-and-dance, acrobatics and juggling, animals and comedy routines, and star turns by actors from the legitimate theater. Catering to working- and middle-class audiences of men, women, and children, vaudeville was as emblematic of New York about 1900 as any public park, Chinese restaurant, or department store.

Like his Ashcan colleagues, Shinn was inspired by French realists such as Jean-Louis Forain, Jean-François Raffaëlli, and especially Degas, whom he called "the greatest painter France has ever turned out."[182] After his first successful solo exhibition in New York in 1900, Shinn's dealer, Boussod, Valadon & Company, underwrote a five-month trip to London and Paris, which expanded his knowledge of these artists' works and his interest in theatrical subjects. Shinn's painting of Old Proctor's demonstrates both his debt to and distance from Degas. In 1868–69 the French artist had challenged the tradition of portraiture in *The Orchestra of the Opera* (fig. 173), his

first radical opera scene, by focusing on specific musicians in the pit and cropping the heads of the corps de ballet. Shinn, by contrast, places the viewer in Old Proctor's first row, staring at the brass rod and crimson velvet curtain that demarcate the pit and at the back of an anonymous musician. Having completed the seventh act in the bill, as the placard at the left of the harshly lighted stage announces, a dancer takes her bow, her body distorted by the steep viewing angle.[183] A somewhat transgressive variation on Degas's prototype, Shinn's vaudeville scene is a world apart—geographically, temperamentally, and stylistically—from midcentury American accounts of rural musical performances such as Bingham's *Jolly Flatboatmen* (fig. 49) or Mount's *Power of Music* (fig. 65).

Inviting viewers to share his immersion in modern life, Shinn offers them front-row seats at a vaudeville show. Similarly, second-generation Ashcan artist George Bellows provides a ringside seat at a boxing match in his contemporaneous *Club Night* (fig. 174). Originally entitled *Stag at Sharkey's*, this was the first of three dynamic, large-scale scenes that would identify Bellows with the subject of boxing.[184] Bellows's early fight paintings record brawls at the sleazy athletic club located across Broadway from his studio in the Lincoln Arcade at Sixty-sixth Street and run by the retired pugilist Tom Sharkey.[185] Such "clubs" evaded a 1900 municipal law outlawing public prizefighting by selling visitors five-dollar monthly membership passes instead of charging admission. As the art historian Marianne Doezema pointed out, these louche urban sites "sustained connections with machine politicians and catered to payoffs, gambling, and underworld crime."[186] Bellows himself observed in a 1910 letter to an Ohio acquaintance that "the atmosphere around the fighters is a lot more immoral than the fighters themselves."[187]

In his boxing images, Bellows followed the example of Eakins, the Ashcan painters' hero and the progenitor of artistic principles passed down to him through Anshutz and Henri. Eakins had calmed the action and diluted violence in his boxing and wrestling scenes, such as *Between Rounds* (fig. 159). Bellows, by contrast, amplifies brutality in *Club Night*, recording a seedy private venue and ignoring everything but the sport's essence. Eschewing Eakins's painstaking technique, Bellows summarizes with ferocious painterly shorthand the two pugilists' combat at peak intensity, capturing the moment when the menacing fighter on the right delivers a blow to his opponent's jaw and seems ready to bring his knee up to the man's groin. Bellows increases the drama by condensing the ring to a narrow, bright sliver of space—the spectators are squeezed against its edge or leaning on it—and compressing the towering boxers' agitated forms with the upper edge of the canvas. He illuminates the smoky interior with hellish light that outlines muscles and casts jagged shadows. He

Fig. 174. George Bellows. *Club Night*, 1907. Oil on canvas, 43 × 53⅛ in. (109.2 × 135 cm). National Gallery of Art, Washington, D.C. John Hay Whitney Collection 1982.76.1

also places the painting's viewer in the second row, amid the bloodthirsty crowd, a repulsive member of which swivels to meet his gaze. Although most seamy neighborhood saloons like Sharkey's attracted a working-class clientele, some of them were destinations for slumming, as the spectators in evening dress on the far side of the ring indicate. This detail invites bourgeois observers—including visitors to the National Academy's 1907–8 winter exhibition—to experience the gritty scene as if they, too, were slumming swells.

In *Club Night*, Bellows proclaims the essence of "the passion for boxing" that a French visitor to America had noted, at least among men, in 1895.[188] He echoes, too, Jack London's novel *The Game: A Transcript from Real Life* (1905), which tells of a sailmaker who augments his income by prizefighting in sporting clubs, as well as London's short story "A Piece of Steak" (1909), which describes fighting as "a plain business proposition," a sport for which "audiences assembled and paid for the spectacle of men knocking each other out."[189] Bellows also responds to Theodore Roosevelt's well-known enthusiasm for boxing, which he took up as a youth and continued until his left eye was injured during his presidency.[190] Like Remington's images of cowboys and cavalrymen, which Roosevelt favored as well, Bellows's boxing scenes glorify virile action more than quiet thought and popular experience more than highbrow culture. Finally, by rejecting refinement and cosmopolitanism, which had saturated late nineteenth-century American culture and still maintained a hold on painters such as Sargent and Paxton, Bellows anticipates philosopher George Santayana's influential 1911 repudiation of the "genteel tradition."[191]

Although the New York realists depicted slumming, they rarely portrayed slums. An exception is Bellows's *Cliff Dwellers* (fig. 175), which features a Lower East Side intersection swarming with people.[192] Between 1870 and 1915, New York City's population grew from 1.5 million to 5 million, largely as the result of the arrival of huge numbers of Italian, Jewish, Irish, and Chinese immigrants, many of whom crowded into five- and six-story tenement houses on Manhattan's Lower East Side—an area north of the Brooklyn Bridge, south of Houston Street, and east of the Bowery. In 1890, the district averaged 522 people per acre—in contrast to 114 per acre in all of Manhattan and 60 per acre in the city of New York as a whole—and, in 1905, 1,100 people per acre.[193] Although the Lower East Side was never exclusively Jewish, it provided temporary or permanent shelter to most of the 1.5 million Jews who arrived in the United States between 1899 and 1914.

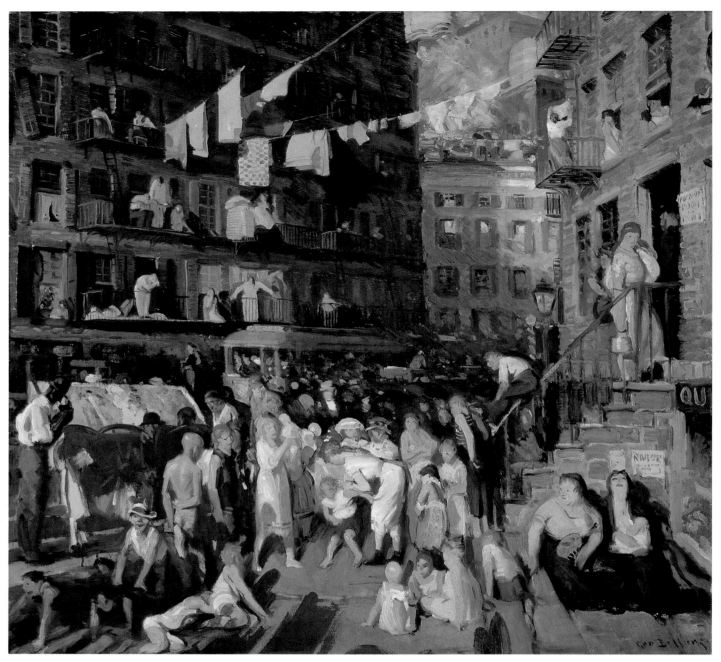

Fig. 175. George Bellows. *Cliff Dwellers*, 1913. Oil on canvas, 40¼ × 42⅛ in. (102.1 × 106.8 cm). Los Angeles County Museum of Art. Los Angeles County Fund 16.4

Between 1880 and 1910, New York's Jewish population grew from 80,000 to 1.25 million.[194]

With dark, narrow, poorly ventilated two-room "dumb-bell" apartments crammed with large families, along with their relatives and boarders, much of life on the Lower East Side—shopping at pushcarts, caring for children, playing, or enjoying a passing breeze—was lived on stoops and fire escapes or in the streets. Bellows's initial lithographic version of *Cliff Dwellers* (fig. 176) conveys the neighborhood's density and intensity. It also documents the locale as East Broadway, which runs southwest from Grand Street, changes its name to Park Row at Chatham Square, and terminates at Vesey

Street, the destination announced on the trolley car. In the lithograph—satirically titled *Why Don't They Go to the Country for Vacation?* when it was reproduced in August 1913 in the radical journal *The Masses*—Bellows emphasized that "the architecture seemed to sweat humanity at every window and door," as an English visitor had observed in 1912.[195] In the painting, by contrast, he mitigates claustrophobia by replacing the confining black-and-white crosshatching with bright colors selected and arranged according to the artist Hardesty G. Maratta's theories.[196] He also recasts details more cheerfully than in the lithograph: a breeze snaps the laundry hung on lines between the buildings; the trolley is less

impacted in the press of humanity; the young mother at center stage appears less haggard and less burdened by her child; the children at lower left have more space in which to play leapfrog; and the provocative young woman carrying a bucket of beer into the tenement at the right has been replaced by a more matronly woman with a child.

Despite its euphemistic approach, *Cliff Dwellers* offended some critics. After seeing the painting in an October 1913 exhibition at Montross Gallery, Henry McBride, writing for the *New York Sun*, called it "appalling" and asked, "Can anything in Bedlam or Hogarth's prints equal this?"[197] Although *Cliff Dwellers* does suggest the slums' dehumanizing congestion, it is a far more sympathetic account of the Lower East Side than the one offered by the critic John C. Van Dyke, who declared in 1909: "It is a menace to the public health, a prolific source of contagion. Worst of all, it is a sink of crime and immorality. It is not creditable to New York. It is one of the city's most hideous features, one of its most violent and forbidding contrasts."[198] Rather than providing grounds for complaint—or even suggesting the need for tenement-house reform, which muckrakers and other social commentators advocated—*Cliff Dwellers* emphasizes the Lower East Side's appeal.[199] It resonates with genial descriptions of immigrant life like that offered by critic Mariana Griswold Van Rensselaer in 1892: "We cannot appreciate the picturesqueness which New York wears to both mind and eye unless we

Fig. 176. George Bellows. *Why Don't They Go to the Country for Vacation?* 1913. Transfer lithograph, reworked with pen, 25 × 22½ in. (63.5 × 57.2 cm). Los Angeles County Museum of Art. Los Angeles County Fund 60.43.1

go immediately from the stately commercialism of its downtown streets to the adjacent tenement-house districts. Pestholes to the sanitarian and the moralist, loathsome abodes of filth and horror to the respectable citizen, many parts of these districts gratify the eye that seeks pictorial pleasure."[200] *Cliff Dwellers* also recalls Howells's characteristically positive account, in *A Hazard of New Fortunes* (1890), of Isabel and Basil March's unplanned visit to a tenement neighborhood: "The fire escapes, with their light iron balconies and ladders of iron, decorated the lofty house fronts; the roadway and sidewalks and doorsteps swarmed with children; women's heads seemed to show at every window. . . . Ash barrels lined the sidewalks and garbage heaps filled the gutters; teams of all trades stood idly about; a peddler of cheap fruit urged his cart through the street and mixed his cry with the joyous screams and shouts of the children and the scolding and gossiping voices of the women." Although Isabel March protested their driver's decision to take them through "such a disgusting street," her husband concluded—as Bellows might have—"I haven't seen a jollier crowd anywhere in New York."[201]

Bellows plunged into New York's teeming streets to create *Cliff Dwellers*, fulfilling Charles Baudelaire's 1863 prescription for the painter of modern life: "For the perfect *flâneur*, for the passionate spectator, it is an immense joy to set up house in the heart of the multitude, amid the ebb and flow of movement, in the midst of the fugitive and the infinite."[202] The differences in subject, composition, style, and effect on the viewer between Bellows's painting and Krimmel's comparatively restrained description of 1812 Philadelphia, *Fourth of July in Centre Square* (fig. 19), could not be more striking or more perfectly epitomize the transformation of American urban life and urban imagery over the course of a remarkable century.

Modernism and Anti-Modernism

Bellows's *Cliff Dwellers* may have offended fastidious critics when it was put on view in October 1913, but it was far less radical in subject and style than many of the works that had appeared eight months earlier in a huge exhibition held at New York's Sixty-ninth Infantry Regiment Armory. The Armory Show included examples by several American Impressionists, other more traditional painters, and the Ashcan School, but all were overwhelmed by works by Henri Matisse, Pablo Picasso, Marcel Duchamp, and other European modernists.[203] Although many conservative artists and critics recoiled, Sloan found inspiration for his own formal experiments in the paintings of Paul Cézanne, Vincent van Gogh, and Georges Braque. Members of Alfred Stieglitz's circle, including John Marin, Marsden Hartley, and Arthur Dove, had already experimented with modernist pictorial strategies in Paris, Berlin, and other European capitals. These artists, and others

Fig. 177. John Singer Sargent. *The Sketchers*, ca. 1913. Oil on canvas, 22 × 28 in. (55.9 × 71.1 cm). Virginia Museum of Fine Arts, Richmond. The Arthur and Margaret Glasgow Fund 58.11

who were drawn to abstraction and other varieties of modernism just after 1900, increasingly rejected the notion that paintings should tell stories. Yet Sargent and Dewing, who lived until 1925 and 1938, respectively; Paxton and Brush, who both lived until 1941; Glackens and Shinn, who lived until 1938 and 1953, respectively, and many others continued not only to honor familiar muses but also to sustain patronage.

In *Sketchers* (fig. 177), painted thirty-five years after he first embraced Impressionism, Sargent demonstrates the durability of nineteenth-century styles and narrative devices into the twentieth century.[204] This quintessential Impressionist studio scene is believed to portray Wilfred Gabriel de Glehn and his wife, Jane, working outdoors in September 1913

near Lake Garda in San Vigilio, Italy, where they had joined Sargent's entourage. Detached from the claims of mundane existence, they are absorbed in making art by transcribing nature. There is no hint of human intrusion in the landscape, no recognition of Sargent's or the viewer's presence. *The Sketchers* preserves the genteel existence that Sargent and his contemporaries enjoyed, an existence that would be forever altered by the international social and political changes wrought by World War I.[205] In Sargent's account of sunlit San Vigilio in early autumn 1913, there is no premonition of the guns of August 1914 at Sarajevo, and no acknowledgment of the radical changes in art that were already challenging the practice of painting American stories.

1. *Indianapolis Star* 1917, quoted in Pisano 1983–84, p. 25.

2. See Cikovsky 1976; Blaugrund 1997.

3. Bisland 1889, pp. 5–6, labeled Chase's studio a cabinet of curiosities and described its contents in detail. Artists' penchant for collecting bric-a-brac was fostered by the Aesthetic movement, which promoted the use of decorative objects in domestic and public spaces and established artists and artisans as arbiters of taste. See Burke, D. 1986–87, p. 322.

4. The author thanks Andrew Walker, Assistant Director for Curatorial Affairs and Curator of American Art, the Saint Louis Art Museum, for sharing his thoughts on the content of the painting.

5. Trachtenberg 2007; Wiebe 1967; Harris, ed. 1970; Schlereth 1991. See also Lears 1981. Data cited in this essay was also drawn from Schlesinger 2004; Carruth 1997.

6. See, for example, Shinn, ed. 1879–80; Saltzman 2008.

7. James 1876, reprinted in James 1956, p. 109. James's comment is the epigraph in Saltzman 2008.

8. The professionalization of artists and critics should be viewed against the same phenomenon in other fields, for which see Bledstein 1976, especially chapters 3 and 5; Haskell, ed. 1984.

9. James 1887, reprinted with emendations in James 1893; the later version, here quoted, is reprinted in James 1956, p. 216.

10. Blaugrund et al. 1989–90; Carr and Gurney et al. 1993; Fischer et al. 1999–2001. See also Hobbs 1976; Gold 2004; Orcutt 2005; Pyne et al. 1983; Fink 1990. For art at a key pre-Centennial fair, see Troyen 1984. Like the 1867 Paris Exposition Universelle and the Centennial, the art displays at the fairs in Atlanta (1895), Nashville (1897), Omaha (1898), Buffalo (1901), and especially the Panama-Pacific International Exposition, San Diego (1915) invite further study. See Applegate in progress.

11. See Weinberg 1991.

12. Bacon's 1875 Paris Salon painting, *Boston Boys and General Gage* (1875, George Washington University, Washington, D.C.), was shown at the Centennial. Junkin 1986, pp. 162–63, notes that two of the four Sargent oil sketches that Bacon owned at the time of his death were shipboard scenes, possibly done during one of Sargent's crossings to visit the Centennial.

13. See Winslow Homer's double-page wood engraving, *Homeward Bound,* in *Harper's Weekly*, December 21, 1867 (Homer, W. 1867). Bacon's sources are described in Junkin 1986, pp. 162–71; Troyen 1980–81, p. 156; Bullington 2000.

14. The *Périere* was built in Glasgow in 1865 for the French shipping firm Compagnie Generale Transatlantique and was named for one of its founders. In 1867 it set a record by crossing the Atlantic in eight days and sixteen hours. See "Jacob Émile Périere" 2001.

15. Attire is prescribed in Knox 1881, pp. 56–57, cited in Bullington 2000, p. 64.

16. "RMS *Etruria* and her sister ship RMS *Umbria* were the last two Cunarders that were fitted with auxiliary sails. RMS *Etruria* was built by John Elder & Co of Glasgow, Scotland in 1884. The *Etruria* and her sister *Umbria*, by the standards of the time, were record breakers. They were the largest liners then in service, and they plied the Liverpool to New York Service." See Logghe, ed. 2006.

17. Bullington 2000, p. 74.

18. Nieriker 1879; Knox 1881; White 1891.

19. James 1878; Howells 1879; Hazeltine 1879. Bullington 2000, pp. 75–86, links James's Daisy Miller and Howells's Lydia Blood (who is described on an ocean crossing) to women featured in specific canvases by Bacon.

20. Junkin 1986, pp. 168–69. Tissot's *L'Escalier* appeared at Sotheby's, New York, in 1993, lot 111. The author thanks John D. Olsen, Kendall Scully, and Janelle Sing at Sotheby's, New York, for their assistance in locating the painting.

21. Whiteing 1882, p. 116. Arthur Burdett Frost's *Incidents of an Ocean Trip*, in *Harper's Weekly*, August 10, 1878 (Frost 1878), is a similar montage of illustrations, but on a single sheet.

22. For the relationship between modern urban life and the development of Impressionism, see Herbert 1988; Rubin 2008.

23. For commentary on the painting, see Weinberg, Bolger, and Curry 1994–95, pp. 135–38; Elaine Kilmurray, catalogue entry, in Kilmurray, Ormond, and Volk 1998–99, pp. 84–85.

24. Robinson, W. 1869, pp. 76–81.

25. Charles Baudelaire, "Le Peintre de la vie moderne"(1863), translated in Baudelaire 1863, 1964, p. 9.

26. Elaine Kilmurray, catalogue entry, in Kilmurray, Ormond, and Volk 1998–99, p. 85.

27. Curry 1984, pp. 74–87, provides a sociocultural history of Cremorne Gardens.

28. Sutton, D. 1963, pp. 67–68. See also Spassky et al. 1985, pp. 367–70.

29. See, for example, Édouard Manet, *Music in the Tuileries* (1862, National Gallery, London); Pierre-Auguste Renoir, *Le Moulin de la Galette* (1876, Musée d'Orsay, Paris); James-Jacques-Joseph Tissot, *The Artists' Wives* (1885, Chrysler Museum of Art, Norfolk, Virginia).

30. Elizabeth Robins Pennell and Joseph Pennell describe Whistler's "sauce" in Pennell 1908, vol. 1, pp. 164–65. The author acknowledges with appreciation the advice of Richard Dorment.

31. Curry 1984, pp. 80–81.

32. Richard Dorment, "Cremorne," in Dorment and MacDonald et al. 1994–95, pp. 132–35; the quotation is taken from pp. 134–35.

33. Ibid.; the quotation is taken from p. 133.

34. Curry 1984, p. 75.

35. See Merrill et al. 2003–4; Simpson et al. 2008.

36. See Weinberg 1991; Adler, Hirshler, and Weinberg et al. 2006–7; Lovell 1984–85; Lovell 1989; Stebbins et al. 1992–93.

37. Fairbrother 1994, pp. 99–101; Ormond and Kilmurray 2002, pp. 154–55; Richard Ormond, catalogue entry, in Kilmurray, Ormond, and Volk 1998–99, pp. 151–52.

38. Pennell 1921, p. 39.

39. James 1902.

40. Cassatt mentions Degas's participation in Mary Cassatt, Beaufresne, Tuesday [1903], to Ambroise Vollard, reproduced in Mathews, ed. 1984, p. 281.

41. Barter 1998–99, p. 72, notes the parallel with Cluysenaar's portrait.

42. Bacon 1882, p. 95.

43. See Weinberg 2006–7, pp. 115–50. A pioneering study is Jacobs 1985. Lübbren 2001 surveys the trend. Pese et al. 2001–2 focuses on visiting artists' subjects.

44. Gerdts 1993, pp. 26–30, summarizes memoirs that mention the initial visitors. According to Nina Lübbren (2001), p. 169, Giverny attracted (until 1907) ninety-two artists, of whom 15 percent were women and 87 percent were Americans. See Hôtel Baudy 1887–99.

45. Greta 1887.

46. Diary entry for July 20, 1892, in Robinson, T. 1892–96. Johnston, S., and Tucker 2004–5, pp. 56, 140. The author acknowledges with appreciation the assistance of Katie Bourguignon, Associate Curator, Musée d'Art Américain/Terra Foundation for American Art, Giverny, who provided a photocopy of Butler's wedding certificate from the Archives Départementales de l'Eure, Évreux, France.

47. Diary entry for August 5, 1892, in Robinson, T. 1892–96.

48. Waller 1879.

49. See, for example, *Home Scene* (ca. 1871, Brooklyn Museum); *Elizabeth at the Piano* (1875, Addison Gallery of American Art, Phillips Academy, Andover, Massachusetts); *Baby at Play* (1876, National Gallery of Art, Washington, D.C.).

50. For *Singing a Pathetic Song*, the following sources were helpful: Simpson 2001–2b, p. 110; Johns 1983, pp. 133–35. See also Homer, W. I. 1992, pp. 117, 120; Sarah Cash, catalogue entry, in Heartney et al. 2002, p. 110.

51. Van Rensselaer 1881, p. 199, quoted in Simpson 2001–2b, p. 110.

52. Johns 1983, pp. 133–35.

53. For musical images, see Betsky 1984.

54. See Bolger 1996–97, pp. 44–45. For the discussion of *Swimming* in this essay, see pp. 156–57.

55. Broude 2000–2001, p. 42. Other useful commentary appears in Barter 1998–99, p. 54.

56. Huysmans 1883, pp. 233–34, translated and quoted in Effeny 1991, p. 66. The French text appears in Spassky et al. 1985, p. 634.

57. Useful references include Spassky et al. 1985, pp. 638–42; Mathews, ed. 1984, pp. 174–76, 320–21.

58. Havemeyer 1927, p. 382; quoted in Spassky et al. 1985, p. 640.

59. Havemeyer 1927, pp. 378, 381; quoted in Spassky et al. 1985, p. 650.

60. Redating the painting from the commonly accepted "ca. 1888" to 1887, Barbara Dayer Gallati emphasizes Cosy's birth on February 9, 1887, a day after the Chases' marriage, and suggests that the couple moved to Brooklyn to avoid embarrassment. Gallati 2000–2001, pp. 37, 56–61, passim.

61. Art Institute of Chicago 1915–16, no. 73; American Art Association 1917, lot 375 (as *The Backyard: Breakfast Out of Doors*).

62. Carol Troyen, catalogue entry, in Stebbins and Troyen et al. 1983–84, p. 314.

63. Day and Sturges, eds. 1987, p. 165 n. 4, mentions the original title of *Sunlight and Shadow*.

64. Pertinent to this discussion are Atkinson and Cikovsky 1987–88; Weinberg, Bolger, and Curry 1994–95, pp. 105–16.

65. Wharton 1934, p. 249. James's remark emerged during a visit to Bodiam Castle, Kent, England, in the first decade of the twentieth century.

66. See, for example, Mitchell, S. W. 1884. The rest cure that Mitchell prescribed for Charlotte Perkins Gilman provided the idea for her short story "The Yellow Wall-paper" (Gilman 1892), in which the narrator is driven insane by her rest cure. A recent source on the phenomenon is Williams, K., et al. 2004–5.

67. Hobbs and Gallati 1996–97, pp. 160–61. Hobbs reviews women's association with contemporary evolutionary theory—which placed delicate forms at the top of the scale—and "the fin-de-siècle mood of uncertainty and anxiety." Kathleen Pyne develops the connection between Dewing's women and contemporary evolutionary theory in Pyne 1993.

68. Elaine Kilmurray, catalogue entry, in Tottis, ed. 2005, p. 234.

69. Eliza Wedgwood recalled Sargent's characterization of the *garde mangers* in notes she prepared in 1925 for Evan Charteris, quoted in Elaine Kilmurray, catalogue entry, in Tottis, ed. 2005, p. 234.

70. Van Hook 1996, p. 107.

71. James 1877, p. 48, quoted in Winner 1970, p. 132. James 1881, vol. 2, p. 9. For discussion of these references, see Saisselin 1984, p. 61, and Weinberg, Bolger, and Curry 1994–95, p. 273.

72. Veblen 1899, chapter 4 passim.

73. For the Boston School, see Leader 1982; Fairbrother 1986–87, pp. 64–82.

74. The author thanks her colleague Beth Wees, Curator of American Decorative Arts, for her observations on the props. An astute account of the painting was written by Meredith Hahn in May 2000 for a Barnard College seminar taught by the author; copy in Departmental Files, American Paintings and Sculpture, The Metropolitan Museum of Art.

75. "*Breakfast*: Painted by William M. Paxton," in *Ladies Home Journal*, March 1913 (Paxton 1913), cited in Docherty 1991. Todd 1870, p. 33.

76. For the complete song, see Lamb 1900.

77. Chase and his wife had seven living children born between 1887 and 1902, when he stopped teaching at Shinnecock; their daughter Mary was born in 1904, when the family still spent summers at the resort.

78. Harvey 2006–7, p. 42.

79. Selchow and Righter 1888, p. 36, reproduced in Weinberg, Bolger, and Curry 1994–95, p. 299.

80. Downes 1909, p. xxix, quoted in Harvey 2006–7, p. 45.

81. *New York Times* 1910, quoted in Harvey 2006–7, p. 45.

82. Alger 1868, 1926. See also Tebbel 1963; Scharnhorst 1980.

83. Brown quoted in "The Street Gamin Has Vanished from New York" (*New York Times* 1912): "Our typical youngster of the streets has gone for good.They are required to attend school during the age when they used to be at their best. Up to four or five years ago I was still able to find enough bright, creditable boys to keep me busy, but then they began to go to school."

84. See Claudia Vess, catalogue entry, in McElroy et al. 1990, p. 95.

85. Carr 1993, pp. 86–87, discusses the dispute that arose over the New York jury's selection of paintings.

86. Ibid., pp. 106–7.

87. Howells 1891, p. 128. Howells himself had ignored that prescription in *A Modern Instance, a Novel* (Howells 1882), which includes suicide and divorce.

88. Crane 1893; Dreiser 1900. Unable to find a publisher, Crane paid for the publication of *Maggie*, and Dreiser's publisher suppressed *Sister Carrie* after it appeared. Zola 1880.

89. For a discussion of the painting, see Burns 1988.

90. Larkin, S., and Nichols 2005–6, pp. 18–35, provides an excellent overview of American images of rural and industrial labor.

91. *Nation* 1883, p. 348, quoted in Cikovsky and Kelly et al. 1995–96, p. 323. The same review appeared in *Evening Post* 1883.

92. *Boston Evening Transcript* 1916, clipping in Thomas B. Clarke Scrapbook (J–7), p. 128, Archives of American Art, Smithsonian Institution, Washington, D.C.

93. See *Sleeping Ariadne* (3rd century B.C., Vatican Museums, Rome).

94. The drawings, in the collection of the Sterling and Francine Clark Art Institute, Williamstown, Massachusetts, are reproduced in Cikovsky and Kelly et al. 1995–96, pp. 232–33.

95. *Boston Daily Evening Transcript* 1887, quoted in Cikovsky and Kelly et al. 1995–96, pp. 233–34. The author thanks the following scholars for sharing with her their observations on *Undertow*: Marc Simpson, Curator of American Art, Sterling and Francine Clark Art Institute, Williamstown, Massachusetts; Dr. Robert M. Browning, Chief Historian, United States Coast Guard; Dr. Dennis L. Noble, independent researcher and author of *That Others Might Live: The U.S. Life-Saving Service, 1878–1915* (Noble 1994) and other books on marine rescues.

96. Cikovsky and Kelly et al. 1995–96, p. 324.

97. Spassky et al. 1985, pp. 471–75, documents the changes Homer made to the canvas.

98. *New-York Daily Tribune* 1901, quoted in Cikovsky and Kelly et al. 1995–96, p. 333.

99. *The Thankful Poor* is illustrated in Boime 1993, p. 427.

100. See Kaplan et al. 1987–88.

101. An overview of craft genre that emphasizes Jefferson D. Chalfant, Ulrich, and George de Forest Brush appears in Shapiro 2003.

102. See, for example, Robert Frederick Blum, *Venetian Lace Makers* (1887, Cincinnati Art Museum); Harriet Campbell Foss, *A Flower Maker* (1892, private collection), which is reproduced and discussed in Carr and Gurney et al. 1993, p. 152.

103. Shapiro 2003, pp. 104–9, provides a useful account of the work.

104. Brush 1885, p. 57.

105. Nemerov 1991–92, pp. 323–26, discusses torpor in the painting.

106. Mieder 1993; Jackson 1881. Morgan 1983, pp. 70–71, describes attitudes to the American Indian and how they affected Brush's decision to abandon Indian subjects.

107. *New-York Times* 1886.

108. Koehler, in *The Journal* (Minneapolis), March 23, 1901, quoted in Hills 1974–75, p. 123. For *The Strike*, see also Weisberg 1992, pp. 165–67; Judith Hayward, catalogue entry, in Blaugrund et al. 1989–90, p. 181.

109. For a summary of these hardships, see Trachtenberg 2007, pp. 90–95.

110. Isham 1927, p. 344.

111. Pauly 1988, p. 346.

112. Anshutz would later hone his technical skills in the French capital and then share them with members of the Ashcan School and his other students at the Pennsylvania Academy. For Anshutz as a teacher, see Griffin 1994.

113. Cornell 2005, p. 198. Mathews 2005–7, p. 76, suggests Anshutz's awareness of contemporaneous studies in motion photography by Eadweard Muybridge, which also engaged Eakins's attention.

114. Strobridge's artists might have seen Anshutz's painting in *The Private Collection of Paintings by Exclusively American Artists, owned by Thomas B. Clarke* (Koehler 1883–84, no. 3), or reproduced in a wood engraving by F. Juengling in *Harper's Weekly*, August 30, 1884 (Anshutz 1884). Bowman 1973, pp. 32–33, described Harley Procter's commission to the Strobridge company and the group photograph taken on the roof of the Strobridge plant. Procter & Gamble's poster was created by cutting out the individual figures from the photograph and pasting them on to the painted background of a foundry to create a composite image that was then rephotographed, blown up, lithographed, and hand colored. Bowman (1973, p. 32) concluded: "The similarity between the Anshutz painting and the commercial lithograph is evident and clearly intentional." Nancy

Mowll Mathews (Mathews 2005–7, pp. 76–77), commented: "Whether deliberately or not, the poster replicated Anshutz's painting by making analytic photographs of the workers at the lithography company in motion." Both Bowman and Mathews reproduce the poster and date it about 1883.

115. Clarke 1891, pp. 7–8. Although Pauly 1988, p. 346, mentions that the title of Anshutz's painting echoes Brown's, it should be noted that Anshutz originally titled it *The Ironworkers*, and then *Dinner Time*; it was Clarke who changed the title to *The Ironworkers' Noontime* after he purchased it.

116. Wehle et al. 1939, p. 206; Griffin 1994, pp. 37, 50. Griffin offers extended accounts of the painting in Griffin 1990; and Griffin 2004, pp. 45–69.

117. Cornell 2005, p. 200.

118. See *American Art Review* 1881, p. 168; Thomas B. Clarke, New York, August 15, 1883, to S[ylvester] R[osa] Koehler, Koehler Papers, Archives of American Art, Smithsonian Institution, Washington, D.C., reel D183, frames 426–27.

119. Simpson 1996–97.

120. Ibid., pp. 4, 5.

121. Ibid., p. 6. Two later commentaries that focus on gender in *Swimming* are Berger 1997; Griffin 1995. The painting is also considered in Berger 2000.

122. Simpson 1996–97, p. 9.

123. Regarding the photographs, see Walter 1995, p. 139, citing Danly and Leibold, eds. 1994, nos. 393–402.

124. Walter 1995, p. 144. Eakins painted two more boxing scenes—*Taking the Count* (1898, Yale University Art Gallery) and *Salutat* (1898, Addison Gallery of American Art, Phillips Academy, Andover, Massachusetts)—and *The Wrestlers* (1899, Los Angeles County Museum of Art).

125. Simpson 2001–2c, p. 266. Simpson's commentary on Eakins's boxing paintings, pp. 266–68, was useful, as was the documentation provided in Walter 1995.

126. Walter 1995, pp. 244–82, summarizes available information on Smith and speculates on why Eakins painted him.

127. Charley McKeever and Jack Daly wear colored sashes in *Taking the Count*, as does Smith in *Salutat*.

128. The photograph of Homer with the painting on his easel is reproduced in many sources, including Beam et al. 1990–91, p. 94.

129. Winslow Homer, New York, February 17, 1902, to M. Knoedler and Company, quoted in Spassky et al. 1985, p. 484.

130. Burroughs 1907.

131. In an undated article quoted in Downes 1911, p. 135, Riter Fitzgerald in the *Philadelphia Item* described "a naked negro lying in a boat while a school of sharks were waltzing around him in the most ludicrous manner."

132. Spassky et al. 1985, p. 486. Cikovsky 1995–96, pp. 369–70, adds Eugène Delacroix's *Barque of Dante* (1822, Musée du Louvre, Paris) and Thomas Cole's *Voyage of Life* (1840, Munson-Williams-Proctor Institute, Utica, N.Y.) to the list of possible sources for *The Gulf Stream* and discusses Homer's access to all these works. Stein, R. 1975, p. 112, analyzes *The Gulf Stream* in relation to the Romantic tradition.

133. Boime 1990, pp. 36–37. See also Boime 1989.

134. Cikovsky 1995–96, p. 369. Cikovsky also notes the funerary implications of details such as the cross-shaped cleat on the bow, the broken mast, the hatch, and the sail (Cikovsky and Kelly et al. 1995–96, pp. 382–83). Other psychoanalytic and personal readings of the painting appear in Adams 1983a; Honour 1989, pt. 2, p. 202; Johns 2002, pp. 155–56.

135. Staiti 2001, p. 31.

136. Wood, P. 2004.

137. This account is indebted to the excellent overviews offered in Johnson, M. 2002; and Saunders 1988. From the vast literature on the subject, the following (listed in chronological order) have also been useful: Nemerov 1991–92; Slotkin 1992; Prown et al. 1992–93; Dippie 1994; Dippie 1998; Hassrick 2000–2001; Hassrick et al. 2007.

138. For the "buckskin brigade," see Dippie 1998, p. 25.

139. Neff 2006–7, p. 51, notes that the U.S. Bureau of the Census "defined a frontier as having no more than two people per square mile." See Turner 1894.

140. For example, in late July 1887, following his break with the Pennsylvania Academy and likely at the suggestion of Dr. S. Weir Mitchell and

141. Dr. Horatio Wood, Eakins set out for a ten-week stay on a Dakota Territory ranch. Walt Whitman, whom the painter had met a few months earlier, later observed that Eakins had been "sick, rundown, out of sorts: he went right along among the cowboys: herded: built up miraculously." Traubel 1953, p. 135, quoted in Simpson 2001–2b, p. 117.

141. Johnson, M. 2002, pp. 33–34. Key primary sources include Turner 1893, 1894; Roosevelt 1888; Wister 1902.

142. Finson 2000, p. 148.

143. Burke, D. 1980, pp. 400–404.

144. Fischer 1999–2001, p. 67.

145. Coffin 1892, p. 348.

146. Nemerov 1991–92, p. 287.

147. Emily Ballew Neff, catalogue entry, in Neff and Phelan 2000, p. 82.

148. Ibid., pp. 80–85.

149. Nemerov 1991–92.

150. Truettner 1991, pp. 552–53.

151. Loomis 1887, pp. 341–42.

152. Elaine Kilmurray, catalogue entry, in Kilmurray, Ormond, and Volk 1998–99, p. 85. Whistler, who had made etchings and pastels of London, Paris, and Venice, and had painted Cremorne Gardens amusement park (fig. 110) may also have influenced Chase, who visited him in London in the summer of 1885.

153. The painter Stuart Davis distinguished between two generations of Ashcan artists in "Stuart Davis Reminisces," interview by Harlan B. Phillips, 1962, p. 53, unpublished typescript, collection of Earl Davis, cited in Hunter 1991–92, p. 32. The term Ashcan School was suggested by a drawing by Bellows captioned *Disappointments of the Ash Can*, which appeared in the *Philadelphia Record* in April 1915. It was invoked by the cartoonist Art Young in a disparaging critique that appeared in the *New York Sun* in April 1916, and given curatorial currency by Holger Cahill and Alfred H. Barr Jr. in a 1934 exhibition at New York's Museum of Modern Art (Cahill and Barr et al. 1934, p. 91). Hunter 1991–92, pp. 35–37, recounts in detail the origin of the term Ashcan School. Recent interest in the Ashcan artists is reflected in Zurier, Snyder, and Mecklenburg 1995–96; Zurier 2006; Tottis et al. 2007–8.

154. These included a group display at the National Arts Club in 1904; the landmark February 1908 show of The Eight at the Macbeth Galleries, which included the five senior Ashcan School painters, along with Ernest Lawson, Maurice Prendergast, and Arthur B. Davies; the 1910 Exhibition of Independent Artists; and the 1913 Armory Show. See National Arts Club 1904; Macbeth Galleries 1908; Zilczer 1984; Independent Artists 1910; Wilmington Society of the Fine Arts 1960; Armory Show 1913.

155. Weinberg, Bolger, and Curry 1994–95, pp. 3–13, provides an introduction to the parallels and differences between the American Impressionists and the Ashcan painters, to which the present account is indebted.

156. Rowland Elzea, catalogue entry for John Sloan, *Sunday, Women Drying Their Hair* (fig. 168), in Faxon, Berman, and Reynolds et al. 1996, p. 468. See also Zurier 2006, pp. 268–69. For a recent examination of Sloan, see Coyle and Schiller et al. 2007–9.

157. Weinberg, Bolger, and Curry 1994–95, pp. 225–27. For documentation of the painting, see Elzea 1991, vol. 1, p. 150.

158. Phillips et al. 1909.

159. St. John, ed. 1965, pp. 292, 299, 300, 305.

160. Sloan 1939, p. 221.

161. Greusel 1893, quoted in Mayer 1958, pp. 417–18. Mayer, p. 418, reproduces *Restaurant in Chinatown, 1905*; *24 Pell Street*, a photograph from the Byron Collection of the Museum of the City of New York.

162. Weinberg, Bolger, and Curry 1994–95, p. 227.

163. Zurier 2006, pp. 27, 29, 272.

164. St. John, ed. 1965, pp. 38–39.

165. Sloan, February 27, 1942, to Margit Varga, quoted in Elzea 1991, vol. 1, pp. 69–70. See also Sloan 1939, p. 208.

166. Sims, P. 1985, pp. 26–27.

167. An undated account by Albert E. Gallatin, preserved in the "Living American Artist file" of the Addison Gallery of American Art, Phillips Academy, Andover, Massachusetts, quotes Sloan: "'Sunday, Women Drying Their Hair,' was painted at the time that I occupied a studio on

the eleventh floor of a loft building, otherwise infested with small sweating manufacturers."

168. Sloan 1939, p. 233.

169. See, for example, Carrick 1900; Cranston 1906; Maule 1907.

170. Introductions to the history of the department store and American consumerism include Benson, S. 1986; Leach 1993; Bowlby 2001; Domosh 2004.

171. Roznoy 1990, suggests the locale, proposes that the painting acknowledged the opening of Wanamaker's New York branch, and offers other useful information. See also *New York Times* 1903, and Davis, H. 1907. Wanamaker's occupied the blocks bounded by Fourth Avenue and Broadway, Eighth and Tenth streets. For an extended account of Glackens's painting, see Weinberg, Bolger, and Curry 1994–95, pp. 272–77.

172. For Wanamaker, see Ershkowitz 1999.

173. Gerdts and Santis 1996, pp. 80–81, mentions that Glackens had earlier portrayed shoppers in an illustration for John J. A'Becket, "New York's Christmas Atmosphere," in *Harper's Bazaar* (A'Becket 1900), p. 2077.

174. Wharton 1905, 1926, pp. 17–18.

175. Chamberlin 1908; Huneker 1908. Both comments are quoted in Gerdts and Santis 1996, p. 81.

176. John Sloan, *Movies, Five Cents* (1907, private collection) is reproduced in Weinberg, Bolger, and Curry 1994–95, p. 219.

177. DeShazo 1974, p. 71. For a fuller account, see Ferber 1990.

178. The painting and related images are considered in Weinberg, Bolger, and Curry 1994–95, pp. 217–18.

179. *New York Times* 1900. For Proctor, see Marston and Feller 1943.

180. *New York Times* 1906. Yount 1992, pp. 102–7, describes some of Shinn's vaudeville paintings and refers to accounts of vaudeville, including Caffin 1914; Stein, C., ed. 1984; Erenberg 1981; Snyder 1989.

181. Sanjek 1988, p. 338.

182. Unidentified document in Everett Shinn Papers, Box 9, Shinn Autobiographical Notes, Helen Farr Sloan Library, Delaware Art Museum, quoted in Wong 2000–2001, p. 41.

183. Information from DiMeglio 1973, summarized in Wong 2000–2001, p. 79.

184. The other major early canvases are *Stag at Sharkey's* (1909, Cleveland Museum of Art) and *Both Members of This Club* (1909, National Gallery of Art, Washington, D.C.). See Carmean et al. 1982–83; Haywood 1988; Wilmerding 1991; Weinberg, Bolger, and Curry 1994–95, pp. 233–40. Bellows also depicted boxing in lithographs.

185. For Thomas Joseph "Sailor Tom" Sharkey (1873–1953), see his obituary, *Time* 1953. *New York Times* 1905 gives the address of the Sharkey Athletic Club as Sixty-fifth Street and Broadway. Perlman 1991, p. 89, gives the location of Bellows's studio. Bellows, June 10, 1922, to William Milliken, Director, Cleveland Museum of Art, Cleveland Museum of Art Archives, quoted in Haywood 1988, p. 3: "Before I married and became semi-respectable, I lived on Broadway opposite The Sharkey Athletic Club where it was possible under the law to become a 'member' and see the fights for a price."

186. Doezema 1992–93, pp. 104–5. See also Doezema 1992, pp. 66–121, which analyzes Bellows's boxing pictures.

187. Bellows, 1910, to Miss Katherine Hiller, quoted in Beer 1927, p. 15; quoted in Doezema 1992, p. 87.

188. Bourget 1895, p. 333. Weinberg, Bolger, and Curry 1994–95, p. 234, comments that Bourget's description of a match (pp. 334–35) reads like a description of *Club Night*. Sammons (1988), p. 54, observes, "Perhaps no sport has been more confined to the realm of men than boxing."

189. London 1905. The connection with London's novel is mentioned in Snyder and Zurier 1995–96, p. 182. London 1909, 1961, p. 29, quoted in Weinberg, Bolger, and Curry 1994–95, p. 234.

190. Roosevelt described his boxing experiences in *Theodore Roosevelt: An Autobiography* (Roosevelt 1913), chapter 2, "The Vigor of Life," pp. 27–53. See also the account of Roosevelt's friend and sparring partner Michael J. Donovan in *The Roosevelt That I Know: Ten Years of Boxing with the President* (Donovan 1909).

191. Santayana's essay, "The Genteel Tradition in American Philosophy," presented to the Philosophical Union of the University of California in 1911, appears in Santayana 1967.

192. Citing Bellows Record Book, book A, p. 157, Jean Bellows Booth Collection, La Jolla, California, Fort and Quick 1991, p. 241, gives the painting's date as May 1913. The painting's title reiterated that of Henry Blake Fuller's popular novel about Chicago apartment life, *The Cliff-Dwellers, A Novel* (Fuller 1893). Fort and Quick 1991, p. 241, indicates that Bellows wrote the title originally as *The Cliff Dwellers*, but then crossed out the definite article in Bellows Record Book, book A, p. 157.

193. Kouwenhoven 1953, p. 381; Russell 1909, p. 177.

194. Sources on immigration and ethnic populations include Glazer and Moynihan 1970; Hammack 1982; Bodnar 1985. For the arrival and establishment of the Jews in the United States, see Sachar 1992. For an overview of the Lower East Side, see Schoener, ed. 1966; Schoener, ed. 1967; Cavallo 1971; Sanders 1979; Goodman 1979, especially pp. 3–19; Sante 1991; Hindus, ed. 1995; Maffi 1995; Diner, Shandler, and Wenger 2000; Dowling 2007; Epstein 2007.

195. Bennett 1912, p. 187; quoted in Doezema 1992, p. 189. On p. 188, Doezema notes that "Bellows produced five drawings that would appear in *The Masses* during the spring and summer of 1913. They were all worked in a variety of media."

196. Quick 1992–93, p. 38, claims that *Cliff Dwellers* represents Bellows's "most complex exploration of the Maratta color system."

197. McBride 1913, quoted in Doezema 1992–93, p. 119. In discussing *Cliff Dwellers* here and elsewhere, Doezema emphasizes Bellows's negative social commentary. See, by contrast, the description in Fort and Quick 1991, pp. 240–44, which also summarizes pertinent documentation.

198. Van Dyke 1909, p. 269.

199. See Lubove 1962.

200. Van Rensselaer 1892, p. 172.

201. Howells 1890, 1983, pp. 56–57.

202. Charles Baudelaire, "Le Peintre de la vie moderne" (1863), translated in Baudelaire 1863, 1964, p. 9.

203. Armory Show 1913.

204. For an in-depth discussion of this picture, see Mount 1978.

205. Hills 1986–87, p. 203: "What Sargent wanted to see was not reality, but the holiday, aestheticized world of the late nineteenth and the early twentieth centuries."

Bibliography

Works in the Exhibition

Index

Photograph Credits

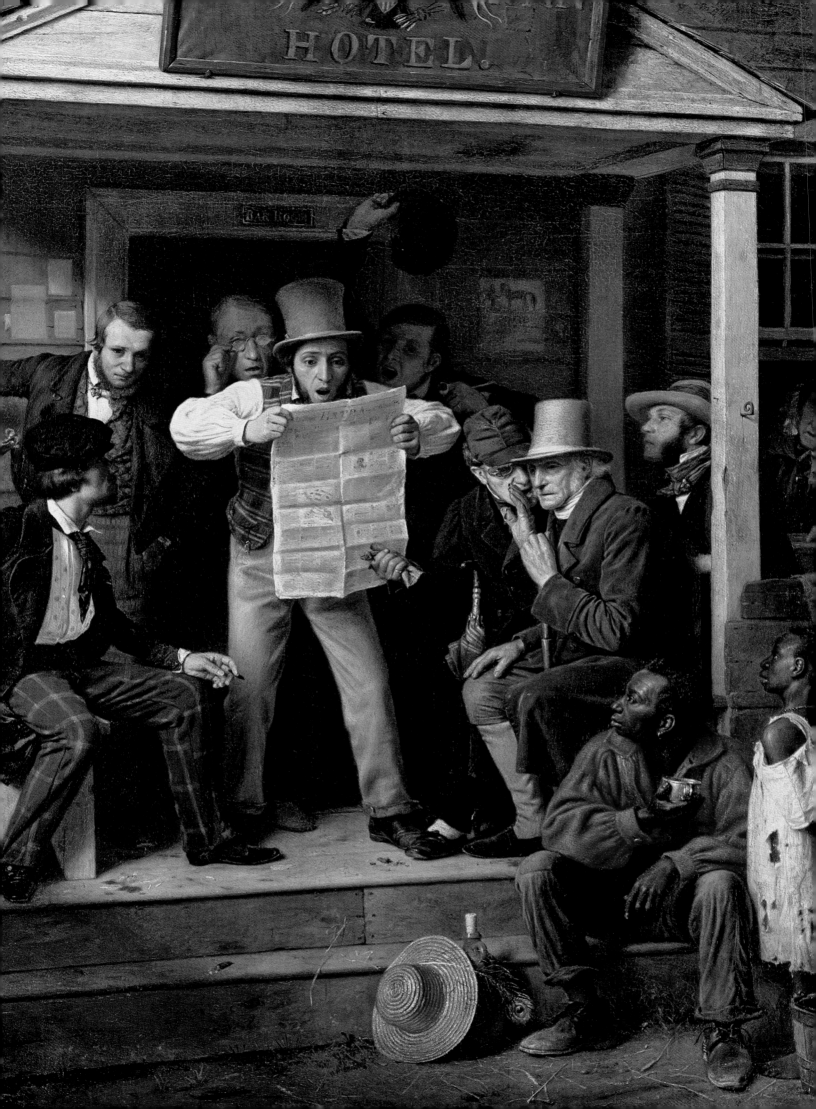

Bibliography

A'Becket 1900
A'Becket, John J. "New York's Christmas Atmosphere." *Harper's Baza[a]r* 33, no. 50 (December 15, 1900), pp. 2073–79.

Abrams 1979
Abrams, Ann Uhry. "Politics, Prints, and John Singleton Copley's *Watson and the Shark*." *The Art Bulletin* 61, no. 2 (June 1979), pp. 265–76.

Adams 1983a
Adams, Henry. "Mortal Themes: Winslow Homer." *Art in America* 71, no. 2 (February 1983), pp. 112–26.

Adams 1983b
Adams, Henry. "The Development of William Morris Hunt's *The Flight of Night*." *The American Art Journal* 15, no. 2 (Spring 1983), pp. 43–52.

Adler, Hirshler, and Weinberg et al. 2006–7
Adler, Kathleen, Erica E. Hirshler, and H. Barbara Weinberg et al. *Americans in Paris, 1860–1900*. Exh. cat., National Gallery, London, February 22–May 21, 2006; Museum of Fine Arts, Boston, June 25–September 24, 2006; The Metropolitan Museum of Art, New York, October 17–January 28, 2007. London: National Gallery, 2006.

Albion 1859
"Fine Arts. The National Academy of Design, Third and Final Notice." *The Albion* 37, no. 22 (May 28, 1859), p. 261.

Albion 1865
"Fine Arts. The National Academy of Design, Third Notice." *The Albion* 43, no. 21 (May 27, 1865), pp. 249–50.

Alger 1868, 1926
Alger, Horatio, Jr. *Ragged Dick, or, Street Life in New York*. 1868. New York: Street and Smith, 1926.

Allen 2004
Allen, Brian T. *Sugaring Off: The Maple Sugar Paintings of Eastman Johnson*. Exh. cat., Sterling and Francine Clark Art Institute, Williamstown, Massachusetts, January 18–April 18, 2004; The Huntington Library, Art Collections, and Botanical Gardens, San Marino, California, May 11–August 1, 2004. Williamstown, Mass.: Sterling and Francine Clark Art Institute, 2004.

American Art Association 1917
The Completed Pictures, Studies and Sketches Left by the Late William Merritt Chase, N.A. Sale cat., American Art Galleries, New York, May 14–17, 1917. New York: American Art Association, [1917].

American Art Journal 1866
"The Studios." *American Art Journal* 5, no. 16 (August 9, 1866), pp. 243–44.

American Art Review 1881
"Clubs and Societies: Philadelphia Sketch Club." *American Art Review* 2, pt. 1 (February 1881), p. 168.

American Educational Monthly 1866
"Croquet." *American Educational Monthly* 3, no. 8 (August 1866), pp. 289–96.

Anshutz 1884
"'The Iron-Workers Noon-Time'—Engraved by F. Juengling from the Painting by Thomas Anshutz in the Thomas B. Clarke Collection." *Harper's Weekly* 28, no. 1445 (August 30, 1884), p. 570.

Applegate in progress
Applegate, Heidi. "Staging Modernism at the 1915 San Francisco World's Fair." PhD diss., Columbia University, in progress.

Appletons' Journal 1872
"The Spring Exhibition of the National Academy." *Appletons' Journal of Literature, Science, and Art* 7, no. 165 (May 25, 1872), pp. 578–80.

Aristotle 1984
Aristotle. *Poetics*. In *The Complete Works of Aristotle: The Revised Oxford Translation*, edited by Jonathan Barnes, vol. 2, pp. 2316–40. 2 vols. Bollingen Series, 71, pt. 2. Princeton, N.J.: Princeton University Press, 1984.

Armory Show 1913
Catalogue of International Exhibition of Modern Art, Association of American Painters and Sculptors. Cover title: *International Exhibition of Modern Art, New York 1913*. Exh. cat., Armory of the Sixty-ninth Infantry, Lexington Avenue, Twenty-fifth and Twenty-sixth Streets, New York, February 15–March 15, 1913. New York: Vreeland Advertising Press, 1913.

Arnold 1865
Arnold, George. "Art Matters." *New York Leader*, June 24, 1865, p. 1.

Art Institute of Chicago 1915–16
Catalogue of the Twenty-eighth Annual Exhibition of American Oil Paintings and Sculpture. Exh. cat., The Art Institute of Chicago, November 16, 1915–January 2, 1916. [Chicago, 1915].

Atkinson and Cikovsky 1987–88
Atkinson, D. Scott, and Nicolai Cikovsky Jr. *William Merritt Chase: Summers at Shinnecock 1891–1902*. Exh. cat., National Gallery of Art, Washington, D.C., September 6–November 29, 1987; Terra Museum of American Art, Chicago, December 11, 1987–February 28, 1988. Washington, D.C.: National Gallery of Art, 1987.

Ayres, L. 1987–88
Ayres, Linda. "William Ranney." In Hassrick et al. 1987–88, pp. 78–107.

Ayres, W., et al. 1993–94
Ayres, William, et al. *Picturing History: American Painting 1770–1930*. Exh. cat., IBM Gallery of Science and Art, New York, September 28–November 27, 1993; The Corcoran Gallery of Art, Washington, D.C., January 29–April 2, 1994; Dallas Museum of Art, May 1–July 10, 1994; Center for the Fine Arts, Miami, August 6–November 13, 1994. New York: Rizzoli International Publications and Fraunces Tavern Museum, 1994.

Opposite: Richard Caton Woodville. *War News from Mexico*, 1848 (detail of fig. 46)

Bacon 1882
Bacon, Henry. *A Parisian Year*. Boston: Roberts Brothers, 1882.

Baker 1848
Baker, Benjamin A. *A Glance at New York: A Local Drama in Two Acts*. New York: Samuel French and Son; London: Samuel French, 1848.

Baldwin, Daniel, and Greenough et al. 2004–5
Baldwin, Gordon, Malcolm Daniel, and Sarah Greenough et al. *All the Mighty World: The Photographs of Roger Fenton, 1852–1860*. Exh. cat., National Gallery of Art, Washington, D.C., October 17, 2004–January 2, 2005; J. Paul Getty Museum, Los Angeles, February 1–April 25, 2005; The Metropolitan Museum of Art, New York, May 17–August 14, 2005. New York: The Metropolitan Museum of Art, 2004.

Barratt 2000–2001
Barratt, Carrie Rebora. "Mapping the Venues: New York City Art Exhibitions." In Voorsanger and Howat et al. 2000–2001, pp. 46–81.

Barratt 2004–5
Barratt, Carrie Rebora. "Anna Dorothea Foster and Charlotte Anna Dick." In *Gilbert Stuart*, by Carrie Rebora Barratt and Ellen G. Miles, pp. 87–90. Exh. cat., The Metropolitan Museum of Art, October 21, 2004–January 16, 2005; National Gallery of Art, Washington, D.C., March 27–July 31, 2005. New York: The Metropolitan Museum of Art, 2004.

Barratt and Staiti et al. 1995–96
[Barratt], Carrie Rebora, and Paul [J.] Staiti et al. *John Singleton Copley in America*. Exh. cat., Museum of Fine Arts, Boston, June 7–August 27, 1995; The Metropolitan Museum of Art, New York, September 26, 1995–January 7, 1996; The Museum of Fine Arts, Houston, February 4–April 28, 1996; Milwaukee Art Museum, May 22–August 25, 1996. New York: The Metropolitan Museum of Art, 1995.

Barter 1998–99
Barter, Judith A. "Mary Cassatt: Themes, Sources, and the Modern Woman." In Barter et al. 1998–99, pp. 44–107.

Barter et al. 1998–99
Barter, Judith A., et al. *Mary Cassatt: Modern Woman*. Exh. cat., The Art Institute of Chicago, October 10, 1998–January 10, 1999; Museum of Fine Arts, Boston, February 14–May 9, 1999; National Gallery of Art, Washington, D.C., June 6–September 6, 1999. Chicago: The Art Institute of Chicago, 1998.

Baudelaire 1863, 1964
Baudelaire, Charles. "The Painter of Modern Life." 1863. In *The Painter of Modern Life and Other Essays*, by Charles Baudelaire, pp. 1–40. Trans. Jonathan Mayne. London: Phaidon Press, 1964.

Bayor and Meagher, eds. 1996
Bayor, Ronald H., and Timothy J. Meagher, eds. *The New York Irish*. Baltimore: Johns Hopkins University Press, 1996.

Beam et al. 1990–91
Beam, Philip C., et al. *Winslow Homer in the 1890s: Prout's Neck Observed*. Exh. cat., Memorial Art Gallery of the University of Rochester, August 18–October 21, 1990; Terra Museum of American Art, Chicago, November 17, 1990–January 13, 1991; National Museum of American Art, Smithsonian Institution, Washington, D.C., February 8–May 27, 1991; Sterling and Francine Clark Art Institute, Williamstown, Massachusetts, June 22–September 2, 1991. New York: Hudson Hills Press, in association with Memorial Art Gallery of the University of Rochester, 1990.

Beecher 1842
Beecher, Catherine E. *A Treatise on Domestic Economy, for the Use of Young Ladies at Home, and at School*. Boston: T. H. Webb and Co., 1842.

Beer 1927
Beer, Thomas. "George W. Bellows, August 12, 1882–January 8, 1925." In *George W. Bellows: His Lithographs*, by Thomas Beer et al., pp. 9–31. New York and London: Alfred A. Knopf, 1927.

Bell 1996
Bell, Christine Anne. "A Family Conflict: Visual Imagery of the 'Homefront' and the War Between the States, 1860–1866." PhD diss., Northwestern University, 1996.

Benedict 1872
Benedict, Frank Lee. "A Game Two Can Play At." *Peterson's Magazine* 62 (November 1872), pp. 314–21.

Bennett 1912
Bennett, Arnold. *Your United States: Impressions of a First Visit*. New York and London: Harper and Brothers, 1912.

Benson, E. 1870
Benson, Eugene. "The Annual Exhibition of the Academy." *Putnam's Magazine* 5, no. 30 (June 1870), pp. 699–708.

Benson, E. 1872
Benson, Eugene. "The Peasant-Painter—Jean François Millet." *Appletons' Journal of Literature, Science, and Art* 8, no. 185 (October 12, 1872), pp. 404–5.

Benson, S. 1986
Benson, Susan Porter. *Counter Cultures: Saleswomen, Managers, and Customers in American Department Stores, 1890–1940*. The Working Class in American History. Urbana, Ill.: University of Illinois Press, 1986.

Berger 1997
Berger, Martin A. "Modernity and Gender in Thomas Eakins's *Swimming*." *American Art* 11, no. 3 (Fall 1997), pp. 32–47.

Berger 2000
Berger, Martin A. *Man Made: Thomas Eakins and the Construction of Gilded Age Manhood*. Berkeley and Los Angeles: University of California Press, 2000.

Betsky 1984
Betsky, Celia. "American Musical Paintings, 1865–1910." In *The Art of Music: American Paintings and Musical Instruments, 1770–1910*, pp. 51–75. Exh. cat., Fred L. Emerson Gallery, Hamilton College, Clinton, New York, April 7–June 3, 1984; Whitney Museum of American Art at Philip Morris, New York, July 19–September 19, 1984; Duke University Museum of Art, Durham, North Carolina, October 1–November 5, 1984; Lamont Gallery, The Phillips Exeter Academy, Exeter, New Hampshire, November 18–December 16, 1984. Clinton, N.Y.: Fred L. Emerson Gallery, 1984.

Bettelheim 1976
Bettelheim, Bruno. *The Uses of Enchantment: The Meaning and Importance of Fairy Tales*. New York: Alfred A. Knopf, 1976.

Bisland 1889
Bisland, Elizabeth. "The Studios of New York." *The Cosmopolitan* 7, no. 1 (May 1889), pp. 2–22.

Blaugrund 1997
Blaugrund, Annette. *The Tenth Street Studio Building: Artist-Entrepreneurs from the Hudson River School to the American Impressionists.* Exh. cat., Parrish Art Museum, Southampton, New York, June 8–August 10, 1997; National Academy of Design, New York, August 21–November 16, 1997. Southampton, N.Y.: Parrish Art Museum, 1997.

Blaugrund et al. 1989–90
Blaugrund, Annette, et al. *Paris 1889: American Artists at the Universal Exposition.* Exh. cat., Chrysler Museum, Norfolk, Virginia, September 29–December 17, 1989; Pennsylvania Academy of the Fine Arts, Philadelphia, February 1–April 15, 1990; Brooks Museum of Art, Memphis, May 6–July 15, 1990. Philadelphia: Pennsylvania Academy of the Fine Arts; New York: Harry N. Abrams, 1989.

Bledstein 1976
Bledstein, Burton J. *The Culture of Professionalism: The Middle Class and the Development of Higher Education in America.* New York: W. W. Norton, 1976.

Blevins 2001
Blevins, Win[fred]. *Dictionary of the American West.* Seattle: Sasquatch Books, 2001.

Blight 2001
Blight, David W. *Race and Reunion: The Civil War in American Memory.* Cambridge, Mass.: The Belknap Press of Harvard University Press, 2001.

Bloch 1967
Bloch, E. Maurice. *George Caleb Bingham.* Vol. 1, *The Evolution of an Artist.* California Studies in the History of Art, 7. Berkeley and Los Angeles: University of California Press, 1967.

Bodnar 1985
Bodnar, John. *The Transplanted: A History of Immigrants in Urban America.* Bloomington, Ind.: Indiana University Press, 1985.

Boettger 1992
Boettger, Suzaan. "Eastman Johnson's *Blodgett Family* and Domestic Values During the Civil War Era." *American Art* 6, no. 4 (Fall 1992), pp. 50–67.

Boime 1989
Boime, Albert. "Blacks in Shark-Infested Waters: Visual Encodings of Racism in Copley and Homer." *Smithsonian Studies in American Art* 3, no. 1 (Winter 1989), pp. 18–47.

Boime 1990
Boime, Albert. *The Art of Exclusion: Representing Blacks in the Nineteenth Century.* Washington, D.C.: Smithsonian Institution Press, 1990.

Boime 1993
Boime, Albert. "Henry Ossawa Tanner's Subversion of Genre." *The Art Bulletin* 75, no. 3 (September 1993), pp. 415–42.

Bolger. *See also* Burke, D.

Bolger 1996–97
Bolger, Doreen. "'Kindly Relations': Edward Hornor Coates and *Swimming.*" In Bolger and Cash et al. 1996–97, pp. 36–48.

Bolger and Cash et al. 1996–97
Bolger, Doreen, and Sarah Cash et al. *Thomas Eakins and the Swimming Picture.* Exh. cat., Amon Carter Museum, Fort Worth, February 10–May 5, 1996; The Corcoran Gallery of Art, Washington, D.C., June 8–September 8, 1996; Brandywine River Museum, Chadds Ford, Pennsylvania, September 20–November 24, 1996; Museum of Art, Rhode Island School of Design, Providence, January 17–April 27, 1997. Fort Worth: Amon Carter Museum, 1996.

***Boston Daily Evening Transcript* 1887**
"Art Notes. American Pictures at Doll & Richards." *Boston Daily Evening Transcript,* January 21, 1887.

***Boston Evening Transcript* 1916**
"Winslow Homer's 'Great Gale.'" *Boston Evening Transcript,* April 8, 1916.

Bourget 1895
Bourget, Paul [Charles Joseph]. *Outre-Mer: Impressions of America.* New York: Charles Scribner's Sons, 1895.

Bowlby 2001
Bowlby, Rachel. *Carried Away: The Invention of Modern Shopping.* New York: Columbia University Press, 2001.

Bowman 1973
Bowman, Ruth. "Nature, The Photograph and Thomas Anshutz." *Art Journal* 33, no. 1 (Fall 1973), pp. 32–40.

Brace 1872, 1973
Brace, Charles Loring. *The Dangerous Classes of New York and Twenty Years' Work Among Them.* 1872. Reprint. Washington, D.C.: National Association of Social Workers, 1973.

Brigham 1995
Brigham, David R. *Public Culture in the Early Republic: Peale's Museum and Its Audience.* Washington, D.C., and London: Smithsonian Institution Press, 1995.

Broude 2000–2001
Broude, Norma. "Mary Cassatt: Modern Woman or the Cult of True Womanhood?" *Woman's Art Journal* 21, no. 2 (Fall 2000–Winter 2001), pp. 36–43, cover illus.

Brown, D., and Nissenbaum 1999
Brown, Dona, and Stephen Nissenbaum. "Changing New England: 1865–1945." In *Picturing Old New England: Image and Memory,* by William H. Truettner and Roger B. Stein et al., pp. 1–13. Exh. cat., National Museum of American Art, Smithsonian Institution, Washington, D.C., April 2–August 22, 1999. Washington, D.C., 1999.

Brown, J. 2006
Brown, Joshua. *Beyond the Lines: Pictorial Reporting, Everyday Life, and the Crisis of Gilded Age America.* Berkeley and Los Angeles: University of California Press, 2006.

Brush 1885
Brush, George de Forest. "An Artist Among the Indians." *The Century Magazine* 30, no. 1 (May 1885), pp. 54–57.

Buckley 1984
Buckley, Peter G. "'The Place to Make an Artist Work': Micah Hawkins and William Sidney Mount in New York City." In *Catching the Tune: Music and William Sidney Mount,* edited by Janice Gray Armstrong, pp. 22–39. Exh. cat., The Museums at Stony Brook, Stony Brook, New York, 1984. Stony Brook, N.Y., 1984.

***Bulletin of the American Art-Union* 1848a**
"The American Art-Union." *Bulletin of the American Art[-]Union* 1, no. 15 (November 25, 1848), pp. 15–20.

***Bulletin of the American Art-Union* 1848b**
"The Fine Arts. The Art[-]Union and Its Friends." *Bulletin of the American Art[-]Union* 1, no. 15 (November 25, 1848), pp. 43–45.

Bulletin of the American Art-Union 1848c
"To the Members of the American Art-Union." *Bulletin of the American Art-Union* 1, no. 7 (July 25, 1848), pp. 12–14.

Bulletin of the American Art-Union 1849
"Catalogue of Works of Art." *Bulletin of the American Art-Union* 2, no. 8 (November 1849), pp. 30–48.

Bulletin of the American Art-Union 1850a
"Chronicle of Facts and Opinions. American Art and Artists. New Work by Bingham." *Bulletin of the American Art-Union* 3, no. 4 (July 1850), pp. 64–65.

Bulletin of the American Art-Union 1850b
"The Record of the Distribution." *Bulletin of the American Art-Union* 3, no. 9, supplement (December 31, 1850), pp. 167–78.

Bulletin of the American Art-Union 1850c
"To the Friends of the Art-Union." *Bulletin of the American Art-Union* 3, no. 1 (April 1, 1850), pp. 2–3.

Bulletin of the American Art-Union 1851a
W. "Development of Nationality in American Art." *Bulletin of the American Art-Union* 4, no. 9 (December 1, 1851), pp. 137–39.

Bulletin of the American Art-Union 1851b
N. N. "The Twenty-sixth Exhibition of the National Academy of Design. Second Notice." *Bulletin of the American Art-Union* 4, no. 3 (June 1, 1851), pp. 40–43.

Bullington 2000
Bullington, Judy. "Henry Bacon's Imaging of Transatlantic Travel in the Gilded Age." *Nineteenth Century Studies* 14 (2000), pp. 63–91.

Burke, D. *See also* Bolger.

Burke, D. 1980
Burke, Doreen Bolger. *American Paintings in The Metropolitan Museum of Art.* Vol. 3, *A Catalogue of Works by Artists Born between 1846 and 1864.* Edited by Kathleen Luhrs. New York: The Metropolitan Museum of Art, 1980.

Burke, D. 1986–87
Burke, Doreen Bolger. "Painters and Sculptors in a Decorative Age." In *In Pursuit of Beauty: Americans and the Aesthetic Movement,* by Doreen Bolger Burke et al., pp. 294–339. Exh. cat., The Metropolitan Museum of Art, New York, October 23, 1986–January 11, 1987. New York, 1986.

Burke, E. 1757
Burke, Edmund. *A Philosophical Enquiry into the Origin of Our Ideas of the Sublime and Beautiful.* London: R. and J. Dodsley, 1757.

Burnham and Giese, eds. 1995
Burnham, Patricia M., and Lucretia Hoover Giese, eds. *Redefining American History Painting.* Cambridge and New York: Cambridge University Press, 1995.

Burns 1986
Burns, Sarah. "Yankee Romance: The Comic Courtship Scene in Nineteenth-Century American Art." *The American Art Journal* 18, no. 4 ([Autumn] 1986), pp. 51–75.

Burns 1988
Burns, Sarah. "The Country Boy Goes to the City: Thomas Hovenden's *Breaking Home Ties* in American Popular Culture." *The American Art Journal* 20, no. 4 ([Autumn] 1988), pp. 59–73.

Burns 1989
Burns, Sarah. *Pastoral Inventions: Rural Life in Nineteenth-Century American Art and Culture.* Philadelphia: Temple University Press, 1989.

Burns 2004a
Burns, Sarah. *Painting the Dark Side: Art and the Gothic Imagination in Nineteenth-Century America.* Berkeley and Los Angeles: University of California Press, 2004.

Burns 2004b
Burns, Sarah. "The Underground Man." In Burns 2004a, pp. 44–74, 257–60.

Burns 2006–7
Burns, Sarah. "Winslow Homer's Ambiguously New Women." In Connor et al. 2006–7, pp. 53–90, 132–38.

Burroughs 1907
B[urroughs], B[ryson]. "Principal Accessions." *The Metropolitan Museum of Art Bulletin* 2, no. 1 (January 1907), p. 14.

Burrows and Wallace 1999
Burrows, Edwin G., and Mike Wallace. *Gotham: A History of New York City to 1898.* New York and Oxford: Oxford University Press, 1999.

Bushman 1992
Bushman, Richard L. *The Refinement of America: Persons, Houses, Cities.* New York: Alfred A. Knopf, 1992.

Cadbury and Marsh 1986
Cadbury, Warder H., and Henry F. Marsh. *Arthur Fitzwilliam Tait, Artist in the Adirondacks: An Account of His Career by Warder H. Cadbury; A Checklist of His Works by Henry F. Marsh.* Newark, Del.: University of Delaware Press; Cranbury, N.J.: Associated University Presses, 1986.

Caffin 1914
Caffin, Caroline. *Vaudeville.* New York: M[itchell] Kennerley, 1914.

Cahill and Barr et al. 1934
Cahill, Holger, and Alfred H. Barr Jr. et al. *Art in America: A Complete Survey.* New York: Reynal and Hitchcock, 1934.

Caldwell and Rodriguez Roque et al. 1994
Caldwell, John, and Oswaldo Rodriguez Roque et al. *American Paintings in The Metropolitan Museum of Art.* Vol. 1, *A Catalogue of Works by Artists Born by 1815.* Edited by Kathleen Luhrs. New York: The Metropolitan Museum of Art, 1994.

Carbone 1999
Carbone, Teresa A. "Eastman Johnson's Portrait of Aging New England." *The Magazine Antiques* 156, no. 5 (November 1999), pp. 700–707.

Carbone 1999–2000
Carbone, Teresa A. "The Genius of the Hour: Eastman Johnson in New York, 1860–1880." In Carbone and Hills et al. 1999–2000, pp. 48–119.

Carbone and Hills et al. 1999–2000
Carbone, Teresa A., and Patricia Hills et al. *Eastman Johnson: Painting America.* Exh. cat., Brooklyn Museum of Art, October 29, 1999–February 6, 2000; San Diego Museum of Art, February 26–May 21, 2000; Seattle Art Museum, June 8–September 10, 2000. Brooklyn: Brooklyn Museum of Art, 1999.

Carbone et al. 2006
Carbone, Teresa A., et al. *American Paintings in the Brooklyn Museum: Artists Born by 1876*. 2 vols. Brooklyn: Brooklyn Museum, in association with D. Giles, London, 2006.

Carmean et al. 1982–83
Carmean, E. A., Jr., et al. *Bellows: The Boxing Pictures*. Exh. cat., National Gallery of Art, Washington, D.C., September 5, 1982–January 2, 1983. Washington, D.C., 1982.

Carr 1993
Carr, Carolyn Kinder. "Prejudice and Pride: Presenting American Art at the 1893 World's Columbian Exposition." In Carr and Gurney et al. 1993, pp. 62–123.

Carr and Gurney et al. 1993
Carr, Carolyn Kinder, and George Gurney et al. *Revisiting the White City: American Art at the 1893 World's Fair*. Exh. cat., National Museum of American Art and the National Portrait Gallery, Smithsonian Institution, Washington, D.C., April 16–August 15, 1993. Washington, D.C., 1993.

Carrick 1900
Carrick, Alice Van Leer. "Shop Girls as They Are." *National Magazine* 11, no. 5 (February 1900), pp. 526–30.

Carruth 1997
Carruth, Gorton. *The Encyclopedia of American Facts and Dates*. 10th ed. 1956. New York: Harper Collins Publishers, 1997.

Casper 1999
Casper, Scott E. *Constructing American Lives: Biography and Culture in Nineteenth-Century America*. Chapel Hill, N.C., and London: The University of North Carolina Press, 1999.

Casteras 1985
Casteras, Susan P. "The 1857–58 Exhibition of English Art in America: Critical Responses to Pre-Raphaelitism." In Ferber and Gerdts et al. 1985, pp. 109–33.

Catlin 1840
Catlin, George. *A Descriptive Catalogue of Catlin's Indian Gallery; Containing Portraits, Landscapes, Costumes, &c. and Representations of the Manners and Customs of the North American Indians, Collected and Painted Entirely by Mr. Catlin, During Seven Years' Travel Amongst 48 Tribes, Mostly Speaking Different Languages*. London: C. Adlard, [1840].

Cavallo 1971
Cavallo, Diana. *The Lower East Side, A Portrait in Time*. New York: Crowell-Collier Press, 1971.

Cawelti 1976
Cawelti, John G. "The Frontier and the Native American." In Taylor and Cawelti 1976, pp. 133–83.

Chamberlin 1908
Chamberlin, Joseph Edgar. "Two Significant Exhibitions." *New York Evening Mail*, February 4, 1908, p. 6.

Chambers 1976
Chambers, Bruce W. "The Pythagorean Puzzle of Patrick Lyon." *The Art Bulletin* 58, no. 2 (June 1976), pp. 225–33.

Chambers 1980–81
Chambers, Bruce W. *The World of David Gilmour Blythe (1815–1865)*. Exh. cat., National Collection of Fine Arts, Smithsonian Institution, Washington, D.C., October 17, 1980–January 11, 1981; Memorial Art Gallery of the University of Rochester, February 7–March 29, 1981; Museum of Art, Carnegie Institute, Pittsburgh, May 9–July 5, 1981. Washington, D.C.: Smithsonian Institution Press, 1980.

Chicago Daily News 1876
"The Fashions. Latest Modes." *Chicago Daily News*, April 9, 1876, p. 15.

Chiego et al. 1987
Chiego, William J., et al. *Sir David Wilkie of Scotland (1785–1841)*. Exh. cat., Yale Center for British Art, New Haven, January 20–March 15, 1987; North Carolina Museum of Art, Raleigh, April 4–May 31, 1987. Raleigh: North Carolina Museum of Art, 1987.

Cikovsky 1976
Cikovsky, Nicolai, Jr. "William Merritt Chase's Tenth Street Studio." *Archives of American Art Journal* 16, no. 2 (1976), pp. 2–14.

Cikovsky 1988–89
Cikovsky, Nicolai, Jr. "A Harvest of Death: *The Veteran in a New Field*." In Simpson et al. 1988–89, pp. 82–101.

Cikovsky 1995–96
Cikovsky, Nicolai, Jr. "Good Pictures." In Cikovsky and Kelly et al. 1995–96, pp. 368–77.

Cikovsky and Kelly et al. 1995–96
Cikovsky, Nicolai, Jr., and Franklin Kelly et al. *Winslow Homer*. Exh. cat., National Gallery of Art, Washington, D.C., October 15, 1995–January 28, 1996; Museum of Fine Arts, Boston, February 21–May 26, 1996; The Metropolitan Museum of Art, New York, June 20–September 22, 1996. Washington, D.C.: National Gallery of Art, 1995.

Circular 1866
H. "The Beauties of Croquet." *The Circular* 3, no. 25 (September 3, 1866), p. 197.

Clark 1987–88
Clark, Carol. "Charles Deas." In Hassrick et al. 1987–88, pp. 50–77.

Clarke 1891
[Clarke, Thomas B.]. *Catalogue of the Thomas B. Clarke Collection of American Pictures*. Exh. cat., Pennsylvania Academy of the Fine Arts, Philadelphia, October 15–November 28, 1891. Philadelphia, 1891.

Clinton 1984
Clinton, Catherine. *The Other Civil War: American Women in the Nineteenth Century*. New York: Hill and Wang, 1984.

Coffin 1892
Coffin, William A. "American Illustration of To-day. Third Paper." *Scribner's Magazine* 11, no. 3 (March 1892), pp. 333–49.

Cohen, Gilfoyle, and Horowitz 2008
Cohen, Patricia Cline, Timothy J. Gilfoyle, and Helen Lefkowitz Horowitz. *The Flash Press: Sporting Male Weeklies in 1840s New York*. Chicago: University of Chicago Press, 2008.

Cole 1835–36, 1965
Cole, Thomas. "Essay on American Scenery." 1835–36. In *American Art, 1700–1960: Sources and Documents*, edited by John W. McCoubrey, pp. 98–110. Sources and Documents in the History of Art. Englewood Cliffs, N.J.: Prentice-Hall, 1965.

Commercial Advertiser 1871
"What Our Artists Are Doing." *Commercial Advertiser*, March 31, 1871, p. 4.

Conkling 1857
Conkling, Margaret Cockburn [Henry Lunettes, pseud.]. *The American Gentleman's Guide to Politeness and Fashion*. New York: Derby and Jackson, 1857.

Conn 2002
Conn, Steven. "Narrative Trauma and Civil War History Painting, or Why Are These Pictures So Terrible?" *History and Theory* 41, no. 4 (December 2002), pp. 17–42.

Connor et al. 2006–7
Connor, Holly Pyne, et al. *Off the Pedestal: New Women in the Art of Homer, Chase, and Sargent*. Exh. cat., The Newark Museum, March 18–June 18, 2006; Marion Koogler McNay Art Museum, San Antonio, July 26–October 15, 2006; Frick Art and Historical Center, Pittsburgh, November 4, 2006–January 14, 2007. Newark, N.J.: The Newark Museum; New Brunswick, N.J.: Rutgers University Press, 2006.

Conrads 2001–2
Conrads, Margaret C. *Winslow Homer and the Critics: Forging a National Art in the 1870s*. Exh. cat., The Nelson-Atkins Museum of Art, Kansas City, Missouri, February 18–May 6, 2001; Los Angeles County Museum of Art, June 10–September 9, 2001; High Museum of Art, Atlanta, October 6, 2001–January 6, 2002. Princeton, N.J.: Princeton University Press, 2001.

Cook 1865
[Cook, Clarence]. "National Academy of Design. Fortieth Annual Exhibition. (Fifth Article)." *New-York Daily Tribune*, June 23, 1865, p. 6.

Cook 1870
[Cook, Clarence]. "Fine Arts. The Landscapes at the Academy." *New-York Daily Tribune*, April 30, 1870, p. 5.

Cook 1875
[Cook, Clarence]. "Fine Arts. The National Academy of Design. Fiftieth Annual Exhibition. (Third Notice)." *New-York Daily Tribune*, April 29, 1875, p. 7.

Cook 1876a
[Cook, Clarence]. "Academy of Design. Fifty-first Annual Exhibition. (Third Notice)." *New-York Daily Tribune*, April 22, 1876, p. 7.

Cook 1876b
[Cook, Clarence]. "A Ramble among the Studios. Opinions of New-York Painters on the Artistic Outlook—Goupil's New Gallery." *New-York Daily Tribune*, November 25, 1876, p. 2.

Cooper, H., et al. 1996–97
Cooper, Helen A., et al. *Thomas Eakins: The Rowing Pictures*. Exh. cat., National Gallery of Art, Washington, D.C., June 23–September 29, 1996; Yale University Art Gallery, New Haven, October 11, 1996–January 14, 1997; The Cleveland Museum of Art, February 19–May 15, 1997. New Haven: Yale University Art Gallery, 1996.

Cooper, S. 1870
Cooper, Susan. "Female Suffrage. A Letter to the Christian Women of America. Part I." *Harper's New Monthly Magazine* 41, no. 243 (August 1870), pp. 438–46.

Copley and Pelham 1914
Letters and Papers of John Singleton Copley and Henry Pelham, 1739–1776. Edited by Guernsey Jones. Massachusetts Historical Society Collections, 71. Boston: The Massachusetts Historical Society, 1914.

Cornell 2005
Cornell, Daniell. "Common Heroes: Thomas Pollock Anshutz, *The Ironworkers' Noontime*." In *Masterworks of American Painting at the de Young*, edited by Timothy Anglin Burgard, pp. 197–200. San Francisco: The Fine Arts Museums of San Francisco, 2005.

Cosmopolitan Art Journal 1856
"Masters of Art and Literature. Second Article." *Cosmopolitan Art Journal* 1, no. 2 (November 1856), pp. 47–52.

Coyle and Schiller et al. 2007–9
Coyle, Heather Campbell, and Joyce K. Schiller et al. *John Sloan's New York*. Exh. cat., Delaware Art Museum, Wilmington, October 20, 2007–January 20, 2008; Westmoreland Museum of American Art, Greensburg, Pennsylvania, February 10–April 27, 2008; The David and Alfred Smart Museum of Art, The University of Chicago, May 22–September 14, 2008; Reynolda House Museum of American Art, Winston-Salem, North Carolina, October 4, 2008–January 4, 2009. Wilmington: Delaware Art Museum; New Haven and London: Yale University Press, 2007.

Crane 1893
Crane, Stephen [Johnston Smith, pseud.]. *Maggie: A Girl of the Streets; A Story of New York*. New York, 1893.

Cranston 1906
Cranston, Mary Rankin. "The Girl Behind the Counter." *The World To-Day* 10, no. 3 (March 1906), pp. 270–74.

Crayon 1859a
"Hints to American Artists." *The Crayon* 6, pt. 5 (May 1859), pp. 145–46.

Crayon 1859b
"National Academy of Design. Second Notice." *The Crayon* 6, pt. 6 (June 1859), pp. 189–93.

Crayon 1861
"Postscript.—Artists Going to the Seat of War." *The Crayon* 8, pt. 5 (May 1861), p. 120.

Cull, Culbert, and Welch, eds. 2003
Cull, Nicholas J., David Culbert, and David Welch, eds. *Propaganda and Mass Persuasion: A Historical Encyclopedia, 1500 to the Present*. Santa Barbara, Calif.: ABC–CLIO, 2003.

Curry 1984
Curry, David Park. *James McNeill Whistler at the Freer Gallery of Art*. Exh. cat., Freer Gallery of Art, Washington, D.C., May 11–November 5, 1984. Washington, D.C.: Freer Gallery of Art; New York and London: W. W. Norton and Company, 1984.

Curry 1984–85
Curry, David Park. *Winslow Homer: The Croquet Game*. Exh. cat., Yale University Art Gallery, New Haven, April 18–June 24, 1984; The Corcoran Gallery of Art, Washington, D.C., July 14–September 16, 1984; Albright-Knox Art Gallery, Buffalo, September 29–November 25, 1984; The Art Institute of Chicago, December 8, 1984–February 3, 1985; National Academy of Design, New York, March 7–May 5, 1985. New Haven: Yale University Art Gallery, 1984.

Danly and Leibold, eds. 1994
Danly, Susan, and Cheryl Leibold, eds. *Eakins and the Photograph: Works by Thomas Eakins and His Circle in the Collection of the Pennsylvania Academy of the Fine Arts*. Washington, D.C., and London: Published for the Pennsylvania Academy of the Fine Arts by the Smithsonian Institution Press, 1994.

Darley and Neal 1843
Darley, Felix O. C., and Joseph C. Neal. *In Town and About; or, Pencillings and Pennings*. Philadelphia: Godey and McMichael, 1843.

Davis, E. 2000–2001
Davis, Elliot Bostwick. "The Currency of Culture: Prints in New York City." In Voorsanger and Howat et al. 2000–2001, pp. 188–225.

Davis, H. 1907
Davis, Hartley. "The Department Store at Close Range." *Everybody's Magazine* 17, no. 3 (September 1907), pp. 312–23.

Davis, J. 1996
Davis, John. "Children in the Parlor: Eastman Johnson's *Brown Family* and the Post–Civil War Luxury Interior." *American Art* 10, no. 2 (Summer 1996), pp. 50–77.

Davis, J. 1998
Davis, John. "Eastman Johnson's *Negro Life at the South* and Urban Slavery in Washington, D.C." *The Art Bulletin* 80, no. 1 (March 1998), pp. 67–92.

Day and Sturges, eds. 1987
Day, Holliday T., and Hollister Sturges, eds. *Joslyn Art Museum: Paintings and Sculpture from the European and American Collections*. Omaha, Neb.: Joslyn Art Museum, 1987.

Dearinger et al. 2000–2001
Dearinger, David B., et al. *Rave Reviews: American Art and Its Critics, 1826–1925*. Exh. cat., National Academy of Design, New York, September 20–December 31, 2000; Gilcrease Museum, Tulsa, Oklahoma, January 31–April 1, 2001; Indianapolis Museum of Art, April 29–July 1, 2001. New York: National Academy of Design, 2000.

Dearinger et al. 2004
Dearinger, David B., et al. *Paintings and Sculpture in the Collection of the National Academy of Design*. Vol. 1, *1826–1925*. New York and Manchester, Vt.: Hudson Hills Press, 2004.

DeShazo 1974
DeShazo, Edith. *Everett Shinn, 1876–1953: A Figure in His Time*. New York: Clarkson N. Potter, 1974.

DiMeglio 1973
DiMeglio, John E. *Vaudeville U.S.A.* Bowling Green, Ohio: Bowling Green University Popular Press, 1973.

Diner, Shandler, and Wenger 2000
Diner, Hasia R., Jeffrey Shandler, and Beth S. Wenger. *Remembering the Lower East Side: American Jewish Reflections*. Bloomington and Indianapolis, Ind.: Indiana University Press, 2000.

Dippie 1994
Dippie, Brian W. "The Visual West." In *The Oxford History of the American West*, edited by Clyde A. Milner II, Carol A. O'Connor, and Martha A. Sandweiss, pp. 673–705. New York and Oxford: Oxford University Press, 1994.

Dippie 1998
Dippie, Brian W. *West Fever*. Los Angeles: Autry Museum of Western Heritage; Seattle: University of Washington Press, 1998.

Docherty 1991
Docherty, Linda J. "The Open Book and the American Woman." Paper presented at symposium, The Iconography of the Book. American Antiquarian Society, Worcester, Massachusetts, June 15, 1991.

Doezema 1992
Doezema, Marianne. *George Bellows and Urban America*. New Haven and London: Yale University Press, 1992.

Doezema 1992–93
Doezema, Marianne. "The 'Real' New York." In Quick et al. 1992–93, pp. 96–133.

Domosh 2004
Domosh, Mona. "Creating New York's Nineteenth-Century Retail District." In *American Architectural History: A Contemporary Reader*, edited by Keith L. Eggener, pp. 206–26. London and New York: Routledge, 2004.

Donovan 1909
Donovan, Michael J. *The Roosevelt That I Know: Ten Years of Boxing with the President and Other Memories of Famous Fighting Men*. New York: B. W. Dodge and Co., 1909.

Dorment and MacDonald et al. 1994–95
Dorment, Richard, and Margaret F. MacDonald et al. *James McNeill Whistler*. Exh. cat., Tate Gallery, London, October 13, 1994–January 8, 1995; Musée d'Orsay, Paris, February 6–April 30, 1995; National Gallery of Art, Washington, D.C., May 28–August 20, 1995. London: Tate Gallery Publications, 1994.

Douglas 1977
Douglas, Ann. *The Feminization of American Culture*. New York: Alfred A. Knopf, 1977.

Dowling 2007
Dowling, Robert M. *Slumming in New York: From the Waterfront to Mythic Harlem*. Urbana, Ill.: University of Illinois Press, 2007.

Downes 1909
Downes, William Howe. "William Merritt Chase, a Typical American Artist." *The International Studio* 39, no. 154 (December 1909), pp. xxix–xxxvi.

Downes 1911
Downes, William Howe. *The Life and Works of Winslow Homer*. Boston: Houghton Mifflin Company, 1911.

Downing 1850, 1969
Downing, A[ndrew] J[ackson]. *The Architecture of Country Houses*. 1850. New York: Dover Publications, 1969.

Dreiser 1900
Dreiser, Theodore. *Sister Carrie*. New York: Doubleday, Page and Co[mpany], 1900.

Dunlap 1834
Dunlap, William. *History of the Rise and Progress of the Arts of Design in the United States*. 2 vols. New York: George P. Scott and Co., 1834.

Dunlap 1834, 1969
Dunlap, William. *A History of the Rise and Progress of the Arts of Design in the United States*. Reprint ed., edited by Rita Weiss. 2 vols. in 3. 1834. New York: Dover Publications, 1969.

Eastlake 1868
Eastlake, Charles L. *Hints on Household Taste in Furniture, Upholstery, and Other Details*. London: Longmans, Green, 1868.

Edwards 1982
Edwards, Lee M. "The Life and Career of Jerome Thompson." *The American Art Journal* 14, no. 4 (Autumn 1982), pp. 5–30.

Edwards, Ramirez, and Burgard 1986
Edwards, Lee M., Jan Seidler Ramirez, and Timothy Anglin Burgard. *Domestic Bliss: Family Life in American Painting, 1840–1910*. Exh. cat., The Hudson River Museum, Yonkers, New York, May 18–July 14, 1986; The Margaret Woodbury Strong Museum, Rochester, August 17–November 30, 1986. Yonkers, N.Y.: The Hudson River Museum, 1986.

Effeny 1991
Effeny, Alison. *Cassatt*. London: Studio Editions, 1991.

Elzea 1991
Elzea, Rowland. *John Sloan's Oil Paintings, A Catalogue Raisonné*. 2 vols. Newark, Del.: University of Delaware Press; London and Toronto: Associated University Presses, 1991.

Emerson 1843–44, 2005
Emerson, Ralph Waldo. "New England: Genius, Manners and Customs." 1843–44. In *The Selected Lectures of Ralph Waldo Emerson*, edited by Ronald A. Bosco and Joel Myerson, pp. 98–115. Athens, Ga., and London: The University of Georgia Press, 2005.

Emerson 1847, 1983
Emerson, Ralph Waldo. "Self-Reliance." 1847. In *Essays and Lectures*, pp. 257–82. New York: The Library of America, 1983.

Emerson 1960–82
The Journals and Miscellaneous Notebooks of Ralph Waldo Emerson. Edited by William H. Gilman et al. 16 vols. Cambridge, Mass.: The Belknap Press of Harvard University Press, 1960–82.

Episcopal Recorder 1849
A Looker-on. "A Picture." *The Episcopal Recorder* 27, no. 6 (April 21, 1849), p. 22.

Epstein 2007
Epstein, Lawrence J. *At the Edge of a Dream: The Story of Jewish Immigrants on New York's Lower East Side, 1880–1920*. San Francisco: Jossey-Bass, 2007.

Erenberg 1981
Erenberg, Lewis A. *Steppin' Out: New York Nightlife and the Transformation of American Culture, 1890–1930*. Westport, Conn.: Greenwood Press, 1981.

Ershkowitz 1999
Ershkowitz, Herbert. *John Wanamaker: Philadelphia Merchant*. Conshohocren, Pa.: Combined Pub., 1999.

Evening Post 1863
"The National Academy of Design. The Thirty-eighth Annual Exhibition. Fifth Article." *The Evening Post* (New York), June 12, 1863, p. 1.

Evening Post 1864
"Fine Arts. New Works by Our Artists." *The Evening Post* (New York), October 13, 1864, p. 2.

Evening Post 1877
"Winslow Homer's 'Cotton Pickers.'" *The Evening Post* (New York), March 30, 1877, p. 2.

Evening Post 1883
"Fine Arts. Fifty-eighth Annual Exhibition of the National Academy of Design." *The Evening Post* (New York), April 19, 1883.

Eyal 2007
Eyal, Yonatan. *The Young America Movement and the Transformation of the Democratic Party, 1828–1861*. Cambridge and New York: Cambridge University Press, 2007.

Fahs 2001
Fahs, Alice. *The Imagined Civil War: Popular Literature of the North and South, 1861–1865*. Chapel Hill, N.C., and London: The University of North Carolina Press, 2001.

Fairbrother 1986–87
Fairbrother, Trevor J. "Painting in Boston, 1870–1930." In *The Bostonians: Painters of an Elegant Age, 1870–1930*, by Trevor J. Fairbrother et al., pp. 31–92. Exh. cat., Museum of Fine Arts, Boston, June 11–September 14, 1986; The Denver Art Museum, October 25, 1986–January 18, 1987; Terra Museum of American Art, Chicago, March 13–May 10, 1987. Boston: Museum of Fine Arts, 1986.

Fairbrother 1994
Fairbrother, Trevor [J.]. *John Singer Sargent*. The Library of American Art. New York: Harry N. Abrams; Washington, D.C.: National Museum of American Art, Smithsonian Institution, 1994.

Falk, ed. 1988
Falk, Peter Hastings, ed. *The Annual Exhibition Record of the Pennsylvania Academy of the Fine Arts*. Vol. 1, *1807–1870*. Madison, Conn.: Sound View Press, 1988.

Faxon, Berman, and Reynolds et al. 1996
Faxon, Susan C., Avis Berman, and Jock Reynolds et al. *Addison Gallery of American Art: 65 Years, A Selective Catalogue*. Exh. cat., Addison Gallery of American Art, Phillips Academy, Andover, Massachusetts, April 13–July 31, 1996. Andover, Mass., 1996.

Ferber 1990
Ferber, Linda S. "Stagestruck: The Theater Subjects of Everett Shinn." In *American Art around 1900: Lectures in Memory of Daniel Fraad*, edited by Doreen Bolger and Nicolai Cikovsky Jr. *Studies in the History of Art* 37 (1990), pp. 50–67.

Ferber and Gerdts et al. 1985
Ferber, Linda S., and William H. Gerdts et al. *The New Path: Ruskin and the American Pre-Raphaelites*. Exh. cat., Brooklyn Museum, March 29–June 10, 1985; Museum of Fine Arts, Boston, July 3–September 8, 1985. Brooklyn: Brooklyn Museum, 1985.

Ferrell 2003
Ferrell, Claudine L. *Reconstruction*. Westport, Conn.: Greenwood Press, 2003.

Fink 1990
Fink, Lois Marie. *American Art at the Nineteenth-Century Paris Salons*. Washington, D.C.: National Museum of American Art, Smithsonian Institution; Cambridge and New York: Cambridge University Press, 1990.

Finson 2000
Finson, Bradley A. "Phantom Heroes." In *The American West: Out of Myth, into Reality*, by Peter H. Hassrick et al., pp. 148–57. Exh. cat., Mississippi Museum of Art, Jackson, February 12–June 6, 2000; Terra Museum of American Art, Chicago, June 24–September 17, 2000; The Toledo Museum of Art, October 8–December 31, 2000. Washington, D.C.: Trust for Museum Exhibitions, 2000.

Fischer 1999–2001
Fischer, Diane P. "Constructing the 'American School' of 1900." In Fischer et al. 1999–2001, pp. 1–94, 206–10.

Fischer et al. 1999–2001
Fischer, Diane P., et al. *Paris 1900: The "American School" at the Universal Exposition.* Exh. cat., The Montclair Art Museum, Montclair, New Jersey, September 18, 1999–January 16, 2000; Pennsylvania Academy of the Fine Arts, Philadelphia, February 11–April 16, 2000; Columbus Museum of Art, Columbus, Ohio, May 18–August 13, 2000; and two other institutions through May 15, 2001. [Montclair, N.J.]: The Montclair Art Museum; New Brunswick, N.J.: Rutgers University Press, 1999.

Fitzgerald 1868
Fitzgerald, Thomas. "John Neagle, the Artist." *Lippincott's Magazine of Literature, Science, and Education* 1 (May 1868), pp. 477–91.

Flag of Our Union 1862
"Maple Sugar." *The Flag of Our Union* 17, no. 9 (March 1, 1862), p. 4.

Foner 1988
Foner, Eric. *Reconstruction: America's Unfinished Revolution, 1863–1877.* New York: Harper and Row, 1988.

Foner and Brown 2005
Foner, Eric, and Joshua Brown. *Forever Free: The Story of Emancipation and Reconstruction.* New York: Alfred A. Knopf, 2005.

Fort and Quick 1991
Fort, Ilene Susan, and Michael Quick. *American Art: A Catalogue of the Los Angeles County Museum of Art Collection.* Los Angeles: Los Angeles County Museum of Art, 1991.

Fortune 1990
Fortune, Brandon Brame. "Charles Willson Peale's Portrait Gallery: Persuasion and the Plain Style." *Word and Image* 6, no. 4 (October–December 1990), pp. 308–24.

Foster, G. 1850
Foster, George G. *New York by Gas-light, with Here and There a Streak of Sunshine.* New York: Dewitt and Davenport, 1850.

Foster, K., et al. 1997
Foster, Kathleen A., et al. *Thomas Eakins Rediscovered: Charles Bregler's Thomas Eakins Collection at the Pennsylvania Academy of the Fine Arts.* Philadelphia: Pennsylvania Academy of the Fine Arts; New Haven and London: Yale University Press, 1997.

Frankenstein 1975
Frankenstein, Alfred. *William Sidney Mount.* New York: Harry N. Abrams, 1975.

Frost 1878
Frost, Arthur Burdett. "Incidents of an Ocean Trip.—[Drawn by A. B. Frost.]." *Harper's Weekly* 22, no. 1128 (August 10, 1878), p. 628.

Fuller 1893
Fuller, Henry Blake. *The Cliff-Dwellers, A Novel.* New York: Harper and Bros., 1893.

Gage 1876
Gage, Matilda Joslyn. "Woman a Mystery." *Appletons' Journal of Literature, Science, and Art* 15, no. 371 (April 29, 1876), pp. 565–67.

Gallati 2000–2001
Gallati, Barbara Dayer. *William Merritt Chase: Modern American Landscapes, 1886–1890.* Exh. cat., Brooklyn Museum of Art, May 26–August 13, 2000; The Art Institute of Chicago, September 7–November 26, 2000; The Museum of Fine Arts, Houston, December 13, 2000–March 11, 2001. Brooklyn: Brooklyn Museum of Art; New York: Harry N. Abrams, 2000.

Gerdts 1977
Gerdts, William H. "Henry Inman: Genre Painter." *The American Art Journal* 9, no. 1 (May 1977), pp. 26–48.

Gerdts 1993
Gerdts, William H. *Monet's Giverny: An Impressionist Colony.* New York: Abbeville Press, 1993.

Gerdts and Santis 1996
Gerdts, William H., and Jorge H. Santis. *William Glackens.* Fort Lauderdale: Museum of Art; New York, London, and Paris: Abbeville Press, 1996.

Gerdts and Thistlethwaite 1988
Gerdts, William H., and Mark Thistlethwaite. *Grand Illusions: History Painting in America.* Anne Burnett Tandy Lectures in American Civilization, 8. Fort Worth: Amon Carter Museum, 1988.

Gibbs 1981
Gibbs, Linda Mary Jones. "Enoch Wood Perry Jr.: A Biography and Analysis of His Thematic and Stylistic Development." Master's thesis, University of Utah, 1981.

Giese 1979
Giese, Lucretia H. "James Goodwyn Clonney (1812–1867): American Genre Painter." *The American Art Journal* 11, no. 4 (October 1979), pp. 5–31.

Gilbert 1995–96
Gilbert, Barbara C. *Henry Mosler Rediscovered: A Nineteenth-Century American-Jewish Artist.* Exh. cat., Skirball Museum, Los Angeles, October 21, 1995–June 2, 1996; Cincinnati Art Museum, June 23–September 2, 1996. Los Angeles: Skirball Museum, Skirball Cultural Center, 1995.

Gilman 1892
Gilman, Charlotte Perkins [Charlotte Perkins Stetson, pseud.]. "The Yellow Wall-paper." *The New England Magazine*, n.s., 5, no. 5 (January 1892), pp. 647–56.

Glazer and Moynihan 1970
Glazer, Nathan, and Daniel Patrick Moynihan. *Beyond the Melting Pot: The Negroes, Puerto Ricans, Jews, Italians and Irish of New York City, 1800–1915.* 2nd ed. 1963. Cambridge, Mass., and London: The MIT Press, 1970.

Glyndon 1870
Glyndon, Howard. "Department of Packard's Monthly: Young Womanhood in America." *The Phrenological Journal and Science of Health* 50, no. 5 (May 1870), pp. 344–47.

Gold 2002
Gold, Susanna W. "A Measured Freedom: National Unity and Racial Containment in Winslow Homer's *The Cotton Pickers*, 1876." *Mississippi Quarterly* 55, no. 2 (Spring 2002), pp. 163–84.

Gold 2004
Gold, Susanna W. "Imaging Memory: Re-Presentations of the Civil War at the 1876 Centennial Exhibition." PhD diss., University of Pennsylvania, 2004.

Goodman 1979
Goodman, Cary. *Choosing Sides: Playground and Street Life on the Lower East Side.* New York: Schocken Books, 1979.

Green 2005
Green, Jonathon. *Cassell's Dictionary of Slang.* 2nd ed. 1998. London: Weidenfeld and Nicholson, 2005.

Greenwood Diaries 1752–58
Greenwood, John. Diaries, 1752–58. Manuscript Collection. New-York Historical Society, New York.

Greta 1887
Greta. "Boston Art and Artists." *The Art Amateur* 17, no. 5 (October 1887), p. 93.

Greusel 1893
Greusel, John Hubert. "Some Oddities of Chinatown." *Once a Week* (July 1, 1893).

Griffin 1990
Griffin, Randall C. "Thomas Anshutz's *The Ironworkers' Noontime*: Remythologizing the Industrial Worker." *Smithsonian Studies in American Art* 4, nos. 3–4 (Summer–Fall 1990), pp. 128–43.

Griffin 1994
Griffin, Randall C. *Thomas Anshutz: Artist and Teacher.* Exh. cat., Heckscher Museum, Huntington, New York, September 3–November 20, 1994. Huntington, N.Y.: Heckscher Museum; Seattle: University of Washington Press, 1994.

Griffin 1995
Griffin, Randall C. "Thomas Eakins' Construction of the Male Body, or 'Men Get to Know Each Other Across the Space of Time.'" *Oxford Art Journal* 18, no. 2 (1995), pp. 70–80.

Griffin 2004
Griffin, Randall C. *Homer, Eakins, and Anshutz: The Search for American Identity in the Gilded Age.* University Park, Pa.: The Pennsylvania State University Press, 2004.

Griffin 2006
Griffin, Randall C. *Winslow Homer: An American Vision.* London: Phaidon Press, 2006.

Hahn 2003
Hahn, Steven. *A Nation Under Our Feet: Black Political Struggles in the Rural South from Slavery to the Great Migration.* Cambridge, Mass., and London: The Belknap Press of Harvard University Press, 2003.

Hale 1868, 1972
Hale, Sarah J[osepha]. *Manners; or Happy Homes and Good Society All the Year Round.* 1868. Reprint. New York: Arno Press, 1972.

Hammack 1982
Hammack, David C. *Power and Society: Greater New York at the Turn of the Century.* New York: Russell Sage Foundation, 1982.

Harding 1994
Harding, Anneliese. *John Lewis Krimmel: Genre Artist of the Early Republic.* Winterthur, Del.: Winterthur Museum, 1994.

Harding 2003
Harding, Anneliese. "British and Scottish Models for the American Genre Paintings of John Lewis Krimmel." *Winterthur Portfolio* 38, no. 4 (Winter 2003), pp. 221–43.

Harris 1982
Harris, Neil. *The Artist in American Society: The Formative Years, 1790–1860.* New ed. 1966. Chicago and London: University of Chicago Press, 1982.

Harris, ed. 1970
Harris, Neil, ed. *The Land of Contrasts, 1880–1901.* New York: George Braziller, 1970.

Harvey 2006–7
Harvey, Eleanor Jones. *An Impressionist Sensibility: The Halff Collection.* Exh. cat., Smithsonian American Art Museum, Washington, D.C., November 3, 2006–February 4, 2007. Washington, D.C.: Smithsonian American Art Museum; London: D. Giles, 2006.

Haskell, ed. 1984
Haskell, Thomas L., ed. *The Authority of Experts: Studies in History and Theory.* Interdisciplinary Studies in History. Bloomington, Ind.: Indiana University Press, 1984.

Hassrick 2000–2001
Hassrick, Peter H. *Remington, Russell and the Language of Western Art.* Exh. cat., Brooks Museum of Art, Memphis, November 19, 2000–January 28, 2001, and four other museums through December 9, 2001. Washington, D.C.: Trust for Museum Exhibitions, 2000.

Hassrick et al. 1987–88
Hassrick, Peter [H.], et al. *American Frontier Life: Early Western Painting and Prints.* Exh. cat., Buffalo Bill Historical Center, Cody, Wyoming, June 12–September 10, 1987; Amon Carter Museum, Fort Worth, October 17, 1987–January 3, 1988; Pennsylvania Academy of the Fine Arts, Philadelphia, January 28–April 22, 1988. New York: Abbeville Press, 1987.

Hassrick et al. 2007
Hassrick, Peter H., et al. *Redrawing Boundaries: Perspectives on Western American Art.* Denver: The Institute of Western American Art, Denver Art Museum, 2007.

Havemeyer 1927
Havemeyer, Louisine W. "Mary Cassatt." *The Pennsylvania Museum Bulletin* 22, no. 113 (May 1927), pp. 377–82.

Haywood 1988
Haywood, Robert. "George Bellows's *Stag at Sharkey's*: Boxing, Violence, and Male Identity." *Smithsonian Studies in American Art* 2, no. 2 (Spring 1988), pp. 2–15.

Hazeltine 1879
Hazeltine, Mayo W. *The American Woman in Europe, and the Keys to New York Society.* New York: American News Company, 1879.

Heartney et al. 2002
Heartney, Eleanor, et al. *A Capital Collection: Masterworks from the Corcoran Gallery of Art.* Washington, D.C.: The Corcoran Gallery of Art; London: Third Millennium Publishing, 2002.

Henkin 2006
Henkin, David M. *The Postal Age: The Emergence of Modern Communications in Nineteenth-Century America.* Chicago: University of Chicago Press, 2006.

Herbert 1988
Herbert, Robert L. *Impressionism: Art, Leisure, and Parisian Society.* New Haven and London: Yale University Press, 1988.

Hesselman 1998
Hesselman, Dorothy. "*Talking It Over*: A Patriotic Genre Painting by Enoch Wood Perry." *Metropolitan Museum Journal* 33 (1998), pp. 297–303.

Hills 1972
Hills, Patricia. *Eastman Johnson.* Exh. cat., Whitney Museum of American Art, New York, March 28–May 14, 1972; Detroit Institute of Arts, June 7–July 22, 1972; Cincinnati Art Museum, August 15–September 30, 1972; Milwaukee Art Center, October 20–December 3, 1972. New York: Whitney Museum of American Art, 1972.

Hills 1974–75
Hills, Patricia. *The Painter's America: Rural and Urban Life, 1810–1910*. Exh. cat., Whitney Museum of American Art, New York, September 20–November 10, 1974; The Museum of Fine Arts, Houston, December 5, 1974–January 19, 1975; Oakland Museum, February 10–March 30, 1975. New York: Praeger Publishers, 1974.

Hills 1986–87
Hills, Patricia. "'Painted Diaries': Sargent's Late Subject Pictures." In *John Singer Sargent*, by Patricia Hills et al., pp. 180–207. Exh. cat., Whitney Museum of American Art, New York, October 7, 1986–January 4, 1987; The Art Institute of Chicago, February 7–April 19, 1987. New York: Whitney Museum of American Art, 1986.

Hills 2006
Hills, Patricia. "Cultural Racism: Resistance and Accommodation in the Civil War Art of Eastman Johnson and Thomas Nast." In Johnston, P., ed. 2006, pp. 103–23.

Hindus, ed. 1995
Hindus, Milton, ed. *The Jewish East Side, 1881–1924*. 1969. New Brunswick, N.J.: Transaction Publishers, 1995.

Hobbs 1976
Hobbs, Susan. *1876: American Art of the Centennial*. Exh. cat., National Collection of Fine Arts, Smithsonian Institution, Washington, D.C., May 28–November 28, 1976. Washington, D.C.: Smithsonian Institution Press, 1976.

Hobbs and Gallati 1996–97
Hobbs, Susan A., and Barbara Dayer Gallati. *The Art of Thomas Wilmer Dewing: Beauty Reconfigured*. Exh. cat., Brooklyn Museum, March 21–June 9, 1996; National Museum of American Art, Washington, D.C., July 19–October 14, 1996; Detroit Institute of Arts, November 9, 1996–January 19, 1997. Brooklyn: Brooklyn Museum; Washington, D.C., and London: Smithsonian Institution Press, 1996.

Hodge, F. 1964
Hodge, Francis. *Yankee Theatre: The Image of America on the Stage, 1825–1850*. Austin, Tex.: University of Texas Press, 1964.

Hodge, F. W. 1929
Hodge, F. W. "A Proposed Indian Portfolio by John Mix Stanley." *Indian Notes* 6 (1929), pp. 359–67.

Hoffmann 1977
Hoffmann, Horst. *Theodor Ludwig Kaufmann, Maler und Freiheitskämpfer (1814–1896)*. Uelzener Beiträge, 6. Uelzen: Heimatverein des Kreises Uelzen, 1977.

Holmes 1861
[Holmes, Oliver Wendell]. "Sun-Painting and Sun-Sculpture; with a Stereoscopic Trip Across the Atlantic." *The Atlantic Monthly* 8, no. 45 (July 1861), pp. 13–29.

Home Journal 1859
"The Old Kentucky Home." *Home Journal*, August 27, 1859.

Homer, W. 1867
Homer, Winslow. "Homeward–Bound.—[Drawn by Winslow Homer.]." *Harper's Weekly* 11, no. 573 (December 21, 1867), pp. 808–9.

Homer, W. I. 1992
Homer, William Innes. *Thomas Eakins, His Life and Art*. New York, London, and Paris: Abbeville Press, 1992.

Hone 1936
Hone, Philip. *The Diary of Philip Hone, 1828–1851*. Edited by Allan Nevins. New and enl. ed. 2 vols. 1927. New York: Dodd, Mead and Company, 1936.

Honour 1989
Honour, Hugh. *The Image of the Black in Western Art*. Vol. 4, *From the American Revolution to World War 1*. 2 vols. Cambridge, Mass.: Harvard University Press, 1989.

Hoock 2003
Hoock, Holger. *The King's Artists: The Royal Academy of Arts and the Politics of British Culture, 1760–1840*. Oxford: Clarendon Press, 2003.

Hoopes and Moure 1974
Hoopes, Donelson F., and Nancy Wall Moure. *American Narrative Painting*. Exh. cat., Los Angeles County Museum of Art, October 1–November 17, 1974. Los Angeles, 1974.

Hoppin 1989
Hoppin, Martha J. *Country Paths and City Sidewalks: The Art of J. G. Brown*. Exh. cat., George Walter Vincent Smith Art Museum, Springfield, Massachusetts, March 19–May 21, 1989; National Academy of Design, New York, July 10–September 10, 1989; Joslyn Art Museum, Omaha, Nebraska, October 13–December 3, 1989. Springfield, Mass.: George Walter Vincent Smith Art Museum, 1989.

Horne, ed. 1999
Horne, Philip, ed. *Henry James: A Life in Letters*. New York: Viking, 1999.

Hôtel Baudy 1887–99
Hôtel Baudy. *Registre pour inscrire les voyageurs* [Hôtel Baudy Guest Register]. 1887–99. Department of Prints, Drawings, and Photographs, Philadelphia Museum of Art. Microfilm available at the Archives of American Art, Smithsonian Institution, Washington, D.C., reel 4236. Transcribed by Carol Lowrey in Gerdts 1993, pp. 222–27.

House 1965
House, Kay Seymour. *Cooper's Americans*. [Columbus, Ohio]: Ohio State University Press, 1965.

Howe 2007
Howe, Daniel Walker. *What Hath God Wrought: The Transformation of America, 1815–1848*. The Oxford History of the United States. New York: Oxford University Press, 2007.

Howells 1879
Howells, W[illiam] D[ean]. *The Lady of the Aroostook*. Boston: Houghton, Osgood and Company, 1879.

Howells 1882
Howells, William D[ean]. *A Modern Instance, a Novel*. Boston: J[ames] R. Osgood and Company, 1882.

Howells 1890, 1983
Howells, William Dean. *A Hazard of New Fortunes*. 1890. New York: New American Library, 1983.

Howells 1891
Howells, W[illiam] D[ean]. *Criticism and Fiction*. New York: Harper and Brothers, 1891.

Huneker 1908
[Huneker, James]. "Eight Painters: Second Article." *New York Sun*, February 10, 1908, p. 6.

Hunter 1991–92
Hunter, Robert. "The Rewards and Disappointments of the Ashcan School: The Early Career of Stuart Davis." In Sims, L., et al. 1991–92, pp. 31–44.

Husch 2000
Husch, Gail E. *Something Coming: Apocalyptic Expectation and Mid-Nineteenth-Century American Painting*. Hanover, N.H., and London: University Press of New England, 2000.

Huysmans 1883
Huysmans, J.-K. *L'Exposition des Indépendants en 1881*. Reprinted in *L'Art moderne*, pp. 223–57. Paris: G. Charpentier Éditeur, 1883.

Ignatiev 1995
Ignatiev, Noel. *How the Irish Became White*. New York and London: Routledge, 1995.

Independent 1872
"National Academy of Design." *The Independent* 24, no. 1221 (April 25, 1872), p. 2.

Independent Artists 1910
Catalogue, Exhibition of Independent Artists, From April 1st to 27th 1910, Galleries, 29–31 West Thirty-fifth St., N.Y. Exh. cat., New York, April 1–27, 1910. New York, 1910.

Indianapolis Star 1917
"Janitor Brother Tells How Chance Aided W. M. Chase." *Indianapolis Star*, March 25, 1917.

Isham 1927
Isham, Samuel. *The History of American Painting*. New ed. 1905. New York: The Macmillan Company, 1927.

Ives 1892
Ives, A. E. "Talks with Artists: Mr. Childe Hassam on Painting Street Scenes." *The Art Amateur* 27, no. 5 (October 1892), pp. 116–17.

Jackson 1881
Jackson, H[elen] H[unt]. *A Century of Dishonor: A Sketch of the United States Government's Dealings with Some of the Indian Tribes*. New York: Harper and Brothers, 1881.

"Jacob Émile Péreire" 2001
"Jacob [É]mile P[é]reire." In *Virtual American Biographies*. 2001. http://www.famousamericans.net/jacobemilepereire/ (March 22, 2009).

Jacobs 1985
Jacobs, Michael. *The Good and Simple Life: Artist Colonies in Europe and America*. Oxford: Phaidon Press, 1985.

Jaffee 1991
Jaffee, David. "Peddlers of Progress and the Transformation of the Rural North, 1760–1860." *The Journal of American History* 78, no. 2 (September 1991), pp. 511–35.

James 1876
James, Henry. "Parisian Sketches. Letter from Henry James, Jr. Meissonier's Battle of Friedland . . ." *New-York Daily Tribune*, January 22, 1876, p. 3.

James 1877
James, Henry. *The American*. Boston: J[ames] R. Osgood and Company, 1877.

James 1878
James, Henry. *Daisy Miller, a Study*. New York: Harper and Brothers, 1878.

James 1881
James, Henry. *The Portrait of a Lady*. 2 vols. Boston and New York: Houghton, Mifflin and Company, 1881.

James 1887
James, Henry. "John S. Sargent." *Harper's New Monthly Magazine* 75, no. 449 (October 1887), pp. 683–91.

James 1893
James, Henry. *Picture and Text*. New York: Harper and Brothers, 1893.

James 1902
James, Henry. *The Wings of the Dove*. 2 vols. New York: Charles Scribner's Sons, 1902.

James 1956
James, Henry. *The Painter's Eye: Notes and Essays on the Pictorial Arts by Henry James*. Edited with an introduction by John L. Sweeney. London: Rupert Hart-Davis, 1956.

Jarves 1863
Jarves, James Jackson. "Art in America, Its Condition and Prospects." *The Fine Arts Quarterly Review* [1] (October 1863), pp. 393–401.

Johns 1983
Johns, Elizabeth. *Thomas Eakins: The Heroism of Modern Life*. Princeton, N.J.: Princeton University Press, 1983.

Johns 1991
Johns, Elizabeth. *American Genre Painting: The Politics of Everyday Life*. New Haven and London: Yale University Press, 1991.

Johns 2002
Johns, Elizabeth. *Winslow Homer: The Nature of Observation*. Berkeley and Los Angeles: University of California Press, 2002.

Johnson, D., et al. 1998–99
Johnson, Deborah J., et al. *William Sidney Mount: Painter of American Life*. Exh. cat., The New-York Historical Society, August 14–October 25, 1998; The Frick Art Museum, Pittsburgh, November 19, 1998–January 10, 1999; Amon Carter Museum, Fort Worth, February 5–April 4, 1999. New York: The American Federation of Arts, 1998.

Johnson, M. 2002
Johnson, Marilynn S. "Enduring Icons, Changing Realities: The Westward Trail of the Cowboy in American Art." In *Cowboys, Indians, and the Big Picture*, edited by Heather Fryer, pp. 33–43. Exh. cat., Charles S. and Isabella V. McMullen Museum of Art, Boston College, October 6–December 8, 2002. Boston, 2002.

Johnston, D. C. 1837
Johnston, David Claypoole. *Phrenology Exemplified and Illustrated: With Upwards of Forty Etchings: Being Scraps No. 7, for the Year 1837*. Scraps, 7. Boston: [Johnston], 1837.

Johnston, P. 2006
Johnston, Patricia. "Samuel F. B. Morse's *Gallery of the Louvre*: Social Tensions in an Ideal World." In Johnston, P., ed. 2006, pp. 42–65.

Johnston, P., ed. 2006
Johnston, Patricia, ed. *Seeing High and Low: Representing Social Conflict in American Visual Culture*. Berkeley and Los Angeles: University of California Press, 2006.

Johnston, S., and Tucker 2004–5
Johnston, Sona, and Paul Tucker. *In Monet's Light: Theodore Robinson at Giverny*. Exh. cat., Baltimore Museum of Art, October 17, 2004–January 9, 2005; Phoenix Museum of Art, February 6–May 8, 2005; Wadsworth Atheneum, Hartford, Conn., June 4–September 4, 2005. Baltimore: Baltimore Museum of Art; London: Philip Wilson Publishers, 2004.

Jones 1841
J[ones, William A.]. "The Culture of the Imagination." *Arcturus* 1, no. 4 (March 1841), pp. 236–43.

Junkin 1986
Junkin, Sara Caldwell. "The Europeanization of Henry Bacon (1839–1912), American Expatriate Painter." PhD diss., Boston University, 1986.

Kaplan et al. 1987–88
Kaplan, Wendy, et al. *"The Art that is Life": The Arts and Crafts Movement in America, 1875–1920*. Exh. cat., Museum of Fine Arts, Boston, March 4–May 31, 1987; Los Angeles County Museum of Art, August 16–November 1, 1987; Detroit Institute of Arts, December 9, 1987–February 28, 1988; Cooper-Hewitt Museum, New York, April 5–June 26, 1988. Boston: Museum of Fine Arts, 1987.

Kasson 1990
Kasson, John F. *Rudeness and Civility: Manners in Nineteenth-Century Urban America*. New York: Hill and Wang, 1990.

Kelly et al. 1996
Kelly, Franklin, et al. *American Paintings of the Nineteenth Century. Part I*. The Collections of the National Gallery of Art, Systematic Catalogue. Washington, D.C.: National Gallery of Art, 1996.

Kenny n.d.
Kenny, R. W. "John Greenwood's *Sea Captains Carousing in Surinam*." Unpublished paper for Department of English, Brown University, n.d. Curatorial files, Saint Louis Art Museum.

Keyes 1969
Keyes, Donald D. "The Sources for William Sidney Mount's Earliest Genre Paintings." *Art Quarterly* 32, no. 3 (Autumn 1969), pp. 258–68.

Kilmurray, Ormond, and Volk 1998–99
Kilmurray, Elaine, Richard Ormond, and Mary Crawford Volk. *John Singer Sargent*. Exh. cat., Tate Gallery, London, October 15, 1998–January 17, 1999; National Gallery of Art, Washington, D.C., February 21–May 31, 1999; Museum of Fine Arts, Boston, June 23–September 26, 1999. London: Tate Gallery Publishing, 1998.

Kincaid 1992
Kincaid, James R. *Child-Loving: The Erotic Child and Victorian Culture*. New York and London: Routledge, 1992.

Kleinberg 1999
Kleinberg, S. J. *Women in the United States, 1830–1945*. New Brunswick, N.J.: Rutgers University Press, 1999.

Knickerbocker 1857
"Editor's Table." *The Knickerbocker* 49, no. 3 (March 1857), pp. 309–24.

Knox 1881
Knox, Thomas W. *How to Travel: Hints, Advice, and Suggestions to Travelers by Land and Sea All Over the Globe*. New York: C[harles] T. Dillingham; Boston: Lee and Shepard, 1881.

Koehler 1883–84
Koehler, S[ylvester] R[osa]. *The Private Collection of Paintings by Exclusively American Artists, owned by Thomas B. Clarke*. Exh. cat., American Art Galleries, New York, December 28, 1883–January 12, 1884. New York: The Studio Press, [1883].

Koke et al. 1982
Koke, Richard J., et al. *American Landscape and Genre Paintings in The New-York Historical Society: A Catalog of the Collection, Including Historical, Narrative, and Marine Art*. 3 vols. New York: The New-York Historical Society; Boston: G. K. Hall and Co., 1982.

Kornhauser 1986
Kornhauser, Elizabeth Mankin. "Ralph Earl as an Itinerant Artist: Pattern of Patronage." In *Itinerancy in New England and New York*, edited by Peter Benes and Jane Montague Benes, pp. 172–89. The Dublin Seminar for New England Folklife. [Vol. 9], Annual Proceedings, June 16 and 17, 1984. [Boston]: Boston University, 1986.

Kornhauser et al. 1991–92
Kornhauser, Elizabeth Mankin, et al. *Ralph Earl: The Face of the Young Republic*. Exh. cat., National Portrait Gallery, Washington, D.C., November 1, 1991–January 1, 1992; Wadsworth Atheneum, Hartford, Conn., February 2–April 5, 1992; Amon Carter Museum, Fort Worth, May 16–July 12, 1992. New Haven and London: Yale University Press, 1991.

Kouwenhoven 1953
Kouwenhoven, John A. *The Columbia Historical Portrait of New York*. Garden City, N.Y.: Doubleday and Company, 1953.

Krane et al. 1987
Krane, Susan, et al. *The Wayward Muse: A Historical Survey of Painting in Buffalo*. Exh. cat., Albright-Knox Art Gallery, Buffalo, March 28–May 24, 1987. Buffalo, N.Y., 1987.

Lamb 1900
Lamb, Arthur J. "A Bird in a Gilded Cage." 1900. http://www.ingeb.org/songs/shesonly.html (March 22, 2009).

Larkin, J. 1988
Larkin, Jack. *The Reshaping of Everyday Life, 1790–1840*. New York: Harper and Row, 1988.

Larkin, S., and Nichols 2005–6
Larkin, Susan G., and Arlene Katz Nichols. *American Impressionism: The Beauty of Work*. Exh. cat., Bruce Museum of Arts and Science, Greenwich, Connecticut, September 24, 2005–January 8, 2006. Greenwich, Conn., 2005.

Layton 1861
Layton, Mrs. J. H. "American Art." *The Knickerbocker, or New-York Monthly Magazine* 58, no. 1 (July 1861), pp. 48–52.

Leach 1993
Leach, William. *Land of Desire: Merchants, Power, and the Rise of a New American Culture*. New York: Pantheon Books, 1993.

Leader 1982
Leader, Bernice Kramer. "Anti-Feminism in the Paintings of the Boston School." *Arts Magazine* 56, no. 5 (January 1982), pp. 112–19.

Lears 1981
Lears, T. J. Jackson. *No Place of Grace: Antimodernism and the Transformation of American Culture, 1880–1920*. New York: Pantheon Books, 1981.

Lehuu 2000
Lehuu, Isabelle. *Carnival on the Page: Popular Print Media in Antebellum America.* Chapel Hill, N.C., and London: The University of North Carolina Press, 2000.

Leja 2004
Leja, Michael. *Looking Askance: Skepticism and American Art from Eakins to Duchamp.* Berkeley and Los Angeles: University of California Press, 2004.

Liedtke 1990–91
Liedtke, Walter. "Dutch Paintings in America: The Collectors and Their Ideals." In *Great Dutch Paintings from America,* by Ben Broos et al., pp. 14–59. Exh. cat., Mauritshuis, The Hague, September 28, 1990–January 13, 1991; The Fine Arts Museums of San Francisco, February 16–May 5, 1991. The Hague: Mauritshuis; Zwolle: Waanders Publishers, 1990.

Lighter 1997
Lighter, J. E. "Money Talks." *The Atlantic Monthly* 297, no. 6 (June 1997), p. 124.

Literary World **1852**
"The Fine Arts. Exhibition of the National Academy of Design.—No. II." *The Literary World* 10, no. 274 (May 1, 1852), pp. 314–16.

Littell's Living Age **1864**
"Croquet." *Littell's Living Age,* no. 1064 (October 22, 1864), pp. 174–77.

Littell's Living Age **1870**
"The Nemesis of Flirtation." *Littell's Living Age,* no. 1338 (January 22, 1870), pp. 251–54.

Logghe, ed. 2006
Logghe, Frederic, ed. *Maritime Digital Encyclopedia.* 2006. http://www.ibiblio.org/maritime/photolibrary/index.php?cat=1640 (March 22, 2009).

London 1905
London, Jack. *The Game: A Transcript from Real Life.* New York: The Macmillan Company; London: Macmillan and Company, 1905.

London 1909, 1961
London, Jack. "A Piece of Steak." 1909. In *Sport, U.S.A.: The Best from the Saturday Evening Post,* edited by Harry T. Paxton, pp. 28–29. New York: Nelson, 1961.

Loomis 1887
Loomis, Samuel Lane. "The Growth of Modern Cities." *The Andover Review* 7, no. 40 (April 1887), pp. 341–58.

Lovell 1984–85
Lovell, Margaretta M. *Venice: The American View, 1860–1920.* Exh. cat., The Fine Arts Museums of San Francisco, California Palace of the Legion of Honor, October 20, 1984–January 20, 1985; The Cleveland Museum of Art, February 27–April 21, 1985. San Francisco: The Fine Arts Museums of San Francisco, 1984.

Lovell 1989
Lovell, Margaretta M. *A Visitable Past: Views of Venice by American Artists, 1860–1915.* Chicago and London: University of Chicago Press, 1989.

Lovell 2005
Lovell, Margaretta M. *Art in a Season of Revolution: Painters, Artisans, and Patrons in Early America.* Philadelphia: University of Pennsylvania Press, 2005.

Lübbren 2001
Lübbren, Nina. *Rural Artists' Colonies in Europe, 1870–1910.* Manchester, U.K.: Manchester University Press, 2001.

Lubin 1994
Lubin, David M. *Picturing a Nation: Art and Social Change in Nineteenth-Century America.* New Haven and London: Yale University Press, 1994.

Lubove 1962
Lubove, Roy. *The Progressives and the Slums: Tenement House Reform in New York City, 1890–1917.* [Pittsburgh, Pa.]: University of Pittsburgh Press, 1962.

Lurie 1981
Lurie, Alison. *The Language of Clothes.* New York: Random House, 1981.

Lyon 1799
Lyon, Patrick. *The Narrative of Patrick Lyon, who suffered three months severe imprisonment in Philadelphia gaol; on merely a vague suspicion, of being concerned in the robbery of the Bank of Pennsylvania, with his remarks thereon.* Philadelphia: Francis and Robert Bailey, 1799.

Macbeth Galleries 1908
Exhibition of Paintings by Arthur B. Davies, William J. Glackens, Robert Henri, Ernest Lawson, George Luks, Maurice B. Prendergast, Everett Shinn, and John Sloan. Exh. cat., Macbeth Galleries, New York, February 3–15, 1908. New York, 1908.

Maffi 1995
Maffi, Mario. *Gateway to the Promised Land: Ethnic Cultures on New York's Lower East Side.* New York: New York University Press, 1995.

Marryat 1840
Marryat, [Frederick]. *Second Series of A Diary in America, with Remarks on Its Institutions.* Philadelphia: T. K. and P. G. Collins, 1840.

Marston and Feller 1943
Marston, William Moulton, and John Henry Feller. *F. F. Proctor, Vaudeville Pioneer.* New York: Richard R. Smith, 1943.

Marten 1998
Marten, James. *The Children's Civil War.* Chapel Hill, N.C., and London: The University of North Carolina Press, 1998.

Mathews 2005–7
Mathews, Nancy Mowll. "The Body in Motion." In *Moving Pictures: American Art and Early Film, 1880–1910,* by Nancy Mowll Mathews et al., pp. 73–94. Exh. cat., Williams College Museum of Art, Williamstown, Massachusetts, July 16–December 11, 2005; Reynolda House Museum of American Art, Winston-Salem, North Carolina, March 24–July 16, 2006; Grey Art Gallery of New York University, New York, September 13–December 9, 2006; Phillips Collection, Washington, D.C., February 17–May 20, 2007. New York: Hudson Hills Press; Williamstown, Mass.: Williams College Museum of Art, 2005.

Mathews, ed. 1984
Mathews, Nancy Mowll, ed. *Cassatt and Her Circle: Selected Letters.* New York: Abbeville Press, 1984.

Maule 1907
Maule, Mary K. "What Is a Shop-Girl's Life? Her Pay, Hours, 'Home,' Outlook, and Chance of Enjoyment." *The World's Work* 14, no. 5 (September 1907), pp. 9311–16.

Mayer 1958
Mayer, Grace M. *Once Upon a City, New York 1890–1910.* New York: The Macmillan Company, 1958.

McBride 1913
[McBride, Henry]. "What Is Doing in World of Art, Artists and Art Dealers." *New York Sun*, October 26, 1913, section 7, p. 2.

McCurdy 2005
McCurdy, Melinda Ruth. "History and Human Experience in the Art of David Wilkie, 1806–1835." PhD diss., University of California, Santa Barbara, 2005.

McDermott 1959
McDermott, John Francis. *George Caleb Bingham: River Portraitist*. Norman, Okla.: University of Oklahoma Press, 1959.

McDermott 1961
McDermott, John Francis. *Seth Eastman: Pictorial Historian of the Indian*. Norman, Okla.: University of Oklahoma Press, 1961.

McElroy et al. 1990
McElroy, Guy C., et al. *Facing History: The Black Image in American Art, 1710–1940*. Exh. cat., The Corcoran Gallery of Art, Washington, D.C., January 13–March 25, 1990; Brooklyn Museum, April 20–June 25, 1990. San Francisco: Bedford Arts, Publishers; Washington, D.C.: The Corcoran Gallery of Art, 1990.

McPherson 1988
McPherson, James M. *Battle Cry of Freedom: The Civil War Era*. The Oxford History of the United States. New York and Oxford: Oxford University Press, 1988.

Melville 1857
Melville, Herman. *The Confidence-Man: His Masquerade*. New York: Dix, Edwards and Co., 1857.

Merrill et al. 2003–4
Merrill, Linda, et al. *After Whistler: The Artist and His Influence on American Painting*. Exh. cat., High Museum of Art, Atlanta, November 22, 2003–February 8, 2004; Detroit Institute of Arts, March 13–June 6, 2004. New Haven and London: Yale University Press; Atlanta: High Museum of Art, 2003.

Mieder 1993
Mieder, Wolfgang. "'The Only Good Indian Is a Dead Indian': History and Meaning of a Proverbial Stereotype." *Journal of American Folklore* 106, no. 419 (Winter 1993), pp. 38–60.

Miles 1993
Miles, Ellen G. "Copley's *Watson and the Shark*." *The Magazine Antiques* 143, no. 1 (January 1993), pp. 162–71.

Miles and Reinhardt 1996
Miles, Ellen G., and Leslie Reinhardt. "Art conceal'd: Peale's Double Portrait of Benjamin and Eleanor Ridgely Laming." *The Art Bulletin* 78, no. 1 (March 1996), pp. 56–74.

Miller, A. 1992
Miller, Angela. "The Mechanisms of the Market and the Invention of Western Regionalism: The Example of George Caleb Bingham." *Oxford Art Journal* 15, no. 1 (1992), pp. 3–20.

Miller, A. 2006
Miller, Angela. "Death and Resurrection in an Artist's Studio." *American Art* 20, no. 1 (Spring 2006), pp. 84–95.

Miller, L. 1982
Miller, Lillian B. *Patrons and Patriotism: The Encouragement of the Fine Arts in the United States, 1790–1860*. 1966. Chicago and London: University of Chicago Press, 1982.

Miller, L., ed. 1983
Miller, Lillian B., ed. *The Selected Papers of Charles Willson Peale and His Family*. Vol. 1, *Charles Willson Peale: Artist in Revolutionary America, 1735–1791*. New Haven and London: Yale University Press, 1983.

Miller, L., ed. 1996–97
Miller, Lillian B., ed. *The Peale Family: Creation of a Legacy, 1770–1870*. Exh. cat., Philadelphia Museum of Art, November 3, 1996–January 5, 1997; The Fine Arts Museums of San Francisco, M. H. de Young Memorial Museum, January 25–April 6, 1997; The Corcoran Gallery of Art, Washington, D.C., April 26–July 6, 1997. New York: Abbeville Press, 1996.

Miller, L., ed. 2000
Miller, Lillian B., ed. *The Selected Papers of Charles Willson Peale and His Family*. Vol. 5, *The Autobiography of Charles Willson Peale*. New Haven and London: Yale University Press, 2000.

Mills 1988–89
Mills, Sally. "*Pitching Quoits*, 1865." In Simpson et al. 1988–89, pp. 208–15.

Mitchell, M. 2002
Mitchell, Mary Niall. "'Rosebloom and Pure White,' Or So It Seemed." *American Quarterly* 54, no. 3 (September 2002), pp. 369–410.

Mitchell, R. 1993
Mitchell, Reid. *The Vacant Chair: The Northern Soldier Leaves Home*. New York and Oxford: Oxford University Press, 1993.

Mitchell, S. W. 1884
Mitchell, S[ilas] Weir. *Fat and Blood: An Essay on the Treatment of Certain Forms of Neurasthenia and Hysteria*. 3rd ed., rev. 1877. Philadelphia: J. B. Lippincott and Co., 1884.

MMA Bulletin 1918
"In Memoriam: Robert Gordon." *The Metropolitan Museum of Art Bulletin* 13, no. 7 (July 1918), p. 160.

Morgan 1983
Morgan, Joan B. "The Indian Paintings of George de Forest Brush." *The American Art Journal* 15, no. 2 (Spring 1983), pp. 60–73.

Morrison 1992
Morrison, Toni. *Playing in the Dark: Whiteness and the Literary Imagination*. The William E. Massey, Sr., Lectures in the History of American Civilization, 1990. Cambridge, Mass.: Harvard University Press, 1992.

Morse 1833
Morse, Samuel F. B. *Descriptive Catalogue of the Pictures, Thirty-seven in Number, from the Most Celebrated Masters, Copied into the Gallery of the Louvre. Painted in Paris in 1831–32, by Samuel F. B. Morse, P.N.A.* New York: Clayton and Van Norden, 1833.

Mount 1978
Mount, Charles Merrill. "A Phoenix at Richmond." *Arts in Virginia* 18 (Spring 1978), pp. 2–19.

Myers 2000–2001
Myers, Kenneth John. "The Public Display of Art in New York City, 1664–1914." In Dearinger et al. 2000–2001, pp. 30–51.

NAD Exhibition Record (1826–1860) 1943
[Cowdrey, Mary Bartlett, ed.]. *National Academy of Design Exhibition Record, 1826–1860*. 2 vols. New York: The New-York Historical Society, 1943.

NAD Exhibition Record (1861–1900) 1973
Naylor, Maria, ed. *The National Academy of Design Exhibition Record, 1861–1900*. 2 vols. New York: Kennedy Galleries, 1973.

Nation 1868
"Why Is Single Life Becoming More General?" *The Nation* 6, no. 140 (March 5, 1868), pp. 190–91.

Nation 1883
"Fine Arts. Fifty-eighth Annual Exhibition of the National Academy of Design." *The Nation* 36, no. 929 (April 19, 1883), pp. 348–49.

National Arts Club 1904
Loan Exhibition of Pictures by Robert Henri, William Glackens, George Luks, Arthur B. Davies, Maurice Prendergast, and John Sloan. Exh. cat., National Arts Club, New York, January 19–31, 1904. New York, 1904.

Neff 2006–7
Neff, Emily Ballew. "The End of the Frontier: Making the West Artistic." In *The Modern West: American Landscapes, 1890–1950*, by Emily Ballew Neff and Barry Lopez, pp. 50–95, 276–79. Exh. cat., The Museum of Fine Arts, Houston, October 29, 2006–January 28, 2007; Los Angeles County Museum of Art, March 4–June 3, 2007. New Haven and London: Yale University Press; Houston: The Museum of Fine Arts, 2006.

Neff and Phelan 2000
Neff, Emily Ballew, and Wynne H. Phelan. *Frederic Remington: The Hogg Brothers Collection of the Museum of Fine Arts, Houston.* Princeton, N.J.: Princeton University Press; Houston: The Museum of Fine Arts, 2000.

Neff and Pressly 1995–96
Neff, Emily Ballew, and William L. Pressly. *John Singleton Copley in England.* Exh. cat., National Gallery of Art, Washington, D.C., October 11, 1995–January 7, 1996; The Museum of Fine Arts, Houston, February 4–April 28, 1996. Houston: The Museum of Fine Arts; London: Merrell Holberton, Publishers, 1995.

Nemerov 1991–92
Nemerov, Alex[ander]. "Doing the 'Old America': The Image of the American West, 1880–1920." In Truettner et al. 1991–92, pp. 284–343.

Nevins 1971
Nevins, Allan. *The Emergence of Modern America, 1865–1878.* 1927. Chicago: Quadrangle Books, 1971.

New-York Daily Tribune 1901
"Art Exhibitions. American Paintings at the Union League Club." *New-York Daily Tribune*, January 12, 1901, p. 8.

New York Evening Mail 1869
"On the Easel." *New York Evening Mail*, April 8, 1869, p. 1.

New York Evening Mail 1870
"On the Easel." *New York Evening Mail*, January 17, 1870, p. 1.

New York Evening Telegram 1872
"The Realm of Art." *New York Evening Telegram*, April 20, 1872.

New York Herald 1876
"Fine Arts. Notes from the Studios of New York and Paris." *The New York Herald*, January 28, 1876, p. 2.

New York Herald 1913
"Mr. John G. Brown, Artist, Dies of Pneumonia at 81." *The New York Herald*, February 9, 1913, p. 8.

New-York Mirror 1833
"Original Notices of the Fine Arts. Mr. Morse's Gallery of the Louvre." *New-York Mirror* 11, no. 18 (November 2, 1833), p. 142.

New-York Semi-Weekly Tribune 1859
"National Academy." *New-York Semi-Weekly Tribune*, May 24, 1859, p. 3.

New-York Times 1862
"Brady's Photographs. Pictures of the Dead at Antietam." *The New-York Times*, October 20, 1862, p. 5.

New-York Times 1865a
"National Academy of Design, North Room." *The New-York Times*, May 29, 1865, pp. 4–5.

New-York Times 1865b
"National Academy of Design. South Room." *The New-York Times*, June 13, 1865, pp. 4–5.

New-York Times 1867
"The Paris Exposition." *The New-York Times*, May 16, 1867, p. 1.

New-York Times 1876a
"The Fine Arts. Exhibition of the National Academy. An Unusually Poor Array—No Great Pictures—Commendable Progress of Some Juniors—The Falling Off of Some Seniors. [Third Article.]." *The New-York Times*, April 8, 1876, pp. 6–7.

New-York Times 1876b
"The Fine Arts. The Academy Exhibition. Notes of the Principal Works on View—Comparison with Previous Exhibitions." *The New-York Times*, April 3, 1876, pp. 4–5.

New-York Times 1886
"The Academy of Design. Spring Exhibition of Paintings and Sculptures." *The New-York Times*, April 4, 1886, p. 4.

New York Times 1900
"Dramatic and Musical. 'Continuous' Vaudeville at the Fifth Avenue Theatre. Mr. Proctor's First Bill in His Newly-Acquired House—Other Performances Yesterday—Gossip of the Stage." *The New York Times*, May 8, 1900, p. 6.

New York Times 1903
"Plans for the New Wanamaker Store Here. Building to be Thirteen Stories High, Grand Court in the Centre Extending to the Eighth Floor." *The New York Times*, May 8, 1903, p. 1.

New York Times 1905
"Fleet Champions Fight and Britisher Wins." *The New York Times*, November 18, 1905, p. 1.

New York Times 1906
"Fifth Avenue Theatre a Gorgeous Playhouse. Interior Transformed in Red, Green, and Ivory." *The New York Times*, October 1, 1906, p. 7.

New York Times 1910
"News and Notes of the Art World." *The New York Times*, January 9, 1910, p. SM14.

New York Times 1912
"'The Street Gamin Has Vanished from New York.'" *The New York Times*, November 17, 1912, p. SM9.

Nieriker 1879
Nieriker, May Alcott. *Studying Art Abroad, and How to Do It Cheaply.* Boston: Roberts Brothers, 1879.

Noble 1994
Noble, Dennis L. *That Others Might Live: The U.S. Life-Saving Service, 1878–1915.* Annapolis, Md.: Naval Institute Press, 1994.

Oedel and Gernes 1988
Oedel, William T., and Todd S. Gernes. "'The Painter's Triumph': William Sidney Mount and the Formation of a Middle-Class Art." *Winterthur Portfolio* 23, nos. 2–3 (Summer–Autumn 1988), pp. 111–27.

Orcutt 2005
Orcutt, Kimberly. "'Revising History': Creating a Canon of American Art at the Centennial Exhibition." PhD diss., The City University of New York, 2005.

Ormond and Kilmurray 2002
Ormond, Richard, and Elaine Kilmurray. *John Singer Sargent: Portraits of the 1890s*. The Complete Paintings of John Singer Sargent, vol. 2. New Haven and London: Yale University Press for The Paul Mellon Centre for Studies in British Art, 2002.

Parry 1974
Parry, Elwood. *The Image of the Indian and the Black Man in American Art, 1590–1900*. New York: G. Braziller, 1974.

Pauly 1988
Pauly, Thomas H. "American Art and Labor: The Case of Anshutz's *The Ironworkers' Noontime*." *American Quarterly* 40, no. 3 (September 1988), pp. 333–58.

Paxson 1928
Paxson, Frederic L. *The Last American Frontier*. New York: MacMillan, 1928.

Paxton 1913
"*Breakfast*: Painted by William M. Paxton." *The Ladies' Home Journal* 30, no. 3 (March 1913), p. 17.

Pennell 1908
Pennell, E[lizabeth] R[obins], and J[oseph] Pennell. *The Life of James McNeill Whistler*. 2 vols. London: William Heinemann; Philadelphia: J. B. Lippincott Company, 1908.

Pennell 1921
Pennell, E[lizabeth] R[obins], and J[oseph] Pennell. *The Whistler Journal*. Philadelphia: J. B. Lippincott Company, 1921.

Pennington 1841
Pennington, James W. C. *A Text Book of the Origin and History, etc., etc., of the Colored People*. Hartford, Conn.: L. Skinner, 1841.

Perlman 1991
Perlman, Bennard B. *Robert Henri: His Life and Art*. New York: Dover Publications, 1991.

Perry 2006–7
Perry, Claire. *Young America: Childhood in Nineteenth-Century Art and Culture*. Exh. cat., Iris and B. Gerald Cantor Center for Visual Arts, Stanford University, February 1–May 7, 2006; Smithsonian American Art Museum, Washington, D.C., July 4–September 17, 2006; Portland Museum of Art, Portland, Maine, November 1, 2006–January 7, 2007. New Haven and London: Yale University Press, 2006.

Pese et al. 2001–2
Pese, Claus, et al. *Künstlerkolonien in Europe, Im Zeichen der Ebene und des Himmels*. Exh. cat., Germanisches Nationalmuseum, Nuremberg, November 15, 2001–February 17, 2002. Nuremberg, 2001.

Phillips et al. 1909
Phillips, Amy Lyman, et al. "Famous American Restaurants and Some of the Delicacies for Which They Are Noted." *Good Housekeeping* 48 (January 1909), p. 22.

Pisano 1983–84
Pisano, Ronald G. *A Leading Spirit in American Art: William Merritt Chase, 1849–1916*. Exh. cat., Henry Art Gallery, University of Washington, Seattle, October 2, 1983–January 29, 1984; The Metropolitan Museum of Art, New York, March 9–June 3, 1984. Seattle: Henry Art Gallery, University of Washington, 1983.

Plante 1997
Plante, Ellen M. *Women at Home in Victorian America: A Social History*. New York: Facts on File, 1997.

Pohl 1994
Pohl, Frances K. "Black and White in America." In *Nineteenth Century Art: A Critical History*, edited by Stephen F. Eisenman, pp. 163–87, 366. London: Thames and Hudson, 1994.

Prown et al. 1992–93
Prown, Jules David, et al. *Discovered Lands, Invented Pasts: Transforming Visions of the American West*. Exh. cat., Buffalo Bill Historical Center, Cody, Wyoming, June 15–August 16, 1992; Yale University Art Gallery, New Haven, September 19, 1992–January 3, 1993; Gilcrease Museum, Tulsa, Oklahoma, February 6–April 11, 1993. New Haven: Yale University Art Gallery, 1992.

Pyne 1993
Pyne, Kathleen. "Evolutionary Typology and the American Woman in the Work of Thomas Dewing." *American Art* 7, no. 4 (Fall 1993), pp. 12–29.

Pyne et al. 1983
Pyne, Kathleen, et al. *The Quest for Unity: American Art Between World's Fairs, 1876–1893*. Exh. cat., Detroit Institute of Arts, August 22–October 30, 1983. Detroit, 1983.

Quick 1992–93
Quick, Michael. "Technique and Theory: The Evolution of George Bellows's Painting Style." In Quick et al. 1992–93, pp. 8–95.

Quick et al. 1992–93
Quick, Michael, et al. *The Paintings of George Bellows*. Exh. cat., Los Angeles County Museum of Art, February 16–May 10, 1992; Whitney Museum of American Art, New York, June 5–August 30, 1992; Columbus Museum of Art, Columbus, Ohio, October 11, 1992–January 3, 1993; Amon Carter Museum, Fort Worth, February 20–May 9, 1993. New York: Harry N. Abrams, 1992.

Rash 1995
Rash, Nancy. "A Note on Winslow Homer's *Veteran in a New Field* and Union Victory." *American Art* 9, no. 2 (Summer 1995), pp. 88–93.

Rather 1993
Rather, Susan. "A Painter's Progress: Matthew Pratt and *The American School*." *Metropolitan Museum Journal* 28 (1993), pp. 169–83.

Rather 1997
Rather, Susan. "Carpenter, Tailor, Shoemaker, Artist: Copley and Portrait Painting around 1770." *The Art Bulletin* 79, no. 2 (June 1997), pp. 269–90.

Retford 2006
Retford, Kate. *The Art of Domestic Life: Family Portraiture in Eighteenth-Century England*. New Haven and London: The Paul Mellon Centre for Studies in British Art; Yale University Press, 2006.

Revere Waste and Account Book 1768
Revere Waste and Account Book, 1768. Revere Family Papers. Massachusetts Historical Society, Boston.

Richardson 2001
Richardson, Heather Cox. *The Death of Reconstruction: Race, Labor, and Politics in the Post–Civil War North, 1865–1901*. Cambridge, Mass.: Harvard University Press, 2001.

Robertson 1992
Robertson, Bruce. "*The Power of Music*: A Painting by William Sidney Mount." *Bulletin of the Cleveland Museum of Art* 79, no. 2 (February 1992), pp. 38–62.

Robertson 1998
Robertson, Bruce. "Mount's *The Power of Music*: Who's Listening to What?" Paper presented at symposium, Performing Race in Antebellum America, Getty Works in Progress Series, March 13, 1998. The Getty Research Institute, Getty Center, Los Angeles, California.

Robinson, T. 1892–96
Robinson, Theodore. Diary. 1892–96. Frick Art Reference Library, New York.

Robinson, W. 1869
Robinson, W[illiam]. *The Parks, Promenades, and Gardens of Paris*. London: J[ohn] Murray, 1869.

Roosevelt 1888
Roosevelt, Theodore. *Ranch Life and the Hunting-Trail*. New York: The Century Co[mpany], 1888.

Roosevelt 1913
Roosevelt, Theodore. *Theodore Roosevelt: An Autobiography*. New York: Macmillan, 1913.

Rose 1999–2000
Rose, Anne C. "Eastman Johnson and the Culture of American Individualism." In Carbone and Hills et al. 1999–2000, pp. 214–35.

Rothman 1984
Rothman, Ellen K. *Hands and Hearts: A History of Courtship in America*. New York: Basic Books, 1984.

Rotundo 1993
Rotundo, E. Anthony. *American Manhood: Transformations in Masculinity from the Revolution to the Modern Era*. New York: Basic Books; HarperCollins, 1993.

Round Table 1864
L. "Philadelphia Art Notes." *The Round Table* 1, no. 15 (March 26, 1864), p. 234.

Round Table 1865
L. "Philadelphia Art Notes." *The Round Table* [3], no. 4 (September 30, 1865), p. 60.

Roznoy 1990
Roznoy, Cynthia. "Social Discourse in William Glackens' *The Shoppers*." Unpublished research paper, Graduate School and University Center of the City University of New York, Fall 1990.

Rubin 2008
Rubin, James H. *Impressionism and the Modern Landscape: Productivity, Technology, and Urbanization from Manet to Van Gogh*. Berkeley and Los Angeles: University of California Press, 2008.

Russell 1909
Russell, Charles Edward. "The Slum as a National Asset." *Everybody's Magazine* 20, no. 2 (February 1909), pp. 170–80.

Ruxton 1848
Ruxton, George F. *Adventures in Mexico and the Rocky Mountains*. New York: Harper and Brothers, 1848.

Sachar 1992
Sachar, Howard M. *A History of the Jews in America*. New York: Alfred A. Knopf, 1992.

Saisselin 1984
Saisselin, Rémy G. *The Bourgeois and the Bibelot*. New Brunswick, N.J.: Rutgers University Press, 1984.

Saltzman 2008
Saltzman, Cynthia. *Old Masters, New World: America's Raid on Europe's Great Pictures, 1880–World War I*. New York: Viking, 2008.

Sammons 1988
Sammons, Jeffrey T. *Beyond the Ring: The Role of Boxing in American Society*. Urbana, Ill.: University of Illinois Press, 1988.

Sanders 1979
Sanders, Ronald. *The Lower East Side: A Guide to Its Jewish Past with 99 New Photographs*. New York: Dover Publications, 1979.

Sanjek 1988
Sanjek, Russell. *American Popular Music and Its Business, The First Four Hundred Years*. Vol. 2, *From 1790 to 1909*. New York: Oxford University Press, 1988.

Santayana 1967
Santayana, George. "The Genteel Tradition in American Philosophy." 1911. In *The Genteel Tradition: Nine Essays by George Santayana*, edited by Douglas L. Wilson, pp. 37–64. Cambridge, Mass.: Harvard University Press, 1967.

Sante 1991
Sante, Luc. *Low Life: Lures and Snares of Old New York*. New York: Farrar, Straus, Giroux, 1991.

Santley 1871
Santley, Herbert. "Marriage." *Lippincott's Magazine of Popular Literature and Science* 8 (October 1871), pp. 395–403.

Saunders 1988
Saunders, Richard H. *Collecting the West: The C. R. Smith Collection of Western American Art*. Austin: University of Texas Press, 1988.

Saunders 1995
Saunders, Richard H. *John Smibert: Colonial America's First Portrait Painter*. New Haven and London: Yale University Press, 1995.

Scharnhorst 1980
Scharnhorst, Gary. *Horatio Alger, Jr.* Boston: Twayne Publishers, 1980.

Schimmel 1983
Schimmel, Julia Ann. "John Mix Stanley and Imagery of the West in Nineteenth-Century American Art." PhD diss., New York University, 1983.

Schimmel 1991–92
Schimmel, Julie. "Inventing 'the Indian.'" In Truettner et al. 1991–92, pp. 148–89.

Schlereth 1991
Schlereth, Thomas J. *Victorian America: Transformations in Everyday Life, 1876–1915*. New York: HarperCollins Publishers, 1991.

Schlesinger 2004
Schlesinger, Arthur M., Jr. *The Almanac of American History*. Rev. ed. 1983. New York: Barnes and Noble Books, 2004.

Schoener, ed. 1966
Schoener, Allon, ed. *The Lower East Side: Portal to American Life (1870–1924)*. Exh. cat., The Jewish Museum, New York, September 21–November 6, 1966. New York, 1966.

Schoener, ed. 1967
Schoener, Allon, ed. *Portal to America: The Lower East Side, 1870–1925, Photographs and Chronicles*. New York: Holt, Rinehart and Winston, 1967.

Schwartz 2006
Schwartz, David G. *Roll the Bones: The History of Gambling*. New York: Gotham Books, 2006.

Selchow and Righter 1888
Selchow and Righter. *Wholesale Catalogue of Games and Home Amusements, October 1, 1888*. [New York]: E. G. Selchow; J. H. Righter, [1888].

Sellers 1952
Sellers, Charles Coleman. *Portraits and Miniatures by Charles Willson Peale*. Transactions of the American Philosophical Society, 42, pt. 1. Philadelphia: American Philosophical Society, 1952.

Sellers 1969
Sellers, Charles Coleman. *Charles Willson Peale*. New York: Charles Scribner's Sons, 1969.

Semonin 2000
Semonin, Paul. *American Monster: How the Nation's First Prehistoric Creature Became a Symbol of National Identity*. New York: New York University Press, 2000.

Semonin 2004
Semonin, Paul. "Peale's Mastodon: The Skeleton in Our Closet." *Common-Place* 4, no. 2 (January 2004), unpaged. http://www.common-place.org (February 16, 2009).

Severa 1995
Severa, Joan L. *Dressed for the Photographer: Ordinary Americans and Fashion, 1840–1900*. Kent, Ohio: Kent State University Press, 1995.

Sewell et al. 2001–2
Sewell, Darrel, et al. *Thomas Eakins*. Exh. cat., Philadelphia Museum of Art, October 4, 2001–January 6, 2002; Musée d'Orsay, Paris, February 5–May 12, 2002; The Metropolitan Museum of Art, New York, June 18–September 15, 2002. Philadelphia: Philadelphia Museum of Art, 2001.

Shalhope 1990
Shalhope, Robert E. *The Roots of Democracy: American Thought and Culture, 1760–1800*. Boston: Twayne Publishers, 1990.

Shapiro 2003
Shapiro, Emily Dana. "Machine Crafted: The Image of the Artisan in American Genre Painting, 1877–1908." PhD diss., Stanford University, 2003.

Shinn 1876
Shinn, Earl [Edward Strahan, pseud.]. *The Masterpieces of the Centennial International Exhibition*. Vol. 1, *Fine Art*. Philadelphia: Gebbie and Barrie, Publishers, [1876].

Shinn, ed. 1879–80
Shinn, Earl [Edward Strahan, pseud.], ed. *The Art Treasures of America; Being the Choicest Works of Art in the Public and Private Collections of North America*. 3 vols. Philadelphia: George Barrie Publisher, [1879–80].

Siegfried 2007
Siegfried, Susan L. "Femininity and the Hybridity of Genre Painting." In *French Genre Painting in the Eighteenth Century* [Proceedings of a symposium held at the National Gallery of Art, Washington, D.C., December 12–13, 2003], edited by Philip Conisbee. Center for Advanced Study in the Visual Arts, Symposium Papers, 49. *Studies in the History of Art* 72 (2007), pp. 14–37.

Silbey 1977
Silbey, Joel H. *A Respectable Minority: The Democratic Party in the Civil War Era, 1860–1868*. New York: W. W. Norton Company, 1977.

Simpson 1996–97
Simpson, Marc. "*Swimming* Through Time: An Introduction." In Bolger and Cash et al. 1996–97, pp. 1–12.

Simpson 2001–2a
Simpson, Marc. "The 1870s." In Sewell et al. 2001–2, pp. 27–40, 390–94.

Simpson 2001–2b
Simpson, Marc. "The 1880s." In Sewell et al. 2001–2, pp. 107–20, 397–402.

Simpson 2001–2c
Simpson, Marc. "The 1890s." In Sewell et al. 2001–2, pp. 257–69, 415–19.

Simpson et al. 1988–89
Simpson, Marc, et al. *Winslow Homer: Paintings of the Civil War*. Exh. cat., The Fine Arts Museums of San Francisco, M. H. de Young Memorial Museum, July 2–September 18, 1988; Portland Museum of Art, October 8–December 18, 1988; Amon Carter Museum, Fort Worth, January 7–March 12, 1989. San Francisco: The Fine Arts Museums of San Francisco, 1988.

Simpson et al. 2008
Simpson, Marc, et al. *Like Breath on Glass: Whistler, Inness, and the Art of Painting Softly*. Exh. cat., Sterling and Francine Clark Art Institute, Williamstown, Massachusetts, June 22–October 19, 2008. Williamstown, Mass., 2008.

Sims, L., et al. 1991–92
Sims, Lowery Stokes, et al. *Stuart Davis, American Painter*. Exh. cat., The Metropolitan Museum of Art, New York, November 23, 1991–February 16, 1992; San Francisco Museum of Modern Art, March 26–June 7, 1992. New York: The Metropolitan Museum of Art, 1992.

Sims, P. 1985
Sims, Patterson. *Whitney Museum of American Art: Selected Works from the Permanent Collection*. New York: Whitney Museum of American Art; New York and London: W. W. Norton and Company, 1985.

Singleton 1991–92
Singleton, Theresa A. "The Archaeology of Slave Life." In *Before Freedom Came: African-American Life in the Antebellum South*, edited by Edward D. C. Campbell Jr. and Kym S. Rice, pp. 154–75, 188–91. Exh. cat., The Museum of the Confederacy, Richmond, Virginia, July–December 1991; McKissick Museum, University of South Carolina, Columbia, January–March 1992; National Afro-American Museum and Cultural Center, Wilberforce, Ohio, April–June 1992. Charlottesville, N.C.: University Press of Virginia, 1991.

Sloan 1939
Sloan, John. *Gist of Art: Principles and Practise Expounded in the Classroom and Studio*. New York: American Artists Group, 1939.

Slotkin 1992
Slotkin, Richard. *Gunfighter Nation: The Myth of the Frontier in Twentieth-Century America.* New York: Atheneum, 1992.

Smith-Rosenberg 1985
Smith-Rosenberg, Carroll. *Disorderly Conduct: Visions of Gender in Victorian America.* New York and Oxford: Oxford University Press, 1985.

Snay 2001
Snay, Mitchell. "Abraham Lincoln, Owen Lovejoy, and the Emergence of the Republican Party in Illinois." *Journal of the Abraham Lincoln Association* 22, no. 1 (Winter 2001), pp. 82–99.

Snyder 1989
Snyder, Robert W. *The Voice of the City: Vaudeville and Popular Culture in New York.* New York: Oxford University Press, 1989.

Snyder and Zurier 1995–96
Snyder, Robert W., and Rebecca Zurier. "Picturing the City." In Zurier, Snyder, and Mecklenburg 1995–96, pp. 84–189, 216–18.

Solkin, ed. 2001
Solkin, David H., ed. *Art on the Line: The Royal Academy Exhibitions at Somerset House, 1780–1836.* New Haven and London: Yale University Press, 2001.

Sotheby's, New York 1993
19th Century European Paintings, Drawings and Sculpture. Sotheby's, New York, sale no. 6428, May 26, 1993. New York, 1993.

Spassky et al. 1985
Spassky, Natalie, et al. *American Paintings in The Metropolitan Museum of Art.* Vol. 2, *A Catalogue of Works by Artists Born between 1816 and 1845.* Edited by Kathleen Luhrs. New York: The Metropolitan Museum of Art, 1985.

Spencer 1957
Spencer, Benjamin T. *The Quest for Nationality: An American Literary Campaign.* Syracuse, N.Y.: Syracuse University Press, 1957.

Staiti 1989
Staiti, Paul J. *Samuel F. B. Morse.* Cambridge Monographs on American Artists. Cambridge and New York: Cambridge University Press, 1989.

Staiti 1995–96a
Staiti, Paul [J.]. "Accounting for Copley." In Barratt and Staiti et al. 1995–96, pp. 25–51.

Staiti 1995–96b
Staiti, Paul [J.]. "Character and Class." In Barratt and Staiti et al. 1995–96, pp. 53–77.

Staiti 2001
Staiti, Paul [J.]. "Winslow Homer and the Drama of Thermodynamics." *American Art* 15, no. 1 (Spring 2001), pp. 10–33.

Standish 1908
Standish, W. Howard. "J. G. Brown: Painter of Humble Folk." *New Broadway Magazine* 19 (March 1908), p. 749.

Stebbins and Troyen et al. 1983–84
Stebbins, Theodore E., Jr., and Carol Troyen et al. *A New World: Masterpieces of American Painting, 1760–1910.* Exh. cat., Museum of Fine Arts, Boston, September 7–November 13, 1983; The Corcoran Gallery of Art, Washington, D.C., December 7, 1983–February 12, 1984; Grand Palais, Paris, March 16–June 11, 1984. Boston: Museum of Fine Arts, 1983.

Stebbins et al. 1992–93
Stebbins, Theodore E., Jr., et al. *The Lure of Italy: American Artists and the Italian Experience, 1760–1914.* Exh. cat., Museum of Fine Arts, Boston, September 16–December 13, 1992; The Cleveland Museum of Art, February 3–April 11, 1993; The Museum of Fine Arts, Houston, May 23–August 8, 1993. Boston: Museum of Fine Arts, 1992.

Stein, C., ed. 1984
Stein, Charles W., ed. *American Vaudeville as Seen by Its Contemporaries.* New York: Alfred A. Knopf, 1984.

Stein, R. 1975
Stein, Roger B. *Seascape and the American Imagination.* Exh. cat., Whitney Museum of American Art, New York, June 10–September 9, 1975. New York: Clarkson N. Potter; Whitney Museum of American Art, 1975.

Stein, R. 1976
Stein, Roger B. "Copley's *Watson and the Shark* and Aesthetics in the 1770s." In *Discoveries and Considerations: Essays on Early American Literature and Aesthetics,* edited by Calvin Israel, pp. 85–130. Albany, N.Y.: State University of New York Press, 1976.

Stein, R. 1981
Stein, Roger B. "Charles Willson Peale's Expressive Design: *The Artist in His Museum.*" *Prospects* 6 (1981), pp. 139–85.

Stine, Cabak, and Groover 1996
Stine, Linda France, Melanie A. Cabak, and Mark D. Groover. "Blue Beads as African-American Cultural Symbols." *Historical Archaeology* 30, no. 3 (1996), pp. 49–75.

St. John, ed. 1965
St. John, Bruce, ed. *John Sloan's New York Scene, from the Diaries, Notes and Correspondence, 1906–1913.* New York: Harper and Row, 1965.

Streeby 2002
Streeby, Shelley. *American Sensations: Class, Empire, and the Production of Popular Culture.* Berkeley and Los Angeles: University of California Press, 2002.

Strong 1952
Strong, George Templeton. *Diary.* Edited by Allan Nevins and Milton Halsey Thomas. 4 vols. New York: Macmillan, 1952.

Styles and Vickery 2006
Styles, John, and Amanda Vickery. *Gender, Taste, and Material Culture in Britain and North America, 1700–1830.* New Haven and London: Yale University Press, 2006.

Sutton, D. 1963
Sutton, Denys. *Nocturne: The Art of James McNeill Whistler.* London: Country Life Limited, 1963.

Sutton, R. 2003
Sutton, Robert P. *Communal Utopias and the American Experience: Religious Communities, 1732–2000.* Westport, Conn.: Praeger Publishers, 2003.

Sutton, R. 2004
Sutton, Robert P. *Communal Utopias and the American Experience: Secular Communities, 1824–2000.* Westport, Conn.: Praeger Publishers, 2004.

Tatar, ed. 2002
Tatar, Maria, ed. *The Annotated Classic Fairy Tales.* New York: W. W. Norton, 2002.

Taylor 1976
Taylor, Joshua C. "The American Cousin." In Taylor and Cawelti 1976, pp. 37–94.

Taylor and Cawelti 1976
Taylor, Joshua C., and John G. Cawelti. *America as Art*. New York: Harper and Row, 1976.

Tebbel 1963
Tebbel, John William. *From Rags to Riches: Horatio Alger, Jr. and the American Dream*. New York: Macmillan, 1963.

***Time* 1953**
Obituary of Thomas Joseph ("Sailor Tom") Sharkey. *Time* 61, no. 17 (April 27, 1953), p. 67.

Todd 1870
Todd, Sereno Edwards. *Todd's Country Homes and How to Save Money: A Practical Book by a Practical Man*. Hartford, Conn.: Hartford Pub[lishing] Co[mpany], 1870.

Torchia 1989a
Torchia, Robert W. *John Neagle: Philadelphia Portrait Painter*. Exh. cat., The Historical Society of Pennsylvania, Philadelphia, April 19–July 29, 1989. Philadelphia, 1989.

Torchia 1989b
Torchia, Robert W. "The *Pat Lyon* Case Reopened." In Torchia 1989a, pp. 77–92.

Tottis, ed. 2005
Tottis, James W., ed. *Forging a Modern Identity: Masters of American Painting Born after 1847*. American Paintings in the Detroit Institute of Arts, Vol. 3. Detroit: Detroit Institute of Arts; London: D. Giles Limited, 2005.

Tottis et al. 2007–8
Tottis, James W., et al. *Life's Pleasures: The Ashcan Artists' Brush with Leisure, 1895–1925*, Exh. cat., Frist Center for the Visual Arts, Nashville, August 2–October 28, 2007; The New-York Historical Society, November 18, 2007–February 10, 2008; Detroit Institute of Arts, March 2–May 25, 2008. London and New York: Merrell, 2007.

Townley 1870
Townley, D. O'C. "Art Gossip." *New York Evening Mail*, May 4, 1870, p. 1.

Trachtenberg 2007
Trachtenberg, Alan. *The Incorporation of America: Culture and Society in the Gilded Age*. 1982. New York: Hill and Wang, 2007.

Traubel 1953
Traubel, Horace. *With Walt Whitman in Camden*. Vol. 4, *January 21–April 7, 1889*. Edited by Sculley Bradley. Philadelphia: University of Pennsylvania Press, 1953.

Trollope 1832, 1949
Trollope, Frances. *Domestic Manners of the Americans*. Edited by Donald Smalley. 1832. New York: Alfred A. Knopf, 1949.

Troyen 1980–81
Troyen, Carol. *The Boston Tradition: American Paintings from the Museum of Fine Arts, Boston*. Exh. cat., Des Moines Art Center, November 25, 1980–January 7, 1981; The Museum of Fine Arts, Houston, February 6–March 29, 1981; Whitney Museum of American Art, New York, April 21–June 14, 1981; Pennsylvania Academy of the Fine Arts, Philadelphia, June 26–August 16, 1981. New York: The American Federation of Arts, 1980.

Troyen 1984
Troyen, Carol. "Innocents Abroad: American Painters at the 1867 Exposition Universelle, Paris." *The American Art Journal* 16, no. 4 (Autumn 1984), pp. 3–29.

Truettner 1991
Truettner, William H. "Reinterpreting Images of Westward Expansion, 1820–1920." *The Magazine Antiques* 139, no. 3 (March 1991), pp. 542–55.

Truettner 1991–92
Truettner, William H. "Ideology and Image." In Truettner et al. 1991–92, pp. 27–53.

Truettner et al. 1991–92
Truettner, William H., et al. *The West as America: Reinterpreting Images of the Frontier, 1820–1920*. Exh. cat., National Museum of American Art, Smithsonian Institution, Washington, D.C., March 15–July 7, 1991; The Denver Art Museum, August 3–October 13, 1991; Saint Louis Art Museum, November 9, 1991–January 12, 1992. Washington, D.C., and London: Smithsonian Institution Press, 1991.

Tuckerman 1847
Tuckerman, Henry T. *Artist-life: or, Sketches of American Painters*. New York: D. Appleton and Company; Philadelphia: Geo. S. Appleton, 1847.

Tuckerman 1867
Tuckerman, Henry T. *Book of the Artists*. New York: G. P. Putnam and Sons, 1867.

Tuckerman 1870, 1966
Tuckerman, Henry T. *Book of the Artists: American Artist Life, Comprising Biographical and Critical Sketches of American Artists, Preceded by an Historical Account of the Rise and Progress of Art in America*. 1867. Reprint of 2nd ed., 5th printing, 1870. New York: James F. Carr, 1966.

Turner 1893, 1894
Turner, Frederick Jackson. "The Significance of the Frontier in American History." Read July 12, 1893, American Historical Association, Chicago. Published in *Proceedings of the Forty-first Annual Meeting of the State Historical Society of Wisconsin, 1894*, pp. 79–112. Madison, Wis., 1894.

***United States Mail and Post Office Assistant* 1860**
"Official Courtesy, etc." *United States Mail and Post Office Assistant* 1 (November 1860), p. 1.

Upton 2000–2001
Upton, Dell. "Inventing the Metropolis: Civilization and Urbanity in Antebellum New York." In Voorsanger and Howat et al. 2000–2001, pp. 2–45.

Van Cott 1841
V[an] C[ott, J. M.]. "The City Article. The Barry Case." *Arcturus* 1, no. 3 (February 1841), pp. 176–85.

Van Dyke 1909
Van Dyke, John C. *The New New York: A Commentary on the Place and the People*. New York: The Macmillan Company, 1909.

Van Hook 1996
Van Hook, Bailey. *Angels of Art: Women and Art in American Society, 1876–1914*. University Park, Pa.: Pennsylvania State University Press, 1996.

Van Rensselaer 1881
Van Rensselaer, M[ariana] G[riswold]. "The New York Art Season." *The Atlantic Monthly* 48, no. 286 (August 1881), pp. 193–202.

Van Rensselaer 1892
Van Rensselaer, M[ariana] G[riswold]. "Picturesque New York." *The Century Magazine* 45, no. 2 (December 1892), pp. 164–75.

Veblen 1899
Veblen, Thorstein. *The Theory of the Leisure Class: An Economic Study in the Evolution of Institutions.* New York: The Macmillan Company; London: Macmillan and Co., 1899.

Vernon 1864
Vernon, H. J. "Croquet and Troco." *Peterson's Magazine* 45, no. 6 (June 1864), pp. 451–52.

Viele 1962
Viele, Chase. "Four Artists of Mid-Nineteenth Century Buffalo." *New York History* 43, no. 1 (January 1962), pp. 48–78.

Viele 1999
Viele, Chase. "From Flames to Fame: The 1865 Sidway Double Portrait." *Western New York Heritage* 3 (Winter 1999), pp. 32–42.

Viola, Crothers, and Hannan 1987–88
Viola, Herman J., H. B. Crothers, and Maureen Hannan. "The American Indian Genre Paintings of Catlin, Stanley, Wimar, Eastman, and Miller." In Hassrick et al. 1987–88, pp. 130–65.

Volo and Volo 2007
Volo, James M., and Dorothy Denneen Volo. *Family Life in Nineteeth-Century America.* Westport, Conn.: Greenwood Press, 2007.

Voorsanger and Howat et al. 2000–2001
Voorsanger, Catherine Hoover, and John K. Howat et al. *Art and the Empire City: New York, 1825–1861.* Exh. cat., The Metropolitan Museum of Art, New York, September 19, 2000–January 7, 2001. New York, 2000.

Wallach 1998
Wallach, Alan. "Long Term Visions, Short-Term Failures: Art Institutions in the United States, 1800–1860." In *Art in Bourgeois Society, 1790–1850,* edited by Andrew Hemingway and William Vaughan, pp. 297–313. Cambridge and New York: Cambridge University Press, 1998.

Waller 1879
Waller, Frank. *Report on Art Schools.* [New York: Art Students League], 1879.

Walter 1995
Walter, Marjorie Alison. "Fine Art and the Sweet Science: On Thomas Eakins, His Boxing Paintings, and Turn-of-the-Century Philadelphia." PhD diss., University of California, Berkeley, 1995.

Ward 1996–97
Ward, David C. "Democratic Culture: The Peale Museums, 1784–1850." In Miller, L., ed. 1996–97, pp. 260–75, 299–301.

Ward 2004
Ward, David C. *Charles Willson Peale: Art and Selfhood in the Early Republic.* Berkeley and Los Angeles: University of California Press, 2004.

Wehle et al. 1939
Wehle, Harry B., et al. *Life in America: A Special Loan Exhibition of Paintings Held during the Period of the New York World's Fair.* Exh. cat., The Metropolitan Museum of Art, New York, April 24–October 29, 1939. New York, 1939.

Weidner 2002
Weidner, Ruth Irwin. *The Lambdins of Philadelphia: Newly Discovered Works; The Lambdin Family Collection of Paintings by James Reid Lambdin and George Cochran Lambdin.* Exh cat., The Schwarz Gallery, Philadelphia, 2002. Philadelphia, 2002.

Weidner 2003
Weidner, Ruth Irwin. *The Lambdin Family Collection of Paintings by James Reid Lambdin and George Cochran Lambdin.* Exh. cat., The Schwarz Gallery, Philadelphia, 2003. Philadelphia, 2003.

Weinberg 1991
Weinberg, H. Barbara. *The Lure of Paris: Nineteenth-Century American Painters and Their French Teachers.* New York: Abbeville Press, 1991.

Weinberg 2006–7
Weinberg, H. Barbara. "Summers in the Country." In Adler, Hirshler, and Weinberg et al. 2006–7, pp. 114–77.

Weinberg, Bolger, and Curry 1994–95
Weinberg, H. Barbara, Doreen Bolger, and David Park Curry. *American Impressionism and Realism: The Painting of Modern Life, 1885–1915.* Exh. cat., The Metropolitan Museum of Art, New York, May 10–July 24, 1994; Amon Carter Museum, Fort Worth, August 21–October 30, 1994; The Denver Art Museum, December 3, 1994–February 5, 1995; Los Angeles County Museum of Art, March 12–May 14, 1995. New York: The Metropolitan Museum of Art, 1994.

Weisberg 1992
Weisberg, Gabriel P. *Beyond Impressionism: The Naturalist Impulse.* New York: Harry N. Abrams, 1992.

Wharton 1905, 1926
Wharton, Edith. *The House of Mirth.* 1905. New York: C[harles] Scribner's Sons, 1926.

Wharton 1934
Wharton, Edith. *A Backward Glance.* New York and London: D. Appleton–Century Company, 1934.

White 1891
White, Annie R. *Polite Society at Home and Abroad: A Complete Compendium of Information upon All Topics Classified under the Head of Etiquette.* Chicago and Philadelphia: Monarch Book Company, 1891.

Whiteing 1882
Whiteing, Richard. "Gallery and Studio: Henry Bacon." *The Art Amateur* 7, no. 6 (November 1882), pp. 111, 114–16.

Widmer 1999
Widmer, Edward L. *Young America: The Flowering of Democracy in New York City.* New York and Oxford: Oxford University Press, 1999.

Wiebe 1967
Wiebe, Robert H. *The Search for Order, 1877–1920.* The Making of America. New York: Hill and Wang, 1967.

Williams, H. 1961–62
Williams, Hermann Warner, Jr. *The Civil War: The Artist's Record.* Exh. cat., The Corcoran Gallery of Art, Washington, D.C., November 18–December 31, 1961; Museum of Fine Arts, Boston, February 1–March 4, 1962. Washington, D.C., and Boston, 1961.

Williams, H. 1973
Williams, Hermann Warner. *Mirror to the American Past: A Survey of American Genre Painting, 1750–1900.* Greenwich, Conn.: New York Graphic Society, 1973.

Williams, K., et al. 2004–5
Williams, Katherine, et al. *Women on the Verge: The Culture of Neurasthenia in Nineteenth-Century America*. Exh. cat., The Iris and B. Gerald Cantor Center for Visual Arts at Stanford University, Palo Alto, November 11, 2004–February 6, 2005. [Palo Alto, Calif.], 2004.

Williamson 1864
Williamson, T. S. "Art. III.—The Indian Tribes, and the Duty of the Government to Them." *American Presbyterian and Theological Review* 2, no. 8 (October 1864), pp. 587–611.

Wilmerding 1991
Wilmerding, John. "George Bellows's Boxing Pictures and the American Tradition." In *American Views: Essays on American Art*, pp. 305–28, 345. Princeton, N.J.: Princeton University Press, 1991.

Wilmington Society of the Fine Arts 1960
Wilmington Society of the Fine Arts. *The Fiftieth Anniversary of the Exhibition of Independent Artists in 1910*. Exh. cat., Delaware Art Center, Wilmington, January 9–February 21, 1960. Wilmington, Del., 1960.

Wilson 1985
Wilson, Christopher Kent. "Winslow Homer's *The Veteran in a New Field*: A Study of the Harvest Metaphor and Popular Culture." *The American Art Journal* 17, no. 4 (Autumn 1985), pp. 3–27.

Winner 1970
Winner, Viola Hopkins. *Henry James and the Visual Arts*. Charlottesville, Va.: The University Press of Virginia, 1970.

Wishy 1968
Wishy, Bernard. *The Child and the Republic: The Dawn of Modern American Child Nurture*. Philadelphia: University of Pennsylvania Press, 1968.

Wister 1902
Wister, Owen. *The Virginian: A Horseman of the Plains*. New York: The Macmillan Company; London: Macmillan and Co., 1902.

Wolf 1995
Wolf, Bryan J. "History as Ideology: Or, 'What You Don't See Can't Hurt You, Mr. Bingham.'" In Burnham and Giese, eds. 1995, pp. 242–62, 371–73.

Wolff 2002
Wolff, Justin. *Richard Caton Woodville: American Painter, Artful Dodger*. Princeton, N.J., and Oxford: Princeton University Press, 2002.

Wong 2000–2001
Wong, Janay. *Everett Shinn: The Spectacle of Life*. Exh. cat., Berry-Hill Galleries, New York, November 28, 2000–January 13, 2001. New York, 2000.

Wood, G. 1992
Wood, Gordon S. *The Radicalism of the American Revolution*. New York: Alfred A. Knopf, 1992.

Wood, P. 2004
Wood, Peter H. *Weathering the Storm: Inside Winslow Homer's Gulf Stream*. Mercer University Lamar Memorial Lectures, no. 46. Athens, Ga., and London: The University of Georgia Press, 2004.

Yochelson 1992
Yochelson, Ellis L. "Mr. Peale and His Mammoth Museum." *Proceedings of the American Philosophical Society* 136, no. 4 (December 1992), pp. 487–506.

Yount 1992
Yount, Sylvia L. "Consuming Drama: Everett Shinn and the Spectacular City." *American Art* 6, no. 4 (Fall 1992), pp. 86–109.

Zilczer 1984
Zilczer, Judith. "The Eight on Tour, 1908–1909." *The American Art Journal* 16, no. 3 (Summer 1984), pp. 20–48.

Zola 1880
Zola, Émile. *Nana*. Les Rougon-Macquart, [9]. Paris: G. Charpentier, 1880.

Zucker 1950
Zucker, A. E. "Theodor Kaufmann, Forty-eighter Artist." *The American-German Review* 17, no. 1 (October 1950), pp. 17–24.

Zurier 2006
Zurier, Rebecca. *Picturing the City: Urban Vision and the Ashcan School*. Berkeley and Los Angeles: University of California Press, 2006.

Zurier, Snyder, and Mecklenburg 1995–96
Zurier, Rebecca, Robert W. Snyder, and Virginia M. Mecklenburg. *Metropolitan Lives: The Ashcan Artists and Their New York*. Exh. cat., National Museum of American Art, Washington, D.C., November 17, 1995–March 17, 1996. Washington, D.C., 1995.

Works in the Exhibition

THOMAS ANSHUTZ, 1851–1912

The Ironworkers' Noontime, 1880

Oil on canvas, 17 × 23⅞ in. (43.2 × 60.6 cm)
Fine Arts Museums of San Francisco. Gift of Mr. and Mrs. John D.
Rockefeller 3rd 1979.7.4 (fig. 156)

HENRY BACON, 1839–1912

First Sight of Land, 1877

Oil on canvas, 28¾ × 19⅞ in. (73 × 50.5 cm)
In the collection of Art and Elaine Baur (fig. 107)

GEORGE BELLOWS, 1882–1925

Cliff Dwellers, 1913

Oil on canvas, 40¼ × 42⅛ in. (102.1 × 106.8 cm)
Los Angeles County Museum of Art. Los Angeles County Fund 16.4
(fig. 175)

Club Night, 1907

Oil on canvas, 43 × 53⅛ in. (109.2 × 135 cm)
National Gallery of Art, Washington, D.C. John Hay Whitney
Collection 1982.76.1 (fig. 174)

GEORGE CALEB BINGHAM, 1811–1879

The County Election, 1852

Oil on canvas, 38 × 52 in. (96.5 × 132.1 cm)
Saint Louis Art Museum. Gift of Bank of America 44:2001 (fig. 44)

Fur Traders Descending the Missouri, 1845

Oil on canvas, 29 × 36½ in. (73.7 × 92.7 cm)
The Metropolitan Museum of Art, New York. Morris K. Jesup Fund,
1933 33.61 (fig. 48)

The Jolly Flatboatmen, 1846

Oil on canvas, 38⅛ × 48½ in. (96.8 × 123.2 cm)
Manoogian Collection (fig. 49)

Shooting for the Beef, 1850

Oil on canvas, 33⅜ × 49 in. (84.8 × 124.5 cm)
Brooklyn Museum. Dick S. Ramsay Fund 40.342 (fig. 50)
MMA only

CHARLES FELIX BLAUVELT, 1824–1900

A German Immigrant Inquiring His Way, 1855

Oil on canvas, 36⅛ × 29 in. (91.8 × 73.7 cm)
North Carolina Museum of Art, Raleigh. Purchased with funds from
the State of North Carolina 52.9.2 (fig. 63)

DAVID GILMOUR BLYTHE, 1815–1865

Post Office, ca. 1859–63

Oil on canvas, 24 × 20⅛ in. (61 × 51.1 cm)
Carnegie Museum of Art, Pittsburgh. Purchase 42.9 (fig. 71)

JOHN GEORGE BROWN, 1831–1913

The Card Trick, 1880–89

Oil on canvas mounted on panel, 26 × 31 in. (66 × 78.7 cm)
Joslyn Art Museum, Omaha, Nebraska. Gift of the Estate of Sarah
Joslyn JAM1944.14 (fig. 136)

The Music Lesson, 1870

Oil on canvas, 24 × 20 in. (61 × 50.8 cm)
The Metropolitan Museum of Art, New York. Gift of Colonel Charles A.
Fowler, 1921 21.115.3 (fig. 93)
MMA only

GEORGE DE FOREST BRUSH, 1855–1941

The Picture Writer's Story, ca. 1884

Oil on canvas, 23 × 36 in. (58.4 × 91.4 cm)
The Anschutz Collection (fig. 152)

WILLIAM HENRY BURR, 1819–1908

The Intelligence Office, 1849

Oil on canvas, 22 × 27 in. (55.9 × 68.6 cm)
Collection of The New-York Historical Society. Museum Purchase,
Abbott-Lenox Fund, 1959 1959.46 (fig. 62)

MARY CASSATT, 1844–1926

The Cup of Tea, ca. 1880–81

Oil on canvas, 36⅜ × 25¾ in. (92.4 × 65.4 cm)
The Metropolitan Museum of Art, New York. From the Collection of
James Stillman, Gift of Dr. Ernest G. Stillman, 1922 22.16.17 (fig. 121)
LACMA only

Lady at the Tea Table, 1883–85

Oil on canvas, 29 × 24 in. (73.7 × 61 cm)
The Metropolitan Museum of Art, New York. Gift of the artist, 1923
23.101 (fig. 122)
MMA only

Little Girl in a Blue Armchair, 1878

Oil on canvas, 35½ × 51⅛ in. (89.5 × 129.8 cm)
National Gallery of Art, Washington, D.C. Collection of
Mr. and Mrs. Paul Mellon 1983.1.18 (fig. 114)

Mother About to Wash Her Sleepy Child, 1880

Oil on canvas, 39½ × 25⅞ in. (100.3 × 65.8 cm)
Los Angeles County Museum of Art. Mrs.
Fred Hathaway Bixby Bequest M.62.8.14 (fig. 124)
LACMA only

A Woman and a Girl Driving, 1881

Oil on canvas, 35¼ × 51⅜ in. (89.7 × 130.5 cm)
Philadelphia Museum of Art. Purchased with the W. P. Wilstach Fund,
1921 W1921-1-1 (fig. 120)
MMA only

Young Mother Sewing, 1900

Oil on canvas, 36⅜ × 29 in. (92.4 × 73.7 cm)
The Metropolitan Museum of Art, New York. H. O. Havemeyer Collection,
Bequest of Mrs. H. O. Havemeyer, 1929 29.100.48 (fig. 125)
MMA only

WILLIAM MERRITT CHASE, 1849 – 1916

Idle Hours, ca. 1894

Oil on canvas, 39 × 48⅝ in. (99.1 × 123.5 cm)
Amon Carter Museum, Fort Worth, Texas 1982.1 (fig. 128)
MMA only

The Lake for Miniature Yachts, ca. 1888

Oil on canvas, 16 × 24 in. (40.6 × 61 cm)
The Terian Collection of American Art (fig. 165)

The Open Air Breakfast, ca. 1887

Oil on canvas, 37½ × 56¾ in. (95.3 × 144.1 cm)
Toledo Museum of Art, Ohio. Purchased with funds from the Florence
Scott Libbey Bequest in Memory of her Father, Maurice A. Scott
1953.136 (fig. 126)
MMA only

Ring Toss, 1896

Oil on canvas, 40⅜ × 35⅛ in. (102.6 × 89.2 cm)
Marie and Hugh Halff (fig. 134)
MMA only

The Tenth Street Studio, 1880

Oil on canvas, 40⅜ × 52½ in. (102.6 × 133.4 cm)
Saint Louis Art Museum. Bequest of Albert Blair 48:1933 (fig. 104)

JOHN SINGLETON COPLEY, 1738 – 1815

Paul Revere, 1768

Oil on canvas, 35⅛ × 28½ in. (89.2 × 72.4 cm)
Museum of Fine Arts, Boston. Gift of Joseph W. Revere, William B. Revere,
and Edward H. R. Revere 30.781 (fig. 7)

Watson and the Shark, 1778

Oil on canvas, 71¾ × 90½ in. (182.1 × 229.7 cm)
National Gallery of Art, Washington, D.C. Ferdinand Lammot Belin
Fund 1963.6.1 (fig. 10)

CHARLES DEAS, 1818 – 1867

The Death Struggle, 1845

Oil on canvas, 30 × 25 in. (76.2 × 63.5 cm)
Collections of the Shelburne Museum, Shelburne, Vermont
27.1.5-018 (fig. 54)

THOMAS WILMER DEWING, 1851 – 1938

A Reading, 1897

Oil on canvas, 20¼ × 30¼ in. (51.3 × 76.8 cm)
Smithsonian American Art Museum. Bequest of Henry Ward Ranger
through the National Academy of Design 1948.10.5 (fig. 130)

THOMAS EAKINS, 1844 – 1916

Between Rounds, 1898 – 99

Oil on canvas, 50⅛ × 39⅞ in. (127.3 × 101.3 cm)
Philadelphia Museum of Art. Gift of Mrs. Thomas Eakins and
Miss Mary Adeline Williams, 1929 1929-184-16 (fig. 159)
MMA only

The Champion Single Sculls (Max Schmitt in a Single Scull), 1871

Oil on canvas, 32¼ × 46¼ in. (81.9 × 117.5 cm)
The Metropolitan Museum of Art, New York. Purchase, The Alfred N.
Punnett Endowment Fund and George D. Pratt Gift, 1934 34.92 (fig. 97)
MMA only

Singing a Pathetic Song, 1881

Oil on canvas, 45 × 32¼ in. (114.3 × 81.8 cm)
Corcoran Gallery of Art, Washington, D.C. Museum Purchase,
Gallery Fund 19.26 (fig. 119)

Swimming, 1885

Oil on canvas, 27⅜ × 36⅜ in. (69.5 × 92.4 cm)
Amon Carter Museum, Fort Worth, Texas. Purchased by the Friends
of Art, Fort Worth Art Association, 1925; acquired by the Amon Carter
Museum, 1990, from the Modern Art Museum of Fort Worth through
grants and donations from the Amon G. Carter Foundation, the Sid W.
Richardson Foundation, the Anne Burnett and Charles Tandy Foundation,
Capital Cities/ABC Foundation, Fort Worth Star-Telegram, The R. D. and
Joan Dale Hubbard Foundation, and the people of Fort Worth 1990.19.1
(fig. 157)
MMA only

RALPH EARL, 1751 – 1801

Elijah Boardman, 1789

Oil on canvas, 83 × 51 in. (210.8 × 129.5 cm)
The Metropolitan Museum of Art, New York. Bequest of Susan W. Tyler,
1979 1979.395 (fig. 16)
MMA only

FRANCIS WILLIAM EDMONDS, 1806 – 1863

The City and Country Beaux, ca. 1838 – 40

Oil on canvas, 20⅛ × 24¼ in. (51.1 × 61.6 cm)
Sterling and Francine Clark Art Institute, Williamstown, Massachusetts
1955.915 (fig. 37)

The Image Pedlar, ca. 1844

Oil on canvas, 33¼ × 42¼ in. (84.5 × 107.3 cm)
Collection of The New-York Historical Society. Gift of The New-York Gallery of the Fine Arts 1858.71 (fig. 26)

The New Bonnet, 1858

Oil on canvas, 25 × 30⅛ in. (63.5 × 76.5 cm)
The Metropolitan Museum of Art, New York. Purchase, Erving Wolf Foundation Gift and Gift of Hanson K. Corning, by exchange, 1975
1975.27.1 (fig. 34)

WILLIAM GLACKENS, 1870–1938

The Shoppers, 1907–8

Oil on canvas, 60 × 60 in. (152.4 × 152.4 cm)
Chrysler Museum of Art, Norfolk, Virginia. Gift of Walter P. Chrysler Jr.
71.651 (fig. 169)

JOHN GREENWOOD, 1727–1792

Sea Captains Carousing in Surinam, ca. 1752–58

Oil on bed ticking, 37¾ × 75¼ in. (95.9 × 191.1 cm)
Saint Louis Art Museum. Museum Purchase 256:1948 (fig. 4)

SEYMOUR JOSEPH GUY, 1824–1910

The Contest for the Bouquet: The Family of Robert Gordon in Their New York Dining-Room, 1866

Oil on canvas, 24⅝ × 29½ in. (62.5 × 74.9 cm)
The Metropolitan Museum of Art, New York. Purchase, Gift of William E. Dodge, by exchange, and Lila Acheson Wallace Gift, 1992 1992.128 (fig. 86)
MMA only

Making a Train, 1867

Oil on canvas, 18⅛ × 24⅛ in. (46 × 61.3 cm)
Philadelphia Museum of Art. The George W. Elkins Collection, 1924
E1924-4-14 (fig. 91)
MMA only

Story of Golden Locks, ca. 1870

Oil on canvas, 34 × 28 in. (86.4 × 71.1 cm)
Lent by Mathew Wolf and Daniel Wolf, in memory of Diane R. Wolf
(fig. 90)

WINSLOW HOMER, 1836–1910

Breezing Up (A Fair Wind), 1873–76

Oil on canvas, 24¼ × 38¼ in. (61.5 × 97 cm)
National Gallery of Art, Washington, D.C. Gift of the W. L. and May T. Mellon Foundation 1943.13.1 (fig. 100)

The Cotton Pickers, 1876

Oil on canvas, 24⅛ × 38⅛ in. (61.1 × 96.8 cm)
Los Angeles County Museum of Art. Acquisition made possible through Museum Trustees: Robert O. Anderson, R. Stanton Avery, B. Gerald Cantor, Edward W. Carter, Justin Dart, Charles E. Ducommun, Camilla Chandler Frost, Julian Ganz Jr., Dr. Armand Hammer, Harry Lenart, Dr. Franklin D. Murphy, Mrs. Joan Palevsky, Richard E. Sherwood, Maynard J. Toll, and Hal B. Wallis M.77.68 (fig. 101)
LACMA only

Croquet Scene, 1866

Oil on canvas, 15⅞ × 26⅛ in. (40.3 × 66.2 cm)
The Art Institute of Chicago. Friends of American Art Collection, Goodman Fund 1942.35 (fig. 95)

Dressing for the Carnival, 1877

Oil on canvas, 20 × 30 in. (50.8 × 76.2 cm)
The Metropolitan Museum of Art, New York. Amelia B. Lazarus Fund, 1922 22.220 (fig. 102)
MMA only

Eagle Head, Manchester, Massachusetts (High Tide), 1870

Oil on canvas, 26 × 38 in. (66 × 96.5 cm)
The Metropolitan Museum of Art, New York. Gift of Mrs. William F. Milton, 1923 23.77.2 (fig. 96)

The Gale, 1883–93

Oil on canvas, 30¼ × 48¼ in. (76.8 × 122.7 cm)
Worcester Art Museum, Massachusetts. Museum Purchase 1916.48
(fig. 142)
MMA only

The Gulf Stream, 1899

Oil on canvas, 28⅛ × 49⅛ in. (71.4 × 124.8 cm)
The Metropolitan Museum of Art, New York. Catherine Lorillard Wolfe Collection, Wolfe Fund, 1906 06.1234 (fig. 160)

Pitching Quoits, 1865

Oil on canvas, 26¾ × 53¾ in. (68 × 136.5 cm)
Harvard University Art Museums, Fogg Art Museum. Gift of Mr. and Mrs. Frederic Haines Curtiss 1940.298 (fig. 79)
MMA only

Snap the Whip, 1872

Oil on canvas, 12 × 20 in. (30.5 × 50.8 cm)
The Metropolitan Museum of Art, New York. Gift of Christian A. Zabriskie, 1950 50.41 (fig. 89)
MMA only

The Veteran in a New Field, 1865

Oil on canvas, 24⅛ × 38⅛ in. (61.3 × 96.8 cm)
The Metropolitan Museum of Art, New York. Bequest of Miss Adelaide Milton de Groot (1876–1967), 1967 67.187.131 (fig. 82)

CHARLES CROMWELL INGHAM, 1796–1863

The Flower Girl, 1846

Oil on canvas, 36 × 28⅞ in. (91.4 × 73.3 cm)
The Metropolitan Museum of Art, New York. Gift of William Church Osborn, 1902 02.7.1 (fig. 61)
MMA only

EASTMAN JOHNSON, 1824–1906

Negro Life at the South, 1859

Oil on canvas, 36 × 45¼ in. (91.4 × 114.9 cm)
Collection of The New-York Historical Society. The Robert L. Stuart Collection, on permanent loan from The New York Public Library
S-225 (fig. 67)

The New Bonnet, 1876

Oil on academy board, 20¾ × 27 in. (52.7 × 68.6 cm)
The Metropolitan Museum of Art, New York. Bequest of Collis P.
Huntington, 1900 25.110.11 (fig. 99)

Not at Home (An Interior of the Artist's House), ca. 1873

Oil on laminated paperboard, 26½ × 22⅜ in. (67.1 × 56.7 cm)
Brooklyn Museum. Gift of Gwendolyn O. L. Conkling 40.60 (fig. 87)
MMA only

Sugaring Off, ca. 1865

Oil on canvas, 34 × 54 in. (86.4 × 137.2 cm)
The Huntington Library, Art Collections, and Botanical Gardens, San
Marino. Gift of the Virginia Steele Scott Foundation 83.8.28 (fig. 69)

THEODOR KAUFMANN, 1814–1896

On to Liberty, 1867

Oil on canvas, 36 × 56 in. (91.4 × 142.2 cm)
The Metropolitan Museum of Art, New York. Gift of Erving and Joyce
Wolf, in memory of Diane R. Wolf, 1982 1982.443.3 (fig. 83)
MMA only

JOHN LEWIS KRIMMEL, 1786–1821

Fourth of July in Centre Square, 1812

Oil on canvas, 22¾ × 29 in. (57.8 × 73.7 cm)
Pennsylvania Academy of the Fine Arts, Philadelphia. Pennsylvania
Academy purchase from the estate of Paul Beck Jr. 1845.3.1 (fig. 19)

The Quilting Frolic, 1813

Oil on canvas, 16¾ × 22¼ in. (42.5 × 56.5 cm)
Winterthur Museum. Museum Purchase 1953.0178.002A (fig. 20)
MMA only

GEORGE COCHRAN LAMBDIN, 1830–1896

The Consecration, 1861, 1865

Oil on canvas, 24 × 18¼ in. (61 × 46.4 cm)
Indianapolis Museum of Art. James E. Roberts Fund 71.179 (fig. 80)

THOMAS LE CLEAR, 1818–1882

Buffalo Newsboy, 1853

Oil on canvas, 24 × 20 in. (61 × 50.8 cm)
Albright-Knox Art Gallery, Buffalo, New York. Charlotte A. Watson Fund,
1942 1942:3 (fig. 58)
MMA only

Interior with Portraits, ca. 1865

Oil on canvas, 25⅞ × 40½ in. (65.7 × 102.9 cm)
Smithsonian American Art Museum. Museum purchase made possible by
the Pauline Edwards Bequest 1993.6 (fig. 68)

Young America, ca. 1863

Oil on canvas, 26½ × 34 in. (67.3 × 86.4 cm)
Anonymous Loan (fig. 74)
MMA only

CHRISTIAN FRIEDRICH MAYR, 1803–1851

Kitchen Ball at White Sulphur Springs, Vi rginia, 1838

Oil on canvas, 24 × 29½ in. (61 × 74.9 cm)
North Carolina Museum of Art, Raleigh. Purchased with funds from
the State of North Carolina 52.9.23 (fig. 66)

SAMUEL F. B. MORSE, 1791–1872

Gallery of the Louvre, 1831–33

Oil on canvas, 73¾ × 108 in. (187.3 × 274.3 cm)
Terra Foundation for American Art, Chicago. Daniel J. Terra Collection
1992.51 (fig. 22)

HENRY MOSLER, 1841–1920

Just Moved, 1870

Oil on canvas, 29 × 36½ in. (73.7 × 92.7 cm)
The Metropolitan Museum of Art, New York. Arthur Hoppock Hearn
Fund, 1962 62.80 (fig. 88)
MMA only

WILLIAM SIDNEY MOUNT, 1807–1868

Bargaining for a Horse (Farmers Bargaining), 1835

Oil on canvas, 24 × 30 in. (61 × 76.2 cm)
Collection of The New-York Historical Society. Gift of The New-York
Gallery of the Fine Arts 1858.59 (fig. 30)
MMA only

Cider Making, 1840–41

Oil on canvas, 27 × 34⅛ in. (68.6 × 86.7 cm)
The Metropolitan Museum of Art, New York. Purchase, Bequest of Charles
Allen Munn, by exchange, 1966 66.126 (fig. 47)
MMA only

Eel Spearing at Setauket, 1845

Oil on canvas, 28½ × 36 in. (72.4 × 91.4 cm)
Fenimore Art Museum, Cooperstown, New York N-395.55 (fig. 64)

The Painter's Triumph, 1838

Oil on wood, 19½ × 23½ in. (49.5 × 59.7 cm)
Pennsylvania Academy of the Fine Arts, Philadelphia. Bequest of
Henry C. Carey (The Carey Collection) 1879.8.18 (fig. 25)

The Power of Music, 1847

Oil on canvas, 17⅛ × 21⅛ in. (43.4 × 53.5 cm)
The Cleveland Museum of Art. Leonard C. Hanna Jr. Fund 1991.110
(fig. 65)

JOHN NEAGLE, 1796–1865

Pat Lyon at the Forge, 1829

Oil on canvas, 94½ × 68½ in. (240 × 174 cm)
Pennsylvania Academy of the Fine Arts, Philadelphia. Gift of the Lyon
Family 1842.1 (fig. 11)
MMA only

WILLIAM McGREGOR PAXTON, 1869–1941

The Breakfast, 1911

Oil on canvas, 28¼ × 35¼ in. (71.8 × 89.5 cm)
Ted Slavin (fig. 133)

Tea Leaves, 1909

Oil on canvas, 36⅛ × 28¾ in. (91.6 × 71.9 cm)
The Metropolitan Museum of Art, New York. Gift of George A. Hearn,
1910 10.64.8 (fig. 132)
MMA only

CHARLES WILLSON PEALE, 1741–1827

The Artist in His Museum, 1822

Oil on canvas, 103¾ × 79⅞ in. (263.5 × 202.9 cm)
Pennsylvania Academy of the Fine Arts, Philadelphia. Gift of Mrs. Sarah
Harrison (The Joseph Harrison Jr. Collection) 1878.1.2 (fig. 17)
MMA only

Benjamin and Eleanor Ridgely Laming, 1788

Oil on canvas, 41¾ × 60 in. (106 × 152.5 cm)
National Gallery of Art, Washington, D.C. Gift of Morris Schapiro
1966.10.1 (fig. 12)

The Exhumation of the Mastodon, 1805–8

Oil on canvas, 50 × 62½ in. (127 × 158.8 cm)
Maryland Historical Society BCLM-MA.5911 (fig. 18)

ENOCH WOOD PERRY, 1831–1915

Talking It Over, 1872

Oil on canvas, 22¼ × 29¼ in. (56.5 × 74.3 cm)
The Metropolitan Museum of Art, New York. Gift of Erving and Joyce
Wolf, in memory of Diane R. Wolf, 1980 1980.361 (fig. 98)
MMA only

MATTHEW PRATT, 1734–1805

The American School, 1765

Oil on canvas, 36 × 50¼ in. (91.4 × 127.6 cm)
The Metropolitan Museum of Art, New York. Gift of Samuel P. Avery,
1897 97.29.3 (fig. 2)

WILLIAM TYLEE RANNEY, 1813–1857

Advice on the Prairie, ca. 1853

Oil on canvas, 38¾ × 55¼ in. (98.4 × 140.3 cm)
Buffalo Bill Historical Center, Cody, Wyoming. Gift of Mrs. J. Maxwell
Moran 10.91 (fig. 51)

FREDERIC REMINGTON, 1861–1909

Fight for the Water Hole, 1903

Oil on canvas, 27¼ × 40⅛ in. (69.2 × 102 cm)
The Museum of Fine Arts, Houston. The Hogg Brothers Collection,
gift of Miss Ima Hogg 43.25 (fig. 164)

THEODORE ROBINSON, 1852–1896

The Wedding March, 1892

Oil on canvas, 22¼ × 26½ in. (56.7 × 67.3 cm)
Terra Foundation for American Art, Chicago. Daniel J. Terra Collection
1999.127 (fig. 117)

JOHN SINGER SARGENT, 1856–1925

In the Luxembourg Gardens, 1879

Oil on canvas, 25⅞ × 36⅜ in. (65.7 × 92.4 cm)
Philadelphia Museum of Art. John G. Johnson Collection, 1917
Cat. 1080 (fig. 109)
MMA only

An Interior in Venice, 1899

Oil on canvas, 26 × 32⅞ in. (66 × 83.5 cm)
Royal Academy of Arts, London 03/1387 (fig. 113)
MMA only

Mosquito Nets, 1908

Oil on canvas, 22½ × 28¼ in. (57.2 × 71.8 cm)
The Detroit Institute of Arts. Founders Society Purchase, Robert H.
Tannahill Foundation Fund, and Founders Society Acquisition Funds
1993.18 (fig. 131)
MMA only

The Sketchers, ca. 1913

Oil on canvas, 22 × 28 in. (55.9 × 71.1 cm)
Virginia Museum of Fine Arts, Richmond. The Arthur and Margaret
Glasgow Fund 58.11 (fig. 177)

A Street in Venice, ca. 1880–82

Oil on canvas, 29⅝ × 20⅝ in. (75.1 × 52.4 cm)
Sterling and Francine Clark Art Institute, Williamstown, Massachusetts
1955.575 (fig. 112)

CHARLES SCHREYVOGEL, 1861–1912

My Bunkie, 1899

Oil on canvas, 25⅛ × 34 in. (64 × 86.4 cm)
The Metropolitan Museum of Art, New York. Gift of the friends of
the artist, by subscription, 1912 12.227 (fig. 162)

EVERETT SHINN, 1876–1953

The Orchestra Pit, Old Proctor's Fifth Avenue Theatre, 1906–7

Oil on canvas, 17½ × 19½ in. (44.3 × 49.5 cm)
Yale University Art Gallery. Bequest of Arthur G. Altschul, B.A. 1943
2002.132.1 (fig. 172)

JOHN SLOAN, 1871–1951

Chinese Restaurant, 1909

Oil on canvas, 26 × 32¼ in. (66 × 81.9 cm)
Memorial Art Gallery of the University of Rochester. Marion Stratton
Gould Fund 51.12 (fig. 166)

The Picnic Grounds, 1906–7

Oil on canvas, 24 × 36 in. (61 × 91.4 cm)
Whitney Museum of American Art, New York. Purchase 41.34 (fig. 167)

Sunday, Women Drying Their Hair, 1912

Oil on canvas, 26⅛ × 32⅛ in. (66.4 × 81.6 cm)
Addison Gallery of American Art, Phillips Academy, Andover,
Massachusetts 1938.67 (fig. 168)
MMA only

ALLEN SMITH JR., 1810–1890

The Young Mechanic, 1848

Oil on canvas, 40¼ × 32⅛ in. (102.2 × 81.6 cm)
Los Angeles County Museum of Art. Gift of the American Art Council
and Mr. and Mrs. J. Douglas Pardee M.81.179 (fig. 60)

LILLY MARTIN SPENCER, 1822–1902

Kiss Me and You'll Kiss the 'Lasses, 1856

Oil on canvas, 29⅞ × 24⅞ in. (76 × 63.3 cm)
Brooklyn Museum. A. Augustus Healy Fund 70.26 (fig. 41)

Reading the Legend, 1852

Oil on canvas, 50⅜ × 38 in. (128 × 96.5 cm)
Smith College Museum of Art, Northampton, Massachusetts.
Gift of Adeline Flint Wing, class of 1898, and Caroline Roberta Wing,
class of 1896 SC 1954:69 (fig. 40)
MMA only

Young Husband: First Marketing, 1854

Oil on canvas, 29½ × 24¾ in. (74.9 × 62.9 cm)
Private collection (fig. 43)

JOHN MIX STANLEY, 1814–1872

Gambling for the Buck, 1867

Oil on canvas, 20 × 15⅞ in. (50.8 × 40.3 cm)
Stark Museum of Art, Orange, Texas 31.23.11 (fig. 84)
MMA only

GILBERT STUART, 1755–1828

Anna Dorothea Foster and Charlotte Anna Dick, 1790–91

Oil on canvas, 36 × 37 in. (91.4 × 94 cm)
Philip and Charlotte Hanes (fig. 14)

ARTHUR FITZWILLIAM TAIT, 1819–1905

The Life of a Hunter: A Tight Fix, 1856

Oil on canvas, 40 × 60 in. (101.6 × 152.4 cm)
Crystal Bridges Museum of American Art, Bentonville, Arkansas (fig. 52)

JEROME B. THOMPSON, 1814–1886

The Belated Party on Mansfield Mountain, 1858

Oil on canvas, 38 × 63⅛ in. (96.5 × 160.3 cm)
The Metropolitan Museum of Art, New York. Rogers Fund, 1969
69.182 (fig. 39)
MMA only

FRANK WALLER, 1842–1923

*Interior View of the Metropolitan Museum of Art when in
Fourteenth Street*, 1881

Oil on canvas, 24 × 20 in. (61 × 50.8 cm)
The Metropolitan Museum of Art, New York. Purchase, 1895 95.29
(fig. 118)

JAMES MCNEILL WHISTLER, 1834–1903

Cremorne Gardens, No. 2, 1872–77

Oil on canvas, 27 × 53⅛ in. (68.6 × 134.9 cm)
The Metropolitan Museum of Art, New York. John Stewart Kennedy Fund,
1912 12.32 (fig. 110)
MMA only

RICHARD CATON WOODVILLE, 1825–1855

Old '76 and Young '48, 1849

Oil on canvas, 21 × 26⅞ in. (53.3 × 68.2 cm)
The Walters Art Museum, Baltimore, Maryland 37.2370 (fig. 35)

Politics in an Oyster House, 1848

Oil on canvas, 16 × 13 in. (40.6 × 33 cm)
The Walters Art Museum, Baltimore, Maryland. Gift of C. Morgan
Marshall, 1945 37.1994 (fig. 45)

War News from Mexico, 1848

Oil on canvas, 27 × 25 in. (68.6 × 63.5 cm)
Crystal Bridges Museum of American Art, Bentonville, Arkansas (fig. 46)

Index

Photograph Credits

We thank the owners of the works included in this book, as named in the captions, for providing photographs and permission to reproduce them. Additional photograph credits are given below.

© Addison Gallery of American Art, Phillips Academy, Andover, Mass. All Rights Reserved: fig. 168.

© The Art Institute of Chicago: figs. 95, 171

Camerarts, Inc.: fig. 1

© 2007 Carnegie Museum of Art, Pittsburgh: figs. 28, 71

© The Cleveland Museum of Art: fig. 65

Sheldan C. Collins: fig. 167

David Stansbury Photography: fig. 74

© 2009 Delaware Art Museum/Artists Rights Society (ARS), N.Y.: figs. 166, 167, 168

© 1993 The Detroit Institute of Arts: fig. 131

Courtesy of Karl Gabosh: fig. 74

© The Estate of William Glackens, courtesy Kraushaar Galleries Inc., N.Y.: figs. 169, 171

Godel & Co. Fine Art, Inc.: fig. 42

Katya Kallsen. © President and Fellows of Harvard College: fig. 79

© Courtesy of the Huntington Library, Art Collections, and Botanical Gardens, San Marino: fig. 69

© Indianapolis Museum of Art: fig. 80

© The Metropolitan Museum of Art, N.Y.: figs. 2, 3, 16, 24, 27, 32, 34, 39, 47, 48, 61, 82, 83, 86, 88, 89, 93, 96, 97, 98, 99, 102, 107, 110, 118, 121, 122, 125, 132, 139, 144, 145, 150, 160, 162, 170

© 2009 Museum Associates/LACMA: figs. 57, 60, 101, 124, 175, 176

© 2009 Museum of Fine Arts, Boston: figs. 7, 13, 29, 106, 135

Courtesy of the Board of Trustees, National Gallery of Art, Washington, D.C.: figs. 10, 12, 15, 100, 114, 174

William J. O'Connor: figs. 56, 152

Andy Olenick: fig. 166

Hervé Lewandowski. Réunion des Musées Nationaux/Art Resource, N.Y.: figs. 123, 146, 173

R. G. Ojeda. Réunion des Musées Nationaux/Art Resource, N.Y.: fig. 111

Prudence Cuming Associates. © Royal Academy of Arts, London: fig. 113

© Shelburne Museum, Shelburne, Vt.: fig. 54

© Courtesy of Sotheby's, Inc., 1995: fig. 72

© Sterling and Francine Clark Art Institute, Williamstown, Mass.: figs. 37, 112, 143

Terra Foundation for American Art, Chicago/Art Resource, N.Y.: figs. 22, 117

© Toledo Museum of Art, 2008: fig. 126

Wen Hwa Ts'ao. © Virginia Museum of Fine Arts, Richmond: fig. 177

Katherine Wetzel. © Virginia Museum of Fine Arts, Richmond: figs. 31, 140

© The Walters Art Museum, Baltimore: figs. 35, 45

Jim Schneck. Courtesy Winterthur Museum: fig. 20

Graydon Wood: figs. 8, 91, 109, 120, 138, 159